LUMINOUS ART

HANUKKAH MENORAHS *of* THE JEWISH MUSEUM

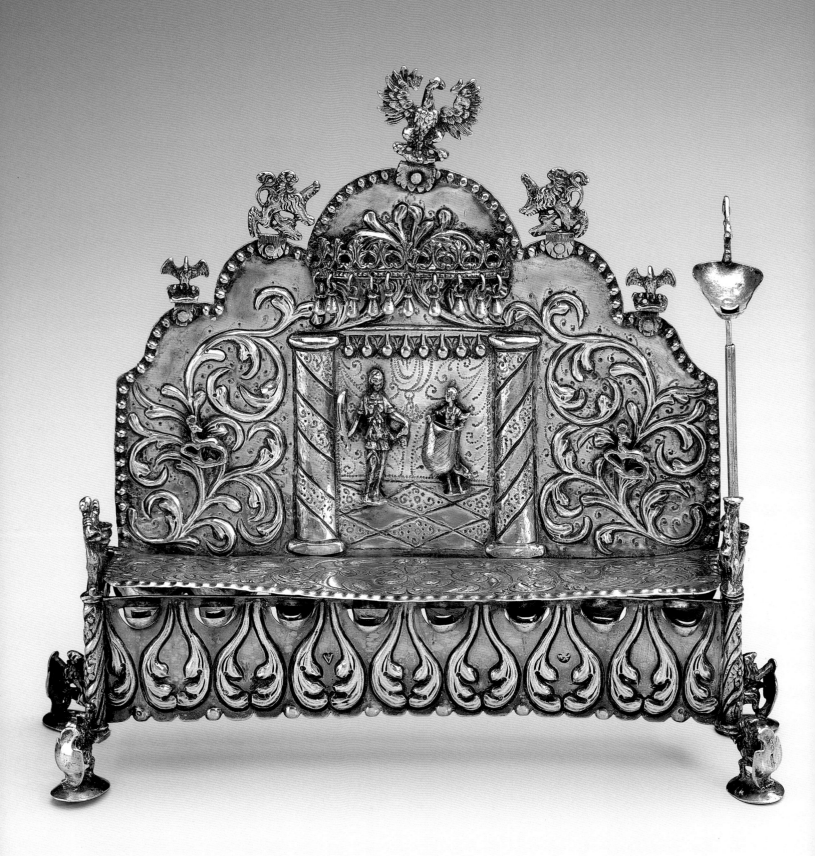

LUMINOUS ART

HANUKKAH MENORAHS *of* THE JEWISH MUSEUM

SUSAN L. BRAUNSTEIN

THE JEWISH MUSEUM

NEW YORK

UNDER THE AUSPICES OF THE
JEWISH THEOLOGICAL SEMINARY OF AMERICA

YALE UNIVERSITY PRESS

NEW HAVEN AND LONDON

This book has been published in celebration
of the centennial of The Jewish Museum, which
was founded in 1904.

The Jewish Museum
Manager of Curatorial Publications:
Michael Sittenfeld
Publications Assistant: Beth Turk

Edited by Joseph N. Newland, Q.E.D.

Yale University Press
Publisher, Art & Architecture: Patricia Fidler
Assistant Editor, Art & Architecture: Michelle Komie
Senior Production Editor: Nancy Moore
Production Manager: Mary Mayer
Photo Editor: John Long

Designed by Steven Schoenfelder, New York
Typeset in Monotype Joanna and
Adobe Formata
Color separations by Professional Graphics,
Rockford, Illinois
Printed and bound by CS Graphics
All photography of Hanukkah lamps by Richard
Goodbody with the following exceptions: John Par-
nell (nos. 18, 26, 69, 71, 82, 103–5, and 109)
and Coxe-Goldberg Photography, Inc. (no. 102).

Front cover: Master BD, no. 61 (detail), Lvov,
1867–72
Frontispiece: Johann Valentin Schüler, no. 11,
Frankfurt, late 17th century
Back cover: Ludwig Y. Wolpert, no. 99, New York
City, 1978

The Jewish Museum
1109 Fifth Avenue
New York, New York 10128
www.thejewishmuseum.org

Yale University Press
P.O. Box 209040
New Haven, Connecticut 06520-9040
www.yalebooks.com

Library of Congress Cataloging-in-Publication Data
Luminous art : Hanukkah menorahs of The Jewish
Museum / Susan L. Braunstein.
p. cm.
Includes bibliographical references and index.
ISBN 0-300-10387-5 (cloth: alk. paper)
1. Hanukkah lamp—Catalogs. 2. The Jewish Mu-
seum (New York, N.Y.)—Catalogs. I. Title.
BM657.H3B73 2004
296.4'61—dc22
2004053763

A catalogue record for this book is available from
the British Library.

The paper in this book meets the guidelines for
permanence and durability of the Committee on
Production Guidelines for Book Longevity of the
Council on Library Resources.
10 9 8 7 6 5 4 3 2 1

CONTENTS

DONORS TO THE CATALOGUE

The Jewish Museum gratefully acknowledges Jeanette
Lerman-Neubauer and Joseph Neubauer for their
generous assistance in the publication of this work.

We are indebted to the Roy J. Zuckerberg Family
Foundation for enthusiastically supporting the schol-
arly research associated with this endeavor.

We also thank The David Berg Foundation, the Getty
Grant Program, and the Andrew W. Mellon Founda-
tion for their support of this book.

FOREWORD

The Jewish Museum holds the most significant collection of Jewish ceremonial works in the Western Hemisphere. The collection, numbering more than 14,000 items, is particularly strong in the areas of eastern European and German Judaica from the seventeenth to the nineteenth centuries, Italian and Ottoman ceremonial art, and the world's foremost collection of Hanukkah lamps.

Since 1996, Susan L. Braunstein, the museum's curator of archaeology and Judaica as well as the head of its Judaica Department, has been working to research and thoroughly catalogue this collection. The result is the two volumes—*Luminous Art: Hanukkah Menorahs of The Jewish Museum* and *Five Centuries of Hanukkah Lamps from The Jewish Museum: A Catalogue Raisonné*. One includes collection highlights with lamps from the most humble to the most elaborate, presented in ten chapters that begin with western Europe and continue eastward with entries arranged chronologically. The second book is a comprehensive compendium documenting all the lamps in the museum's collection. The text of the first volume is folded into the second, which has an additional 543 entries that represent the rest of the lamps in the museum's holdings.

Luminous Art: Hanukkah Menorahs of The Jewish Museum and the accompanying catalogue raisonné are a landmark achievement for The Jewish Museum on several levels. In an era when museum curators are preoccupied largely with changing exhibitions and their accompanying catalogues, the creation of a comprehensive collection catalogue is a rare and welcome occurrence. A museum is founded because of the desire to collect and preserve art and artifacts of special significance and beauty, and it is the work of museum curators to bring their particular expertise to the interpretation and presentation of these works for both general and scholarly audiences. The donors noted in the front of this book understood this and provided the wherewithal for staff to take the time to focus on one of the museum's most important collections. Furthermore, the curators, acquisitions committee members, donors, and museum leadership have recognized the value of a vital collecting program, and thus helped to ensure the range and breadth within the lamp collection that makes it a treasure in the world of ceremonial art.

If the reader can imagine a trip into the museum's storeroom, accompanied by an expert curator elucidating the remarkable stories of the lamps and explaining their origins, dates, and stylistic elements, he or she will have a partial notion of what is found in these volumes. Added to that are the photographs, which can be returned to over and over, and the extensive scholarly information available in the essay and entries written by Dr. Braunstein. She made a number of important discoveries in her years of research. These led her

to create new methods and criteria by which geographical origin, dates, and fabrication techniques, as well as stylistic and formal attributes, can be firmly established. She used these methods to bring to light information about lamp types that was long unclear.

While an in-depth exploration of hundreds of examples of one type of Jewish ceremonial object might seem an exclusive subject of interest to a small population of scholars, these lamps actually open worlds of information. They are visual evidence of the dispersion of the Jewish people and the continuity of their culture over five centuries. Some lamps are reminders of the origins of the Jewish people in the ancient Middle East. Others speak to times of confidence and assimilation, particularly in nineteenth- and twentieth-century European and American cities. Still others have such distinctive forms, styles, and inscriptions that they mirror the time and place in which they were made and reveal the individual stories behind their creation. Two themes emerge: one of continuity, as it is seen in the perpetuation of a ritual over time, with every lamp designed around the need for eight lights and a "lighter"; and the other is creativity—not only the creativity of the artists and artisans who made the lamps, but also the creativity essential to the dynamic of renewal and re-creation that has characterized the Jewish people.

While this project has drawn on the time and talent of many members of The Jewish Museum staff as well as consultants and collaborators beyond the staff, Dr. Braunstein deserves special thanks and congratulations for her enormously important contribution to art history and Jewish history. My gratitude also goes to a number of friends whose belief, coupled with generous donations, has sustained this eight-year endeavor: Jeanette Lerman-Neubauer, vice chairman of the museum's board of trustees, and Joseph Neubauer, both of whom are deeply interested in the nexus of art and Jewish culture; the Roy J. Zuckerberg Family Foundation, whose staunch support for research in the museum's Judaica holdings spans fifteen years; the Andrew W. Mellon Foundation for their grants to this and other collection-based projects; and the Getty Grant Program for making its second grant toward a Jewish Museum publication. In addition to these dear friends, I thank The David Berg Foundation, whose first grant to us has helped realize the completion of this project.

In the process of developing the books, we had the important involvement of staff and consultants who provided scholarly and technical expertise, fundraising skills, and research and administrative support. In producing the books we have had the benefit of the fruitful collaboration between the museum's manager of curatorial publications, Michael Sittenfeld, and our copublisher, Yale University Press. Ruth Beesch, deputy director for program, and Lynn Thommen, deputy director for external affairs, played crucial roles in planning and completing this project. The museum's board of trustees deserves tremendous appreciation. Its commitment to the exploration of the world of art and Jewish culture is what lies at the heart of the eight-year project that has resulted in two books that set a new standard for the research on and interpretation of Jewish ceremonial art.

Joan Rosenbaum
Helen Goldsmith Menschel Director
The Jewish Museum

ACKNOWLEDGMENTS

During the eight-year journey toward the completion of this book, many talented and generous individuals helped in various aspects, from research to publication. I would first like to acknowledge four people whose contributions laid the groundwork for this work. Mordecai Narkiss's seminal 1939 book, *The Hanukkah Lamp*, provided a model for scholarly research in its combination of art-historical analysis, historical background, and textual sources. I am eternally grateful to Dr. Harry G. Friedman, a passionate lover of Judaica who donated nearly seventy percent of the museum's Hanukkah lamps between 1939 and his death in 1965. His generosity resulted in both diversity and depth in the museum's lamp collection, which greatly aided in the study of their dates and origins. My deepest gratitude goes to Roy J. Zuckerberg, who perceived the need for sharing the museum's vast holdings of ceremonial silver with general and scholarly audiences, and who had the grace and generosity to help fund two publications on the collection, the first being *Crowning Glory: Silver Torah Ornaments of The Jewish Museum*. Lastly, I wish to acknowledge the late Rafi Grafman, a Jerusalem specialist in Jewish ceremonial art whose encyclopedic knowledge of and passion for the field greatly advanced the study of Judaica. As the author of *Crowning Glory*, he provided reliable dates and origins for ritual objects that were important for the analysis of the Hanukkah lamps. He was extraordinarily generous with his time and eagerly shared his vast storehouse of information with me.

The museum's director, Joan Rosenbaum, championed this project throughout its long gestation, and I am deeply grateful for her confidence. My thanks go to Ruth Beesch, deputy director for program, who was extremely supportive and helped solve the various problems that came up.

In order to publish the Hanukkah lamp collection, 1,022 lamps needed to be examined and catalogued, and a significant portion of them had to be photographed. I was very fortunate to have a wonderful team to help with this aspect of the project. Sarah E. Lawrence, an Andrew W. Mellon Fellow (and currently the director of the Parsons/Cooper Hewitt Master's Program in the History of Decorative Arts and Design), supervised the organization of the project and contributed her significant expertise in metalwork. A consummate scholar and able administrator, Dr. Lawrence was responsible for the examination and initial cataloguing of the Italian copper-alloy lamps, those made in the Bezalel School in Jerusalem, and the modern lamps. She also worked out the sequence of casting generations for a number of the lamp types and was a constant source of advice on production techniques and styles. I am most grateful for the superlative work she did on this project.

My deepest gratitude extends to the other outstanding members of the Hanukkah lamp team. These include Audrey Malachowsky, a restorer who supervised the polishing of the lamps for over a year with grace, professionalism, and patience. Conservator Joan Schiff repaired broken lamps with skill and expertise so they could be photographed. Project Assistant Sara Olshin was indispensable in pulling out the lamps for examination, conservation, and photography, and also helped maintain the project database. Two terrific research assistants, Sari N. Cohen and Phyllis T. Handler, were thorough and meticulous in tracking down sources, identifying marks, and doing organizational work. Phyllis also wrote the entries for some forty modern and contemporary works in the catalogue raisonné. The superb new photographs were taken by Richard Goodbody, whose patience and good humor through week-long photo shoots were an added bonus to his artistry. Stacey Traunfeld, administrative associate in the Judaica Department, assisted with various tasks with her customary competence and enthusiasm. I owe a special debt of gratitude to Scott Ruby, who at the time was the Henry J. Leir Fellow in Judaica and is now a doctoral student at the Courtauld Institute in London. Scott's expertise in decorative arts was of tremendous help in puzzling out the dates and origins of many of the lamps, and he also undertook to write extended entries on the modern works in *Luminous Art*. I also express my appreciation to Fred Wasserman, Henry J. Leir Curator, for contributing the entry on Matthew McCaslin's lamp. My esteemed colleagues in the Judaica Department, Vivian B. Mann, Eva and Morris Feld Chair in Judaica, and Claudia Nahson, associate curator, provided advice, opinions, and support throughout the course of working on this book, and I am, as always, indebted to them. Members of the Registrar's Department assisted with the movement of artwork from outside locations, and I thank Elissa Myerowitz, Lisa Mansfield, and Jackie Goldstein for their cooperation. I would also like to acknowledge the work of the Development Department, which secured grants from the Andrew W. Mellon Foundation, the Getty Grant Program, and The David Berg Foundation.

An army of volunteers and interns participated in the research and preparation phase of the project, and I wish to thank them for their time and interest. Interns Laura Mass, Aviva Geller, David Ostow, Susanna Eng, Ilana Segal, Rebecca Krasner, and Jenna Simon were accurate and meticulous in the many tasks they performed. Volunteers Roslyn Bowers, Philoine Fried, and Claire Hervey were tireless in their photocopying of parallels from books and journals. A good portion of the mammoth job of polishing some six hundred metal lamps was carried out by a group of dedicated volunteers: Ashella Pearlberger, Sophie Olshin, Sandra Lepelstat, Rose Beer, Trudy Kaplan, Dorothy Bamberger, Jane Zweifler, Tamar Baumgold, Ellen Gummer, Henry Olshin, Rosalyn Tauber Scheidlinger, and Barbara Rosenfeld. I cannot thank them enough for their commitment to the project. Others who generously donated their time to polishing include Charlotte Schwartz, Inez Meisels, Rene Roberts, Doris Travis, and Edith Ratner.

Museum colleagues were most generous in opening up their collections to us, and I am indebted to the following for their invaluable assistance: Chaya Benjamin and Rachel Sarfaty, The Israel Museum; Grace Cohen Grossman, Skirball Cultural Center, Los Angeles; Edward Van Voolen, Joods Historisch Museum, Amsterdam; Bracha Yaniv and Zohar

Hanegbi, Sir Isaac and Lady Edith Wolfson Museum, Jerusalem; the staff of the Jewish Museum, London; and Elka Deitsch, Herbert and Eileen Bernard Museum, Congregation Emanu-El of the City of New York. I also wish to thank the following collectors for allowing me into their homes to see their extraordinary collections: William L. Gross, Ramat Aviv; Abraham Halpern, New York; Joseph Levine, Great Neck; Willy Lindwer, Amstelveen; and Dr. Alfred Moldovan, New York. I am also grateful to Cissy Grossman, curator of the Michael and Judy Steinhardt Collection in New York.

Many curators and scholars shared their knowledge as I researched the dates and origins of the lamps. Special thanks go to Richard E. Stone, senior museum conservator at The Metropolitan Museum of Art, who trained the Judaica staff in the identification of various metalworking techniques and the history of their use. He also acted as a consultant for a number of problems related to the lamps, and I am indebted to his generosity and expertise. Curators from The Metropolitan Museum who also assisted us with our inquiries include Clare Vincent, Charles Little, Stuart Pyrrh, and Helmut Nickel. I am extremely grateful to the following curators and staff from museums around the world who answered my requests for information: Malou Schneider, Musée Alsacian, Strassbourg; Daniela Di Castro Moscati, Museo Ebraico di Roma; Felicitas Heimann-Jelinek, Jüdisches Museum der Stadt Wien; Nicholas Stavroulakis, Hania, Greece; Katia Guth-Dreyfus, Jüdisches Museum der Schweiz in Basel; Michal Friedlander, Jüdisches Museum Berlin; Birgit Schübel, Germanisches Nationalmuseum, Nuremberg; Irene Faber, Joods Historisch Museum, Amsterdam; Idit Sharoni-Pinhas, The Babylonian Jewry Heritage Center, Or-Yehuda, Israel; Ester Muchawsky-Schnapper, The Israel Museum; Nitza Behroozi, Eretz Israel Museum, Tel Aviv; Sarah Harel Hoshen, Beth Hatefutsoth, Museum of the Jewish Diaspora, Tel Aviv; David Shayt, National Museum of American History; and Linda Poe, Judah L. Magnes Museum, Berkeley. My gratitude also goes to Jane A. Kimball, Dorri Rosen of the Bronx Botanical Gardens, Amanda Schollenberger of The Dalton School, and Eric Ascalon of Ascalon Studios in Berlin, New Jersey, for their responses to our inquiries.

The actual production of the book was supervised by Michael Sittenfeld, manager of curatorial publications, whose professionalism, intelligence, and sense of humor make him a continual pleasure to work with. Joseph N. Newland edited the book with erudition and sensitivity, and I am grateful for all his queries that led to greater clarity and accuracy. Steven Schoenfelder's beautiful design created a perfect marriage of text and image, allowing the photographs of these wonderful lamps to shine. Beth Turk was indispensable in organizing the photographs and securing reproduction rights. Ivy Epstein and Erica Stern assisted with many essential tasks. The maps, produced by Adrian Kitzinger, are handsome and easy to read, and enhance the book greatly. Finally, I express my gratitude to Yale University Press—especially Patricia Fidler, Michelle Komie, Nancy Moore, Mary Mayer, and John Long—for the expertise that they brought to the completion of this book.

Susan L. Braunstein
Curator of Archaeology and Judaica
The Jewish Museum

NOTE TO THE READER

Two volumes on the Hanukkah lamps of The Jewish Museum are being published. The first, *Luminous Art: Hanukkah Menorahs of The Jewish Museum*, is intended for the general reader. It consists of highlights from the collection and includes lamps from a wide range of countries and periods, from the humblest to the most elaborate types and materials. The first volume, containing catalogue numbers 1 to 114, is divided into ten chapters according to the origin of the lamps. They begin with western Europe and continue eastward, ending with the Americas. Within each chapter, the entries are arranged chronologically.

The second volume, *Five Centuries of Hanukkah Lamps from The Jewish Museum: A Catalogue Raisonné*, is a comprehensive catalogue, or catalogue raisonné, of all the lamps in the museum's collection. It includes the entire text of the first volume, plus an additional 543 entries that represent the rest of the lamp types in the museum's holdings. Citations of catalogue numbers 115–657 in the general book refer the reader to the catalogue raisonné. The catalogue raisonné is organized into the same chapters as the general book. Within each chapter, the pieces are arranged first according to one of two basic lamp forms (bench or menorah), then according to material and technique, and, finally, according to type (a combination of similar iconography and composition). A number of types were made in more than one geographic region; with some exceptions lamps are listed under the country where they were produced. Entries have been written for 657 of the 1,022 Hanukkah lamps that were in the collection as of December 2003. The remaining 365 lamps are duplicates or variants which provide no further information on maker, origin, or date. These have been listed as "Similar Lamps" under the appropriate entry.

ELEMENTS OF THE CATALOGUE ENTRIES

TERMINOLOGY: The term "Hanukkah lamp" has been used throughout to designate the lighting device that is kindled on Hanukkah. The only exception is in the title of the general book, where the term "Hanukkah menorah" appears. This is in deference to the majority of Americans, who only know the lamp by that name. The application of "menorah" to all Hanukkah lamps is, however, not quite accurate. The term more correctly refers to the seven-branch lampstand consisting of a central shaft and seven arms that stood in the ancient Temple in Jerusalem, and, by extension, to the similarly formed nine-branch candelabrum used for Hanukkah; it has been used with these two meanings in the catalogue. All other Hanukkah lamp forms, such as those with backplates, should therefore not be designated as "menorahs"; the term "Hanukkah lamp" is the more general name that can be applied to all forms.

ILLUSTRATIONS: Nearly all catalogued items are illustrated; exceptions were made for duplicates and near duplicates.

MAKER: For identifiable makers, the artist's nationality is included if known. Life dates are given when possible; "master" indicates when the maker was accepted as a master. If none of these dates is known, the designation "active" indicates the years during which the maker was known to have created works.

ORIGIN: This refers to the locale where the lamp was made, using, when known, the name of the city, region, or political entity at the time of production. If this is unknown, twenty-first century names are employed to convey a sense of geographical region.

MAPS: Designated sites indicate places of origin of lamps in the collection, as well as capital cities.

MATERIALS AND TECHNIQUES: The vast majority of lamps in the collection are metal and were created by one of three basic methods: the working of sheet metal through a variety of hand techniques; the pressing of sheet metal in a die stamp (die-stamping); or casting, in which molten metal is poured into a mold. All silver and copper-alloy cast lamps and elements were sand cast unless otherwise specified.

The primary method used to form the body of the lamp is named immediately after the material, followed by the decorative techniques. For metals, if the main formative technique is not specified, it should be understood to be the hand-working of sheet metal. The production methods of subsidiary parts such as legs, finials, or oil containers are cited after the decoration if different from the primary technique.

Metal surfaces were hand-decorated using a number of methods. Repoussé refers to modeling sheet metal with a hammer on the reverse surface, which is then touched up on the front through engraving, tracing, or punching. These three techniques can be used to embellish the surfaces of die-stamped and cast pieces as well. Engraving and tracing, using a burin and chisel respectively, leave grooves on the front surface. Punching is the stamping of the surface with a patterned punch. Gilding may cover an entire object, or part of it (called parcel-gilding).

DIMENSIONS: The maximum dimensions of each work are given, in the order of height, width, and depth.

ACCESSION NUMBERS: Accession numbers prior to 1980 are prefixed by letters as follows: D = Gift of the Danzig Jewish Community, acquired in 1939; F = Gift of Dr. Harry G. Friedman, acquired 1939–65; JM = Jewish Museum, acquired 1947–79; M = The Rose and Benjamin Mintz Collection, purchased in 1947; S = Jewish Theological Seminary, acquired 1904–46, which includes the earliest objects as well as The H. Ephraim and Mordecai Benguiat Family Collection, acquired in 1925; U and X = objects whose original accession number is unknown or which were not assigned accession numbers in the year of acquisition. (In the citations, "accession number" is abbreviated "acc. no.")

INSCRIPTIONS: Hebrew inscriptions are rendered in both Hebrew and English translation. However, many lamps bear standard Hebrew inscriptions related to Hanukkah. These inscriptions are given in English translation only. The Hebrew for these commonly occurring passages appears at the end of this Note. For biblical citations, the 1955 edition of the Jewish Publication Society Bible is used, except for a change of the word "menorah" to "lampstand."

MARKS: Silver and pewter lamps were often stamped with marks that guaranteed the quality of the metal or that identified the place where made and the maker. The term "hallmark" is used here for the stamps of cities, guilds, officials, or assayists, as well as assay marks that indicate the quality of the metal. The term "maker's mark" is used for masters' stamps, while "signature" signifies names that were engraved, cast, painted, or inked. If the marks have been published, references to standard works are given in the form of author and mark number. When the references did not include mark numbers, the page number in the volume is given. Unpublished marks are described in the entry and are represented photographically at the end of the catalogue raisonné.

PROVENANCE: The history of ownership of each lamp is given as completely as can be reconstructed. If unknown, this line is omitted.

DATE OF ACQUISITION: If there is no known provenance, the date of acquisition by the museum is given. If unknown, this line is omitted.

BIBLIOGRAPHY: Only major publications of the lamp are included.

SIMILAR LAMPS: This refers to other lamps that are identical or very similar. They include Jewish Museum lamps that do not have their own catalogue entries as well as parallels in other collections and publications that provide important information on maker, date, or

origin. Other catalogue entries cited may include additional lists of similar lamps in the collection. "The Jewish Museum" indicates those belonging to the museum in New York; all other museums with that name are designated by their city as well. Jewish Museum lamps are listed by their accession number; donor credit lines are given in parentheses, except for those beginning with D, F, M, as noted under Accession Numbers above.

RELATED LAMPS: This indicates examples that share many characteristics.

AUTHORS: Unless otherwise indicated, all text was written by Susan L. Braunstein. Entries written by other museum staff members are indicated by the following initials:

SR Scott Ruby, Henry J. Leir Fellow in Judaica
PTH Phyllis Trattner Handler, Project Assistant
FW Fred Wasserman, Henry J. Leir Curator

HEBREW INSCRIPTIONS

PRAYERS

Al Ha-Nissim ("For the miracles," first sentence):

על הנסים ועל הנפלאות שעשית לאבותינו בימים ההם ובזמן הזה.

For the miracles and for the wonders that You did for our fathers in those days in this season.

Blessings over kindling the lights: These appear in standard form and are not rendered here in Hebrew. The first prayer blesses God for the commandment to kindle the lights, the second thanks God for the miracles wrought in ancient times, and the third, recited only on the first night, is a general blessing said over anything new, thanking God for our existence.

Ha-Nerot Hallalu (These Lights): This prayer is generally recited after the first light is lit. There are three different versions of the text, one from the medieval legal codes, one Ashkenazi, and one Sephardi. A variant of the Ashkenazi version is the one most commonly rendered on the lamps in the collection and is given here. The other versions are given in Hebrew in the appropriate catalogue entries.

Ashkenazi variation of *Ha-Nerot Hallalu*:

הנרות הללו אנו מדליקין על הנסים ועל הנפלאות ועל התשועות ועל המלחמות, שעשית לאבותינו בימים ההם בזמן הזה על ידי כהניך הקדושים. וכל מצות שמונת ימי חנוכה הנרות הללו קדש הם, ואין לנו רשות להשתמש בהן אלה לראותן בלבד, כדי להודות ולהלל לשמך הגדול על נסיך ועל נפלאותיך ועל ישועתיך.

These lights we kindle, for the miracles, for the wonders, for the deliverances, and for the battles, that You did for our fathers in those days in this season through Your holy priests. And all commanded eight days of Hanukkah, these lights are holy, and we have no authority to make use of them, other than exclusively to see them, in order to give thanks and praise to Your great name, for Your miracles, for Your wonders, and for Your deliverances.

OTHER COMMONLY USED HEBREW PHRASES
(in alphabetical order of the English translation)

Bezalel
בצלאל

"For the commandment is a lamp, and the teaching is light" (Proverbs 6:23)
כי נר מצוה ותורה אור

Hanukkah
חנוכה

Hanukkah light
נר חנוכה

Jerusalem
ירושלים / ירושלם

Light of Hanukkah
נר של חנוכה

"These lights are holy" (from *Ha-Nerot Hallalu*)
הנרות הללו קדש הם/הן

"To kindle the Hanukkah light" (from the first blessing over the lights)
להדליק נר של חנוכה

Zion
ציון

EIGHT LIGHTS, A THOUSAND TALES

HANUKKAH LAMPS OF THE JEWISH MUSEUM

SUSAN L. BRAUNSTEIN

"...these lights are holy, and we have no authority to make use of them, other than exclusively to see them, in order to give thanks and praise to Your great name, for Your miracles, for Your wonders, and for Your deliverances."

(From *Ha-Nerot Hallalu*, prayer said after kindling the Hanukkah lights)

In the constellation of Jewish holidays, Hanukkah is a minor festival, a late institution, one that pales in importance beside such major observances as the Day of Atonement, Sukkot, and Passover. Yet such was the significance of the Hanukkah lamp that the sages of ancient times declared the lights holy; the famous medieval rabbi Moses Maimonides urged Jews to borrow money or sell their clothing to purchase oil for the lamp; and the Jews of eighteenth-century Frankfurt, Germany, considered it one of the three essential silver objects to be given as a wedding present. Today, the celebration of Hanukkah as a time of freedom and miracles still resonates among Jews, and the tradition of kindling the festival lights on a winter's evening continues to have great attraction and meaning.

The importance of the Hanukkah lamp is reflected in The Jewish Museum's collection. With a total of 1,022 lamps at the end of 2003, the collection is the largest assemblage of Hanukkah lamps in the world. Amassed over the one hundred years of the museum's existence, these lamps also comprise the greatest component of the museum's collection of Jewish ceremonial art, outnumbering the Torah crowns, kiddush cups, and spice containers. It is not clear why this particular ritual object should be so well represented at the museum. Whether it is a question of popularity in usage, greater survival through the centuries, or collecting preferences, the Hanukkah lamp's appeal seems out of proportion to the importance of the holiday it is kindled on. One possible explanation for the larger numbers of domestic Hanukkah lamps in comparison with synagogue Judaica is the fact that there are always more homes than houses of worship. A second reason for the lamp's being collected might be its distinctive form. While Jews often used ordinary objects such as cups, candlesticks, and spice containers in the performance of ritual, secular candelabra were rarely made with eight arms in a single plane, and the bench-shaped form with lights is not found in any other context. Thus, collectors could be more confident of the Jewish origin of such a piece if found without any documentation of use.

The lamps in the museum's collection come from six continents, absent only Antarctica. Gazing at them twinkling in the exhibition cases, or massed on the storeroom shelves, one is amazed by their beauty as well as their great variety in form, decoration, and technique. The lamps speak of the multitude of places where Jews have settled and flourished, as they reflect local styles and motifs. Yet they are also the result of something much more fundamental and meaningful. Each lamp encodes a complex interaction of historical events, Jewish law, artistic expression, and personal experiences that accounted for its creation, its use, and its eventual presence in the museum.

Like the Jewish experience itself, the story behind each lamp is rich and varied, embodying tradition and innovation, history and current trends. It begins in antiquity, with the events that inspired the creation

of the eight-day holiday starting on the twenty-fifth day of the Hebrew month of Kislev (which usually falls in December). The tale continues with the religious authorities of ancient and medieval times, who provided some guidelines about the form of the lamp and how it was to be kindled. Next, an artist had to devise and decorate an implement that would allow one to kindle eight lights on the holiday, beginning with one light and increasing by one each night, following the ancient custom. The story then passes to the owners of the lamp, who were affected by political, economic, and social circumstances that determined what kind of lamp they could obtain and how long it stayed in their possession. In one of the last chapters, the lamp may have come into the possession of a Judaica collector, who saved it from oblivion. At the end of the story, it was acquired by the museum, often as a result of world events or individual generosity.

THE HEROES OF THE STORY

The inspiration for the celebration of Hanukkah is an event that occurred more than 1,800 years ago in ancient Israel. The land was under the rule of the Greeks, and one king, Antiochus IV, had outlawed the practice of all non-Greek religions. He removed the implements from the Jewish Temple in Jerusalem, set up a shrine to Zeus there, and began to put to death all Jews who refused to abandon their religion. One Jewish priest, Mattathias, mounted a rebellion against Antiochus, and along with his five sons engaged in guerrilla-style combat with the Greek army. At his death, his son Judah Maccabee continued to lead the struggle (fig. 1). In 164 B.C.E., in one of the many battles, Judah, after praying for divine aid, succeeded in routing the more numerous enemy forces, enabling him to reach Jerusalem and cleanse the Temple. He ordered new implements to be fashioned, including the sacrificial altar, the seven-branch

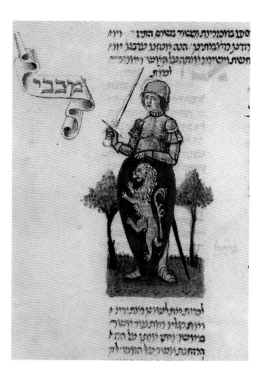

Fig. 1. Judah Maccabee. Detail from the Rothschild Miscellany, Ferrara (?), c. 1470. Vellum: pen and ink, tempera, and gold leaf, 8¼ × 6¼ in. (21 × 16 cm). The Israel Museum, Gift of James A. de Rothschild, London, 1957 (180/51 M803-9-61, fol. 217). Photo by David Harris.

lampstand (menorah), and the table for the showbread. On the twenty-fifth of Kislev, the Temple was rededicated with a sacrificial offering, and the festivities continued for eight days. In remembrance of the reestablishment of worship and the divine assistance rendered, the nation declared an eight-day commemoration of the dedication (*hanukkah* in Hebrew), to be observed with "gladness and joy." These events were recorded in Maccabees I (4:26–59), written around the late second or first century B.C.E., less than one hundred years after the events took place. In Maccabees II, composed in the first century B.C.E., we learn that the celebration was similar to that of the holiday of Sukkot, which involved parades with wreaths and tree branches (II Maccabees 10:1–8). This book also associates the holiday with the fire that descended from heaven at various times in Israelite history to light a new altar.

It is of interest to note that no mention was made in these earliest sources to the lighting of lamps as part of the celebration.

By the first century C.E., the Jewish historian Josephus Flavius called the holiday "Lights," but still gave no clue as to the method of observing the festival. It is not until rabbinical writings of the third to fifth century that we first learn of the custom of kindling lamps on Hanukkah.

THE RABBIS

Rabbis are the teachers, religious judges, and spiritual leaders of the Jewish people who took on increasing importance after the destruction of the ancient Temple in Jerusalem in 70 C.E. and the end of priest-based ritual. Over the centuries rabbis have authored innumerable legal decisions, commentaries on biblical sources, and literary texts. These have been gathered in various compendia since antiquity and serve as the basis for much of Jewish observance today. The two most elemental, the ones on which all later codes are based, are the Mishnah, a collection of legal decisions codified in the early third century, and the Talmud, compiled between the third and fifth centuries. There were actually two Talmuds, the Jerusalem and the Babylonian, each a compendium of commentaries on the Mishnah, legal rulings, biblical interpretations, and Jewish lore. Contained in these and later texts are a number of guidelines that have affected the nature of Hanukkah lamps through time.

THE NATURE OF THE RITUAL

Perhaps the most important discussions are those outlining the ritual that is performed on Hanukkah, the kindling of lights. Talmudic sources of the third to fifth century provide the earliest evidence for the practice of lighting lamps on the festival. They record a debate that took place in the late first or early second century C.E. between two famous rabbinical schools, the houses of Hillel and Shammai. The subject was whether to light one light on the first night and increase to eight by the last, or vice versa.[1]

Another Talmudic passage discusses how many lights one need kindle each night. In actuality, the rabbis required only one light on each night of the holiday. However, they went on to report that the most zealous households lit one light on the first night and increased the number of lights by one each night, so that by the last night of the holiday eight lights were burning.[2] This last practice soon became the custom for all.

THE FORM OF THE LAMP

Aspects of both the shape and components of Hanukkah lamps have been influenced by rabbinical rulings. For example, one Talmudic decision led to the inclusion of a ninth light on many lamps. The rabbis had declared that one could not use the Hanukkah lights for illumination, as they were considered sacred. If the lamp was kindled indoors, and there was no other source of light such as a blazing fire in the room, then an additional lamp should be lit so that one could see to perform other tasks.[3] By the Middle Ages, it became the tradition among Sephardi Jews, who originated in Spain and Portugal, to set another light near the Hanukkah lamp. Ashkenazi Jews from Germanic lands, however, used a separate light, called a *shamash* (servitor), to kindle the eight Hanukkah lights. It was this light that they placed next to the Hanukkah lamp, and soon the *shamash* was incorporated into the lamp itself, becoming the ninth light. It eventually came into use by the Sephardim as well as by the Mizrahi Jews, or those who remained in the Middle East under Islamic rule.

The arrangement of the lights, whether in a straight row or a circle, was another aspect of shape that was affected by Talmudic legislation. Each light had to be perceived as separate from the others, in order to count as one of the eight.[4] In the case of lights arranged in a circle, such as in a bowl, the rabbis ruled that it was acceptable to kindle eight wicks in one bowl as long as it was covered, so that it did not resemble a single

fire. The placement of lights in the round
was accepted by many rabbis in the medieval
period, especially by the master Sephardi
jurist Joseph Caro in his 1525 treatise *Shul-
ḥan Arukh* (A Set Table). And in fact many
European Jews in the medieval and Renais-
sance periods used their multiwick hanging
Sabbath lamps, with spouts arranged in a
star shape, for Hanukkah (fig. 2). Moses Is-
serles, in his Ashkenazi modifications of
the *Shulḥan Arukh* published in 1578, also
allowed the use of the star-shaped chande-
lier, as long as the spouts were sufficient
distance apart to be perceived as distinct

lights. However, he expressed unease with
other types of lamps having lights arranged
in a circle, and recommended that they be
placed in a straight row. Going even further,
he suggested that they should all be on the
same level. Although Isserles's additions to
the *Shulḥan Arukh* are not necessarily fol-
lowed by Sephardi and Mizrahi communi-
ties, his prescription appears to have had a
profound effect on the form of the Hanuk-
kah lamp in the centuries that followed: the
majority of lamps have the lights positioned
in a straight line and on the same level. De-
spite Isserles's objections, menorah-form
lamps with uneven arms continued to be
made sporadically in Ashkenazi regions such
as eastern Europe, Germany, and France into
the eighteenth and nineteenth centuries.[5]
Lamps in the round or with semicircular oil
containers were occasionally used in Islamic
lands and in Asia.[6] However, even there, the
circular form could be looked upon with
suspicion. For example, in Iraq in the 1940s,
when a candelabrum-type lamp with arms
arranged in a circle became popular, many
rabbis were concerned about the form until
the chief rabbi ruled that it was acceptable
as long as there was enough distance be-
tween the lights (see no. 87).

Talmudic legislation required that one
should hang the lamp in the door of one's
home, on the outside, since its purpose was
to publicize the miracle of the holiday. This
led to the proliferation of wall-hung
Hanukkah lamps in bench form, consisting
of a backplate and a row of lights. However,
if one lived on an upper floor, one could
place it in the window, and in times of per-
secution, one could set it on a table.[7] And
indeed, a large number of bench lamps in
the collection from central and eastern Eu-
rope were designed with feet so they could
stand. However, these too have hanging de-
vices on the back, or else have appropriately
placed holes in the backplate that could be
used for suspension. By the twelfth century,
rabbinic sources related that lighting the
lamp indoors, even when there was no

danger, had become the norm in some places.[8] The sixteenth-century rabbi Mordecai Yafeh, prominent in central and eastern Europe, noted that Jews mounted lamps on the doorposts or the doors; by the eighteenth century this practice is no longer mentioned in that region and may have been abandoned.[9] The custom of hanging the lamp outside the door continues in some lands, notably in Israel and North Africa. Yet in other countries, where it has long been discontinued, the vestiges of this tradition were preserved in the lamps through the inclusion of hooks, rings, or holes for suspension.

Drip pans, added below the row of oil containers in many lamps, were designed to catch any oil that spilled. Rabbinic law prohibited the use of any excess oil left over after the lights were extinguished except in the Hanukkah lamp on the following night of the festival.[10] Oil was often a precious commodity, and in fact the rabbis recognized this and made rulings on what to do if one could not afford enough oil to burn on the holiday. Thus, drip pans may have aided in the collection of spilled or excess oil, as allowed by Jewish law. They were prevalent on Dutch and North African lamps, where they had pinched corners that facilitated pouring off the oil, and on German pewter lamps, where some even have little buckets attached to spouts to catch the liquid (see nos. 4, 21, and 78).

Not all Hanukkah lamps were meant to burn oil, and candles were also kindled during the holiday celebration. The choice of lighting medium influenced the shape of the light holders. Oil lamps had eight shallow pans or an oil box, often with spouts to hold the wicks, while lamps designed for candles had sockets or prickets. Rabbinical sources indicate that oil, preferably olive, was considered by many to be the superior medium, since it burned cleanly and because it was used in the menorah in the ancient Temple. However, the lighting of candles in Hanukkah lamps is mentioned

as well, for example, in the thirteenth- and fourteenth-century writings of Menahem ben Solomon Meiri of France and Yom Tov ben Abraham Ishbili of Spain. In addition, Moses Isserles noted in the *Shulḥan Arukh* that it was the custom in Ashkenazi lands.[11] Candles are more common today, since they are easier to kindle and not as messy as oil.[12]

The lamps themselves indicate that while candles were probably always lit in large synagogue lamps, they came into use in domestic lamps only in the nineteenth century, and mainly in Ashkenazi lands. By the twentieth century, candles were greatly preferred to oil in many places. In fact, a popular American tin lamp patented in 1909 bore light holders that allowed one to use either oil or candles. Later in the century, however, the same lamp type was made with only candleholders (no. 92).

LAMP DECORATION

One might think that representations of Judah Maccabee, his military victory, and the rededication of the Temple altar would have been paramount on Hanukkah lamps, since these were the central elements of the biblical Hanukkah story. However, these rarely appear until the twentieth century (see no. 70). Instead, one of the most widespread images on lamps is that of the seven-branch menorah that once stood in the Jerusalem Temple. It appeared most commonly in Germany, Italy, eastern Europe, and the United States in the eighteenth and nineteenth centuries, and in Israel and the United States in the twentieth century.

The explanation for the popularity of the menorah lies in the Talmudic period. By that time, the Temple had been destroyed and the Jews were once again subject to foreign rule. The rabbis seem to have downplayed the nationalistic and martial aspects of the festival and shifted the meaning of the holiday to one of spiritual redemption. When asked why Hanukkah is celebrated, they recounted a story not found in the earlier Maccabean books of how, when it

came time for the priests to relight the Temple menorah, they could only find one small jar of sanctified oil. Although it was enough to burn for only one day, the oil miraculously lasted for eight.[13] It is this later story that is cited today as the origin of the holiday, and which is referred to as the miracle of Hanukkah. The Temple menorah thus became the symbolic representation of this interpretation of the festival. Some Italian lamps even include a hand emerging from the clouds above the menorah, pouring oil from a pitcher, to underscore the divine role in the narrative.

Another image popular on Hanukkah lamps, that of the biblical heroine Judith, also derives from rabbinical commentary. Her story is recorded in the Book of Judith, written probably in the late second or early first century B.C.E., when the family of Judah Maccabee, the Hasmoneans, ruled ancient Israel. According to the biblical version, Judith was a young widow who had lived centuries earlier. When her town was under siege by a foreign army led by the general Holofernes, she vowed to save her people. Dressed in her best finery, she went to visit Holofernes in his camp and convinced him that she was willing to betray her town because of a religious dispute. One night after a banquet she was left alone with him, ostensibly for a romantic liaison. But after he passed out from too much drink, she took his sword, cut off his head, and left the camp with it. The next morning, when Holofernes's soldiers came to rouse him, they saw the headless corpse and fled in terror.

Medieval rabbinical sources altered this story, making Judith a daughter of the Hasmonean king Yoḥanan. Holofernes became a Greek commander attracted to Judith who forced her to spend the night with him. She plied Holofernes with milk and cheese until he fell asleep, after which she cut off his head.[14] This late attribution of Judith to the Hasmonean family contributed to her becoming associated with Hanukkah. Medieval

poems recounting this version are recited during the holiday, and in some communities the Book of Judith is read on the Sabbath of Hanukkah. In the sixteenth century, Moses Isserles reported that some rabbis suggested the eating of cheese at special Hanukkah feasts in order to commemorate the miracle that occurred with Judith.[15] In this way, the rabbis linked Judith's story both with Hanukkah and with the notion of divine redemption.

THE ARTISTS

Hanukkah lamps evolved into distinctive forms in order to meet the requirements of kindling eight lights. They were rarely plain and undecorated, and a rich iconography developed over the centuries. These aspects of the lamp were largely the contribution of craftsmen and artists, both Jewish and non-Jewish, probably in consultation with their Jewish patrons.

RELIGIOUS AFFILIATION

It is commonly stated in the literature on Jewish art that most European ceremonial art was made by Christians, since Jews were forbidden to practice crafts or join the metalworkers' guilds. It is certainly true that their participation was affected by local regulations and restrictions, but the degree to which this occurred varied greatly with time and place. Many documents indicate that Jews were often in conflict with the Christian guilds, since they represented economic competition. Yet, European Jews seem to have succeeded in operating both within the guild system and outside it. Jewish gold- and silversmiths have been reported in all the European countries represented in the collection, often from the medieval period on. For example, there is ample evidence that in Bohemia/Moravia Jews formed their own guilds by the sixteenth century, that a century later the same was true for Poland, and that by the eighteenth century Jews in Hungary were allowed to join Christian

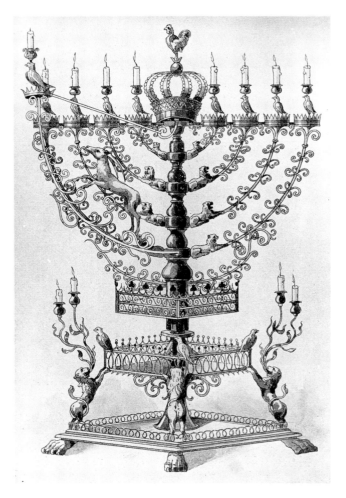

Fig. 3. Hanukkah lamp by Barukh of Pohrebyshche, c. 1700. Drawing by Mathias Bersohn, Warsaw.

guilds. In addition, Jews practiced crafts outside the guild system in Austria, Germany, Italy, and the Netherlands, although many times this activity was forbidden because of complaints from the Christian guilds.[16]

While in theory the silver lamps in the collection could have been made by Jews, those with identifiable makers' marks paint a more varied picture. In Germany, for example, the vast majority of silver lamps in the collection were in fact made by Christians. Some of them, like Rötger Herfurth of Frankfurt and Johann Jakob Runnecke of Fürth, seemed to have catered almost exclusively to a Jewish clientele, based on their recorded output.[17] Lamps without marks, however, very likely were fashioned by Jewish masters working outside the guild system with its stringent regulations about marking silver. In other countries such as Austria, the Netherlands, and Italy, either the

masters are unidentified or their religious affiliation is unknown. By contrast, in Poland it seems likely that most of the silver lamps were created by Jews, since a great number of Polish Jews are known to have been engaged in that craft. For example, around 1850 more than five hundred Jewish goldsmiths were recorded as working outside Warsaw. In Hungary, Jewish masters were allowed into the silver guilds, as exemplified by the Becker family of Bratislava.[18]

In Europe, the makers of copper-alloy (brass or bronze) lamps are generally unknown, as very few examples have foundry marks that would identify where and when they were produced. An exception is no. 22, which bears the mark of a Nuremberg foundry of the early nineteenth century. In Poland and the Ukraine, where the vast majority of lamps were made of cast copper alloy, Jews were prohibited from joining the brass-casting guilds. They are nevertheless documented as brass workers from at least the sixteenth century.[19] The name of only one artisan has survived, that of Barukh of Pohrebyshche in the Ukraine.[20] In the early eighteenth century he created a large menorah-form lamp for his synagogue, with an imaginative decorative scheme including a gazelle, lions, and birds (fig. 3). Pewtersmiths in Germany also had a guild system, but less is known about the various masters. It is therefore impossible to determine if the makers of lamps in these materials were of the Jewish faith.

The situation is quite different in Islamic lands, where Jews had a virtual monopoly on metalwork.[21] Although not specifically prohibited by the Koran, the working of metals was, in later commentaries and interpretations, considered similar to the hoarding and lending of silver and gold, and therefore unsavory for Muslims.[22] Thus, it is more than likely that the metal Hanukkah lamps in the collection from North Africa, the Ottoman Empire, and Iraq were crafted by Jews (fig. 4). This is certainly the case with those created in

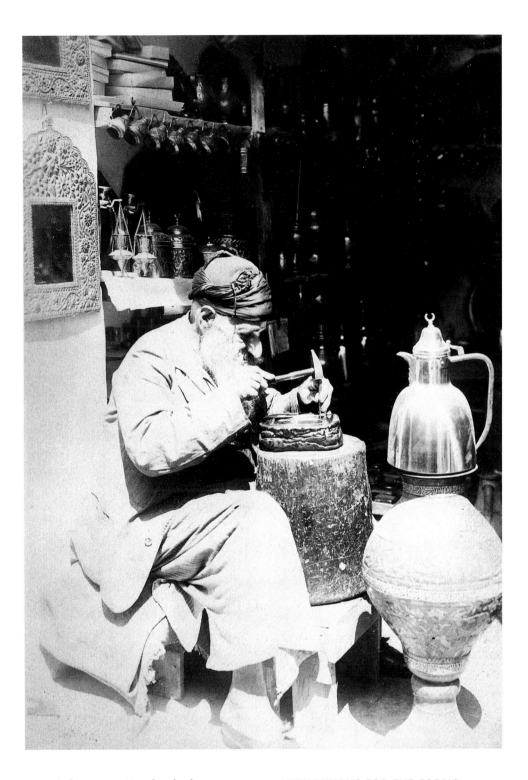

Fig. 4. Jewish coppersmith, Tunis, c. 1900. From Beth Hatefutsoth, The Nahum Goldmann Museum of the Jewish Diaspora, *From Carthage to Jerusalem: The Jewish Community in Tunis* (Tel Aviv, 1986), p. 35.

twentieth-century Israel, whether as part of a conscious effort to invent a new Jewish art style in the earlier part of the century, or to express the identity of the newly born state.

In the United States there were no restrictions on the occupations that Jews could engage in, and at least one early Jewish silversmith gained renown, Myer Myers, who was one of the major smiths in New York during and after the Revolutionary War period.[23]

INSPIRATIONS FOR THE FORMS

Hanukkah lamps can take one of four basic shapes. The bench lamp has a row of lights attached to a backplate that serves as a reflector. Two varieties of bench lamps are known, one that can be hung on the wall, and one with feet for placement on a table or windowsill. The second basic lamp form is that of the menorah, a candelabrum with a central shaft and eight branches that simulates the lampstand that once illuminated the Temple in Jerusalem. Some communities do

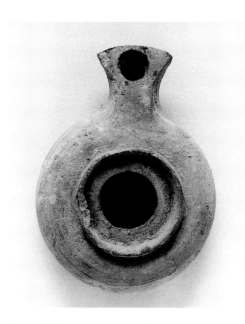

Fig. 5. Oil lamp, ancient Israel, 50 B.C.E.–1st century C.E. Terracotta: wheel-turned and slipped, 1⅛ × 3⅝ in. (3 × 9.1 cm). The Jewish Museum, JM 14-69. Photo by Graydon Wood.

Fig. 6. Burial plaque with menorah, Rome, 3rd–4th century C.E. Marble: carved and painted, 11½ × 10⅜ × 1⅛ in. (29.2 × 26.4 × 2.9 cm). The Jewish Museum, Gift of Henry L. Moses in memory of Mr. and Mrs. Henry P. Goldschmidt, JM 5-50. Photo by Richard Goodbody.

not use a special lamp dedicated to Hanukkah, but line up eight individual cups or oil lamps. Another lamp shape occasionally found is the circular lamp, either suspended from the ceiling or mounted on a shaft, with eight spouts for the Hanukkah lights.

Some of the forms of Hanukkah lamps appear to have been invented specifically for Jewish use, while others were borrowed and modified from secular objects. In antiquity, it is likely that individual clay or metal oil lamps of the kind used for everyday illumination were kindled on Hanukkah (fig. 5). Candelabrum forms with multiple arms were unknown at this time except for the seven-branch menorah in the Temple and later in synagogues. Multiwicked oil lamps were used occasionally but had any number of spouts and therefore cannot be identified definitively with Hanukkah. Furthermore, the use of individual lights is suggested by the biblical description of the Temple menorah as a lampstand upon which separate oil

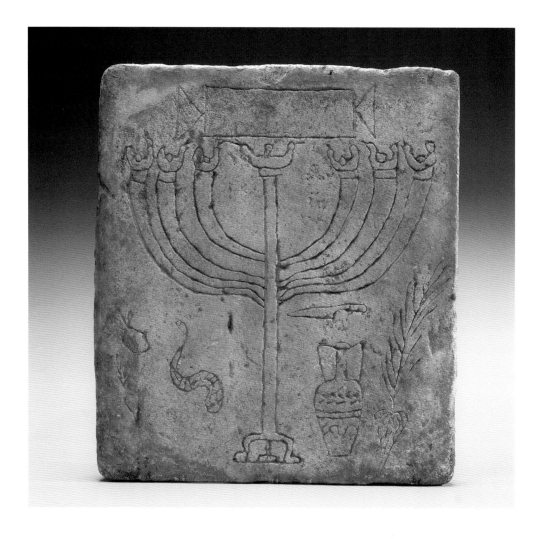

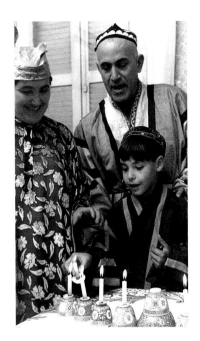

Fig. 7. Bukharan family lighting a Hanukkah lamp in Tel Aviv, 1959. Photo by Fritz Cohen.

lamps were placed (fig. 6). The tradition of kindling individual lights, not combined into a single lamp, continued into the Middle Ages, as documented in a manuscript of the late fifteenth century.[24] Here we find separate lamps suspended by brackets and hooks from a cross-bar. Jews in certain eastern lands such as Iran, Afghanistan, and Central Asia, preferred ceramic and metal cups or lamps (fig. 7).[25] This tradition is echoed in the lamps made of eight chairs that became popular in Germany and eastern Europe in the late nineteenth century (see no. 60), as well as in a group of shiny pebble-like metal candleholders created by contemporary designer Harley Swedler in the 1990s (no. 106).

It is not until the Middle Ages that we encounter the first definite Hanukkah lamps in which eight lights were combined into a single object. Probably the earliest is a stone lamp from Avignon, shaped like a rectangular block, with a Hebrew inscription across the front: "For the commandment is a lamp, and the teaching is light" (Proverbs 6:23) (fig. 8). The dates that most scholars propose for this lamp center around the twelfth to thirteenth centuries.[26] Eight depressions along the top held the oil for kindling the lights. Two other uninscribed lamps of this type are known, although their identification as early Hanukkah lamps is less secure.[27] The

block-form stone lamp may very well have been an adaptation of a cresset stone, a similarly shaped lighting device with multiple depressions for oil (fig. 9). Cresset stones were used by the poorer classes in Europe from antiquity at least through the Middle Ages.[28] Stone Hanukkah lamps with forms related to those of the medieval example were made in Morocco and Yemen as well; extant examples probably date to the nineteenth and twentieth centuries.[29]

A second Hanukkah lamp type that appeared in the thirteenth century in Germany or northern France had a triangular backplate, and was wall-mounted (fig. 10).[30] Decorated with griffins or dragons and lions on the backplate, as well as with the same inscription from Proverbs, these sconcelike lamps represented a completely new type

Fig. 9. Cresset stone, England, 15th century. Limestone: carved, 1½ × 7½ × 5½ in. (3.8 × 19.1 × 14 cm). From John Caspall, *Fire and Light in the Home Pre-1820* (Woodbridge, United Kingdom: Antique Collectors' Club, 1987), p. 207.

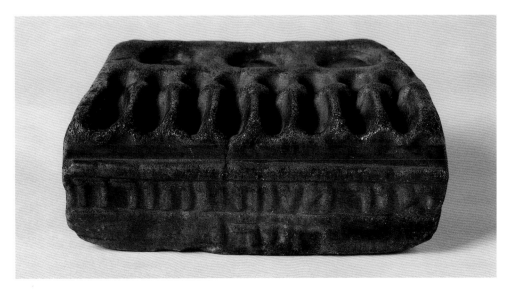

Fig. 8. Hanukkah lamp, found in Avignon, 12th–13th century (?). Marble: carved. 3 × 8¼ × 4¾ in. (7.5 × 21 × 12 cm). Private collection.

of lighting for their time. Wall sconces are first known from the fourteenth and fifteenth centuries, and their forms were quite distinct from those of Hanukkah lamps. They consisted of a single bracket arm, without backplate, that held one or two lights (fig. 11, top right corner).[31] The artists who fashioned the Hanukkah lamps had to devise a new type of lighting device, one that addressed the ritual need for eight lights. Another solution, with a rectangular backplate, is depicted in an Italian manuscript of the fourteenth century (fig. 12).

It was not until the sixteenth century that similar secular lights developed, in the form of sconces with large reflective backplates.[32] These were the models for a series of Dutch-inspired Hanukkah lamps made of silver that appeared in the second half of the seventeenth century (fig. 13). Some closely imitated sconces with their oval or octagonal backplates, plain reflective surfaces in the center, and frames of tulips and other flowers.[33] By the eighteenth century, brass versions became common; by then the backplate took the form of an arch or triangle that was wider at the bottom to accommodate the greater number of lights required (see nos. 1–3).

A third type of early Hanukkah lamp form was the hanging star-shaped lamp, with lights radiating around a central receptacle (see fig. 2). These were common in many medieval homes in Europe. Jews kindled them for both ordinary illumination and also as Sabbath lamps. A commentary by Menahem ben Solomon Meiri of southern France ruled that it was acceptable to use those with eight arms for Hanukkah.[34] In this case, therefore, Jews adopted an already existing lamp type for Hanukkah use, a practice that continued at least until the

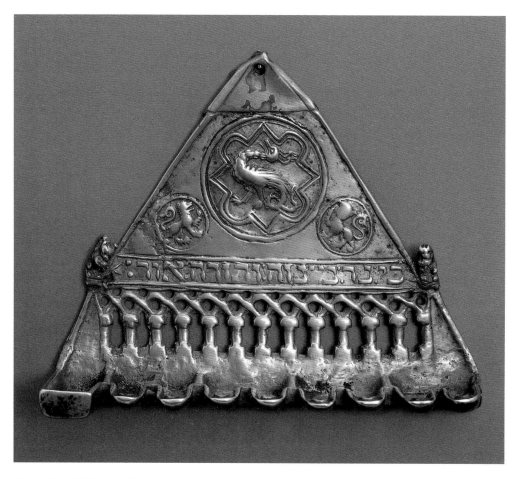

Fig. 10. Hanukkah lamp, Germany or northern France, 13th century. Copper alloy: cast, 5⅜ × 6¹¹⁄₁₆ × 2 in. (13.7 × 17 × 5.1 cm). Congregation Emanu-El of the City of New York, Bequest of Judge Irving Lehman, 1945 (CEE 45-112).

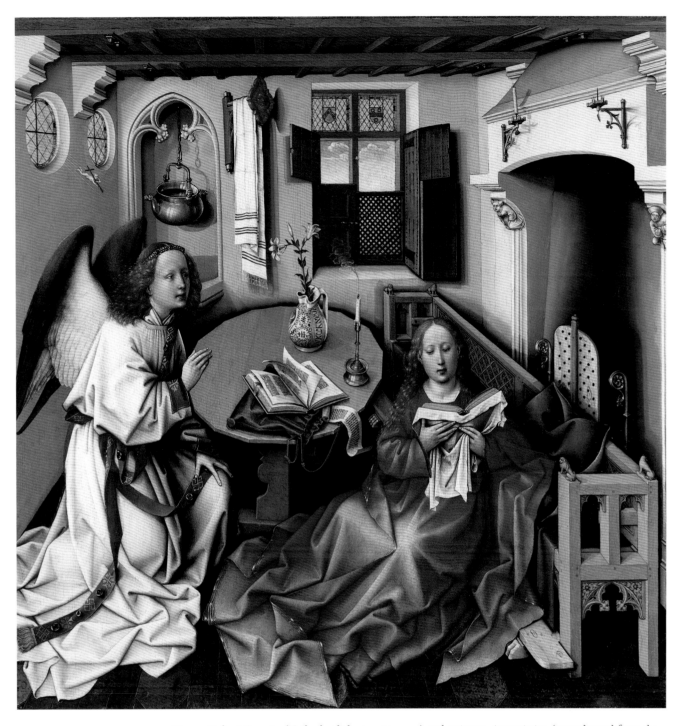

Fig. 11. Robert Campin (Netherlandish, c. 1375–1444) and assistant, *Annunciation* (central panel from the Annunciation Triptych), c. 1425–30. Oil on wood, 25¼ × 24⅞ in. (64.1 × 63.2 cm). The Metropolitan Museum of Art, The Cloisters Collection, 1956 (56.70). Photo © 1996 The Metropolitan Museum of Art.

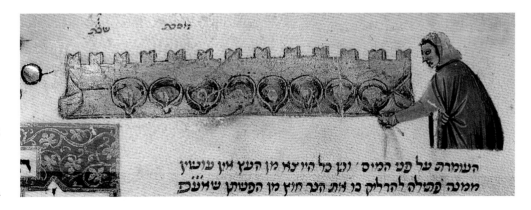

Fig. 12. Lighting a Hanukkah lamp. Detail from an Italian manuscript, dated 1374, in the British Library, London (Ms. Or. 5024, fol. 19 recto).

העומרת על פני המים · ונין כל היוצא מן העץ אין עושין
ממנה פתילה להרליק כו אות הנר חוץ מן הפשתן שנאם

Fig. 13. Hanukkah lamp, Hamburg, 17th century. Silver, 13½ × 10½ in. (34.3 × 26.7 cm). The Metropolitan Museum of Art, Rogers Fund, 1913 (13.41.9). Photo © 1981 The Metropolitan Museum of Art.

sixteenth century, as documented in the *Shulḥan Arukh*.[35]

A major innovation occurred with the appearance of lamps in the shape of the Temple menorah, and which consist of a central shaft and eight arms in a single row. The ancient prototype for the menorah form is first described in Exodus 25:31–40. It was fashioned by the artist Bezalel for the Tabernacle in the desert, and used by the Israelites after the Exodus from Egypt: "And thou shalt make a lampstand of pure gold: of beaten work shall the lampstand be made, even its base, and its shaft; its cups, its knops, and its flowers, shall be of one piece with it. And there shall be six branches going out of the sides thereof; three branches of the lampstand out of one side thereof, and three branches of the lampstand out of the other side thereof; three cups made like almond blossoms, in one branch, a knop and a flower; and three cups made like almond

blossoms in the other branch, a knop and a flower, on the other branch. . . . And thou shalt make the lamps thereof, seven. . . . "

It is not clear when Jews began using a variation on this form with nine lights for Hanukkah. The first probable mention occurs in medieval rabbinical texts that describe the lighting of Hanukkah lamps in synagogues in order to publicize the miracle of the holiday to the congregation. These lamps were compared with the menorah of the Temple, and suggestions were made on how they should be positioned to emulate their predecessor.[36] It is therefore probable that their forms duplicated their predecessor as well. The seven-branch menorah was ubiquitous in Judaism as a symbol for the restoration of the Temple, and actual menorot became a permanent fixture in synagogues in certain parts of the world, despite the Talmudic prohibition against

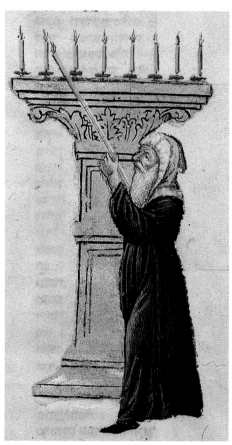

Fig. 14. Lighting a synagogue lamp. Detail from the Rothschild Miscellany, Ferrara (?), c. 1470. Vellum: pen and ink, tempera, and gold leaf, 8¼ × 6¼ in. (21 × 16 cm). The Israel Museum, Gift of James A. de Rothschild, London, 1957 (180/51 M803-9-61, fol. 113 verso). Photo by David Harris.

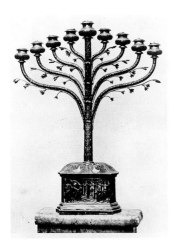

Fig. 15. Hanukkah lamp, Italy, 15th–16th century. Copper alloy.

Fig. 16. Hanukkah lamp, Germany, 1573/74. Copper alloy: cast and chased, 8¾ × 13½ × 4⅛ in. (22.3 × 34.4 × 10.4 cm). The Israel Museum, Gift of Mr. and Mrs. A. A. Hen, The Hague, Netherlands, 1948 (118/350 794.9. 1948). Photo by David Harris.

fashioning one after the Temple was destroyed.[37] Similar menorot were also common in cathedrals and churches from the eighth century on, at first as a symbol of the superiority of the church over the synagogue, and later as the tree of Jesse and the tree of life, a symbol of Jesus.[38] Thus, the seven-branch menorah form survived over the centuries and could easily have served as a model for the candelabrum-form Hanukkah lamp.

The earliest representation of a synagogue lamp occurs in an Italian Hebrew manuscript, the Rothschild Miscellany, dating to the fifteenth century (fig. 14). This lamp does not have distinct arms, but a tall shaft that widens at the top to support the lights. Probably the oldest surviving example of a synagogue lamp is the Renaissance piece in the Padua synagogue, whose tree-

like form and uneven arms suggest a fifteenth- or sixteenth-century date (fig. 15).[39] Later, a smaller lamp for home use was devised, apparently first appearing in Frankfurt in the late seventeenth century (see no. 12).

One of the last forms of Hanukkah lamps to evolve was that of the bench lamp with feet. The earliest firmly dated example appears to be a brass cast lamp inscribed 1573/74 that has sidepieces and legs (fig. 16). Next in time are two lamps in the Jewish Museum collection produced in Frankfurt in the later part of the seventeenth century. One is a simple box for oil with fish-shaped spouts, while the second, also an oil-box type, has an elaborately decorated backplate depicting Judith (nos. 10 and 11). The concept of a box with a lid that flips open for inserting the oil and wicks is very different from that of the open containers found in

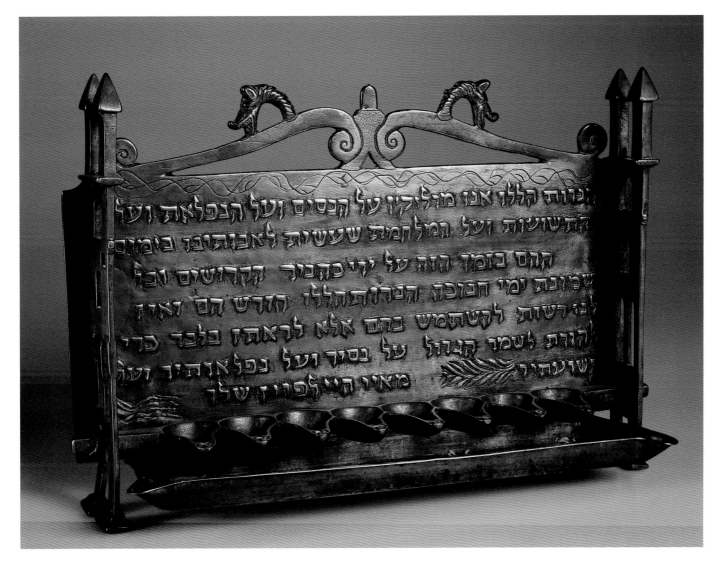

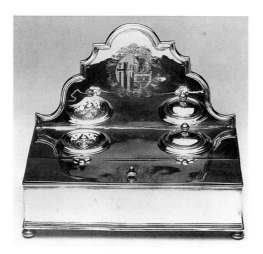

Fig. 17. Inkstand by Nicolaus Lübbert Wichers (German, active 1694–1740), Hamburg, 1724. Silver: cast and engraved, 7⅛ × 9½ × 5⅜ in. (18.2 × 24 × 13.6 cm). Hospital zum Heiligen Geist, Hamburg.

earlier lamps. It would seem to derive from the shape of inkstands of the period, which sometimes consisted of a footed box for holding the inkwell and sand shaker (used for drying the ink). Many such examples also had backplates ornamented with the coats-of-arms of their owners or the scrollwork popular at the time (fig. 17).[40]

The similarity with inkstands is evident in a large number of pewter lamps produced in Germany between 1750 and 1850 (e.g., no. 17). The shapes of the backplate and of the deep, curved base on pewter inkstands are remarkably similar to those on the Hanukkah lamps (fig. 18). The lidded box for the inkwell and other accoutrements was replaced on the lamps by a row of oil containers, situated where the top of the box would be.[41]

It is not until the mid-twentieth century that we see any radical changes in these basic lamp shapes. With the return of American G.I.s and their exodus to the suburbs, a considerable number of synagogues began to be built in the modern style by such architects as Frank Lloyd Wright and Percival Goodman. These architects commissioned well-known sculptors to create Torah arks, eternal lights, menorot, and Hanukkah

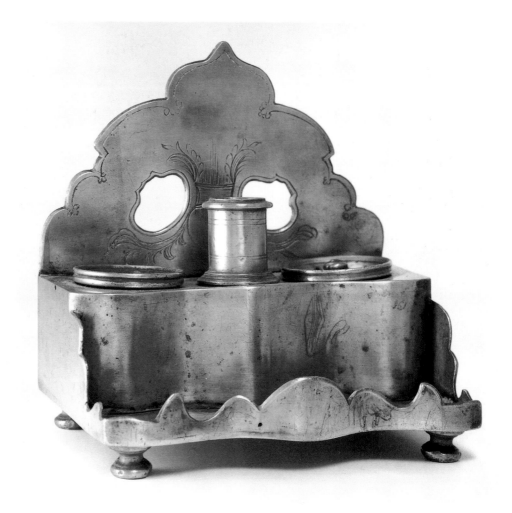

Fig. 18. Inkstand by Joachim L. Keiser (German, active 1750–1800). Pewter: engraved, h. 6⅜ in. (16.2 cm). Swiss National Museum, Zurich, LM-21354. Photo © Swiss National Museum, Zurich.

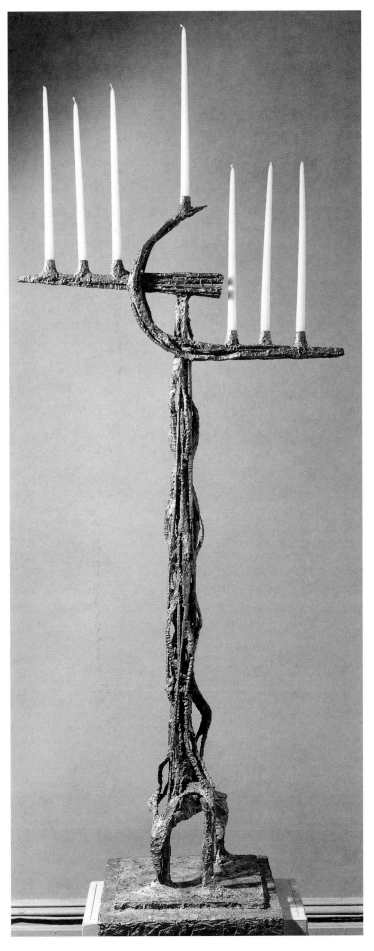

Fig. 19. Synagogue menorah by Calvin Albert (American, b. 1918), 1954. Copper alloy, h. 73 in. (185.4 cm). Park Avenue Synagogue, New York. Photo by Oliver Baker.

lamps. The resulting works of art resembled abstract sculptures that often expanded or redefined the basic menorah form. For example, sculptor Calvin Albert fashioned a seven-branch menorah for the Park Avenue Synagogue in New York in 1954 that resembles a twisting vine; the candleholders are on two different levels (fig. 19). By the 1980s, artists began to expand the number of lights. Amit Shur's lamp of 1986, for example, consists of a large square oil box with numerous holes pierced in the lid. One can choose any of the holes to insert the wicks and light the required number of lights (no. 84). Harley Swedler's *Derivation 36/8*, created in 1992, is a wall-mounted lamp with thirty-six candleholders in a row (no. 105). One kindles a different set of lights each night, moving from the right to the left, to experience spatially the passage of the eight days of the holiday.

SOURCES FOR THE DECORATION

The backplates of Hanukkah lamps were rarely left plain, and over the centuries artists have chosen a variety of motifs to ornament them. Some have a strongly Jewish association, like the Temple menorah discussed above, the arks for holding the Torah (the first five books of the Hebrew Bible) and the synagogues found on eastern European lamps, and biblical figures such as Judith, Moses, and Aaron. Others, including architectural elements, animals, and floral and scroll ornamentation, would appear to be based in secular decorative arts. However, both these categories could have a dual meaning, one in the larger cultural milieu in which Jews lived, and the other a more specific Jewish interpretation based in Jewish literature and tradition.

Many backplates take the form of an actual structure, or are otherwise embellished with architectural elements such as arches, gables, columns, or colonnades. The artists of each country employed the architectural vocabulary common to their times. For example, on the thirteenth-century wall-hung

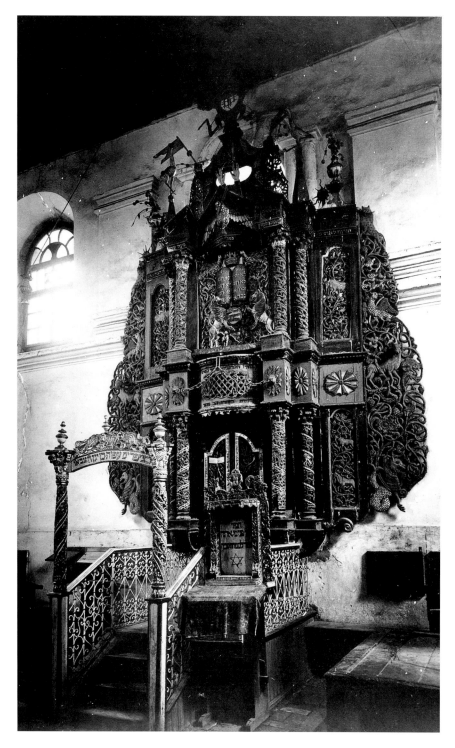

Fig. 20. Torah ark in the synagogue
of Selwa, Poland, 18th century.

shaped, a type characteristic of Islamic architecture. It is possible that the colonnade concept was related to the medieval lamps of Europe, perhaps brought by Jews fleeing Spain in the late fourteenth and fifteenth centuries. Alternatively, it may have developed directly out of the artistic and architectural milieu of Islamic North Africa. In Muslim lands, where the use of human and animal imagery is more restricted than in Europe, arches are common ornaments on a large range of decorative arts objects such as rugs, furniture, silver amulets, and jewelry.[43]

The arches on Italian lamps were derived no doubt from Renaissance models that remained popular in architecture for centuries. One finds purely classical round arches supported by smooth columns as well as broken-pediment facades (see nos. 43 and 44). It is possible that the former was borrowed from another type of wall-hung object of Renaissance date, the wooden tabernacle frame designed to hold religious images for private devotion.[44] In the nineteenth century, the lamps of Germany and Austria reflected the architectural revival styles of Neoclassicism, neo-Gothic, and Moorish (see nos. 23 and 38).

The most explicitly religious architectural models are found on eastern European lamps of the eighteenth and nineteenth centuries with backplates in the form of the Torah arks of local synagogues. Silver examples depict the columns and elaborate openwork scrolls of multistory, carved wooden arks that housed the sacred text (fig. 20). The scrollwork often enclosed a veritable Noah's ark of birds and beasts (see no. 50). Cast copper-alloy lamps depict the exterior of a building, probably a synagogue, that combines western and eastern architectural traditions, complete with a pair of nesting storks on the roof (see no. 52).

The reasons for shaping the backplate like a building are not clear, and the explanation most often proffered is that it symbolized the Temple in Jerusalem. Just as the

lamps from Germany or northern France, there are backplates with an openwork colonnade of interlace arches across the bottom. This is characteristic of Norman architecture of the eleventh through fifteenth century in western Europe (see fig. 10).[42] The motif of an openwork arcade across the bottom of the backplate turns up also on North African lamps of the nineteenth and twentieth centuries, where it is paired with arabesque and scroll ornamentation (e.g., no. 75). Here the arches are horseshoe

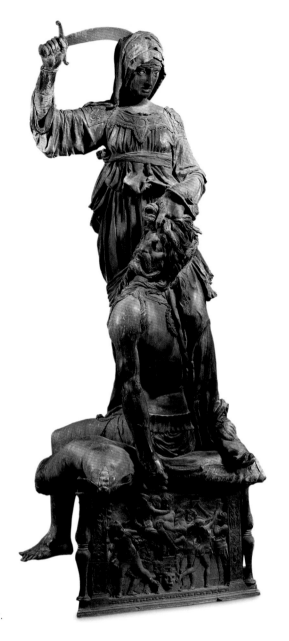

Fig. 21. Donatello (Italian, 1386?–1466), *Judith and Holofernes*, 1456–60. Bronze. Palazzo Vecchio, Florence. Scala/Art Resource, New York.

jects continued through the centuries in Europe, from the magnificent Renaissance gold salt cellar of Benvenuto Cellini, which includes an Ionic temple as the pepper shaker, to an eighteenth-century German table centerpiece representing a birthday party of an Indian mogul, complete with palace, elephants, and a cast of hundreds.[47] In the nineteenth century, table clocks in the form of buildings became popular, for example, a Viennese one shaped like a church.[48] In fact, several Hanukkah lamps of this era included timepieces and may have functioned as or been converted from table clocks (see no. 56). The only period when architectural ornamentation in European decorative arts seems to have declined is between the 1730s and 1770s, the era of the Rococo style, which favored cartouche forms with scrolled edges. This decrease is seen in Hanukkah lamps as well (see no. 5). Thus it appears that Jews favored a secular decorative arts motif that could also be interpreted as a reference to a sacred structure, the Temple.

Human imagery on Hanukkah lamps consisted of figures from classical mythology, such as cherubs, satyrs, and even gods, as well as more strictly Jewish personages from biblical history. Among the last named, the heroine Judith figured prominently in western Europe. As discussed above, rabbinical interpretations that linked Judith with the Hasmonean family contributed to her becoming a popular motif on Hanukkah lamps in Italy, Germany, and the Netherlands. Although the selection of Judith was no doubt rooted in Jewish tradition, it may also have owed something to Judith's larger significance in secular and Christian society and art. In Renaissance Italy, Judith became a symbol for civic virtue during the Florentine revolt against the Medici rulers.[49] This is evidenced by Donatello's sculpture of her, which has an inscription that equates Judith with Humility fighting the corruption of the nobility (fig. 21). It is probably with this symbolism that Judith appears on Italian lamps from the Renaissance through the

Temple menorah is frequently depicted, a reference to the Temple that was rededicated would seem to be an appropriate symbol for the holiday. The artists may also, however, have been influenced by trends common in the decorative arts of their times. For example, Carl Hernmarck notes that "during the Gothic period, architecture was the most important of all arts" and its "hegemony is even mirrored in small objects, which for the most part became a sort of miniature architecture."[45] Consequently, in medieval Europe, censers and church chandeliers were shaped like the holy city of Jerusalem, and Gothic-style buildings served as leg and shaft supports for drinking vessels.[46] The incorporation of architectural elements into tableware and other small objects

nineteenth century.[50] In Germany and the Netherlands, Judith is found on lamps from the later seventeenth century through the eighteenth century,[51] where she may have represented the Protestants' reinterpretation of the heroine as an emblem of the triumph of virtue over wickedness. Over time this symbolism was applied to other situations as well. For example, during the conflict between Empress Maria Theresa of Austria and Frederick the Great of Prussia in the mid-eighteenth century, the empress was seen as the new Judith.[52] Jewish patrons, familiar with the rabbinic interpretation, and artists, aware of Judith's symbolism in the larger cultural milieu as the triumph of virtue, thus may have united in choosing her imagery as appropriate for a Hanukkah lamp.

An examination of the distribution of human imagery on Hanukkah lamps, whether biblical or derived from Greek mythology, indicates that it was favored in western and central Europe (and later in the United States and Israel), but that the communities of eastern Europe, North Africa, and the Middle East appeared to have avoided it. This is understandable in Jewish art made in Islamic lands, where iconoclasm is often predominant. Although the Koran does not forbid the representation of humans and animals, later commentaries on the text led to their rarity in religious works. This explains the situation for the Hanukkah lamps, on which only the occasional bird appears.

In the case of eastern Europe, one wonders if the absence of figures is due to a stricter interpretation of the Second Commandment against creating "a graven image, nor any manner of likeness, of any thing that is in heaven above, or that is in the earth beneath, or that is in the water under the earth" (Exodus 20:3–6). From at least the time of the Mishnah in the third century, this prohibition has been interpreted with varying degrees of leniency.[53] For example, in Prague around 1700, a well-known rabbi's tomb was ornamented with

a sculptural portrait. This and other human figures apparently did not disturb the community members or their leaders, who continued to bury their dead in the cemetery and come there to pray. However, in Hungary in 1832, Rabbi Moses Sofer issued a *responsum* (legal ruling) that a relief image of a man on a tombstone was forbidden, and if it could not be removed, the congregants should not pray over the grave lest it appear they were bowing to an idol.[54] Thus, into the nineteenth century there was concern in some localities with the use of human images in ceremonial contexts.

While rabbinical rulings indicate similarly varied attitudes toward the depiction of animals in Jewish art, the imagery on European Hanukkah lamps suggests there was less concern than with human figures. Perhaps the most popular beasts on Hanukkah lamps are lions, almost always shown in pairs. They stand in the rampant position (on their hind legs), each holding one side of an object placed between them. The use of paired lions in Jewish contexts goes back at least to the third century in ancient Israel. On a fragment of a stone Torah ark from Nabratein, two rampant lions were placed on either side of a triangular gable (fig. 22). This use of two fierce animals to guard the sacred text probably had origins in the biblical description of the Ark of the Covenant in Solomon's Temple, which was protected by creatures called *keruvim*. Thus, in Jewish contexts the paired lions could be interpreted as guardians of the object held between them. Additionally, the lion has been associated in Judaism with one of the Twelve Tribes of Israel, that of Judah, based on the biblical passage in which the patriarch Jacob blesses his son of that name: "Judah is a lion's whelp; from the prey, my son, thou art gone up. . . . The scepter shall not depart from Judah" (Genesis 49:9–10).

While paired lions may have Jewish significance, the particular form that this imagery took on the lamps, in which the item is placed in a shield or medallion, likely

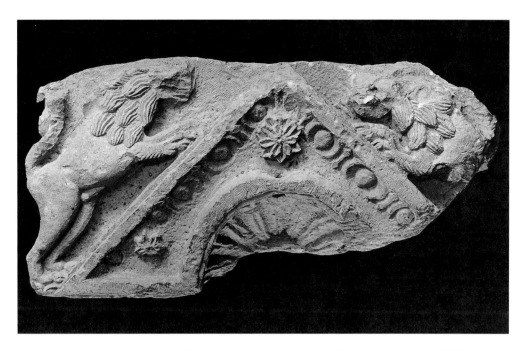

Fig. 22. Fragment of a Torah ark, Nabratein, ancient Israel, second half of the 3rd century C.E. Marble: carved. Photo courtesy of the Israel Antiquities Authority.

came from the idiom of heraldry. The use of paired rampant lions, called supporters, holding an armorial shield, is known from at least medieval times.[55] Lions were chosen as symbols of strength and nobility—the king of beasts and therefore the emblem of royalty.[56]

The most common item on Hanukkah lamps supported by lions is the seven-branch menorah, a motif particularly favored on German and eastern European examples of the eighteenth through the twentieth century. A second popular emblem that is held by lions is the Ten Commandments or Decalogue. Interestingly, although it had been common on synagogue objects for centuries, it appears on lamps only in the mid-nineteenth to early twentieth centuries, and only in Austria, Germany, and eastern Europe. The explanation for its late emergence on lamps might partly lie in ideological developments within Judaism. On the museum's Viennese lamps, which comprise almost all the Austrian lamps in the collection, the seven-branch menorah is absent and only the Decalogue is supported by paired lions. A good portion of the Jewish community there followed the Reform tradition, which denied the messianic hope

for the restoration of the Temple (symbolized by the menorah).[57] However, a different explanation might have to be sought for this trend in eastern Europe. Most of the lamps with Decalogues were created in Warsaw, where assimilationist elements dominated the community in this period, but where the Reform movement never succeeded. It is possible that the motif came to Warsaw from Germany and Vienna.

The emblems of imperial and princely rulers are also occasionally found on Hanukkah lamps as far back as Renaissance Italy, where several lamps bear the coats-of-arms of cardinals and popes.[58] A number of eighteenth-century lamps from Holland, Germany, and Austria were created from grenadiers' helmet shields that incorporate the coats-of-arms of emperors and princes (see no. 112). In addition, the double-headed eagle, symbol of the Holy Roman Empire that was adopted by Austria, Germany, and Russia, is represented on eastern European and German lamps (see nos. 27 and 50).

The practice of incorporating the emblems of one's ruler is seen in other Jewish ritual contexts. European synagogues often had such insignia on the top of the Torah

Fig. 23. Synagogue banner with prayer for a king, Prussia, 1828. Paint on canvas, 44⅛ × 27½ in. (112 × 70 cm). The Jewish Museum, Gift of Dr. Harry G. Friedman, F 6026.

ark or depicted on prayers for the king or prince that were mounted on the wall. A German example of the latter in the collection of The Jewish Museum asks that a blessing be bestowed on the King of Prussia (fig. 23). Created in 1828 under King Friedrich Wilhelm III, the name in the German and Hebrew text was altered to that of Friedrich Wilhelm IV when he succeeded to the throne in 1840. Prayers for the head of state and for the nation in which Jews are living have been included in synagogue services for centuries. This custom is rooted in the words of the prophet Jeremiah to the Jews who were exiled to Babylon in the sixth century B.C.E.: "Build ye houses and dwell in them, and plant gardens, and eat the fruit of them Multiply ye there,

and be not diminished. And seek the peace of the city whither I have caused you to be carried away captive, and pray unto the Lord for it; for in the peace thereof shall ye have peace" (Jeremiah 29:5–7).

STYLISTIC INFLUENCES

The stylistic vocabulary of each lamp for the most part is derived from that of the decorative arts in its period and locale of origin. For example, the large naturalistic flowers and circular scrolls of the European Baroque gave way to the asymmetrical compositions and fantastical shell-like scrolls (rocailles) that characterized the Rococo style of 1730 to 1770 (e.g., no. 5). This florid style, with its scrolls and flowers, was replaced at the end of the eighteenth and into the nine-

teenth century with Neoclassicism, whose quieter, more balanced ornamentation was inspired by Roman and Egyptian antiquities then recently uncovered (see no. 25). Later-nineteenth-century European design was dominated by a return to earlier eras, and thus we find lamps in neo-Gothic and rococo revival styles as well (e.g., nos. 38 and 35). In eastern Europe, more stylized renderings of animals and birds that were derived from local folk art traditions are found on lamps. The surfaces of many lamps made in North Africa and the Middle East are completely covered in arabesque scrolls, reflecting the *horror vacui* (fear of empty space) so predominant in Islamic art (e.g., nos. 72 and 78).

In this same vein, the form and decoration of modern Judaica of the twentieth and twenty-first centuries conforms to trends current in the art and design world. While it appears that in the earlier twentieth century the majority of Jews continued to favor lamps in the revivalist styles of the previous century, a number of artists and firms did produce examples in the newer modes of Arts and Crafts, Art Nouveau, Jugendstil, Art Deco, and Machine Art (see, e.g., nos. 29 and 95). In addition, beginning in the 1920s, we find a few artists espousing the design concepts of the Bauhaus in Jewish ceremonial art. This German school of art and design advocated paring down the form of an object to its functional necessity, devoid of ornamentation, simple in design, using modern techniques and materials. These principles are embodied in a Hanukkah lamp by David Gumbel created in the early 1930s in Heilbronn, Germany (no. 32). It incorporates only the essential elements for function: a short shaft, a flat base for support, and the dominant arms. The geometricization of the Bauhaus style is evident in the circular forms of the arms and disk base.

The functionalist concepts of Bauhaus design eventually came to dominate much of Jewish ceremonial art by the mid-twentieth century, and were disseminated prima-

rily by Gumbel and Ludwig Y. Wolpert. Both were German-trained silversmiths who taught in the New Bezalel School in Jerusalem from the 1930s to the 1950s. Wolpert then became director of the Tobe Pascher Workshop at The Jewish Museum in New York, and emerged as the preeminent influence in American modern Judaica design. Despite the Bauhaus's eschewal of ornamentation and historical content, Wolpert soon added elements of Jewish tradition and spirituality by incorporating Hebrew texts as part of the design, many times so integrated that they are practically illegible (see no. 97).

A second trend in modern and contemporary design is more sculptural in origin, and draws inspiration from various art movements of the 1950s through the present. This is seen in Judith Brown's lamp of 1958: its delicate, spider-web-like arms that swag from one arm to the next[59] are reminiscent of the latticework and droplet-coated rods of Ibram Lassaw's sculptures of the same period.[60] By the 1950s we see monumental seven-branch menorot and Hanukkah lamps for synagogues that are more three-dimensional in form, with heavily textured surfaces, organic lines, and representational imagery.[61]

The interplay between decorative arts and modern art movements is evident in Moshe Zabari's 1967 design for a Hanukkah lamp entitled *Masada* (no. 101). Based on a 1964 sculpture of an armchair of poured polyurethane made by Gunnar Aagaard Andersen, Zabari translated the oozing, undulating surfaces into the crumpled silver of the lamp. The title of the work comes from Zabari's interest in antiquity as one source of his Jewish identity, and his association of the martyrs of ancient Masada, who chose suicide rather than slavery, with the earlier Maccabean victors.[62] The personal and historical associations represented by this work, as well as its emotional content, foreshadow the postmodernist philosophy found in later contemporary art.

THE OWNERS OF THE LAMPS

THE CHANGING SIGNIFICANCE OF HANUKKAH

Over the centuries, the festival of Hanukkah took on different meanings for those who kindled their lamps each year. The first transformation took place in antiquity, as discussed above, when the explanation for celebrating an eight-day holiday shifted from events enacted by human hands, that is, the liberation and rededication of the Jerusalem Temple, to those divinely wrought, represented by the miracle of the jar of oil that burned for eight days. This change parallels the political status of Jews at the time and the major transformation that occurred in Judaism. The Romans, who ruled ancient Israel at that time, had destroyed the Jewish Temple and the sacrificial ritual that was the heart of Jewish religious observance. A new form of worship emerged that was based on the reading and study of the holy book, the Torah. Yet Jews never ceased longing for the restoration of the Temple and the redemption of Zion, and the lighting of the Hanukkah lamp became a reminder of this hoped-for event.

The nineteenth century was a time of great change for Jews the world over, with its emphasis on science over religion, its industrialization and urbanization, and its emancipation movements, which brought Jews into closer contact with the societies among which they lived. The European Enlightenment sought rational and scientific approaches to scholarship, and the Jewish version of this, the *haskalah*, advocated the study of secular subjects as well as the critical study of all things, including Judaism. The *haskalah* movement became popular in many European cities, and efforts to modernize and reinterpret the practice of Judaism led to the birth of the Reform movement. At the same time, a number of European rulers passed regulations requiring Jews to integrate more into society by attending secular schools and abandoning their distinctive languages and customs. The granting of equal rights in many states furthered this process of secularization, enabling Jews to attend university, enter any profession, and live where they chose. All these factors led to increasing acculturation and assimilation. Despite these pressures and opportunities to abandon Jewish ways, large numbers of Hanukkah lamps were produced during the nineteenth century, a testimony to the fact that the holiday retained some meaning and importance. This was depicted in nostalgic illustrations of Jewish rituals, such as German artist Moritz Oppenheim's 1880 grisaille of a festive family Hanukkah celebration (fig. 24).

In a number of Christian countries, the proximity in time of Hanukkah to Christmas elevated the former to new significance and transformed it in the process. For example, by the late nineteenth and early twentieth centuries, the more assimilated German Jews celebrated *Weihnukkah*, a combination of Christmas (*Weihnacht* in German) and Hanukkah, which included the display of a decorated tree. At the same time, in the United States, many Jews, particularly those from Germany, celebrated some form of Christmas, whether it was the exchange of gifts or the trimming of a tree. To make Hanukkah more popular, Jewish leaders attempted to create a more Christmaslike celebration, practically equating the lamps with Christmas trees, and recommending that Hanukkah become a time for family gatherings, with presents and merriment.[63] A final transformation in the celebration of Hanukkah in America paralleled one that occurred with Christmas. In the later nineteenth century, the family-based religious festival became increasingly commercialized, with businesses everywhere urging the purchase of gifts and cards for exchange with friends and loved ones, and of all the trimmings for the tree.[64] This caught on among Jews as well, and even eastern European immigrants, for whom Hanukkah had not been a major holiday, began to be bom-

Fig. 24. Moritz Daniel Oppenheim (German, 1800–1882), *The Kindling of the Hanukkah Lights*, 1880. Oil on canvas (grisaille), 27¾ × 22½ (70.4 × 57.2 cm). The Israel Museum, Gift of Mr. Sally Cramer, London, in memory of his brother Herbert, 506/28. Photo © The Israel Museum, Jerusalem.

barded with advertisements in the Yiddish press for Hanukkah gifts, from household items to cars.[65]

Another trend at the beginning of the twentieth century brought the meaning of Hanukkah full circle, back to the heroic deeds of the ancient Maccabees. The Zionist movement, founded in the late nineteenth century, promoted a new image of the Jew as a pioneer, working the land in Israel and fighting for the right to live there. Theodore Herzl, the founder of the movement, proclaimed, "I believe that a wondrous generation of Jews will spring into existence, the Maccabees will rise again."[66] In eastern Eu-

rope, the United States, and the land of Israel, the association of the holiday with political and religious freedom resonated among Zionist youth, and led to the creation of numerous poems and plays on the Maccabees, as well as to an annual torch race in Israel that started in Modi'in, the place where the revolt began.[67] This symbolism continues today, expressed for example by United States President George W. Bush in December 2001, a few months after the attack on the World Trade Center of September 11. Before he kindled the first Hanukkah lamp to be lit in the White House residence, he remarked, "as we watch the lighting of

this second candle of Hanukkah, we're reminded of the ancient story of Israel's courage and the power of faith to make the darkness bright. We can see the heroic spirit of the Maccabees lives on in Israel today, and we trust that a better day is coming when this Festival of Freedom will be celebrated in a world free from terror." The lamp used in the ceremony was from The Jewish Museum collection, no. 61.

OBTAINING THE LAMPS

The materials from which the lamps are fashioned, as well as their size and quality, indicate a wide range in their owners' economic means and access to skilled craftsmen. Rabbinic texts from several eras indicate that if at all possible, one should have a lamp of gold or silver. For example, in the fifteenth century Moshe N. Makhir of Zeitun in the land of Israel noted that it was important to have a silver lamp even if only one light holder each night was silver, an opinion echoed by Joseph Juspa Hahn Nördlingen in Germany in the seventeenth century.[68] These instructions appear to have been followed most often in Germany, Austria, and eastern Europe, where a good percentage of the lamps are of silver. By contrast, lamps of this metal from the Netherlands, Italy, North Africa, and the Middle East are known, but rare.

In Germany, among the small number of Jews allowed to live in cities, some attained great wealth, and it is perhaps these members of the community who could afford the silver lamps. Even if one had the means, however, obtaining one was not always easy. In Frankfurt, which had a long-standing Jewish community, since at least the Middle Ages, Jews were active patrons of the city's Christian silversmiths, some of whom seemed to cater almost exclusively to a Jewish clientele.[69] In other regions, however, Jews were barred from entering certain cities, among them the major silver-smithing centers. For example, in the eighteenth century Jews were not allowed to

reside in Nuremberg and Augsburg, and could only enter for the day on a special pass for which they had to pay a fee. Yet, a number of eighteenth-century lamps from these cities are known. Apparently, the desire for beautifully crafted works from the renowned centers led those of Jewish faith to go to great lengths in attaining their ceremonial art (see nos. 13 and 23).

The nineteenth-century silver lamps in the collection from Austria and eastern Europe could have been used by those successful Jews who had achieved important positions in industry, commerce, and banking, or even by those in the middle classes who prospered with their workshops or stores that sold the products of industrialization. In addition, the proliferation of machine-made lamps in silver or with silver-plate, produced by the less expensive method of die-stamping, enabled larger numbers of Jews to purchase silver lamps in the second half of the nineteenth century.

According to a fifteenth-century rabbinical *responsum*, the material preferred after gold and silver was brass.[70] This is repeated in a late-seventeenth-century work by Abraham Azulay, who listed in order the fifteen types of materials that should be used for lamps.[71] Brass or bronze lamps (combined in this catalogue under the rubric "copper alloy") are quite common in the Netherlands, Italy, eastern Europe, North Africa, the Middle East, and Asia. Yet, this material was not inexpensive; Zholtov-skiy notes that in eastern Europe, copper-alloy chandeliers could only be afforded by the urban upper and middle classes.[72] The same is likely for the cast copper-alloy Hanukkah lamps of eastern Europe, which were nevertheless quite common.

Sixth and seventh on Rabbi Azulay's list were tin and lead. Based on their distribution, the large number of pewter and tin lamps from Germany suggests what small-town and rural Jews were able to afford. Yet again, pewter was not inexpensive, as the major alloying material, tin, is quite

rare and had to be imported long distances. Thus, the pewter lamps may represent those affordable by middle-class German Jews. The tin-plate lamps used primarily in the Alsace region of Germany, and bordering on France and Switzerland, were apparently mainly for the indigent.[73]

There is a whole stratum of Jewish society, as well as certain locales, for which we have no permanent Hanukkah lamps at all. In Turkey, for example, Jews favored simple tin lamps that were discarded at the end of the holiday.[74] Those who could not afford permanent lamps would use individual eggshells, walnut shells, or even potatoes that had been scooped out for the oil.[75] Rabbi Azulay also lists pomegranate rinds and acorn shells as allowable for Hanukkah, although they are among the least preferred materials. Thus, lamps of certain members of the Jewish community, made of ephemeral materials, are not represented in museum collections.

Although it must have been difficult for the poorest Jews to observe the holiday, rabbinic sources were insistent that the holiday be celebrated if at all possible. The Babylonian Talmud indicates that on the Sabbath during Hanukkah, if one had enough oil for only one light at home, one should light the Sabbath lamp on Friday night since it is used to see with. However, if one had to choose between spending money on oil for the Hanukkah lamp and wine for sanctifying the Sabbath, one should buy the lamp oil.[76] By the twelfth century, observing Hanukkah became even more important, and Moses Maimonides urged that even the poorest Jews who receive charity should borrow funds or sell their clothing in order to be able to purchase oil for the lamp.[77]

IDENTIFYING THE OWNERS

The identities and histories of the owners of most of the lamps in the collection are largely unknown. They were obtained from private collectors, dealers, or individuals from whom provenance information was not always taken. Thus, their original stories have become lost. Only those with inscriptions, emblems, or an unbroken family history provide tantalizing glimpses of those who purchased or commissioned the lamps and the occasions on which they were obtained.

Several lamps in the collection were dedicated to synagogues, ranging from a five-inch-high brass wall lamp from Italy, donated by a Mr. Katz in 1747/48, to a five-foot-high menorah-form lamp from eastern Europe, presented by Mensaḥ Tzvi, son of Moshe Shlomo of Lvov, in 1752/53.[78] Although the names of the donors are recorded, their histories and that of the synagogues they supported have long been obscured. Yet we can imagine the piety and the generosity that motivated them to give objects of such value to their places of worship.

In some cases, we can piece together a bit more of a lamp's story from inscriptions. One such piece was dedicated to a synagogue by Yaakov Israel Bravo (no. 4). A plaque was later added to the lamp to memorialize him after his death in 1756/57. Clues provided in the inscription and in the known provenance imply that the synagogue in question was in Kingston, Jamaica, established in 1750.

Other lamps appear to have been owned by newlyweds and were possibly received as wedding gifts. For example, a German pewter lamp in the collection is inscribed with two sets of couples' names, one dated 1750/51 and the other 1778/79, both from a town called Mardorf (no. 17). Although no other information is provided, one might make the romantic interpretation that the lamp was owned by a couple, possibly even received as a wedding gift, and was then given to a member of the next generation upon his or her marriage. Other lamps in the collection have flaming hearts in the center, which was a symbol of love for many centuries.[79] Such lamps may very well have been gifts presented from one affianced

lover to another. Finally, a silver lamp made in Essaouira, Morocco, in the nineteenth or early twentieth century is decorated with images of fish and birds, both considered symbols of fertility because of the multiple eggs they produce (no. 71). This tempts us to suggest that the lamp may have been given as a wedding gift to wish the couple many children.

Hanukkah lamps seemed to be popular as presentation gifts on other occasions as well. One recipient of such a gift was General Joseph T. McNarney, who served as the Commander in Chief of United States Forces in the European Theatre right after World War II (no. 33). As part of his duties, he was responsible for the Displaced Persons camps in Germany and Austria. In 1945, the residents of a German DP camp fashioned a Hanukkah lamp and presented it to their "Liberator," General McNarney. A lamp formerly in the museum collection acquired great historical distinction when it was given to the State of Israel in 1951 so

that David Ben-Gurion could present it to Harry S. Truman for his birthday (fig. 25). The lamp is currently on display in the Truman Presidential Museum and Library in Independence, Missouri.

Family history helps greatly in reconstructing the full story of a lamp, bringing the original owners and their times back to life and chronicling the often complex peramubulations of the lamp. One example is that of a German menorah-form lamp in the collection created in Hanau in the first quarter of the twentieth century (no. 30). It was purchased there by the Frisch family soon after it was made. They moved to Antwerp, from which they fled in the 1930s to escape the Nazis. The Hanukkah lamp was left behind in their apartment. Although German officers occupied their home, the lamp was untouched, and was retrieved by the family after the war. They brought it to the United States, where they kindled it for many years until the Frisch daughter donated it to the museum in 1997.

Fig. 25. President Harry S. Truman (left) receiving a Hanukkah lamp as a gift from Israeli Prime Minister David Ben-Gurion (center) and Israeli Ambassador Abba Eban (right), 1951. Photo courtesy of Harry S. Truman Presidential Museum and Library, Independence, Missouri.

Fig. 26. The Warburg family, 1917. Frieda Schiff Warburg is seated in the center as her husband, Felix, stands behind her. From Edward M. M. Warburg, *As I Recall: Some Memoirs* (privately published by author), p. 11.

Three of the lamps given to the museum by Frieda Schiff Warburg have diverse stories of ownership and use. An important figure in Jewish Museum history, Mrs. Warburg donated her Fifth Avenue mansion in 1947 for the establishment of The Jewish Museum in its own building (fig. 26). The first Hanukkah lamp is a magnificent silver menorah-form lamp made in Frankfurt in the early eighteenth century that belonged to her parents (no. 12). Her father, Jacob Henry Schiff, was a major American financier and philanthropist originally from Frankfurt. The Schiff family's presence in that city dates back to the fourteenth century, and although there is no definitive information on the lamp's original provenance, it is possible that it had been in the family since its creation between 1706 and 1732. The second lamp is much less elaborate, a stamped silver bench type made in Warsaw in the late nineteenth century that was used in the Warburg home.[80] The third lamp, also an Eastern European bench type in silver, was a gift to the Warburgs from Chaim Weizmann, the first president of Israel; he used it in his own home for Hanukkah.[81]

THE COLLECTORS

The majority of the lamps in the museum consist of private collections formed in the late nineteenth and early twentieth centuries or works donated by one passionate collector of Judaica. The notion of assembling Jewish ceremonial art for private or public display, rather than ritual use, goes back at least to the seventeenth century. At that time, wealthy Jews who served in the courts of Europe as diplomats, financiers, and purveyors became patrons of the arts. In imitation of the sumptuous treasure rooms of the nobility, they acquired great works of art for their homes. Several, notably Baron Manuel de Belmonte, Jeronimo Nunes da Costa, and the baron Lopes Suasso, all of the Netherlands, collected Jewish manuscripts and ritual objects, which they exhibited to gentile visitors as evidence of the glory of Jewish culture.[82] Alexander David of Braunschweig, a German Court Jew of the eighteenth century, also amassed a collection of ceremonial art for his private synagogue, which was preserved intact after his death. His collection represents the seeds of the first Jewish museum.[83]

The Jewish Museum in New York was founded in 1904 with the donation of one such private collection, a gift of twenty-six ritual objects and works of art from Judge Mayer Sulzberger. It was Judge Sulzberger's hope that the collection would "serve as a suggestion for the establishment of a Jewish Museum." His sentiments were echoed in Europe as well, where several Jewish museums were being created around this time in cities such as Vienna, Prague, and Danzig. The impetus for the founding of public collections of Judaica had its origins in several developments of the nineteenth and early twentieth centuries. The Jewish Enlightenment gave birth in the nineteenth century to the *Wissenschaft des Judentums* movement, which focused on analyzing the textual, historical, and philosophical underpinnings of Jewish culture and religion. This removed

ritual art from the realm of the sacred and made it an object of scientific study. In addition, the secularizing tendencies of *haskalah*, as well as emancipation and other external pressures, all led to increasing acculturation and assimilation of Jews into mainstream society in various European countries. Large-scale emigration in the face of harsh economic conditions or pogroms was another contributory factor. Synagogues were being disbanded, ritual objects in homes were being neglected, and the need arose to preserve elements of this Jewish heritage rather than see them destroyed. Finally, a widespread interest in "exotic" cultures by many anthropologists and ethnography museums in the late nineteenth century led to the collection of material culture from ethnic groups who were becoming divorced from their traditions through increasing urbanization and industrialization.[84]

The various collections that make up the museum's holdings reflect these and other motivations for acquiring Jewish ceremonial art. The earliest is that of Hadji Ephraim and Mordecai Benguiat, formed in the nineteenth century and acquired by the museum in 1925. Ephraim Benguiat was

Fig. 27. Hadji Ephraim Benguiat.

an antiques dealer originally from Izmir, Turkey, who found it impossible to sell any of the Jewish ceremonial objects that he purchased, ostensibly for resale (fig. 27). In the words of his son, Mordecai, he felt that "any antiquities saved from the repeated ca-

Fig. 28. Rose and Benjamin Mintz in their Warsaw home, before 1939.

Fig. 29. Lesser Gieldzinski of Danzig
(1830–1910), c. 1904.

collection was in itself an accumulation of objects from several different sources, embodying all the trends in collecting Jewish art described above. One group comprised the ceremonial objects used in the Great Synagogue of Danzig, some of which had been gathered from synagogues in neighboring towns that had closed. A second group consisted of the private Judaica collection of Lesser Gieldzinski, a wealthy merchant and art collector, who had donated it to the Danzig synagogue in 1904 (the same year that The Jewish Museum was founded) (fig. 29). The Gieldzinski collection was displayed in a special room in the synagogue, and constituted one of the earliest Jewish museums. Other ceremonial objects were donated by individuals, for example a large menorah-form lamp dedicated in 1935 by Simon Anker, an important businessman, for use by the children of the congregation.[86]

The children had only four years to celebrate Hanukkah with the lamp before Danzig was invaded by the Germans. The community members were allowed to leave, and they sent their synagogue objects for safekeeping to the Jewish Theological Seminary of New York, under whose auspices The Jewish Museum was founded. They stipulated that if they did not reestablish their community within fifteen years, the seminary was to keep the collection "for the education and inspiration of the rest of the world." While most of the community members survived the war, they did not return to Danzig, and the objects became part of the museum's collection. In 1980, a major exhibition, *Danzig 1939: Treasures of a Destroyed Community*, was mounted and circulated to numerous cities in the United States and Europe in fulfillment of their wishes.

After World War II, thousands of Jewish cultural and ceremonial objects were recovered in Europe by the United States Army. The Jewish Cultural Reconstruction undertook to find homes for them. Whenever possible, the original owners or their heirs were located and the objects returned. The

tastrophes and diaspora are of the greatest value, although they may not all possess the same merit or value as the antiquities of other nations."[85] The Benguiat collection contains some magnificent works, for example, a silver wall lamp from Brody of the late eighteenth century (no. 50). Another important collector was Benjamin Mintz of Warsaw, also an art and antiques dealer who did not have the heart to divest himself of the Judaica that came his way during the course of business (fig. 28). This fine assemblage of mostly eastern European Judaica was brought to New York in 1939 for exhibition at the World's Fair, and thus the Mintzes and the collection were saved from the Nazi invasion of Poland that year. Rose Mintz sold her husband's collection to the museum in 1947. The most striking lamp is a large brass piece decorated with elephants, monkeys, and bears (no. 65).

The upheavals of World War II were responsible for the acquisition of two other collections, one from the Danzig Jewish community and the other through the Jewish Cultural Reconstruction. The Danzig

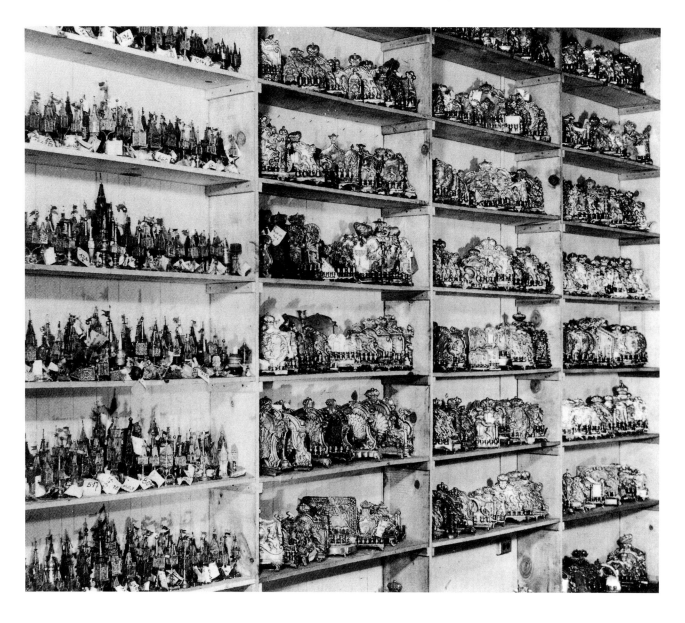

Fig. 30. Judaica recovered by the Jewish Cultural Reconstruction, in storage at The Jewish Museum, c. 1950.

remaining pieces were distributed among a host of Jewish institutions in the United States and Israel. The staging area for the distribution was in the basement of The Jewish Museum (fig. 30). Research associate Guido Schoenberger, who had been a curator at the Jewish Museum in Frankfurt before the war, selected the works that were allotted to the museum. Many were old friends of his, treasures that had once belonged to the Frankfurt museum, including a small silver lamp made by renowned German master Johann Christoph Drentwett I of Augsburg in 1735–36 (no. 15). These works became part of the collection in 1952.

The majority of the Hanukkah lamps in the collection, some sixty-nine percent, were contributed by one remarkable individual, Dr. Harry G. Friedman (fig. 31).

Originally trained as a rabbi, Dr. Friedman had a highly successful career on Wall Street and became a community leader and philanthropist. He considered it his mission to salvage Jewish ceremonial and fine art wherever he could find it. He haunted the thrift shops and antique stores of New York or whatever city he found himself in, and purchased Judaic works that he immediately donated to the museum. Many of these were probably brought to the United States by immigrants in the nineteenth and early twentieth centuries. Sadly, later generations did not appreciate grandma's heavy brass lamp from eastern Europe with the inconvenient oil containers, and the lamps were consigned for sale. In addition, Friedman convinced numerous individuals to donate or sell their works, and during and after the

Fig. 31. Dr. Harry G. Friedman.

Holocaust he acquired pieces that were sold from European collections. Between 1939 and his death in 1965, he contributed more than 6,000 objects to the museum, 706 of them Hanukkah lamps. It did not seem to matter if the piece were homely or if the museum already owned numerous examples of that particular type; all works were considered precious to salvage for the benefit of future generations. To the best of our knowledge, only one of the lamps was actually used by Dr. Friedman or his family. This was a simple well-worn bench lamp that belonged to Dr. Friedman's mother, which he donated with the condition that it never leave the collection (no. 63).

Dr. Friedman's passion for acquiring everything was a tremendous boon in conducting the research for this catalogue. Technological comparisons of multiple examples of a single type enabled the establishment of new chronological indicators. In addition, the large number of lamps of the same kind with marks allowed the determination of their geographic distribution with greater confidence.

The last collector who was instrumental in shaping the museum's holdings was Dr. Abram Kanof, whose collection ranged over various times and places but specialized in modern ceremonial art (fig. 32). He and his wife, Dr. Frances Pascher, founded the Tobe Pascher Workshop at The Jewish Museum in 1956, whose goal was to "apply the principles of contemporary design to Judaica . . . [and produce] objects of quality and excellence according to the new design philosophies but always in the service of the most ancient rituals and traditions."[87] It was hoped that these modern objects would reinvigorate the performance of Jewish ceremony, and help to ensure a vibrant future for Judaism. The workshop provided studio space for the director, Ludwig Y. Wolpert, and his assistant (later the director), Moshe Zabari, to create their own works and to take on students as well (figs. 33–34). Drs. Kanof and Pascher also provided funds for the museum to purchase pieces made in the workshop, which contributed to the sizable number of works by Wolpert and Zabari in the collection.

Fig. 32. Dr. Abram Kanof.

Fig. 33. Ludwig Y. Wolpert in the Tobe Pascher Workshop at The Jewish Museum, 1959. Photo by Frank Darmstaedter.

Generous individuals also have contributed precious family heirlooms to the collection. Sometimes these gifts were tinged with sadness, as the donors had no heirs, or represented the last generation in their family to honor Jewish tradition. Other times, the donors expressed a public-minded spirit, preferring that the lamp be in a museum rather than remain at home where it would be unseen.

IN THE JEWISH MUSEUM

The Hanukkah lamps in the collection now serve a function beyond that originally intended by their creators and previous owners. They help illuminate the multitude of events and people that have contributed to the practice, interpretation, and preservation of Jewish culture over the centuries. True, it is poignant to consider that the lamps will no longer be kindled on the holiday, that they often represent the cast off, the war torn, or the last generation. Yet their very survival represents its own kind of miracle—of the link between the Jewish past and its future, effected through the courage, intellect, creativity, piety, passion, and generosity of so many actors in their stories.

Fig. 34. Moshe Zabari in the Tobe Pascher Workshop at The Jewish Museum, 1980s.

NOTES

1. Babylonian Talmud, Shabbat 21b.
2. Babylonian Talmud, Shabbat 21b.
3. Babylonian Talmud, Shabbat 21b.
4. Babylonian Talmud, Shabbat 23b.
5. Benoschofsky and Scheiber, no. 100; Bendt, no. 168; Jarrassé, pp. 44, 57, 76–77, 105–6.
6. Sharoni-Pinhas, nos. 2–3; Slapak, p. 84 lower right.
7. Babylonian Talmud, Shabbat 21b, 23b.
8. A. Kaplan, p. 15.
9. M. Narkiss, p. 22.
10. A. Kaplan, p. 66.
11. A. Kaplan, p. 32; *Shulḥan Arukh, Oraḥ Ḥayyim* 673:1.
12. A. Kaplan, pp. 31–32.
13. Babylonian Talmud, Shabbat 21b.
14. A. Kaplan, p. 6.
15. Friedman, p. 225; *Shulḥan Arukh, Oraḥ Ḥayyim* 670:2.
16. Wischnitzer, pp. 82, 88, 156–82, 202–3, 205; Wolf, pp. 13, 17; Sed-Rajna, p. 286; Kremer, p. 37; Landsberger 1941, p. 374.
17. See nos. 156 and 170 in the catalogue raisonné.
18. See no. 483 in the catalogue raisonné.
19. Wischnitzer, p. 212; Zholtovskiy, p. 13.
20. Wischnitzer, p. 234.
21. See the discussions in the chapters on North Africa and on the Middle East and Asia, as well as Muchawsky-Schnapper 2000, pp. 113–14.
22. Ghabin, pp. 84–87.
23. See Barquist.
24. Metzger and Metzger, p. 108; Gutmann 1999, fig. 3.
25. Baer, p. 148; Goodman, p. 308; Muller-Lancet, unpag.; Brauer, p. 338; Hanegbi and Yaniv, no. 54.
26. E.g., B. Narkiss 1988, fig. 6; Menahem Schmelzer (personal communication).
27. B. Narkiss 1988, p. 12, figs. 1, 8.
28. Caspall, pp. 206–7.
29. Muchawsky-Schnapper 2000, pp. 174–75; Benjamin 2002, nos. 103, 105–6.
30. Braunstein 1991.
31. Baur, p. 21; Young, p. 116.
32. Baur, p. 26.
33. E.g., see Rheinischer Verein, p. 159; Joods Historisch Museum, acc. no. JHM 243.
34. Metzger and Metzger, p. 108.
35. *Shulḥan Arukh, Oraḥ Ḥayyim* 671:4.
36. A. Kaplan, pp. 18–20.
37. Levine, pp. 109–10.
38. Kühnel, pp. 117–18.
39. See Jarmuth fig. 114 for a fifteenth-century candelabrum with similar arm treatment.
40. E.g., Schliemann, nos. 739, 741, p. 12; Honour, p. 127; Seling, fig. 973.
41. Cf. Nadolski, no. 398, p. 282.
42. Braunstein 1991, p. 8.
43. E.g., Rabaté and Goldenberg, p. 129.
44. E.g., Newbery, Bisacca, and Kanter, p. 24, nos. 7–10.
45. Hernmarck, p. 41.
46. Hernmarck, p. 41, nos. 31, 205, 236; Schnütgen-Museums, p. 264, no. H1.
47. Honour, pp. 75, 150–51.
48. Daniels and Markarian, no. 144.
49. See the discussion in no. 48.
50. E.g., Grossman 1989b, no. 154.
51. E.g., nos. 11 and 19; Barnett, no. 225.
52. See the discussion in nos. 11 and 19.
53. See Mann 2000b, pp. 19, 31.
54. Mann 2000b, pp. 32–34.
55. Fox-Davies, p. 307.
56. Neubecker, p. 90.
57. See the discussion in no. 35.
58. E.g., Keen, no. 23.
59. No. 615 in the catalogue raisonné.
60. E.g., Selz, fig. 1093.
61. Kampf, pp. 55, 68–69, 106, 139.
62. Berman 1986, pp. 15–16.
63. Weissman Joselit, p. 308.
64. Weissman Joselit, p. 305.
65. Weissman Joselit, pp. 310–12.
66. Berman 1996, p. 10.
67. Eliach, p. 425; Edidin, pp. 99–102; Gutmann 1992, p. 6; Berman 1996, p. 10.
68. M. Narkiss, p. 68; Mann and Cohen, no. 128.
69. Mann 1986, p. 389.
70. A. Kaplan, p. 39.
71. Shachar 1981, p. 131.
72. Zholtovskiy, p. 83.
73. Raphaël and Weyl, p. 310.
74. Benjamin 1992, p. 134 n. 63; Eis 1977, no. MC 87.
75. Radovanović and Mihailović, p. 237; Arbel and Magal, p. 144; Brauer, p. 338.
76. Babylonian Talmud, Shabbat 23b.
77. *Mishneh Torah*, Hanukkah 4:12.
78. See, respectively, nos. 323 and 449 in the catalogue raisonné.
79. See nos. 222 and 186 in the catalogue raisonné.
80. Museum acc. no. S 564, listed under no. 353 in the catalogue raisonné.
81. See no. 363 in the catalogue raisonné.
82. Y. Kaplan, p. 22.
83. Busch, p. 63.
84. Cohen; Cohen Grossman 1997: 4–14.
85. The Jewish Museum files.
86. See no. 286 in the catalogue raisonné.
87. Kanof 1986.

HIGHLIGHTS OF THE COLLECTION

THE NETHERLANDS

The earliest evidence for Jewish settlement in the Netherlands is found in a twelfth-century document that describes Jews engaged in moneylending. About 1590, this population was augmented by Sephardi Jews, those originating from Spain and Portugal and using the language and Jewish customs specific to the Iberian Peninsula. These new arrivals were in fact conversos, Jews who had been forced to convert to Christianity but practiced Judaism in secret. A few decades later, they were joined by Jews from Germany and Poland, who followed the Germanic Ashkenazi customs. These two communities maintained separate synagogues and traditions. Until 1796, when Jews were granted equal civil rights, each Dutch city was free to adopt its own policy toward Jewish settlement and livelihood. As a result, the severity of civil regulations on Jewish life varied from place to place. Nevertheless, a few Jews, particularly from the Sephardi community, were able to flourish economically in the seventeenth century; they were engaged in industry, the stock exchange, and book printing, and some also served as purveyors to royal courts.

The Dutch lamps in the collection were all created in the eighteenth and nineteenth centuries, a period of considerable change for the Jewish community. General economic setbacks of the eighteenth century caused a decline in the finances of both the Sephardim and Ashkenazim, although at different times. Prosperity returned again only in the second half of the nineteenth century, with the development of the diamond and cotton industries. After gaining full rights in 1796, there were a number of pressures from within and outside the Jewish community to secularize and assimilate.

SILVER LAMPS

It is not clear whether the financial adversities of the eighteenth century affected the type of lamps that the communities could afford. However, the evidence indicates that silver lamps were rare, and the handful of extant examples date from the late seventeenth to eighteenth century (Den Blaauwen, no. 88; Parke-Bernet 1959, lot 41; Jacobs and Wolf, nos. 1731 and 1743). Although Jews were not allowed in the silversmiths' guilds, there was at least one Dutch-trained Jewish silversmith, Abraham d'Oliveyra, who moved to London and produced magnificent Jewish ceremonial art from the 1710s through the 1730s (Roth 1974, p. xviii; Barnett, nos. 112, 114–15, 117, and 119–20). The Jewish Museum owns only one silver lamp from the Netherlands, an unusual standing example of Ashkenazi type (see no. 5). It is of interest to note that while the population included both Sephardim and Ashkenazim, the majority of Dutch lamps were hanging types more typical of Sephardi lands.

COPPER-ALLOY LAMPS

The material of choice or necessity for most Dutch lamps was copper alloy. The alloy was either brass or bronze, which are difficult to distinguish without the aid of compositional analysis. Some of the earliest lamps were cast, for example, a lamp with lily-form elements dedicated in 1629/30 to the Portuguese Synagogue in Amsterdam (cf. no. 4).

Detail of no. 5.

By far the greatest number were created from sheet metal, with hand-hammered (repoussé) and pierced ornamentation. A wealth of decorative motifs derived from folk art, heraldry, and Jewish tradition are found on the backplates. These include flowers and hearts, paired lions, seven-branch menorot, and Stars of David. The oil rows were often cast, and most lamps have a drip pan attached below to catch any oil that might spill.

These sheet-metal lamps were clearly adapted from secular wall sconces, and were made in much the same way. However, several features differentiate the two types of lighting devices. Backplates of seventeenth- and eighteenth-century sconces were oval, round, or octagonal in form, with a large convex or concave undecorated area in the center that served as a reflector for one or two candles on bracket arms (see fig. 13). The decoration that framed this central reflector was primarily floral in nature and repoussé in technique; piercing was rare. By contrast, Hanukkah lamps, which required eight lights, needed to be widest at the bottom, and thus the makers modified the form of the backplate into an arch. The large central reflector boss was converted into many smaller bosses, hearts, or flowers that served the same function of augmenting the lights. Finally, the makers of Hanukkah lamps favored pierced decoration, which seems to have been derived not from sconces but from heating devices such as bed-warming pans and foot warmers, which have openings to allow the heat to escape.

Much of the production of sheet-metal copper-alloy objects originated in the Maas area of Belgium and the Netherlands, especially in the eighteenth century. It was imitated in other countries such as Germany and spread to many other European lands (Schlee, p. 141; Caspall, p. 246). Judaica scholars had formerly assumed that sheet-metal lamps were therefore Dutch in origin. However, a number of nineteenth- and twentieth-century lamps of this type have been collected in Morocco, and most likely were made there as well. For a discussion of the differences between the European- and Moroccan-made Hanukkah lamps, see no. 77.

The dating of the sheet-metal lamps, which are not signed or marked, has always presented difficulties. However, some chronological indicators were identified through a study of the few Hanukkah lamps that have inscribed dates (nos. 133, 142, and 186 in the catalogue raisonné; Joods Historisch Museum, acc. no. JHM 243, dated 1705; Schoonheim, no. 10, commissioned in 1842; Weizman, no. 2, dated 1807). Also helpful were dated secular objects such as bed warmers, sconces, and foot warmers from the first half of the eighteenth century that exhibit similar techniques and designs (Gentle and Feild, nos. 1 and 3 on p. 283; Schlee, no. 232; Wiswe, no. 177). Based on these examples, eighteenth-century work can be characterized by repoussé tulips and buds (the surface of the latter decorated with many small raised beads), a more refined execution by hand, and the use of continuous lines and complex forms. Piercing, found not in Hanukkah lamps or sconces but in other object types, carefully outlined each element of the design (e.g., Rijksmuseum, no. 193; Schoonheim, no. 10). By contrast, nineteenth-century lamps were simpler in execu-

tion and design, and made by hammering the metal over forms rather than by freehand repoussé (Caspall, p. 250). Dapping, in which most of the design elements are outlined or filled in with small raised dots (e.g., no. 7), became a dominant decorative technique. Finally, the pierced work consisted of crudely chiseled geometric holes that did not completely correspond to the images formed by the raised decoration.

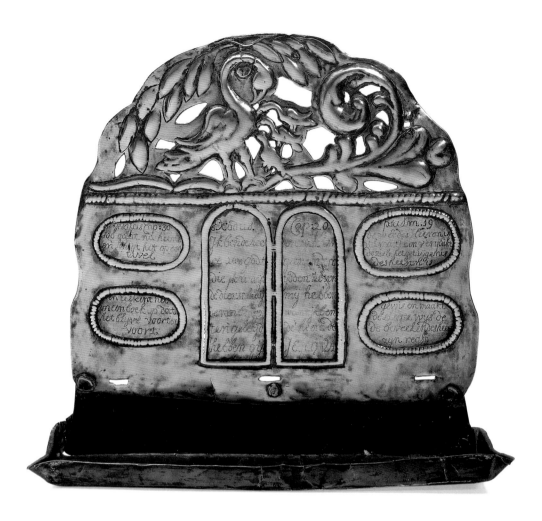

1

Amsterdam(?), early 18th century

Copper alloy: repoussé, pierced,
engraved, punched, and silver-plated;
11 ¹³⁄₁₆ x 13 x 3⁵⁄₁₆ in. (30 x 33 x 8.4 cm)

Gift of Dr. Harry G. Friedman, F 4201

DUTCH INSCRIPTIONS:

Isaiah 30: "Now; go, write it down on a
tablet and inscribe it in a record, that it
may be with them for future days a wit-
ness forever." [Isaiah 30:8]

Exodus 20: "I am the Lord your God, who
brought you out of the land of Egypt, out
of the house of bondage. You shall have
no other gods before me." [Exodus
20:2–3] I am the Lord Jehovah.

Psalm 19: "The law of the Lord is perfect,
restoring the soul; the testimony of the
Lord is sure, making wise the simple. The
precepts of the Lord are right. . . ." [Psalm
19:8–9]

At the top of this lamp is the image of a pelican piercing her breast to feed her young. Since its appearance in the Book of Job, this has been a symbol of the devoted mother, who feeds her young with her own blood when no other sustenance is available. For Christians it also became a symbol of Jesus. In 1639, the three Portuguese Jewish congregations of Amsterdam merged into one community, the Talmud Torah, and adopted the pelican with her young as their emblem. This lamp, bearing the synagogue's symbol, may therefore have been used in the Portuguese Synagogue.

The rendering of the biblical passages in Dutch is enigmatic, since the vast majority of inscriptions on Jewish ceremonial art are in Hebrew. The Sephardi community was founded in 1590 primarily by conversos; while at first their knowledge of Hebrew and Jewish customs may have been sketchy, they founded a yeshivah in 1616 to teach the younger generation about Judaism. The yeshivah became renowned for its Jewish scholarship. It is therefore unlikely that it was a lack of knowledge of Hebrew that contributed to the inscriptions being written in Dutch; furthermore, the community was more likely to have used Ladino, a Judeo-Spanish language that represented medieval Spanish in Hebrew characters.

To date the lamp, one might look at the version of the Bible used. It appears to date somewhere between the States General Bible of 1637 and the Adolf Visscher Amsterdam Bible of 1750, although it is perhaps closer to the later edition. The lamp is quite worn and exhibits considerable age; the row of oil containers is now missing. Its combination of openwork above and solid metal below is unique for Dutch sheet-metal lamps. A dating in the early eighteenth century is suggested by the limited use of pierced decoration.

DATE OF ACQUISITION: 1956.

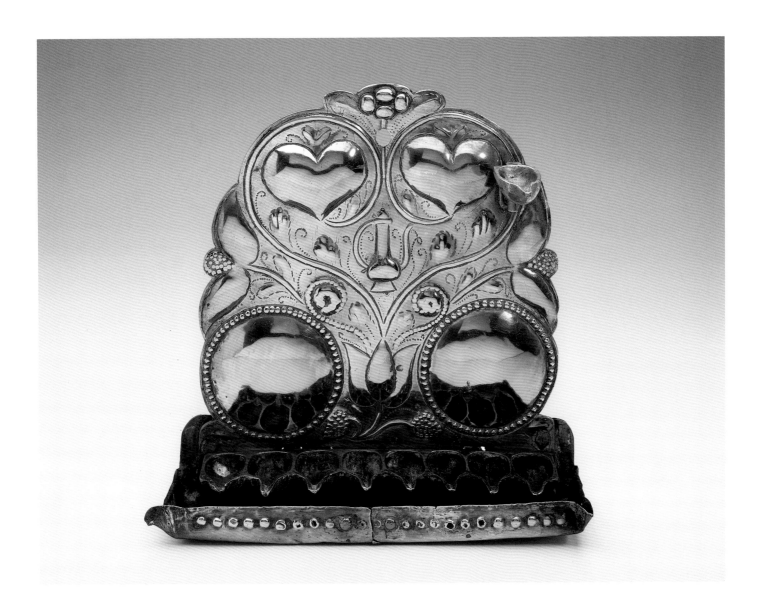

2

The Netherlands, 18th century

Copper alloy: repoussé, traced, punched, and cast; 10⅛ x 10¼ x 4¼ in. (25.7 x 26 x 10.8 cm)

Gift of Dr. Harry G. Friedman, F 3553

The decoration on this lamp and others like it is characterized by several large bosses or hearts in high relief, which form a marvelous reflective surface for the oil lights. These elements, as well as the absence of piercing on the backplate, make this group most similar to secular Dutch sconces.

Many have tulips at the bottom center and beaded buds. The tulip was extremely popular in Holland after it was introduced from Turkey in the sixteenth century. The mania for this flower grew so much that by the early seventeenth century people were speculating wildly on tulip stock and paying exorbitant amounts for bulbs. The ruin for many that followed caused the government to step in and regulate the trade, and tulips soon developed into a major Dutch industry. Tulip and bud decoration was common on Dutch and Dutch-imitation German sheet-brass secular articles from the first half of the eighteenth century. These comparative works help to date this group of Hanukkah lamps.

The ewer in the center of the backplate is, by contrast, a specifically Jewish symbol. It may be a reference to the miracle of the oil that occurred when the ancient Temple menorah was rekindled. Alternatively, the pitcher could indicate that the owner of the lamp was a Levite, a descendant of the servitors of the Temple, as this is the symbol used by the Levites.

SIMILAR LAMPS: The Jewish Museum, F 924 and F 959, and nos. 120 and 121 in the catalogue raisonné; Victoria and Albert Museum (Keen, no. 30).

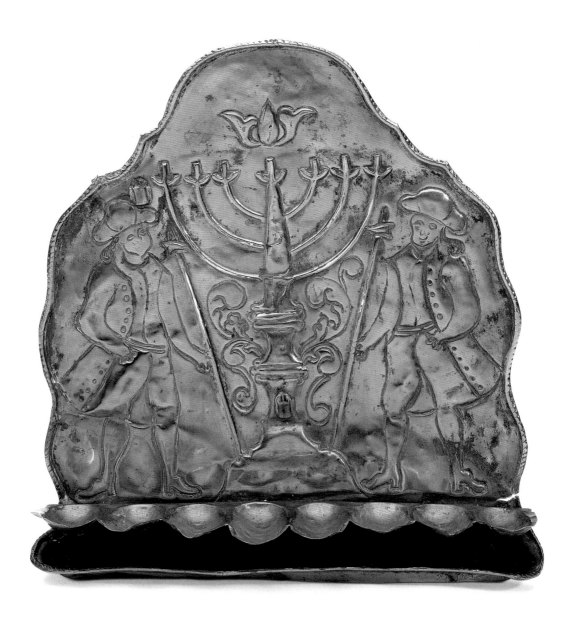

3

The Netherlands, 18th century

Copper alloy: repoussé, chased, and punched; 11¼ x 11⅛ x 2¹³⁄₁₆ in. (28.6 x 28.3 x 7.1 cm)

Gift of Dr. Harry G. Friedman, F 5773

This lamp represents two figures holding long tapers for lighting the Temple menorah. They are clean shaven and wear tricorn hats, wigs, skirted coats, and breeches. This costume and grooming are typical of fashionable Dutch gentlemen of the eighteenth century. In many countries of Europe and the Middle East, Jews were required to wear distinctive colors, badges, hats, or other specific items of clothing. However, no such requirements existed in Holland, and the Sephardi community in particular delighted in wearing the latest styles. By contrast, Dutch Ashkenazi Jews were bearded and wore more traditional styles of clothing, such as the tall-crowned, wide-brimmed hat of Rembrandt's day (Rubens, pp. 127–28).

PROVENANCE: purchased at Coleman Auction Galleries in 1965. BIBLIOGRAPHY: Coleman, lot 199. RELATED LAMP: The Jewish Museum, no. 20.

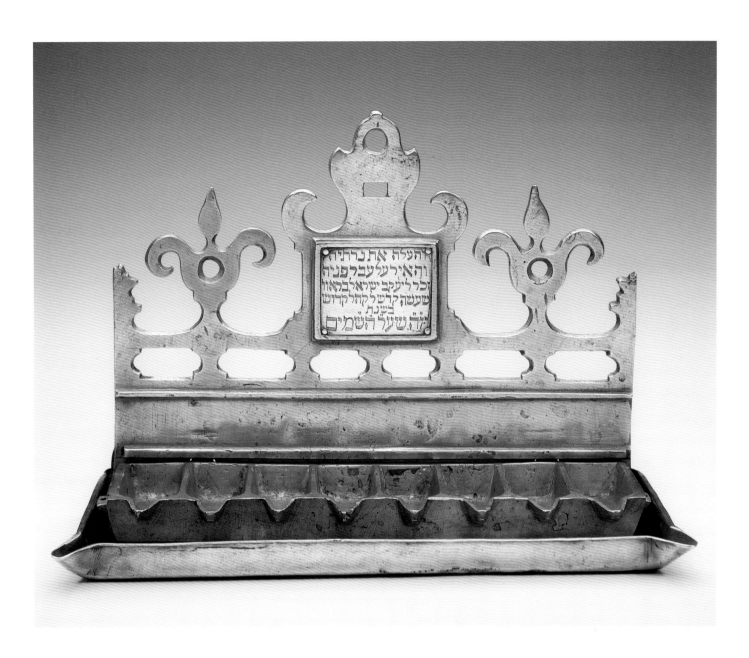

4

The Netherlands and Jamaica(?),
inscription date 1756/57
Copper alloy: cast, appliqué, and
sheet metal; silver: engraved; 8⅝ x
12½ x 5 in. (21.9 x 31.7 x 12.7 cm)
Gift of Dr. Harry Friedenwald, Baltimore,
JM 13-47

HEBREW INSCRIPTION:

והעלה את נרתיה / והאיר על עבר
פניה / זכר ליעקב ישראל בראוו /
שעשה קדוש לקהל קדוש / בשנת /
ו'ז'ה שער' ה'ש'מים

"And they shall light the lamps thereof to
give light over against it" [Exodus 25:37]
In memory of Yaakov Israel Bravo, who
consecrated [this lamp] to the Holy Con-
gregation in the year "And this is the
gate of Heaven" [chronogram for
(5)517 (=1756/57)]

The earliest example of this cast type of lamp with balustrade and fleur-de-lis decoration was dedicated to the Portuguese Synagogue of Amsterdam in 1629/30. The type therefore originated in the Netherlands in the seventeenth century, although it has continued in production until the present day (Weinstein, p. 118). Several factors indicate this lamp type was favored by Sephardi Jews in the Netherlands: the provenance of the Amsterdam lamp from a Sephardi congregation, the Spanish names of several donors of similar lamps, and the Sephardi style of several of the inscription dates.

The inscription on the Jewish Museum lamp and the provenance that came with it provide a fascinating glimpse into Jewish life in the New World. The lamp had been in the possession of a Mendes Cohen of Baltimore, whose handwritten note mentioned that it "was found in a lot of old brass junk brought as merchandise in a vessel from Jamaica about 1850. Its previous history is unknown." The silver inscription plaque on the lamp memorializes Yaakov Israel Bravo, who had given it to a congregation, and is dated 1756/57. The most likely place to look for the origin of this lamp is in Jamaica, its first known provenance.

Jewish settlement in Jamaica was begun by Sephardi Jews before the British takeover in 1655. Jews prospered in the sugar and vanilla industries there, as well as in international trade, and one finds the name Bravo listed among the most prominent Jewish

families in the eighteenth century (*Jewish Encyclopedia*, 7:66). Their origin is not stated, but three members of a London Bravo family were known to have emigrated to Jamaica between 1740 and the 1770s, and indeed there was considerable immigration from England (an offshoot of the Amsterdam community), Curaçao (where there was a Sephardi community of Dutch origins), and Germany. In Kingston, a new Sephardi synagogue, Shaar Hashamayim, was dedicated in 1750. The chronogram in the inscription on the lamp includes the words "Shaar Hashamayim" or "Gate of Heaven." Thus, it probably refers to this new synagogue. The likely reconstruction of the journey of this lamp is that it was imported from the Netherlands, either via an émigré from London or possibly via Curaçao. It was donated to the new synagogue around 1750. When the donor passed away in 1756/57, a silver plaque was added to the lamp that dedicated it to his memory. Around one hundred years later, the lamp was discarded as scrap brass and shipped to Baltimore, for reasons unknown. The synagogue was destroyed in a fire in 1882; so perhaps it was then and not the 1850s that the lamp was shipped to Baltimore.

The same type of lamp was dedicated to the Sephardi synagogue in Charlotte Amalie, St. Thomas, in 1770/71, which demonstrates that it was used by Caribbean communities and helps support the hypothesis of Jamaican provenance.

There are three subtypes of this lamp group. This lamp belongs to the earliest, in which there are dated examples from the seventeenth to mid-eighteenth century. They bear the Hebrew inscription "For the commandment is a lamp, and the teaching is light," which is no doubt also inscribed on this lamp under the silver plaque.

PROVENANCE: arrived in Baltimore c. 1850 (?) on a ship from Jamaica; collection of Mendes Cohen, Baltimore, probably in the late nineteenth to early twentieth century; collection of Eleanor Cohen of Baltimore until 1918; collection of Dr. Harry Friedenwald, Baltimore, 1918–47; acquired in 1947. BIBLIOGRAPHY: Kayser and Schoenberger, no. 133. SIMILAR LAMPS: The Jewish Museum, F 1706, F 3556, and JM 57-59 (Gift of Mrs. Arthur J. Sussel), and no. 115 in the catalogue raisonné; Joods Historisch Museum, acc. nos. JHM 07614 and 217; Portuguese Synagogue, Amsterdam (M. H. Gans, p. 31); Abraham Halpern Collection, New York; Lindwer Collection, the Netherlands, acc. no. 439-92.

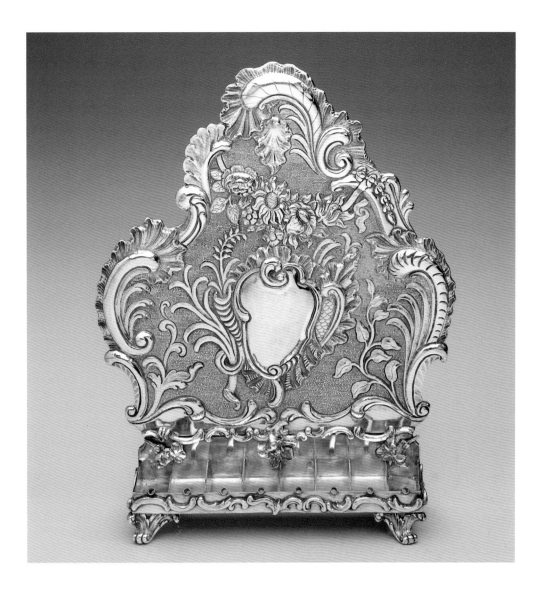

5

Reynier de Haan (Dutch, 1712–1783; master 1731)
The Hague, 1752

Silver: repoussé, engraved, traced, punched, appliqué, and cast; 12 x 9½ x 2¼ in. (30.5 x 24.1 x 5.7 cm)
Gift of Dr. Harry G. Friedman, F 3693

This Hanukkah lamp is a fine example of the Rococo style, commissioned during its heyday in the mid-eighteenth century. The use of the rocaille and C-scrolls around the edges and the asymmetry of the shape of the backplate as well as of the shield in the center are all characteristic of Rococo. The lamp is not the typical Dutch hanging type, but was given legs so it could be placed on a table. Although many table lamps also had hanging devices, none were found on this lamp. In addition, the receptacles for containing the oil are completely different from those on most Dutch lamps, which consist of a removable row of pear-shaped containers with a drip pan below. This example, however, has a fixed box with internal divisions. These details suggest a strong connection to German silver lamps of the eighteenth century (e.g., nos. 15 and 16). It is therefore possible that this lamp was made for a member of the Ashkenazi Jewish community of The Hague, and based on German prototypes.

The Ashkenazi Jews of the Netherlands arrived from Germany and Poland beginning around 1620. They started out very impoverished, but by the eighteenth century, some had achieved economic success as traders, foreign exchange brokers, and diamond brokers for royal courts. One of these wealthy Jews of The Hague probably commissioned this beautifully executed lamp.

HALLMARKS: L. B. Gans, p. 39 (marks for 1752), p. 186, no. 15, and p. 187, no. 8. MAKER'S MARK: Voet, nos. 106h-t. DATE OF ACQUISITION: 1953. BIBLIOGRAPHY: Kayser and Schoenberger, no. 127; Kleeblatt and Mann, pp. 100–101. SIMILAR LAMP: Abraham Halpern Collection, New York; private collection (Citroen, van Erpers Royaards, and Verbeek, no. 136). OTHER WORKS BY DE HAAN: Voet, pp. 179–81; den Blaauwen, no. 121; Christie's Amsterdam 2000, lot 32.

6

The Netherlands, 19th century

Copper alloy: repoussé, pierced, punched, and cast; 11 ¹⁵/₁₆ x 10 ¾ x 4 ¼ in. (30.3 x 27.3 x 10.8 cm)

Gift of Dr. Harry G. Friedman, F 5176

The lively relief decoration consists of a sunflower at top, two pairs of rosette flowers on the sides, and a cluster of grapes. However, if one closely examines the forms created by the pierced decoration, one sees quite a different design: a large central tulip at the top (containing the sunflower) with two smaller tulips on curved, striated stems below. A possible prototype for the openwork forms can be seen in a Dutch wall sconce dated to around 1730, in which a large central flower is flanked by two smaller flowers on curved stems (Gentle and Feild, no. 12 on p. 201). The incongruity between the relief motifs and the pierced ones suggests that the original decorative scheme had been forgotten over time and other embellishments, ones that would be highly reflective of the Hanukkah lights, were added.

A nineteenth-century date for this lamp is based on that of a closely related type with hearts replacing the sunflowers, one example of which was probably commissioned in 1842 (see no. 125 in the catalogue raisonné).

PROVENANCE: purchased from Keyman's Antique Shop, New York, in 1961. SIMILAR LAMPS: The Jewish Museum, F 957, JM 7-54, F 3058, U 7682, F 2679, and F 2533.

7

The Netherlands, 19th century

Copper alloy: repoussé, punched,
and cast; 9¹³/₁₆ x 8⅞ x 3⅛ in.
(25 x 22.5 x 8 cm)

Gift of Dr. Harry G. Friedman, F 3249

The main decorative component of the backplate is a seven-branch menorah. Some lamps of this type also have the word "Hanukkah" in Hebrew, written large, which often overwhelms the menorah. Both elements are made up of a series of small raised dots, created by dapping, or hammering from the reverse. The use of this technique on Hanukkah lamps to form the design elements appears to have flourished in the nineteenth century, as exemplified by a dapped lamp in the collection dated 1865 (no. 133 in the catalogue raisonné). Dapping in Dutch sheet metal may date back to the late eighteenth century, as shown by a match/spill box (Caspall, p. 29 and fig. 37).

DATE OF ACQUISITION: 1952. SIMILAR LAMPS: The Jewish Museum, F 5393, F 489, and F 3266, and nos. 134–37 in the catalogue raisonné; Joods Historisch Museum, acc. no. JHM 5449.

8

The Netherlands, 19th century

Copper alloy and copper: spun
and cast; 55½ x 28⅝ x 17¼ in.
(141 x 72.7 x 43.8 cm)

Gift of Dr. Harry G. Friedman, F 3099

A group of large menorah-form lamps from the Netherlands were fabricated in an un-usual manner, almost completely out of sheet brass. The elements of the shaft, as well as the knobs on the arms, were made by spinning. In this technique, invented in the early nineteenth century, a wooden form with the desired shape is rotated at high speed, and the sheet metal is pressed against it with a blunt tool.

A pleasing decorative effect was created by using two different color metals, one a reddish copper and the other a yellow brass. Four other lamps of this type are known and are remarkably similar in form. Three have a cast finial consisting of a lion holding a shield with three X's on it; this is the emblem of the city of Amsterdam. One of the examples comes from a Dutch synagogue. These factors indicate an origin in the Netherlands.

DATE OF ACQUISITION: 1952. SIMILAR LAMPS: Ner Mitzvah ve-Torah Or Synagogue, Amsterdam (M. H. Gans, p. 701); Max Berger Collection, Vienna (Häusler, no. 456, fig. 18); Franklin Collection (M. Narkiss, no. 177); Sotheby's TA 2000, lot 211.

9

Eduard Hermans
(Dutch, b. 1959)
Leveroy, 1988
Stoneware: glazed;
9⅜ x 16⁷⁄₁₆ x 7⅜ in
(23.7 x 42 x 18.3 cm)
Purchase: Judaica Acquisitions
Fund, 1989-67

Eduard Hermans works as a ceramist, sculptor, painter, and set designer. He was trained at the Gerrit Rietveld Academie in Amsterdam, and his work reveals a preoccupation with geometric shapes and a delight in creating complex sculptural forms (Waale, p. 19).

Herman's Hanukkah lamp, fashioned from a series of joined rectangular ceramic elements, appears at first glance to be an outspreading fanlike sculpture. However, a closer examination reveals a much more complicated form. The artist carefully manipulated each of the elongated rectangular candleholders so that they gradually "step-out" toward the middle of the front and the back, giving the lamp necessary stability.

Although there is no surface patterning, an important component of the lamp is its fine glaze. Hermans chose a muted turquoise blue, and both the color and texture bring a velvety richness and delicacy to this fine piece. SR

SIGNATURE: "Eduard / '88"; "aplage 6/50 / studio 33". PROVENANCE: acquired from De Witte Voet Gallery, Amsterdam, in 1989. BIBLIOGRAPHY: Waale, p. 19.

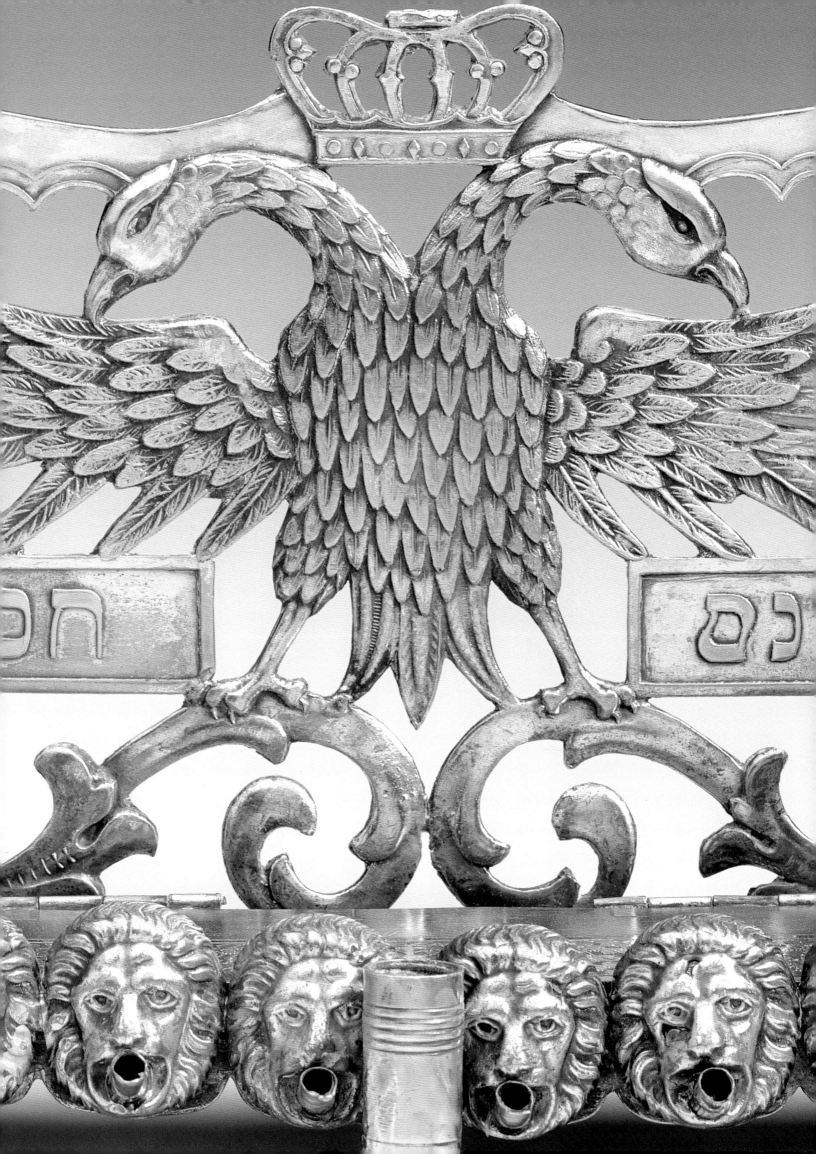

GERMANY

The experience of the German Jewish community through the centuries was often one of extremes, ranging from expulsions to royal invitations to settle, from pogroms to court protection, from poverty to great wealth. Church bans on usury in the twelfth and thirteenth centuries led to Jewish adoption of moneylending as a principal means of earning a living. Over time, Jews further developed their skills in finance until they often became indispensable to local and imperial rulers. While townspeople sometimes saw Jews as competition in crafts and trade, and as menacing to Christians, the nobility sought to attract Jewish residents as a means of financial development and as a source of taxation. Their presence was therefore tolerated, although subject to the whims of the local ruler and to numerous restrictions and regulations. As in other countries, the local population was augmented by Polish Jews who fled the Chmielnicki riots in the mid-seventeenth century, or who were incorporated into Prussia upon the annexation of part of Poland at the end of the eighteenth century.

The majority of German lamps in the collection were produced in the late seventeenth through the nineteenth century. For much of that time, Jews lived in small towns, in communities of no more than a dozen families, where economic conditions were difficult. Limited numbers, often no more than a few hundred families, were occasionally allowed to live in certain of the large cities. These frequently went into trade and banking, and achieved sufficient wealth to purchase magnificent silver Hanukkah lamps for home use and beautiful Torah ornaments for their synagogues. By the nineteenth century, the population shifted to the large commercial centers, where Jews participated in all levels of economic life and contributed greatly to the development of industry and finance.

The Hanukkah lamps of Germany are characterized by several distinctive materials and production techniques, as well as by geographically defined stylistic types. Standing bench lamps were the most common, while the menorah form, used frequently in German synagogues, was developed for home use for the first time in the late seventeenth century. Although the bench lamps were meant to stand, probably for display in the window to publicize the miracle of Hanukkah, most also have devices for hanging to allow for the more ancient tradition of suspending the lamp in or near the doorway. The materials used are silver, pewter, tin, and copper alloy, each the specialty of a different craft industry.

SILVER LAMPS

Silver lamps were produced by masters in the large cities, some of which, like Frankfurt, had considerable Jewish populations. They tell the story of the wealthier urban Jews who could afford to commission them. They also reflect the desire to celebrate the ritual in as magnificent a way as possible, perhaps inspired by the seventeenth-century commentary of Rabbi Joseph Juspa Hahn Nördlingen, who recommended that Hanukkah lamps, or at least one light each night, be made of silver (Mann and Cohen, no. 128).

Detail of no. 27.

Silver Hanukkah lamps were primarily made by Christian masters, since for the most part Jews were not allowed to join the gold- and silversmith guilds in Germany. In addition, they were often forbidden from engaging in crafts independently so as not to compete with the guilds. Nevertheless, there is documentary evidence in medieval rabbinical records for Jewish smiths, and in the mid-seventeenth century Sephardi exiles who settled in Hamburg continued to practice the craft at which they had excelled in Spain and Portugal. By the next century, Jewish craftsmen were working in Silesia and in Berlin. It has been suggested that pieces without makers' or governmental marks were made by Jews, since they still for the most part operated outside the official guild system (Wischnitzer, pp. 88, 202–3; Wolf, p. 13). Regarding Jewish patronage, it is interesting to note that although a number of Jews had the means to acquire silver lamps, few were created by the most renowned court silversmiths. This probably reflects the limited access that Jews had to cities and fairs, as dictated by restrictions on residence and movement within the country.

Several unique characteristics and regional types of bench lamps were developed in Germany. Peculiar to earlier silver lamps, dating from the mid-seventeenth to the early nineteenth century, is the oil receptacle shaped like a box and often lidded. In addition, each city seems to have developed its own backplate forms and decoration in the late seventeenth and eighteenth centuries. For example, Frankfurt produced three distinct types, a small chest-shaped box without backplate, a larger tripartite form with a central dramatic image, and a small pierced lamp with lions and menorah (see nos. 10, 11, and 16). The backplate of the Nuremberg type contains a parchment inscribed with the Hanukkah blessings that is set within a heavily molded frame, while in Berlin a small lamp with flowers and scrolled border became popular in the later eighteenth century (see nos. 13 and 15, and no. 165 in the catalogue raisonné).

Perhaps the earliest known silver menorah-form lamps for domestic use were created in Frankfurt in the late seventeenth century (cf. no. 12). Interest in such candelabrum-type lamps for home use seems to have waned by the late eighteenth century, and was revived only toward the end of the next century, when a large number of domestic-size versions were produced in silver and silver-plate. These included lamps that closely copied the famous Roman-period representation of the Temple menorah on the Arch of Titus in Rome (see no. 265 in the catalogue raisonné).

PEWTER LAMPS

The largest percentage of German lamps in the collection are those made of pewter. They were created in southern Germany in an area encompassing the neighboring regions of southern Hesse, northwestern Bavaria, and southern Baden-Wurttemberg. The marks indicate that they were mostly purchased in small towns, which is where the majority of the Jewish population lived. Pewter was in fact a relatively expensive material. Its primary in-

gredient is tin, which is rare. As a consequence, pewter items, primarily vessels, tableware, and lighting devices, were reserved for the middle and upper classes. An eleventh-century record states that the King of England possessed more than three hundred pieces of pewter tableware; by the thirteenth century, burghers in various parts of Europe were also dining off pewter dishes (Nadolski, pp. 8, 17). The hundreds of lamps used in these small communities is a testimony to the striving for beautification of Jewish ritual. The rabbinical emphasis on silver for Hanukkah lamps in Germany may have led to the popularity of a silvery metal that was expensive but more affordable.

Many of the lamps bear marks, either of the maker or the city where made. These can often help scholars identify the dates and regions of production of different types. However, the pewter marking system was not as closely regulated as that of gold and silver, and the marks often were not registered. Their primary function appears to have been to assure the buyer that the tin content was above a certain percentage, and therefore that the lead content was not at poisonous levels (Nadolski, p. 33).

All the lamps are standing bench forms, and many aspects of the shape seem to be based on other domestic items made in Germany. There is an uncanny resemblance of the lamps to pewter inkstands that became popular in households in the latter half of the eighteenth century through the mid-nineteenth century (fig. 18). The primary difference in the Hanukkah lamp is the substitution of an open bench supporting the oil wells for the inkstand's closed box that contained the inkwell and sand shaker (Nadolski, p. 282).

Judging from the examples that can be dated by mark or inscription, the production of pewter Hanukkah lamps seems to have begun in the mid-eighteenth century and continued for a century. This paralleled the use of pewter objects among the German population at large. By the mid-nineteenth century, the middle class switched to glass and ceramic tableware. This was due to fashion, to doubts about the healthiness of pewter, and to the fact that ceramic and glass wares began to be mass-produced and were therefore less costly (Nadolski, p. 37).

TIN LAMPS

A small number of tin bench and menorah-form lamps come from the Upper Rhine region, comprising southern Germany, Alsace, and the Basel area. These are made of tin plate, which consists of iron hammered into flat sheets and coated with tin. Local tinsmiths would then cut the sheets to make the backplates, sidepieces, oil containers, and drip pans. Many such lamps are undecorated, but occasionally pressed or punched designs in repoussé are found, as well as piercing.

Unlike silver and pewter, tin was not marked, and thus determining the date and origin can only be based on family history and certain technical aspects. The process of producing tin plate originated in Germany, and by at least the seventeenth century the products were disseminated to other European lands. Made originally by hand, rolled sheets

were invented in the early eighteenth century, and the technique of creating rolled grooves was developed in the later part of that century. Tin production seems to have died out by the end of the nineteenth century (Gould, pp. 8, 10).

COPPER-ALLOY LAMPS

A few hanging lamps made of sheet metal are known, but seem anomalous among the silver, pewter, and tin examples for which Germany is known. Casting in copper alloy was reserved for menorah-form lamps. Large examples were used in synagogues, placed near the Torah ark or the desk where the Torah is read, as a reminder of the seven-branch lampstand that stood in the ancient Jerusalem Temple (see, e.g., no. 22). In addition, smaller domestic lamps became common in the late nineteenth and early twentieth centuries.

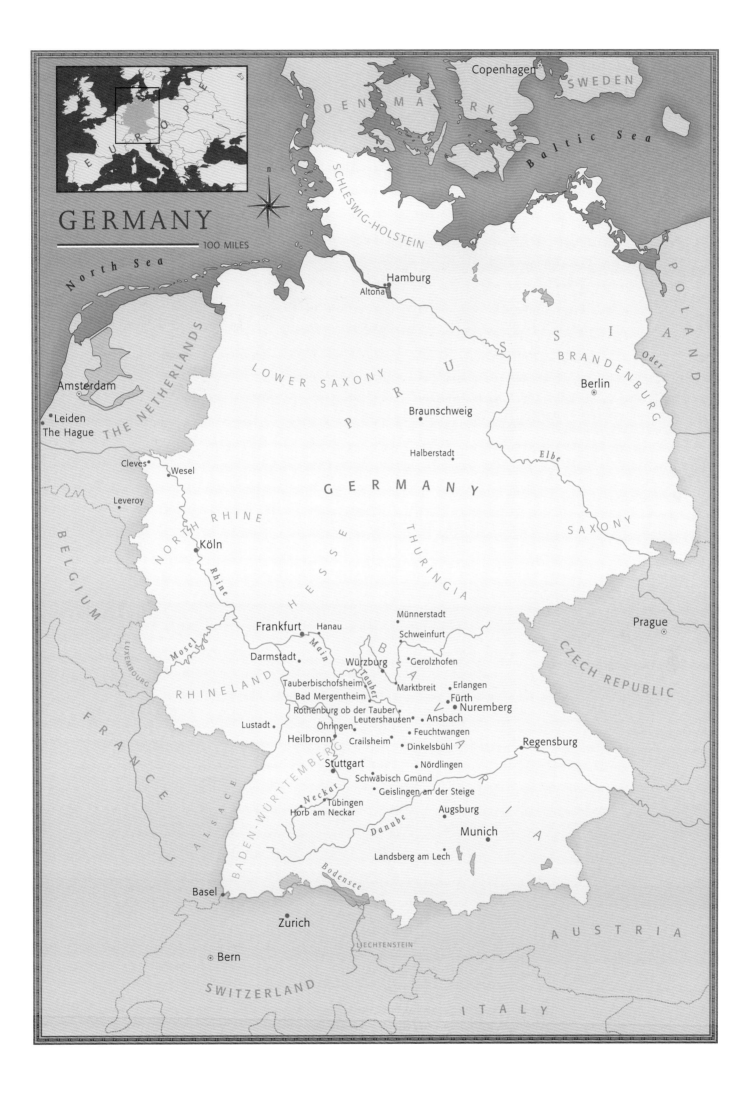

GERMANY

100 MILES

EUROPE

North Sea

DENMARK

Copenhagen

SWEDEN

Baltic Sea

POLAND

SCHLESWIG-HOLSTEIN

Hamburg
Altona

THE NETHERLANDS

Amsterdam

Leiden
The Hague

Cleves

Wesel

Leveroy

BELGIUM

LUXEMBOURG

NORTH RHINE

Köln

Rhine

Mosel

FRANCE

ALSACE

LOWER SAXONY

P R U S S I A

Braunschweig

Halberstadt

Elbe

BRANDENBURG

Berlin

SAXONY

Oder

GERMANY

HESSE

THURINGIA

Prague

CZECH REPUBLIC

Frankfurt Hanau

Main

Darmstadt

RHINELAND

Würzburg

Tauberbischofsheim
Bad Mergentheim

Lustadt

Tauber

Münnerstadt

Schweinfurt

B

Gerolzhofen

Marktbreit

A

Erlangen

Rothenburg ob der Tauber
Leutershausen
Öhringen

Fürth
Ansbach

Nuremberg

Heilbronn

Crailsheim

Feuchtwangen

Dinkelsbühl

Regensburg

Stuttgart

Nördlingen

BADEN-WÜRTTEMBERG

Neckar

Schwäbisch Gmünd

Geislingen an der Steige

Tübingen
Horb am Neckar

Danube

Augsburg

R

U

A

Munich

Landsberg am Lech

Bodensee

Basel

Zurich

LIECHTENSTEIN

AUSTRIA

Bern

SWITZERLAND

ITALY

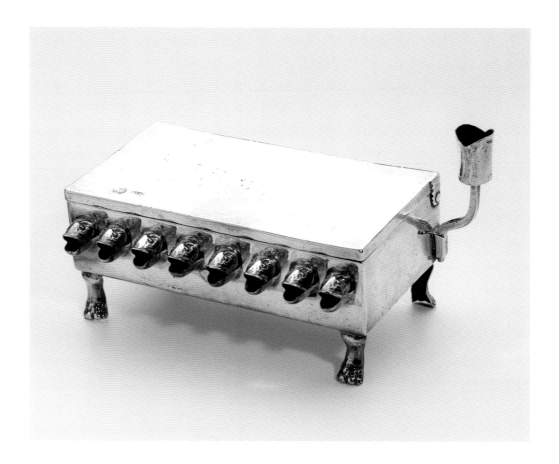

10

Caspar Birckenholtz (German, 1633–1690; master 1661)
Frankfurt, 1661–90

Silver: hand-worked and cast; 2¾ x 5¼ x 2⅞ in. (7 x 13.3 x 7.3 cm)

Gift of Mrs. Albert A. List, JM 14-70

The earliest silver Hanukkah lamp known in Germany is most likely this simple chest form. A version with a vaulted lid appeared later around 1700 through 1775 (see no. 155 in the catalogue raisonné). All but one of these chest-form lamps with identifiable marks were made in Frankfurt.

Jews had lived in Frankfurt since at least the Middle Ages, and by the time this lamp was made had been confined to a ghetto for several centuries. A maximum of 500 families were allowed residence in the ghetto. Some Jews had achieved considerable wealth, and one can surmise that this lamp was commissioned for one such well-to-do resident. The large number of Hanukkah lamps created by Frankfurt silversmiths suggests that Jewish community members were important patrons, and in fact documentary evidence indicates that active patronage of Christian silversmiths went back to at least the sixteenth century (Mann 1986, p. 389). Several silversmiths, such as Rötger Herfurth and Georg Wilhelm Schedel, seem to have catered to an almost exclusively Jewish clientele, since almost all of their known works are Jewish ceremonial objects (see no. 16 and nos. 156 and 157 in the catalogue raisonné).

The only ornamented portions of the lamp are the spouts that held the wicks, which are in the shape of fish's heads, and the paw-shaped feet. This simplicity could reflect the influence of the "undecorated style," one of the trends in early Baroque decorative arts of the second half of the seventeenth century (Hernmarck, pp. 59–61). Alternatively, it could result from the economic means of the purchaser. The inspiration for this form can only be conjectured. A related secular object type from this period was the box-shaped inkstand, and in fact an example made in England in 1717 with flat lid, no decoration, and pull-out drawer on the bottom seems remarkably similar in design (Honour, p. 127).

HALLMARK: Scheffler *Hessens* 119. MAKER'S MARK: Scheffler *Hessens* 233. PROVENANCE: purchased from Moriah Artcraft, New York, in 1970. SIMILAR LAMPS: Eugen Jakobovitz Collection, The Hague (M. Narkiss, no. 169); Bavarian National Museum (Gidalewitsch, fig. 10).

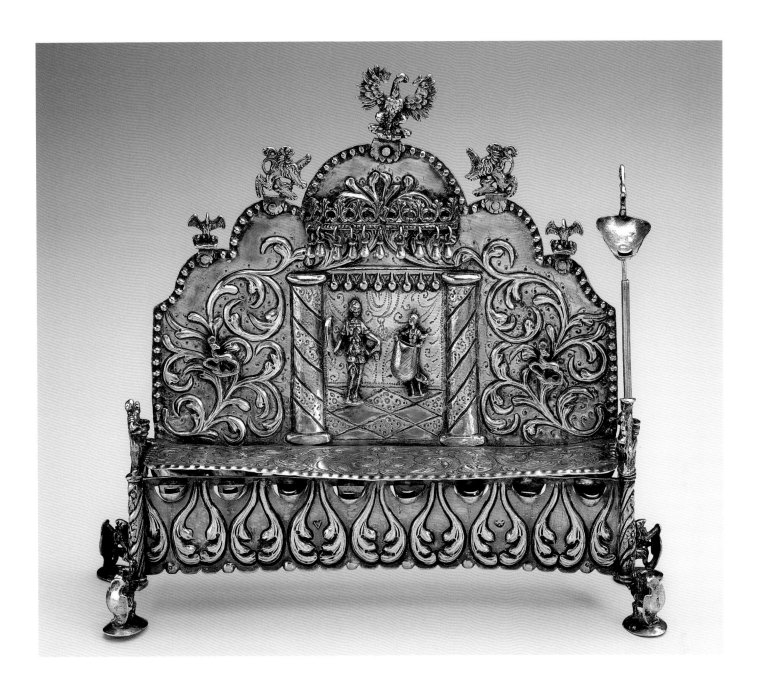

11

Johann Valentin Schüler
(German, 1650–1720; master
1680)

Frankfurt, late 17th century

Silver: repoussé, engraved, traced,
punched, appliqué, parcel-gilt, and
cast; 9⅞ x 11⅜ x 3⅛ in. (25.1 x
28.9 x 7.9 cm)

Purchase: Norman S. Goetz, Mr. and
Mrs. Henry A. Loeb, Mr. and Mrs.
Henry L. Marx, Ira A. Schur, Lawrence
A. Wien, Leonard Block, Gustave L.
Levy, and Robert I. Wishnick Gifts,
JM 19-64

This lamp is among the earliest silver backplate lamps that also have legs for placement on a table or windowsill. It can be dated within Schüler's period of production by the rounded, symmetrical style of the scroll decoration, which is typical of the early Baroque period of the late seventeenth century (cf. Seling, no. 973; Hernmarck, no. 700). Like the chest-shaped lamp (no. 10), there is a resemblance between the form of this lamp and that of silver inkstands in Germany during the same period (fig. 17). These consisted of a closed box with feet, which usually contained the well for ink and a container of sand for blotting, and a backplate.

Having possibly adapted the form of a secular object to that of a Hanukkah lamp, with its requirement of eight lights, the silversmith Schüler added Jewish iconography as a central decorative motif on the backplate. The person represented is the biblical heroine Judith, whose courage, brains, and beauty enabled her to kill the enemy general Holofernes, who was besieging ancient Israel. The scene on the lamp depicts the moment when Judith, seeing Holofernes passed out from too much drink, cuts off his head. She will then place it in a sack that her maid holds open so they can secretly carry it out of Holofernes's camp.

Judith became a popular motif on German and Dutch Hanukkah lamps from the later seventeenth century through the eighteenth century. During this time, she was also the subject of numerous plays and oratorios throughout Europe (see, e.g., *Encyclopedia Judaica*, 10:460–61). In art, drama, and music she had a complex persona, and often represented varied human qualities. During the Reformation of the early sixteenth century, Protestant leaders advocated a return to the biblical text, and particularly to the Hebrew Bible, as the source of all religious authority. Martin Luther promoted Judith as an appropriate subject to represent the triumph of virtue over evil. Counter-Reformation artists such as Lucas Cranach the Younger also represented her, but in a less flattering light (Staatliches Museum Schwerin, no. 13). In yet another interpretation, Judith was included among other classical and biblical heroines who had made fools of men, a theme associated with Protestantism, which emerged in the sixteenth century (Andersson and Talbot, p. 31).

HALLMARKS: Scheffler *Hessens* 134; Tardy 1980, p. 208, top (French import stamp). MAKER'S MARK: Scheffler *Hessens* 245. PROVENANCE: in France sometime between 1893 and 1970 (based on French tax stamp); Mr. and Mrs. Michael M. Zagayski Collection, acquired between 1940 and 1959; purchased at Parke-Bernet in 1964. BIBLIOGRAPHY: Schoenberger and Freudenheim, no. 128; Parke-Bernet 1964, lot 305; Kayser and Schoenberger, no. 128; Mann 1986, p. 397. OTHER WORKS BY SCHÜLER: Schoenberger 1951; Mann 1986, pp. 395–98; Jüdisches Museum Frankfurt, no. 28; Braunstein 1985, no. 3; Grafman 1996, no. 12; Cohen Grossman 1996, p. 139.

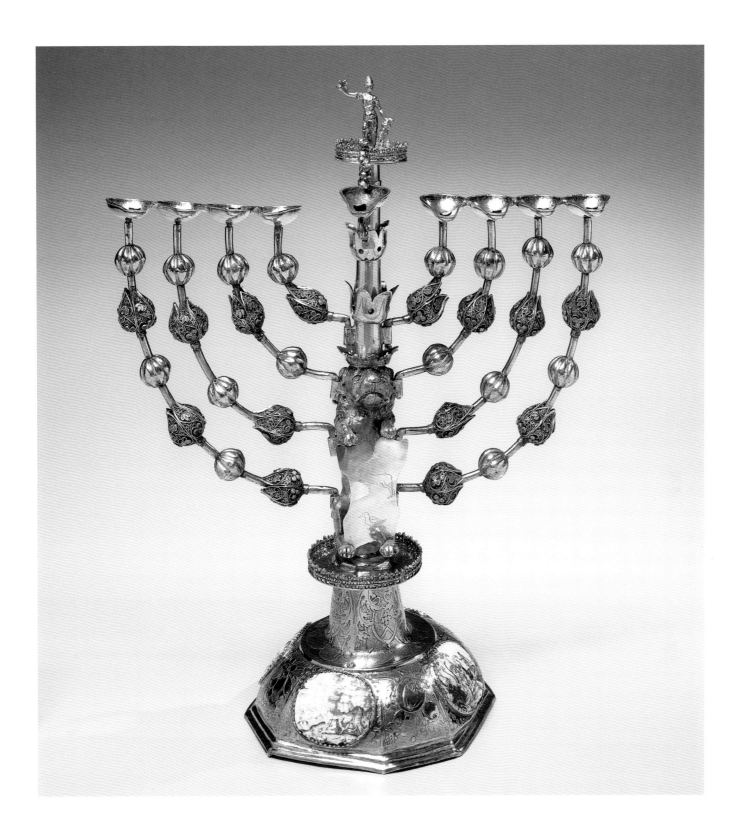

12

Johann Adam Boller (German, 1679–1732; master 1706)

Frankfurt, 1706–32

Silver: cast, filigree, cloisonné enamel, engraved, traced, punched, and parcel-gilt; enamel inlays on copper alloy;

17 x 14½ x 7⅛ in. (43.2 x 36.8 x 18.1 cm)

Gift of Frieda Schiff Warburg, S 563

A new type of Hanukkah lamp for home use, in addition to the bench type, seems to have been developed in Frankfurt in the late seventeenth century—one with a central shaft and curved arms in the form of the ancient menorah. The earliest lamps in this new domestic size were produced by Frankfurt silversmiths Johann Valentin Schüler (1650–1720) and his brother Johann Michael (1658–1718). The two lamps of this type in the museum's collection were made by Johann Michael's brother-in-law, Johann Adam Boller. The lamps all have tubular arms ornamented with alternating flowers and knobs or bell-shaped forms, reminiscent of the biblical description of the first seven-branch menorah crafted during the Exodus. The figure of the biblical heroine Judith is placed at top on a round platform.

Two features on this lamp differentiate it from the others of this type. The first is the rampant lion that serves as the lower portion of the shaft. The second is the introduction of color. Four painted enamel roundels ornament the base, containing a scene of Rebecca meeting Abraham's servant Ezekiel at the well, and three episodes from the life of her son, the patriarch Jacob. Color is also found in the filigree flowers on the arms, which are decorated in cloisonné enamel.

The imagery on the enamels may possibly refer to the first names of the owners, presumably a couple named Rebecca and Jacob. Additionally, the lion on the shaft might represent their last name, since German Jews frequently took their surnames from the towns in which they lived, or from their houses, which were named for animals or objects. The Yiddish for lion is Loew or Lev. However, it seems unlikely that this was the owners' last name, since it is more commonly a man's first name, and, according to Dietz's genealogy of the Frankfurt Jewish community, no family bore that surname in Frankfurt. Alternatively, the lion could simply be a support device as found on other types of objects common in seventeenth-century German silver, particularly standing cups (e.g., Pechstein, no. 186; Schliemann, no. 40).

The shield held by the lion is engraved with the image of a stag and a bird; it is on a thin sheet of metal wedged between the lion's paws, and may be a later addition. These creatures could represent the names of another couple who owned the lamp; Hirsch is a Yiddish name meaning deer, while Feigel is a woman's name signifying a bird. As shown by other lamps in the Jewish Museum collection, Hanukkah lamps were sometimes given as wedding gifts, and this lamp could have been presented several times during its more than two-century history.

HALLMARK: Scheffler *Hessens* 128. MAKER'S MARK: Scheffler *Hessens* 265. PROVENANCE: collection of Jacob Schiff around 1906; acquired from his daughter, Frieda Schiff Warburg, in 1933. BIBLIOGRAPHY: *Jewish Encyclopedia*, 6:227, no. 5; Mann 1982, no. 121; Kleeblatt and Mann, pp. 82–83; Mann 1986, p. 398; Mann and Cohen, no. 130. SIMILAR LAMPS: The Jewish Museum, no. 247 in the catalogue raisonné; Jüdisches Museum Frankfurt (Weber, fig. 1); Musée de Cluny (Klagsbald 1982, no. 91); Max Frenkel Collection, Jerusalem (M. Narkiss, no. 185; and see Mann 1986, p. 395); M. Narkiss, no. 185; Jacob Michael Collection (Jewish Museum Visual Resources Archive); Congregation Emanu-El, New York (Grossman 1989b, no. 161); Wilhelm Kitzinger Collection, Munich (Harburger, p. 481; *Jüdisches Lexikon*, 4: pl. 124); Israel Museum (Benjamin 1987, no. 134). OTHER JUDAICA BY BOLLER: The Jewish Museum (Kayser and Schoenberger, no. 198; Grafman 1996, no. 12); Israel Museum (Schoenberger and Freudenheim, no. 67); Israel Museum (Mann and Cohen, no. 134); Michael and Judy Steinhardt Collection, New York (Grossman 1993, no. 7).

13

Matheus Staedlein

(German, active 1716–1735)

Nuremberg, 1716–35

Silver: repoussé, engraved, traced,

punched, and cast; ink on parchment;

13⅝ x 11⅜ x 3⁷⁄₁₆ in.

(34 x 28.9 x 8.7 cm)

Gift of Dr. Harry G. Friedman, F 197

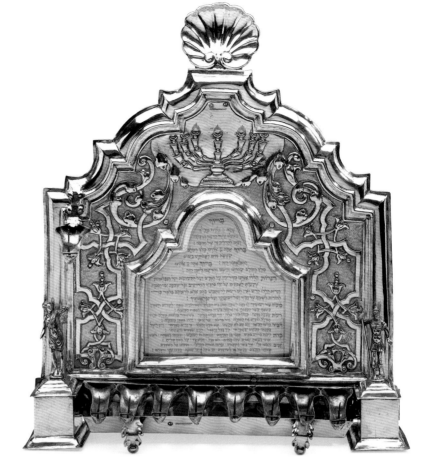

HEBREW INSCRIPTIONS: Three blessings
on kindling the lights; "Ma'oz Tzur" (O
Fortress, Rock of My Salvation), missing
the last verse; variant on the medieval
version of *Ha-Nerot Hallalu*

הנרות הללו אנחנו מדליקין על הנסים
ועל התשועות ועל הנפלאות, שעשית
לאבותינו על ידי כהניך הקדושים. וכל
שמונת ימי חנכה הנרות הללו קדש,
ואין לנו רשות להשתמש בהם אלה
לראותם בלבד, כדי להודות לשמך על
נסיך ועל ישועתך ועל נפלאותיך.

These lights we kindle, for the miracles,
for the deliverances, and for the won-
ders, that You did for our fathers
through Your holy priests. And all eight
days of Hanukkah, these lights are holy,
and we have no authority to make use
of them, other than exclusively to see
them, in order to give thanks and praise
to Your name, for Your miracles, for Your
deliverances, and for Your wonders.

Nuremberg silversmiths produced a distinct type of Hanukkah lamp, characterized by a parchment inset in the center inscribed with the Hanukkah blessings. The backplates are all cartouche-shaped with a heavy molded frame. Similar frames are found on secular objects such as mirrors, sconces, and plates that date between the 1710s and 1730s and are therefore contemporaneous with this lamp (e.g., Seling, no. 961; Pechstein, no. 115; Schliemann, no. 707). Most lamps of this type also have cast figures of Judith and a soldier, possibly meant to be Judah Maccabee.

The marked examples date between 1699 and 1781. During this period, Jews were forbidden to live in Nuremberg, and were only allowed to enter the city for the day to buy goods, provided they paid a tax. It was on such a purchasing expedition that this lamp, and others of its type, might have been commissioned from a Nuremberg silversmith. Alternatively, it may have been obtained at one of the regional fairs. Only six works by the maker of the museum's lamp, Matheus Staedlein, are known, five of them Jewish ceremonial objects, suggesting a mostly Jewish clientele, despite the residence prohibition (Birgit Schübel, Germanisches Nationalmuseum, personal communication). Staedlein's mark has only recently been identified through the work of the Forschungsprojeckt zur Nürnberger Goldschmiedekunst at the Germanisches Nationalmuseum.

HALLMARK: "N" in circle (variant of Rosenberg 3767). MAKER'S MARK: "MS" in oval. PROVENANCE: collection of Frau Jacob H. Weiller, Frankfurt, before 1930; auctioned at Hugo Helbing in Munich in 1930; acquired between 1939 and 1941. BIBLIOGRAPHY: Helbing 1930, lot 231; Kayser and Schoenberger, no. 130; Germanisches Nationalmuseum, no. 3/122. SIMILAR LAMPS: Israel Museum (Germanisches Nationalmuseum, 3/123); private collection (Hirschler, p. 252); Otto Bernheimer Collection, Munich (Harburger, p. 480); Abraham Halpern Collection, New York (by Staedlein; Sotheby's TA 1991, lot 271); private collection, New Jersey; Eileen Wachtel Battat Collection, Hillsborough, Calif. (Eis 2000); Michael and Judy Steinhardt Collection, New York (Grossman 1993, no. 75); Dr. F. Perutz Collection, Munich (Harburger, p. 479). OTHER JUDAICA BY STAEDLEIN: The Jewish Museum (Grafman 1996, no. 20); Michael and Judy Steinhardt Collection, New York, acc. no. NY MJS 9818; Purin 1998, no. 3; Barnett, no. 408. (I am grateful to Rafi Grafman for assembling these references).

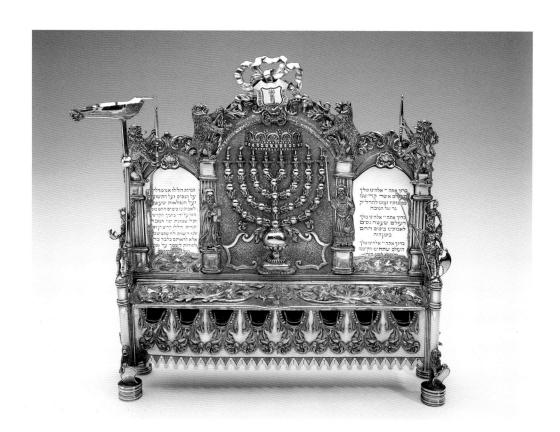

14

Germany, early 18th century

Silver: repoussé, engraved, chased, punched, appliqué, parcel-gilt, and cast; 11 11/16 x 11 1/2 x 3 5/16 in. (29.7 x 29.2 x 8.3 cm)

Gift of Samuel Lemberg, JM 27-53

HEBREW INSCRIPTIONS: Three blessings on kindling the lights; *Ha-Nerot Hallalu*

LATIN INSCRIPTION ON SHIELD: Providentia Tutamur

May we be guarded by Providence

The form and composition of this lamp and others like it seem based on that created by Johann Valentin Schüler of Frankfurt in the late seventeenth century (no. 11). The center of the backplate retained a dominant image, which came to be a menorah, while the sides developed into arches containing the Hebrew blessings said during the kindling of the Hanukkah lights. Small cast figures decorate the corners of the bench, here consisting of Judith, a soldier with shield, a hunter blowing a horn, and a dancing woman. In this context they may have been intended to represent such biblical heroes as Judah Maccabee, Joshua, and Miriam. On the backplate, Moses stands to the left of the menorah, here actually a Hanukkah lamp, while Aaron, the High Priest, kindles the lights. The bears and the coat of arms with Latin inscription may relate to the place where the lamp was made.

Six examples of this lamp type are known, three of them with the mark of an unidentified silversmith from Halberstadt, in Prussia, who began working in 1711. It is possible that the design concept, which may have originated in the more important silversmithing center of Frankfurt, was seen at the major market held in that city, and adapted by masters working further east. The Jewish community of Halberstadt was reestablished in the second half of the seventeenth century, and by 1699 had grown to 118 families. They were allowed to build a synagogue only in 1712, probably around the time that this lamp was made. Community members were engaged in a variety of occupations, including finance and industry, and thus the wealthiest could have afforded such elaborate silver lamps.

The version of *Ha-Nerot Hallalu* is the Ashkenazi variant given in the Note to the Reader, with the reversal of the words "wonders" and "redemptions."

HALLMARKS: L. B. Gans, p. 162, no. 1, and p. 176, no. 6 (both Dutch tax stamps). MAKER'S MARK: Three arrows with points meeting in center. PROVENANCE: in the Netherlands sometime between 1807 and 1893 (based on the Dutch tax marks); acquired in 1953. BIBLIOGRAPHY: Kayser and Schoenberger, no. 129. SIMILAR LAMPS: The Jewish Museum, nos. 163 and 164 in the catalogue raisonné; Israel Museum (Katz, Kahane, and Broshi, no. 155); Collection of Dr. Oppler, Hannover (Moses, p. 161); Central Synagogue, New York (Grossman 1989a, page for November 7–11); later imitation: Christie's Amsterdam 1986, lot 172.

15

Johann Christoph Drentwett I
(German, 1686–1763;
master 1718)
Augsburg, 1735–36
Silver: repoussé, traced, punched,
and cast; 5¹/₁₆ x 5⁹/₁₆ x 3½ in.
(12.9 x 14.1 x 8.9 cm)
Jewish Cultural Reconstruction,
JM 17-52

Around the 1730s a type of lamp appeared in Augsburg and Berlin that would eventually develop into a favorite Berlin type (e.g., no. 165 in the catalogue raisonné). These lamps are quite small, with a rocaille-framed backplate, a very deep oil box, and a leaf projecting from each side of the box. While the majority have a bouquet or basket of flowers in the center, the image in the center of this example is a pitcher and basin, symbolizing the Levites, or servitors, who tended the Jerusalem Temple in antiquity. In all likelihood the owner of the lamp was descended from Levites, a distinction that still carries certain rights and obligations.

Augsburg was one of the major silversmithing centers in Germany. By the seventeenth and eighteenth centuries, it was producing silver on a large enough scale that it was exported by commercial houses to cities all over Europe and sold at the major fairs in Frankfurt and Leipzig (Hernmarck, pp. 24–25). It seems likely that this lamp type originated in Augsburg and then came to the attention of Berlin masters or their clients, possibly through display at the fairs.

The maker of this lamp, Johann Christoph Drentwett I, was a member of one of the two major silversmith families of eighteenth-century Augsburg that provided plate to the kings and princes of Europe (Hernmarck, p. 27). Helmut Seling, in his definitive work on Augsburg silver, lists seventeen works by this master and illustrates eight (Seling, nos. 630–32, 701, 732, 758, 839, 1002). Drentwett created at least one other work of Jewish ceremonial art, a Torah shield in the Israel Museum collection (Fishof 1994, p. 50). Jewish ceremonial silver was generally not made by the most renowned silversmiths, so the fact that this lovely lamp was made by such a highly regarded master is noteworthy.

HALLMARKS: Seling 206 (front of backplate); illegible mark (reverse). MAKER'S MARKS: Seling 2104 (front of backplate); illegible mark (reverse). PROVENANCE: Siegfried Nauheim Collection, Frankfurt; bequest by Nauheim in 1936 to the Museum Jüdischer Altertümer, Frankfurt; acquired from the Jewish Cultural Reconstruction in 1952. BIBLIOGRAPHY: Schoenberger 1937, p. 10; Jüdisches Museum Frankfurt, no. 12. SIMILAR LAMPS: The Jewish Museum, nos. 165–68 in the catalogue raisonné.

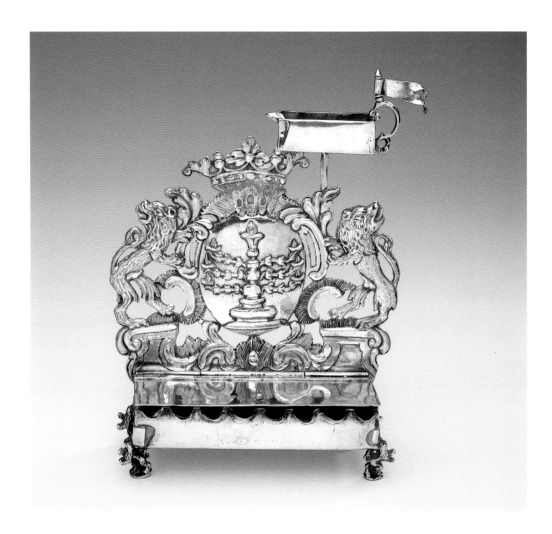

16

Georg Wilhelm Schedel
(German, 1698–1762;
master 1722)
Frankfurt, 1730s–62
Silver: repoussé, traced, punched,
pierced, and cast; 7½ x 5⅞ x 3¾ in.
(19 x 14.9 x 9.5 cm)
Gift of Dr. Harry G. Friedman, F 2820

This lamp type, decorated in pierced work with a central menorah supported by two lions, was very popular in Germany in the second half of the eighteenth and the early nineteenth centuries. Some forty examples are known in public and private collections and from auction sales, with more being revealed each year. The earliest lamps, and the vast majority, were created by Frankfurt silversmiths, indicating quite clearly that this type originated in that city.

Among Frankfurt silversmiths, the most prolific producer of these lamps was Rötger Herfurth. Although scholars have proposed that this Frankfurt type was created by him (e.g., Gundersheimer and Schoenberger, p. 6), it is possible that this Jewish Museum lamp by Schedel is as early as or earlier than what may be Herfurth's earliest known example (no. 156 in the catalogue raisonné). The Frankfurt mark on the Schedel lamp was in use from at least 1694 to 1756, which considerably predates those on the Herfurth pieces. The earliest that the Schedel lamp can be dated is to the 1730s, when the Rococo style, characterized by the shell-like appendages on the scrollwork, began. The type eventually spread to other German cities in the late eighteenth and early nineteenth centuries, and cast copies were made in the twentieth century (e.g., no. 578 in the catalogue raisonné).

Of the eight works known by Georg Wilhelm Schedel, five of them are Jewish ceremonial objects.

HALLMARK: Scheffler *Hessens* 130. MAKER'S MARK: Scheffler *Hessens* 272. DATE OF ACQUISITION: 1951. SIMILAR LAMPS: The Jewish Museum, nos. 156–59, 161, and 162 in the catalogue raisonné; Isi Liebler Collection, Australia (Christie's NY 1985, lot 403); and see Gundersheimer and Schoenberger, nos. 3–5; Mann 1982, no. 27; Mann 1986, p. 402 nn. 64, 69, and 72. OTHER WORKS BY SCHEDEL: The Jewish Museum (Grafman 1996, nos. 14 and 254) and F 3297; Jüdisches Museum Frankfurt (Wachten, p. 52); Consistoire de Paris (Klagsbald 1982, no. 67); Scheffler *Hessens*, p. 271.

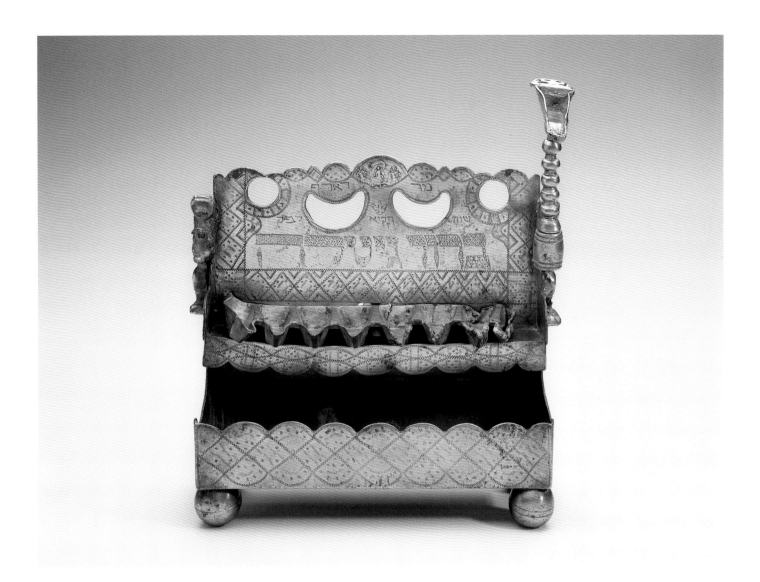

17

Maker: FCB

Hanau, inscription dates
1750/51 and 1777/78

Pewter: wrigglework, engraved, pierced,
appliqué, and cast; 9½ x 9¼ x 3¼ in.
(24.1 x 23.5 x 8.3 cm)

Gift of Dr. Harry G. Friedman, F 184

HEBREW INSCRIPTIONS: On backplate:

מר דארף / שנת תקיא לפק /
ברוך גיטלה

Mardorf; year [5]511 [=1750/51]
Barukh Gittele

On sidepiece:

ה ליב קילה / תקלנ לפק מרדורף

H Leib Kilah [5]538 [=1777/78]
Mardorf

The Hebrew inscriptions suggest that the lamp was both a wedding gift and a treasured family heirloom. The large letters across the backplate mention a couple's names, Barukh and Gittele, along with the date of 1750/51 and the place where they lived. Mardorf was a small town some one hundred kilometers from the city of Hanau, where the lamp was made. Twenty-seven years later, two other names were added to the sidepiece, probably commemorating the marriage of the next generation in the family, also in Mardorf.

Written sources indicate that by the early eighteenth century, Hanukkah lamps were considered important wedding gifts in Germany. For example, a law passed in 1715 by the Jewish Council of Frankfurt prohibited extravagant displays of silver wedding gifts at a special reception held before the ceremony, when the bride and groom sat together for the first time. Only three silver items were allowed, among them a *leuichter*, which was likely a Hanukkah lamp (Weber, p. 174).

A number of other examples of this type, characterized by its scalloped, horizontal upper edge and crescent-shaped holes, are known. Based on their masters' marks and Hebrew inscription dates, the type would appear to have been produced in Hesse and neighboring northern Bavaria in the second half of the eighteenth century through the early nineteenth century.

HALLMARK: angel with illegible inscription above. MAKER'S MARK: "FCB" above Justice in oval. DATE OF ACQUISITION: between 1939 and 1941. SIMILAR LAMPS: The Jewish Museum, F 484, and nos. 192–98 in the catalogue raisonné; Kölnisches Stadtmuseum (Franzheim, no. 178); Israel Museum (Benjamin 1987, no. 141).

18

Maker: RL

Germany, possibly Frankfurt,

inscription date on box 1757

Mirrored glass: engraved and

acid-etched; lead; tin; wood;

12 x 13 x 3⅜ in. (30.5 x 33 x 8.6 cm)

Gift of Vera List, JM 201-67

A storage box that once housed this lamp bore the Hebrew inscription, "In the year 1757 I acquired this Hanukkah lamp made of glass. Jacob Juda Bing Frankfurt a/M." The date of 1757 is consistent with the Rococo style of the lamp, with its rocaille edges and asymmetrical finial. Jacob Juda Bing is known from Klaus Dietz's genealogical study of the Jewish community of Frankfurt, where there is a mention of him in 1762 and a death date of 1798. Bing belonged to a Levite family that was first documented in Frankfurt in 1634, when his grandfather Isaak of Bingen married and was granted right of residence in the city (Dietz 1907, pp. 61–62). Since 1462, the Jews of Frankfurt had been confined to a walled-in ghetto, the Judengasse. Housing could not expand beyond the walls, and by the seventeenth century, when Bing's grandfather arrived, the number of residents was strictly regulated.

Mirrored Hanukkah lamps are very rare, probably due to the fact that until the eighteenth century glass mirrors were quite expensive to make. Large mirrors were so prized that they were often given as gifts from one monarch to another (Child, p. 13). By the eighteenth century domestic markets for mirrors increased in places like Germany, but it was not until the nineteenth century that two labor-saving inventions made mirrors more widely available. These innovations consisted of a chemical means of silvering the glass, and a special furnace that speeded up the glass melting process (Child, pp. 26–27). It is therefore remarkable that the original owner of this lamp was able to afford it.

The use of mirrors on Hanukkah lamps served to intensify greatly the brilliance of the lights, and parallels the use of mirrored backplates on secular wall sconces. The engraved decoration found on the Jewish Museum lamp seems to have been a specialty of Italian mirror makers, as many examples were produced there in the eighteenth century (e.g., Child, nos. 543, 556, 577). Italian glassmakers worked throughout Europe, bringing their skills and techniques with them, and so this piece could certainly have been made in Germany, which was one of the major mirror-producing countries (Child, p. 225).

SIGNATURE: "RL" in pomegranate. PROVENANCE: purchased from the Judah L. Magnes Museum, Berkeley; acquired in 1967. BIBLIOGRAPHY: Kanof 1969, no. 171. SIMILAR LAMPS: Israel Museum (Joods Historisch Museum, no. 24; Shachar 1981, no. 352); Skirball Cultural Center, acc. no. 27-61; M. Kugel Collection, Paris (Klagsbald 1956, no. 68). RELATED MIRRORS AND SCONCES: Child, no. 657; Karlinger, no. 406.

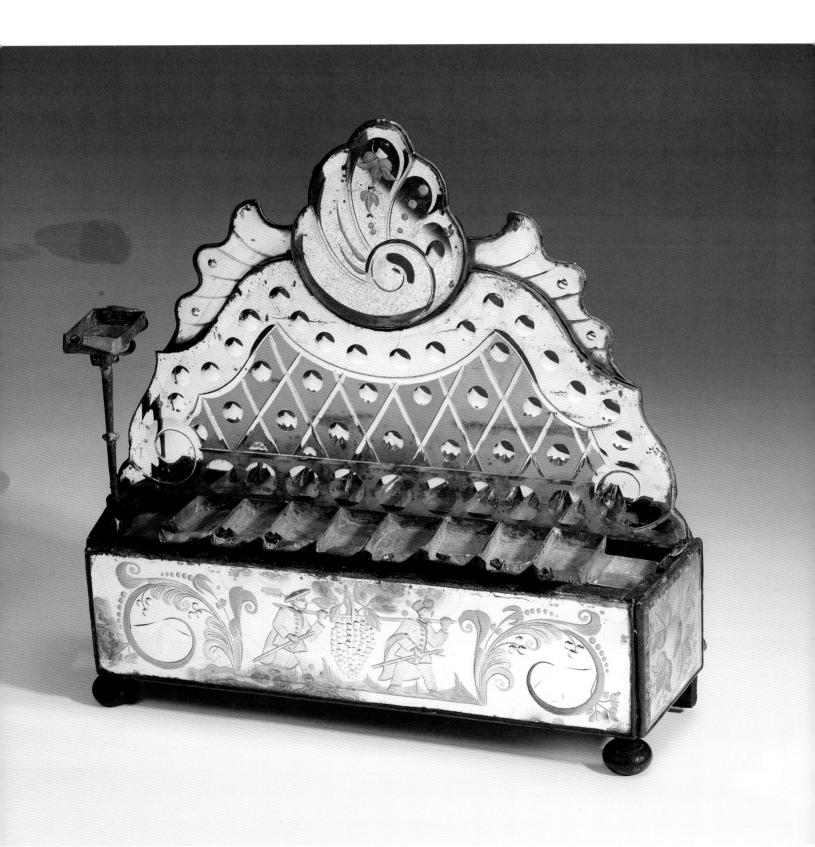

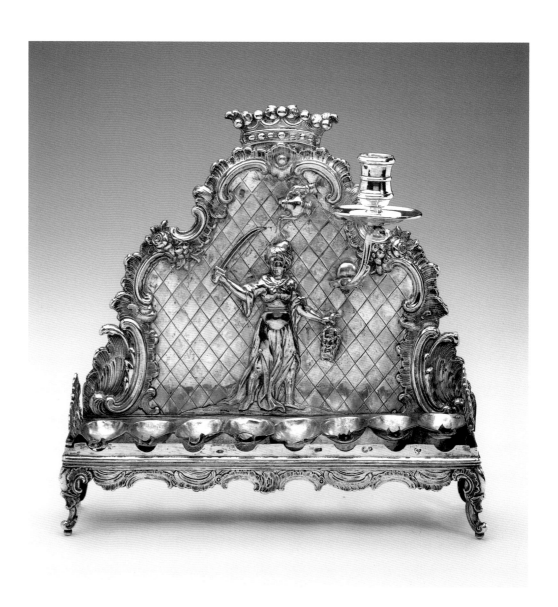

19

Christian Gottlieb Muche
(German, 1717–1772;
master 1746)
Breslau, 1761–72
Silver: repoussé, engraved, traced,
punched, parcel-gilt, and cast; 5¹⁵⁄₁₆ x
11¹⁄₁₆ x 1⅞ in. (15.1 x 28.1 x 4.8 cm)
Purchase: Mr. and Mrs. Joseph
Klingenstein Gift, JM 26-64

The lamp represents the heroine Judith holding the head of Holofernes (see no. 11).
In this version, a hand pours a pitcher of oil on her head, a device seen also on Italian
lamps, where the oil is poured into a seven-branch menorah (see no. 44). This no doubt
was meant to equate the miracle of the single jar of oil with Judith's triumph over
Holofernes, which the medieval rabbis also counted as a miracle.

The inclusion of Judith in this late-eighteenth-century lamp may represent yet an-
other association she engendered over time. The lamp was made in Breslau, which had
been in Austria until it was seized by Frederick the Great of Prussia in 1741. In the politi-
cal struggles that ensued, Empress Maria Theresa of Austria took on the qualities of a tri-
umphant Judith standing up to a new Holofernes (Frederick) in the public imagination.
Two oratorios about Judith were written around this time, possibly inspired by the em-
press, and became wildly popular (*Encyclopedia Judaica*, 10:460). The renewed interest in
Judith in this region, and possibly even Austrian loyalist tendencies, perhaps influenced
the artist's and patron's choice of a heroic figure for this lamp.

HALLMARKS: Hintze *Breslau* 20 and 36; Tardy 1980, p. 398, top row, 2nd and 3rd from right; Rohrwasser, p. 12, bottom
right (last three are Austro-Hungarian restamp marks). MAKER'S MARK: Hintze *Breslau* 158. PROVENANCE: in Brno, Moravia,
in 1806–7 (based on restamp marks); probably collection of Privy Counselor Pinkus of Neustadt, Austria, c. 1906 (Hintze
Breslau, p. 121 with identical dimensions and marks); Mr. and Mrs. Michael M. Zagayski Collection, acquired between 1940
and 1951; purchased at Parke-Bernet in 1964. BIBLIOGRAPHY: Schoenberger and Freudenheim, no. 126; Parke-Bernet 1964,
lot 307. SIMILAR LAMPS: late copies: Swann 1989, lot 499; Sotheby's TA 1993, lot 293.

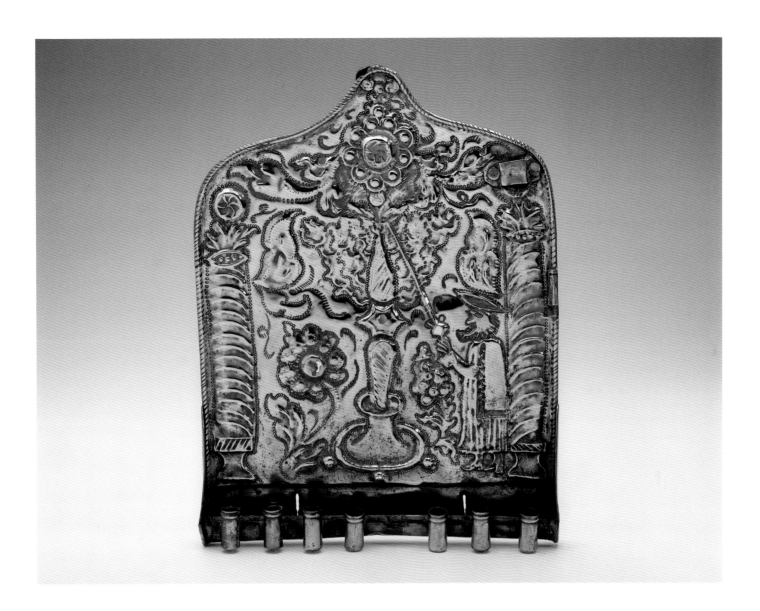

20

Germany (?), 18th century

Copper alloy: repoussé, chased, and punched; 13½ x 10¼ x 1½ in. (34.3 x 26 x 3.8 cm)

Gift of Dr. Harry G. Friedman, F 53

The lamp depicts a man lighting a seven-branch candelabrum with a taper, probably meant to represent the original Temple menorah that was rededicated in ancient times. The figure's costume consists of a flat *barette* or *beret*; a tunic; and a cloak, called a *sarbal*, that originated in Talmudic times. These elements were characteristic of German Jewish costume beginning in the seventeenth century, and remained the traditional dress for prayer in the synagogue until the nineteenth century (Rubens, pp. 105, 114, 122, figs. 164, 168, 177). The Baroque spiral columns, elaborately decorated arms of the menorah, and acanthus scrollwork above suggest an eighteenth-century date.

Copper-alloy Hanukkah lamps from Germany are rare, as are wall-hung lamps. The tradition of making sheet-brass items, such as bed-warming pans and foot warmers, was prevalent in Germany, adopted from the neighboring Netherlands. It is likely that the few German Hanukkah lamps known in this medium represent the dissemination of the type from the Netherlands (see no. 3).

DATE OF ACQUISITION: between 1939 and 1941. SIMILAR LAMP: Israel Museum (Benjamin 1987, no. 171).

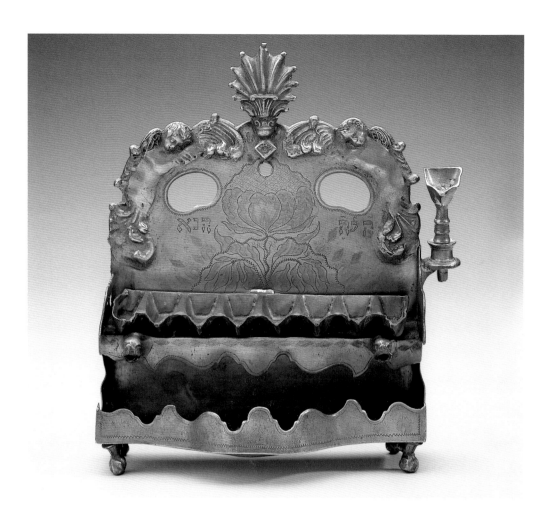

21

C. Sichler
Horb am Neckar,
late 18th century
Pewter: cast, engraved, and punched;
8¹⁵⁄₁₆ x 8⅞ x 3⅜ in.
(22 x 22.5 x 8.6 cm)
Gift of Dr. Harry G. Friedman, F 2370

HEBREW INSCRIPTION: ה"י'ה הנא
HYH HNA

German pewter lamps all have the same basic form: a backplate, a shelf at midpoint which holds a removable row of oil containers, a deep base to catch any oil dripped, and sidepieces. Although they were meant to stand, pierced holes in the backplates could have been used for suspension near the doorway during the holiday. The engraved decoration, like that on much of German pewter, is executed in a technique called wrigglework, in which the lines are made up of zigzags.

This lamp type with two angels curving around the backplate is one of the only pewter groups that has cast relief decoration. Two dolphin-head spouts act as gargoyles to funnel off any precious oil and collect it in a miniature pail that would have hung from their mouths. The Hebrew initials engraved on the lamp most likely represent the names of the owners, probably a married couple. The custom of marking secular and ritual pewter in this way began as early as the sixteenth century, when pewter was such a highly desirable commodity that it was often stolen and sold back to the pewtersmith to melt down for raw material (Nadolski, p. 36). These initials were engraved either by the pewterer or the owner (Laughlin, p. 21).

In the late nineteenth and early twentieth centuries, there was a lively industry in reproductions of antique pewter in Germany, part of the *historismus*, or revival, movement that characterized decorative arts in that period. Manufacturers either used old molds, made exact copies, or created their own pieces in antique styles (Niggl, p. 27). The angel lamp was copied by at least one firm, that of August Weygang in Öhringen, active from 1885 to 1946 (see no. 190 in the catalogue raisonné).

MAKER'S MARK: Hintze *Zinngiesser* V 1272. DATE OF ACQUISITION: 1949. BIBLIOGRAPHY: Kayser and Schoenberger, no. 135.
SIMILAR LAMPS: Israel Museum (Benjamin 1987, no. 140; Shachar 1981, no. 349); Muzeum Narodowe w Warszawie
(Martyna, no. 261).

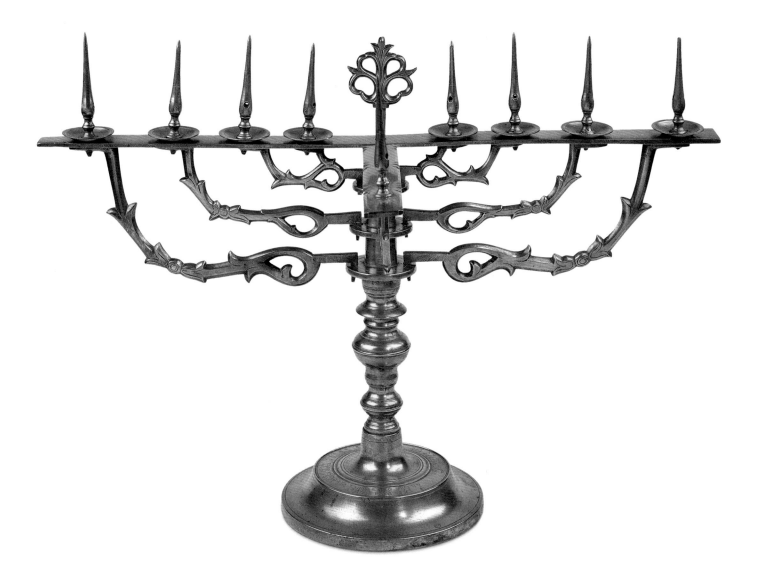

22

Karl Dürschner (?)
(active 1790–1805)
Nuremberg, inscription
date 1809/10

Copper alloy: cast, engraved, and
gilded; 21 15/16 x 31 3/4 x 17 in.
(55.7 x 78.1 x 43.2 cm)
The Jewish Museum, JM 68-79

HEBREW INSCRIPTION:

נ' מן אלמנה ריזלה ע'ה אשת כ'
מאיר ז'ל ת'ק'ע' ל'

A g[ift of the] h[and] from the widow
Reizeleh . . . wife of [the] h[onored]
Meir [may his] m[emory be] f[or a
blessing], [5]570 [=1809/10]

This lamp belongs to a special group of cast synagogue lamps made of copper alloy that use prickets to hold candles instead of candle sockets. They all have a similar form, their arms decorated with scrolls and buds and with a floral finial placed at top. Other examples of this type have been recorded in synagogues primarily in Germany, but also across the border into Bohemia, suggesting the locus of production and use.

It is normally very difficult to determine which cities or foundries manufactured copper-alloy objects, including such Judaica as Hanukkah lamps, Sabbath lamps, and candlesticks. This lamp is exceptional in that it bears a foundry mark that possibly identifies a maker and center of production. The mark is closest to that of Karl Dürschner, a lamp maker in Nuremberg active at the end of the eighteenth and beginning of the nineteenth centuries. His dates of activity are close to that of the inscription. Nuremberg became renowned for its bronze-casting beginning in the fifteenth century, with the arrival of bronze workers from the destroyed center of Dinant, in Flanders (Mickenberg, p. 25).

Dated inscriptions on other lamps of this type indicate they were manufactured from the 1680s to the early nineteenth century.

MAKER'S MARK: cf. Lockner, no. 1649. SIMILAR LAMPS: The Jewish Museum, F 6171, F 2933, F 2935, F 1838, and F 1507; Feldman Collection, Rio de Janeiro (Jewish Museum Visual Resources Archive); Parke-Bernet 1978, lot 204; Niederwerrn Synagogue (Harburger, p. 621); Mühlhausen Synagogue (Harburger, p. 397); Diespeck Synagogue (Harburger, p. 165); Wertheimershaus Synagogue, Eisenstadt (Schubert, no. 1); Dürrmaul Synagogue (Grotte, fig. 44); Chodova Plana Synagogue, Kuttenplan (Israel Museum Photo Archive); Kirchheim Synagogue (Eschwege, fig. 50); Sotheby's TA 1996a, lot 275. RELATED LAMPS: The Jewish Museum, nos. 282–87 in the catalogue raisonné.

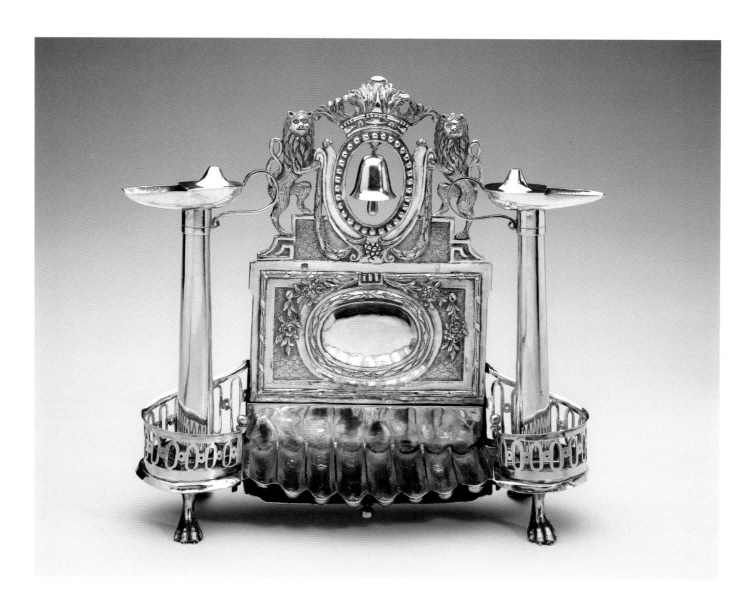

23

Karl Bitzel (1749–1823;
master 1787)
Augsburg, 1803
Silver: repoussé, pierced, traced,
engraved, and cast; 9⁵⁄₁₆ x 9⁷⁄₈ x 3⁷⁄₁₆ in.
(23.2 x 25.1 x 8.7 cm)
Gift of Dr. Harry G. Friedman, F 1536

The excavations in ancient Roman cities like Pompeii and Herculaneum that took place in the mid-eighteenth century created excitement and wonder among the general populace. They also provided symbols of the power of ancient Rome and its emperors with which newly created rulers like Napoleon identified. These factors stimulated a return to more classical compositions and motifs in the decorative arts, after the elaborate and busy scrollwork of the Baroque period. In this lamp, created at the beginning of the nineteenth century, we see the symmetrical arrangement of columns and staircases, as well as the medallions, garlands, and flowers that were characteristic of the Neoclassical style. A wonderful three-dimensionality is obtained by the freestanding columns and the "descending" railing.

The creation of this lamp in 1803 coincided with the year when a Jewish community was established in Augsburg for the first time since the Middle Ages. From the fifteenth until the beginning of the nineteenth century, Jews were only permitted to visit Augsburg during the day, for business purposes. Despite this ban, Jews commissioned a considerable number of ceremonial objects from Augsburg silversmiths throughout the course of the eighteenth century (e.g., no. 15 and Grafman 1996, nos. 2–7, 256). These Jews probably lived in nearby towns where Jewish settlement was permitted.

HALLMARK: Seling 287. MAKER'S MARK: Seling 2608. DATE OF ACQUISITION: 1944. SIMILAR LAMPS: Jüdisches Museum Schweiz (Rosenan, no. 52); Victor Klagsbald Collection, Paris (I am grateful to Rafi Grafman for the information on the latter). OTHER JUDAICA BY BITZEL: Grafman 1996, p. 44 n. 69, nos. 270–71.

24

Maker: CK

Münster(?), inscription date
1807

Stoneware: slipped, painted, and
glazed; 4½ x 10⁹⁄₁₆ x 3⅞ in. (11.4 x
26.8 x 9.8 cm)

Gift of Dr. Harry G. Friedman, F 4939

LATIN INSCRIPTION: Anno 1807

German ceramic Hanukkah lamps are rare, and only nine examples have been published. Most imitate the forms of German pewter lamps, with the row of lights across the middle of the backplate and a wide drip pan below. The method of decoration of the Jewish Museum lamp, consisting of a reddish-brown slip and cream paint that have been glazed, is characteristic of several regions of Germany, particularly Hesse and the Lower Rhineland, and it spread throughout Germany and beyond (Schlee, p. 174, nos. 243 and 246; Scholter-Nees and Jüttner, no. 338). It is impossible to identify the exact town where this lamp was made, even if the signature can be read as Münster, since there are a number of German sites with this name. It is unlikely to be the major city of Münster, since the production of lead-glazed ceramics in Germany was generally carried out in the countryside rather than cities, in order to be near fuel sources and to minimize pollution from the smoke and chlorine gas produced (Schlee, p. 143).

The inclusion of the year in Latin on this lamp reflects the practice, common in Europe since the sixteenth century, of putting a date on a wide range of domestic and religious objects in many media. This may have been done to commemorate a specific occasion for which the piece was commissioned, or perhaps it simply indicates when the piece was made (de Bodt, p. 5). Often, as in this lamp, the date constitutes the chief decorative element of the piece.

SIGNATURE: "CK"; "Müester" [sic] [Münster?]. PROVENANCE: purchased from Adolf Rosenthal, New York, in 1959. BIBLIOGRAPHY: Kanof 1969, color pl. 15. OTHER CERAMIC LAMPS: Kölnisches Stadtmuseum (Franzheim, nos. 177 and 181); Kräling, Scheurmann, and Schwoon, no. 183; Guth-Dreyfus and Hoffman, no. 137; Israel Museum (Shachar 1981, nos. 353–54); Sotheby's TA 1987, lot 230; Sotheby's NY 1986a, lot 295; Sotheby's TA 2001b, lot 215.

25

Berlin, c. 1830

Copper alloy: repoussé, engraved,
and appliqué; iron: cast, gilded,
and painted; 16¼ x 15½ x 3 in.
(41.2 x 39.4 x 7.6 cm)
Gift of the Danzig Jewish
Community, D 208

The Neoclassical style of this lamp and its incorporation of cast-iron elements (in the form of two griffins and an altar) suggest an origin in Berlin around 1830 (Kleeblatt and Mann, p. 142). At the beginning of the nineteenth century iron began to be used for the first time for all forms of decorative arts, including jewelry. Berlin was at the forefront of this production, due to several factors. The Prussian kings sought to stimulate the economy by encouraging the mining and casting of a local resource, iron. In addition, a new type of furnace had been invented, which enabled the casting of very fine pieces for the first time, and these were introduced into Germany. Finally, the conquest of Prussia by Napoleon in 1806 raised the public consumption of iron goods to a new height in a patriotic fervor of support for the local industry (Ilse-Neuman, pp. 55–58; Schmuttermeier, p. 75). Karl Friedrich Schinkel, Prussia's chief architect, promoted Neoclassicism as the essence of the Prussian national style, as suggested by the form and decoration of this lamp. By the 1830s, the black surfaces of cast iron were increasingly covered in a patina, painted, or gilded, as seen here on the wings of the griffins and the flames of the altar (Ilse-Neuman, p. 68). The contrast between the copper-alloy backplate, the gilding, and the black iron creates a bold decorative scheme that is echoed in the broad simple scrollwork framing the backplate.

PROVENANCE: Lesser Gieldzinski Collection, Danzig, late nineteenth century to 1904; donated to the Great Synagogue of Danzig in 1904; acquired in 1939. BIBLIOGRAPHY: Danzig, no. 31; Mann and Gutmann, no. 160; Kleeblatt and Mann, p. 142.

26

Southwestern Germany,
late 19th century

Tin plate; 9⁷⁄₁₆ x 13 x 5⅜ in.
(24 x 33 x 13.7 cm)

Gift of Ilse Baranowski in memory
of Emma Mayer, Lustadt, Pfalz,
Germany, 1996-1

Tin lamps, perhaps the simplest and least expensive to make, are known from parts of Germany, France, and Switzerland that border on the Rhine River. Their use may have been more widespread, but what little is known about tin lamps comes from efforts to collect and document them by museums in Alsace and Basel. These often have as many as four sets of eight lights, a custom followed by Alsatian Jews so that several family members could kindle their own lights. Two types of bench lamps are known: one with a backplate, as seen here, and the other comprising just the oil containers mounted on a rectangular plate (see no. 236 in the catalogue raisonné).

It is often difficult to determine the origin and date for tin lamps without known provenance. The methods used to create works of tin are simple and appear to be universal. The uncertainty is compounded by the fact that there is a paucity of studies on style and form on European tin objects.

Following Alsatian Jewish custom, this lamp has two sets of Hanukkah oil containers. The original owner lived in southwestern Germany, close to Alsace.

PROVENANCE: collection of the donor's grandmother in Lustadt, near Speyer, in the late nineteenth century; collection of the donor until 1996; acquired in 1996. TIN LAMPS WITH PROVENANCE: The Jewish Museum, no. 236 in the catalogue raisonné; Jüdisches Museum der Schweiz in Basel (Ungerleider Mayerson, p. 152 lower; Guth-Dreyfus and Hoffman, nos. 124 and 127); Stadtlisches Museum Göttingen (Kräling, Scheurmann, and Schwoon, no. 184).

27

Germany, second half
19th century

Silver: cast and acid-etched; 5¹¹⁄₁₆ x
10¹⁵⁄₁₆ x 3½ in. (14.4 x 27.7 x 8.9 cm)

Gift of Dr. Harry G. Friedman, F 802

HEBREW INSCRIPTION: זכר לנס חנוכה
In remembrance of the miracle of
Hanukkah

The lively combination of neoclassical columns and garlands with the stylized floral vines indicates that this piece is in the neoclassical revival style of the late nineteenth century. The lamp should be attributed to Germany, based on two related examples with German post-1888 hallmarks.

The inclusion of the double-headed eagle is of interest, as it was the emblem of the German emperors who claimed descent from the Holy Roman Empire. The symbol went out of use in Germany in 1871, when the empire gave way to a national state and the single-headed eagle was selected as its emblem. This lamp therefore probably dates to before 1871. However, Jewish attitudes toward the imperial crown and its symbol must have been ambivalent at best during this period. In their struggle for full civil and political rights, many Jews had joined the revolution of 1848–49, whose Parliament extended equality to Jews. The revolution eventually failed, and it was not until the establishment of the Republic in 1871 that all political and civil restrictions against minority religions were abolished.

DATE OF ACQUISITION: 1941. SIMILAR LAMPS: private collection, New York; Sotheby's NY 1989, lot 324; State Jewish Museum, Prague (D. Altshuler, no. 133); private collection, Aub, Germany (Harburger, p. 26).

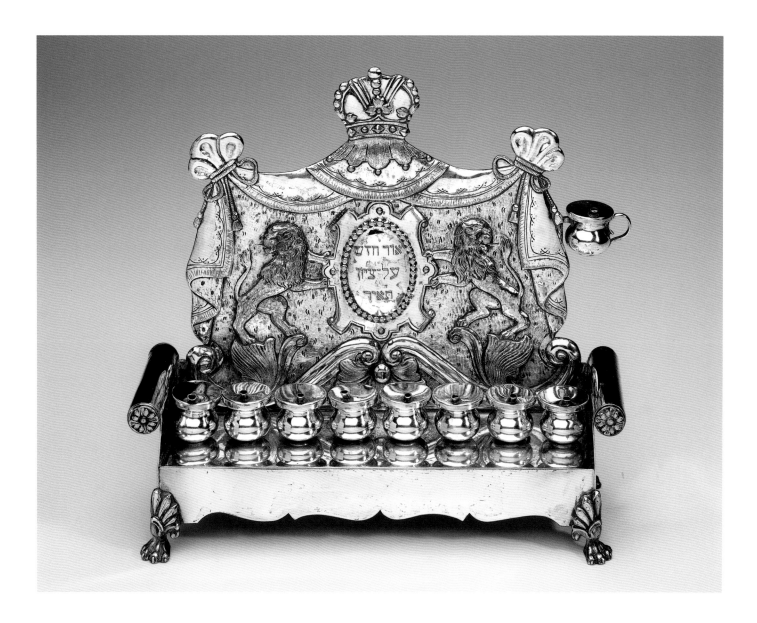

28

Württembergisches
Metallwarenfabrik
(1880–present)
Geislingen an der Steige,
c. 1894

Copper alloy: die-stamped, punched,
chased, silver-plated, and cast; 9¾ x
10¾ x 3½ in. (24.7 x 27.2 x 8.8 cm)
Gift of Dr. Harry G. Friedman, F 2316

HEBREW INSCRIPTION:

אור חדש על ציון תאיר

A new light shall shine for Zion

In the late nineteenth century, numerous factories developed in Germany and elsewhere for the mass production of silver and silver-plate. These were fashioned by die-stamping in a press, rather than through handcrafting. While the original investment in the press apparatus was costly, the number of pieces that could be turned out eventually justified the expense. Although the technique was invented in 1769, die-stamped Judaica does not seem to have become common until the mid-nineteenth century, when it made ceremonial art more affordable to the middle and lower classes.

The firm that created this lamp was the Württembergisches Metallwarenfabrik of Geislingen an der Steige, Germany, which is still in operation today (Sänger, p. 281). Around the turn of the last century it specialized in plated copper-alloy wares, including ritual objects and utensils (Krekel-Aalberse, p. 261). This lamp model first appeared in their pattern book of 1894/95.

The baldachino (crown and canopy) and the scrollwork on this lamp are revivals from the Baroque period, and were common on much of the Judaica of the nineteenth century. The sofa form, evidenced by the rolled arms, was influenced by nineteenth-century Austrian lamps (see no. 35).

MAKER'S MARK: "WMF". PROVENANCE: purchased from E. Pinkus, New York, in 1948. BIBLIOGRAPHY: Württembergisches 1894/95, p. 103, no. 4. OTHER JUDAICA BY WÜRTTEMBERGISCHES METALLWARENFABRIK: The Jewish Museum (Grafman 1996, no. 320); Jüdisches Museum Rendsburg (Mildenberger, no. 208).

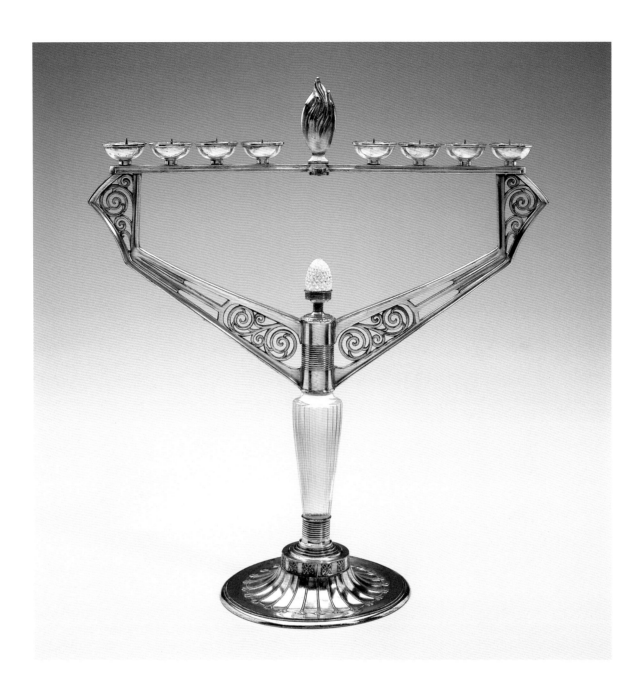

29

Orivit-Aktiengesellschaft
(1900–1905)
Köln-Braunsfeld, 1900–1905

White metal: cast and silver-plated;
glass: mold formed; 13⅞ x 12¾ x
5⁵⁄₁₆ in. (35.3 x 32.4 x 13.5 cm)

Gift of Dr. Harry G. Friedman (?),
F 3573

In the later nineteenth and early twentieth centuries, German silverware factories began producing silver-plated copper-alloy and white-metal objects by newer techniques such as electroplating. Most of the Judaica they designed reached back to Jewish tradition for stylistic inspiration—for example, incorporating the knobbed arms and stepped bases that imitated the ancient Temple menorah—while others continued to turn out pieces in the revival styles of the nineteenth century.

The new styles of early-twentieth-century decorative arts, from Art Nouveau to Art Deco, were largely ignored by the mass manufacturers of Judaica. Exceptions include this lovely lamp in the Jugendstil—the German version of Art Nouveau—with its geometric form and spiral ornamentation. A predilection for spirals was also found in the Austrian Wiener Werkstätte products around the same time. The factory that produced the lamp, Orivit, was only in business for five years under that name, from 1900 to 1905, before it was incorporated into the Württembergisches Metallwarenfabrik of Geislingen.

MAKER'S MARKS: "O" flanked by "A" and "G"; "ORIVIT" within dome; "3528". RELATED LAMPS: The Jewish Museum, nos. 261 and 262 in the catalogue raisonné. OTHER WORKS BY ORIVIT: Hennig, no. 68; Krekel-Aalberse, no. 144.

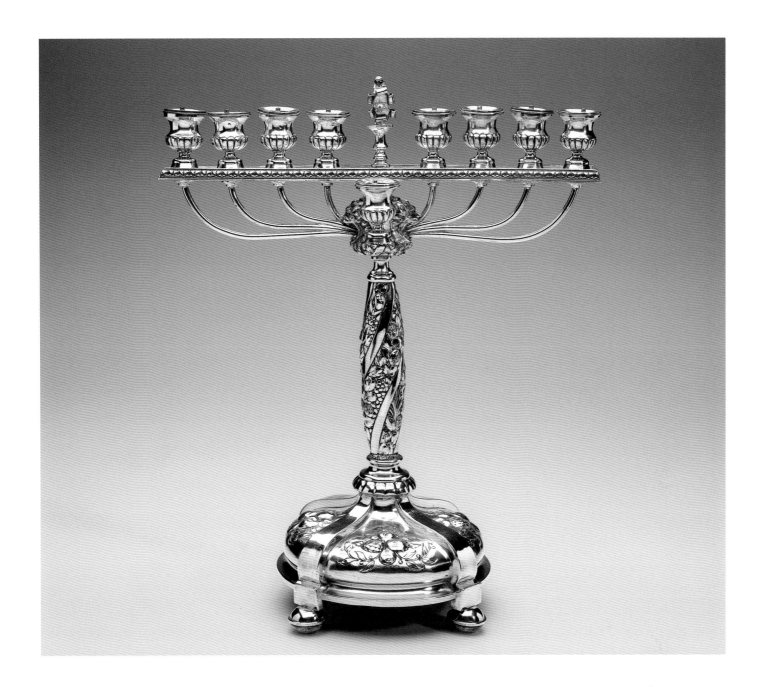

30

Gebrüder Gutgesell
(active 1903–1926)
Hanau, 1903–26

Silver: cast, repoussé, spun, and
parcel-gilt; 16⅛ x 13½ x 8⅛ in.
(41 x 34.3 x 21.6 cm)

Gift of Mrs. Jules Lubell in memory
of her parents, Regina and Leo Frisch,
1997-39

The decoration on this lamp, made in the early twentieth century, harks back to the previous century's enthusiasm for floral ornamentation with a style all its own. Undecorated bands alternate with floral panels, while the arms issue from two lion heads on either side of the shaft. The firm that produced the lamp, Gebrüder Gutgesell, was one of many manufacturers of silver objects in Hanau in the early twentieth century.

The lamp was purchased in Germany by the donor's family, who then moved to Antwerp in the early part of the twentieth century. It was left behind when the family fled to the United States in the 1930s, but was somehow untouched by the German officers who occupied their apartment. The marks on the lamp parallel the history of the family, indicating it was made in Germany and was imported into the Netherlands, perhaps during their move to Antwerp.

HALLMARKS: Tardy 1980, p. 50 and p. 322 (Dutch import mark); "800". MAKER'S MARK: cf. Scheffler *Hessens* 568/569. PROVENANCE: collection of the Frisch family, early twentieth century; acquired from a family member in 1997. SIMILAR LAMP: Parke-Bernet 1980, lot 154. OTHER JUDAICA BY GEBRÜDER GUTGESELL: The Jewish Museum (Grafman 1996, no. 26); Museum für Kunst und Gewerbe, Hamburg (Germanisches Nationalmuseum, no. 3/30); Israel Museum (Shachar 1981, no. 233).

31

Arnold Zadikow (German, 1884–1943)

Probably Munich, 1920s

Copper alloy: cast and traced; 18¹/₁₆ x 19³/₁₆ x 7 in. (45.9 x 48.8 x 17.7 cm)

Gift of Dr. Harry G. Friedman, F 1228

Arnold Zadikow began his working career as a mason and then became a master builder. He soon turned to creating works of art, and during the course of his artistic life produced small plaques and medals, figurines in metal and terra-cotta, and large stone sculptures, including Jewish tombstones. The themes of many of his works were Jewish in nature and included Hebrew inscriptions and representations of biblical figures, such as his statue of David, or his Hanukkah lamp, seen here.

Combining elements of early-twentieth-century design with Jewish imagery, this lamp depicts the emblems of the Twelve Tribes of Israel. These are taken from Genesis 49, in which the patriarch Jacob/Israel blessed his twelve sons, comparing each to an animal or object that represented their character. For example, Judah was likened to a mighty lion, Issachar was an ass giving tribute to others, while Dan was the serpent who stung the Israelites into righteousness. The lotus flower at the top of the shaft and the graceful curve of the crossbar reflect the stylistic trends of Jugendstil, while the use of medallions are derived from Zadikow's early interest in medals. Only one other Hanukkah lamp is known to have been designed by Zadikow, a wooden one made in the concentration camp Theresienstadt, a year before his death in 1943.

Several different versions of this lamp are known. One was displayed in Rome during a Holy Year, almost certainly the one held in 1925, and thus provides an approximate date for its design. According to the museum's accession card, the Jewish Museum lamp once belonged to the Jüdische Museum in Berlin before World War II, and indeed an identical lamp was published as belonging to that museum in a 1933 Berlin Jewish newspaper.

PROVENANCE: Jüdische Museum in Berlin before World War II; acquired in 1942. BIBLIOGRAPHY: *Central-Verein-Zeitung*. SIMILAR LAMPS: Collection Marianne May, Zadikow's daughter; Schwarz n.d.; Jüdische Museumsverein, cover; Sotheby's TA 2001a, lot 228; Temple Israel, Scranton, Penn. (Sheldon and Geffen, p. 20); Holy Land Treasures 2, lot 106. OTHER WORKS BY ZADIKOW: see Schwarz 1913; Schwarz 1928, pp. 199–202; Schwarz 1949, pp. 121–28; The Jewish Museum, medals FB 128, FB 129, FBG 153, and FB 175 (Meshorer, no. 180, misidentified as Adolf Richard Zutt).

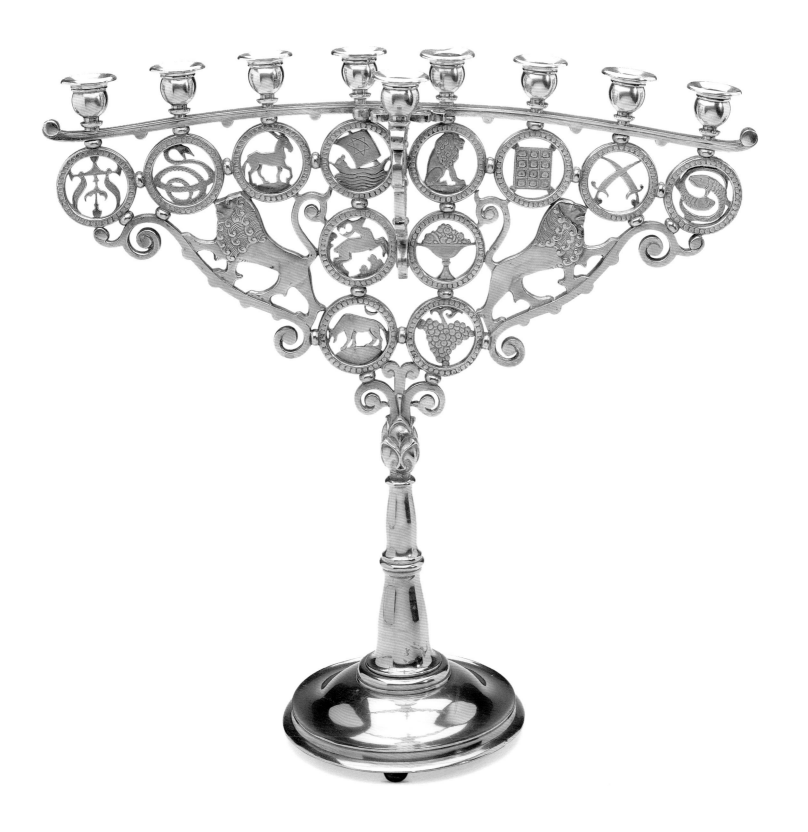

32

David Gumbel
(German/Israeli, 1896–1992)
Heilbronn, early 1930s
Silver: hand-worked; 11⁹⁄₁₆ x 13⁵⁄₁₆ x
5¼ in. (29.9 x 34 x 13.4 cm)
Gift of Hannah and Walter
Flegenheimer, 2002-9

This Hanukkah lamp is highly unusual for the period as it brings to a Jewish ritual object the design aesthetic of the Bauhaus. The lamp's style emphasizes the sleek, elegant proportions and unadorned surfaces advocated by the Bauhaus school and popular in the most avant-garde design trends of the 1930s. In Germany, contemporary art ran afoul of the Nazis. They ordered the removal of abstract art, which they termed "degenerate," from museums throughout Germany and forced the closure of the Bauhaus—Germany's foremost school of contemporary design, architecture, and art. It is therefore remarkable that Judaica made in this revolutionary style survived. This Hanukkah lamp was purchased directly from Gumbel in Germany and brought to America in the 1930s. Its swift exit from Hitler's Europe undoubtedly accounts for its existence today.

The lamp's creator, master silversmith David Heinz Gumbel, was born in Sinsheim, Germany, near Heidelberg. He studied at the Kunstgewerbeschule in Berlin-Charlottenberg from 1927 to 1931 (Jerusalem Post). Although Gumbel did not actually study at the Bauhaus, he was profoundly influenced by its teachings and incorporated its design aesthetic into his silver and Judaica. In 1934 Gumbel fled Nazi Germany and moved to Palestine. As a member of the faculty of the recently opened New Bezalel School in Jerusalem, he joined a group of highly cultured artists and colleagues who worked under the directorship of Joseph Budko, a craftsman who championed the modernist aesthetic (Lawrence). Gumbel taught silversmithing, hammered work, and jewelry design at Bezalel, and retired in 1955 (Jerusalem Post). His personal style always remained classic modern—his objects emphasize streamlined design and graceful contours. SR

HALLMARKS: Tardy 1980, p. 50; "835". MAKER'S MARK: "G" over downward-pointing triangle of 10 dots. PROVENANCE: collection of Flegenheimer family, Germany, 1930s until 2002; acquired in 2002.

33

Landsberg am Lech, 1945

Copper alloy: cast, engraved, punched, and appliqué; wood;

13½ x 10⅜ x 5¼ in.

(34.3 x 26.3 x 13.3 cm)

Gift of General Joseph T. McNarney, S 1406

ENGLISH INSCRIPTION: A souvenir from / the Prof. School of Landsberg/Lech / Jewish-Center / To our Liberator / the glorious hero / Gen. Joseph T. Mc Narney / Dezember 1945 / ORT

HEBREW INSCRIPTION: נ ג ה ש

[A] g[reat] m[iracle] h[appened] th[ere]

This lamp was created in a displaced persons' camp after World War II. The residents were receiving vocational training from ORT, a Jewish organization active throughout Europe. Begun in Russia in 1880 to provide funds for needy Jews, by the 1920s ORT had turned to training Jews in manual labor as a means of changing their economic conditions.

The lamp is dedicated to General Joseph T. McNarney, who served as the Commander in Chief of United States Forces in the European Theatre from November 1945 to March 1947. As such, he was responsible for the displaced persons camps in Germany and Austria. This lamp was presented to him shortly after he took office, perhaps at a visit to the camp. McNarney was considered kindhearted and humane, and when Jews fleeing postwar pogroms in Poland infiltrated illegally into the American-controlled sector, he granted them shelter and care (Genizi, pp. 3, 6, 7). In addition, General McNarney enabled the publication of a complete edition of the Talmud to meet the thirst for Jewish education among surviving European Jews. Acceding to the impassioned plea of Rabbi Philip S. Bernstein, the American advisor on Jewish affairs, McNarney scrounged for scarce paper, imported sets of the Talmud from America to make offset copies, and requisitioned a printing plant to publish the edition, which came out in 1948 (American Jewish Historical Society).

The Hebrew inscription on the lamp, "A great miracle happened there," is found on the tops or dreidls that children play with on Hanukkah in Ashkenazi communities. It refers to the miracle of Hanukkah, but may in this instance also poignantly signify the liberation and salvation of the Jews in the DP camp.

PROVENANCE: presented to General Joseph T. McNarney c. 1945; acquisition date unknown.

AUSTRIA

The first Jewish settlement in Austria is documented in the tenth century, but it may date back to Roman times and the first centuries of the Common Era. The community's experience under Austrian rule was mixed. At certain times Jews were granted city charters and limited rights, while at others they were expelled from particular regions and restrictions were imposed on their activities.

The Austrian lamps in the collection date from the nineteenth through early twentieth century. The majority were made in Vienna, including the earliest example, created in 1815 (no. 301 in the catalogue raisonné). This date is noteworthy, since Jews had been officially expelled from Vienna between 1669 and 1848. By the late seventeenth century, however, the financial losses of the city caused the rulers to allow a small number of wealthy Jews to reside in Vienna, although they were not authorized to establish an official community. In addition, a Turkish Jewish community was founded in 1736, following the 1718 treaty between Austria and Turkey that allowed Turkish subjects greater rights than Austrian Jews. Despite the restrictions, Jewish settlement in Vienna steadily increased. The empress Maria Theresa (r. 1740–1780) permitted certain "tolerated" Jews, mostly financiers and industrialists, to dwell in the city, and the number of inhabitants was augmented after 1772 with the Austrian annexation of Galicia. The size of the Jewish community changed dramatically in the nineteenth century, when the lifting of the expulsion edict and immigration from other lands swelled the population from 520 souls in 1777 to about 15,000 in 1854. This history of Jewish settlement in Vienna helps explain the paucity of Hanukkah lamps from the eighteenth century, and the great increase from the 1840s on. Another reason for the scarcity of lamps before 1800 is that, in 1808, Emperor Francis I confiscated and destroyed most secular and sacred silver unless the owner could pay the government its full value.

SILVER BENCH LAMPS

There is little variety in basic shape and material in the museum's Austrian lamps; nearly every example is silver or silver-plated, and in the form of a bench with legs. Many even imitate the shape of a sofa, with rolled arms and an elaborately scrolled back. Lamps of the early nineteenth century were handmade in repoussé and often pierced. In keeping with Vienna's position as a major silversmithing center since the fifteenth century, the quality of the workmanship is often very high. Later-nineteenth-century examples, however, were primarily silver-plated and mass produced in factories using die stamps. The motifs that ornament the backplates are varied, ranging from hearts with garlands to peacocks to Gothic arches. However, the most common subject is that of two rampant lions holding the Tablets of the Law, discussed in no. 35.

The lamps were probably made by both Jews and Christians. After Emperor Josef II's Edict of Tolerance in 1782, Jews were permitted to learn crafts from Christian masters. However, it appeared that few Christians were willing to train Jews in their art, and cita-

Detail of no. 39.

tions about Jewish silversmiths are not found in the literature until the nineteenth century (Wischnitzer, p. 205; Wolf, p. 17; Grunwald, p. 108).

Austrian lamps have several unique characteristics. The first is the oval shape of many of the oil containers, which resemble the bowls of spoons. These are found on lamps from the 1810s to the 1870s; they also occur on some lamps in Hungary and Bohemia/Moravia, both of which were under Austrian influence and control. In Austria, the ovals were eventually replaced by urn- or pitcher-shaped containers, which were used into the early twentieth century. A second peculiarity of Austrian bench lamps is the way in which the oil containers are attached to the bench. They are mounted on a bar with legs on either end that are inserted into sockets on the bench. Presumably this facilitated cleaning after use.

MENORAH-FORM LAMPS

There are few Austrian menorah-form lamps in the collection. A cursory survey of synagogue interiors published in books or in photographic archives has yielded only one example in an Austrian synagogue of the large nine-branch Hanukkah lamps that were so common in Germany and eastern Europe. This is a silver lamp made in 1846 by I. V. Klinkosch, which stood in the Stadttempel in Vienna (Bronner 1926a, pp. 171–72). A fifteenth-century account by Rabbi Israel Isserlin does mention his seeing a Hanukkah lamp in a Viennese synagogue, but its form is not described (M. Narkiss, p. 72). Furthermore, there was apparently no tradition in Austria of casting Hanukkah lamps in copper alloy, which is the material and technique used to create the vast majority of large menorah-form synagogue lamps. One exception in the collection is a pair of twentieth-century synagogue wall lamps in Italian style, which were marked "Made in Austria" and were probably intended for export (see no. 320 in the catalogue raisonné).

All the other examples of menorah-form lamps in the museum are of silver and most likely intended for home use. They generally consist of just the arms, without the shaft and base. These are converter lamps, designed to be inserted into candlesticks (see no. 316 in the catalogue raisonné).

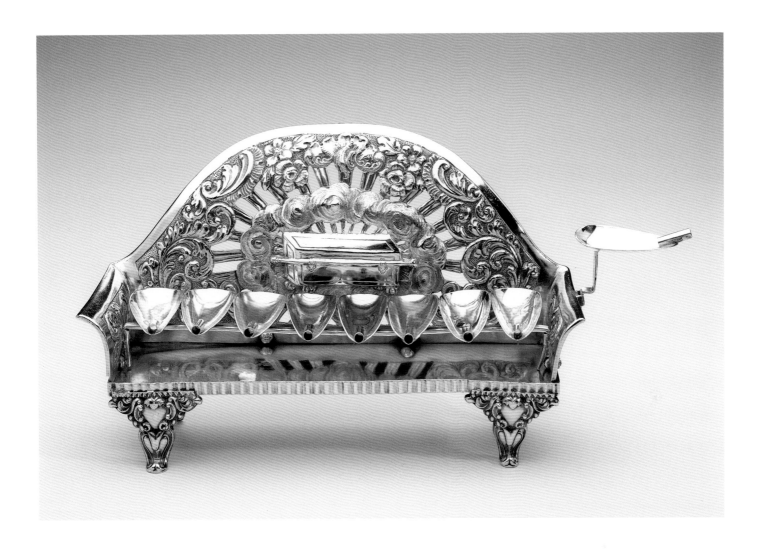

34

Josef Wallnöfer
(Austrian, 1802–1872,
master 1828)
Vienna, 1840s
Silver: repoussé, pierced,
engraved, traced, punched,
and cast; 8 x 10¼ x 3¼ in.
(20.2 x 26 x 8.3 cm)
Gift of Dr. Harry G. Friedman,
F 3263

A number of lamps, most of them made in Austria, transformed the traditional bench shape into that of a sofa. The back of the "couch" is either arched or more rectangular in form, while sofa arms, often curving outward or rolled, are added on either side. These lamps for the most part imitate furniture styles prevalent in the Rococo period of the second half of the eighteenth century. This style is also carried through into the ornamentation of the sofa back, which often consists of elaborate eighteenth-century baroque scrollwork or shell-like Rococo scrolls. Judging from the examples in the collection, the sofa form appears to have been popular from around the 1840s to 1870s (and see Martyna, pp. 250–51).

The motif on the back of this lamp, the Ark of the Covenant surrounded by clouds, is an unusual one for a Hanukkah lamp. The Ark contained the Ten Commandments and was housed in the Holy of Holies of the ancient Temple in Jerusalem. Its use here could refer to the rededication of the Temple that is celebrated at Hanukkah. However, by the time that the events of the Hanukkah story took place, the Ark of the Covenant had been missing for hundreds of years.

HALLMARK: Neuwirth, pl. 4:5. MAKER'S MARK: Reitzner 1246 (in shield). DATE OF ACQUISITION: 1953. SIMILAR LAMPS: Muzeum Narodowe w Warszawie (Martyna, no. 267); Jewish Museum, London (Barnett, no. 271).

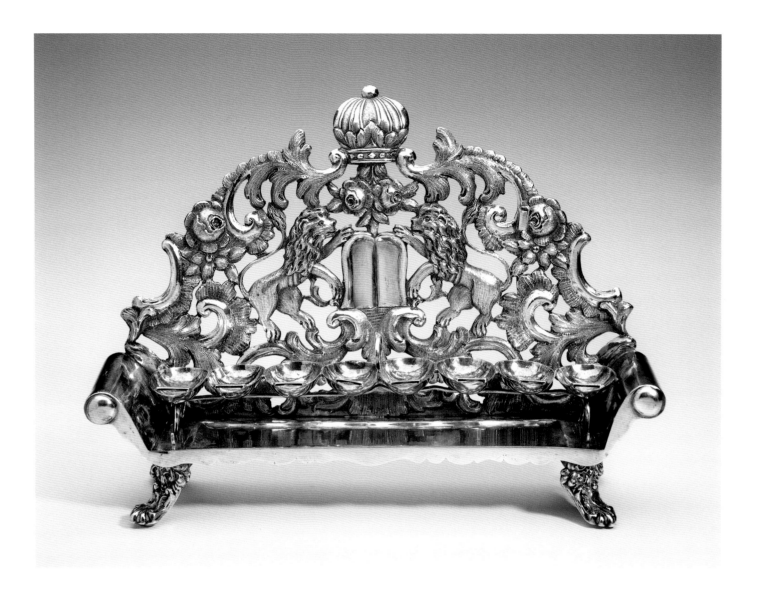

Joseph Reiner
(active 1826–1867)
Vienna, 1858
Silver: repoussé, pierced,
and traced; 7 ¹¹⁄₁₆ x 11 ⅛ x 2⅞ in.
(19.5 x 28.2 x 7.3 cm)
Museum purchase, JM 224-68

The most common motif on the Viennese lamps in the collection consists of two rampant lions flanking the Decalogue (Ten Commandments). The reason for its popularity may be related to the type of Judaism practiced in Vienna in the nineteenth century. While various Jewish traditions and denominations were represented, the community was largely Reform in orientation (Krinsky, pp. 188, 191). One of the tenets of the Reform ideology is that Judaism can evolve and change, and that religious laws and ceremonies followed in one era need not be valid for later generations. As part of this belief, Reform Jews no longer felt it necessary to wish for the return to Zion and the rebuilding of the Temple in Jerusalem, interpreting this messianic hope in more universal terms.

For millennia, the seven-branch menorah had symbolized this Jewish hope for the restoration of Israel, and was represented on all manner of ceremonial objects from ancient tombstones to Hanukkah lamps. The substitution of the Decalogue, symbol of the law that could be freely interpreted in each age, for the menorah would seem to have ideological overtones. In fact, the only Jewish symbol included in the architectural decoration of the first Reform synagogue in Vienna (the Stadttempel, built on the Seitenstettengasse in 1826) was the Decalogue located above the Torah ark (Krinsky, p. 190). Furthermore, the menorah is also absent in the ornamentation of the synagogue's textiles and silver implements for the Torah (Bronner 1926a).

HALLMARK: Neuwirth, pl. 4:6. MAKER'S MARK: Reitzner 1230 (in rectangle). PROVENANCE: purchased from Mr. and Mrs. Henry Farber, Queens, New York, in 1968. SIMILAR LAMPS: The Jewish Museum, nos. 289–97 in the catalogue raisonné.

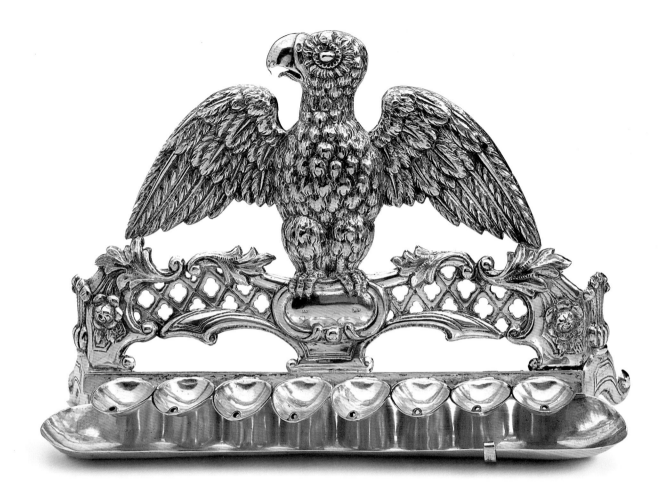

36

Maker: AK

Austrian Empire, 1858

Silver: repoussé, pierced, traced,

and punched; 7⅝ x 11¾ x 4¼ in.

(19.3 x 29.7 x 10.8 cm)

Gift of Dr. Harry G. Friedman, F 3206

Several Austrian lamps, most of them made in Vienna in the second half of the nine-teenth century, bear prominent eagles in the center. The presence of eagles on lamps in general as well as on Hanukkah lamps seems to be associated with the emblem of the ruling power (Jarmuth, p. 172; and see no. 61 below). This does not seem to be the case here, since, while the Austrian Empire did use an eagle as its royal symbol, that eagle was double-headed. It is possible that this lamp was produced in Galicia, the part of Poland that was annexed by Austria in the late eighteenth century. The Polish kings chose the single-headed eagle as their emblem. Alternatively, the eagle on the lamps could be devoid of political association and simply represent strength and ferocity.

HALLMARK: Neuwirth, pl. 4:6 (partial). MAKER'S MARK: "AK" in rectangle. RELATED LAMPS: The Jewish Museum, nos. 304 and 305 in the catalogue raisonné; Abraham Halpern Collection, New York; Eisenberger Collection (Heimann-Jelinek, no. 41).

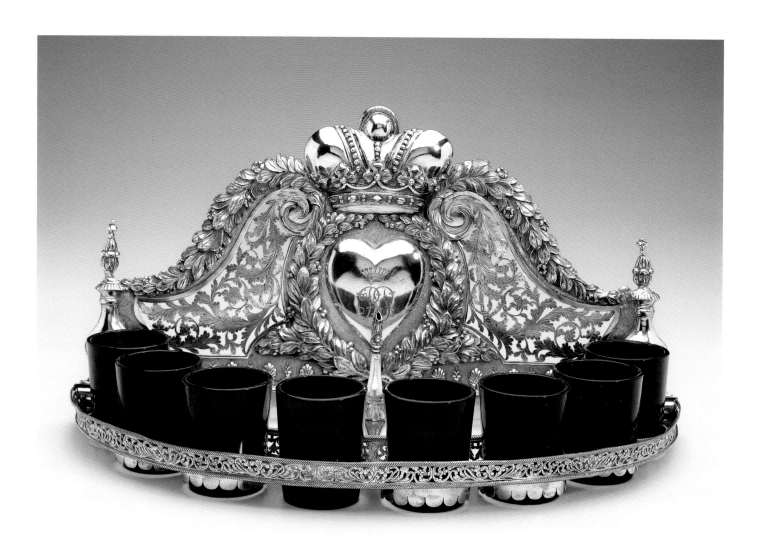

37

Jowanov

Vienna, 1858

Silver: repoussé, pierced, traced,
punched, rolled, and cast; glass;
9¾ x 16½ x 8¼ in.
(24.7 x 41.9 x 21 cm)
Gift of Dr. Harry G. Friedman,
F 3463

INSCRIPTION: "BP" or "BJ"

This beautifully crafted lamp is unusual in its combination of two distinct decorative techniques. The wreath framework and crown are executed in very high relief, which contrasts sharply with the openwork panels, which are completely flat. This type of flatwork is known on other Austrian lamps, but not in this combination.

A second peculiarity of this lamp is the semicircular arrangement of the oil containers. This is found on some seventeenth- and eighteenth-century Sephardi Hanukkah lamps from the Netherlands and Hamburg, and among Mizrahi communities in the Middle East, for example, in Iraq (Sharoni-Pinhas, nos. 2–3). It is, however, highly unusual in Ashkenazi lands, where a widely followed rabbinical ruling by Moses Isserles in the *Shulḥan Arukh* (sixteenth century), based on earlier traditions, indicated that the lights should be in a straight line. It is therefore possible that this lamp was produced for a community of Sephardi or Mizrahi Jews living in Vienna. Sephardi Jews from Turkey had been present since the 1730s, and by 1867 eighty-five Sephardi families were recorded.

Other examples of this type have either semicircular or straight oil rows.

HALLMARK: Neuwirth, pl. 4:6. MAKER'S MARK: "JOWANOV" in oval field. DATE OF ACQUISITION: 1953. SIMILAR LAMPS: The Jewish Museum, nos. 306 and 307 in the catalogue raisonné; Abraham Halpern Collection, New York.

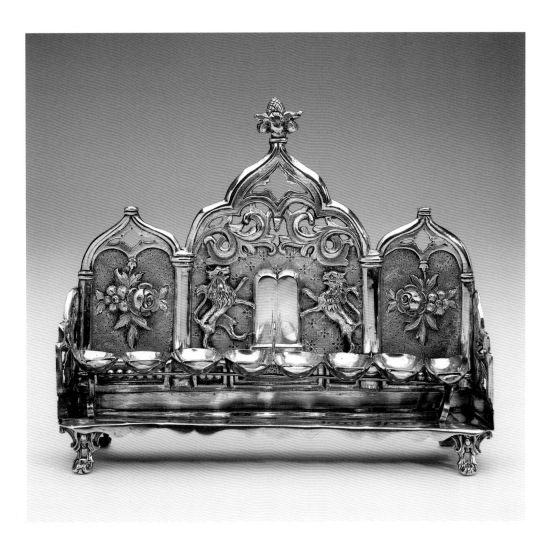

38

C. Schmidtbauer(?)
(active 1824–1870s?)
Vienna, 1870s
Silver: repoussé, pierced, and
cast appliqué; 7⅞ x 9⅝ x 2⅜ in.
(20 x 24.4 x 6 cm)
Gift of Dr. Harry G. Friedman,
F 981

The backplate of this lamp is in the form of a Gothic triple arch. The revival of a number of styles of past eras, from classical to rococo, was quite popular in the nineteenth century, and decorative arts objects in neo-Gothic style began to appear in the 1820s. The height of production occurred in the 1860s, around the time this lamp was created (Glanville, p. 58).

The use of the Gothic style, with its strong associations to Christian churches, was an unusual choice for a Jewish ceremonial object. However, a number of European synagogues during the nineteenth century were built with Gothicizing elements, including the pointed windows and arches as well as the openwork tracery seen here. This might have been a result of the desire on the part of the Jewish community to blend in with their Christian neighbors during a period of inner and outer pressure to assimilate. Jewish architects condoned the practice, explaining that since synagogues of the medieval period were in the style of their time, it was legitimate in a period of architectural historicization to revive the Gothic style for a synagogue. In addition, some argued that the Gothic style expressed like no other the spiritual aspirations of humankind (Krinsky, p. 86).

The maker's mark CS has been tentatively identified as that of C. Schmidtbauer, whose mark appears to have been in use from the 1820s to the 1870s (see other works by CS listed below).

HALLMARK: Neuwirth, pl. 7:3. MAKER'S MARK: Reitzner 1474. DATE OF ACQUISITION: 1942. SIMILAR LAMPS: The Jewish Museum, F 3292, and nos. 310–12 in the catalogue raisonné. OTHER WORKS BY CS: Max Berger Collection, Vienna (Häusler, no. 434); Skirball Cultural Center (Jüdisches Museum Frankfurt, no. 3).

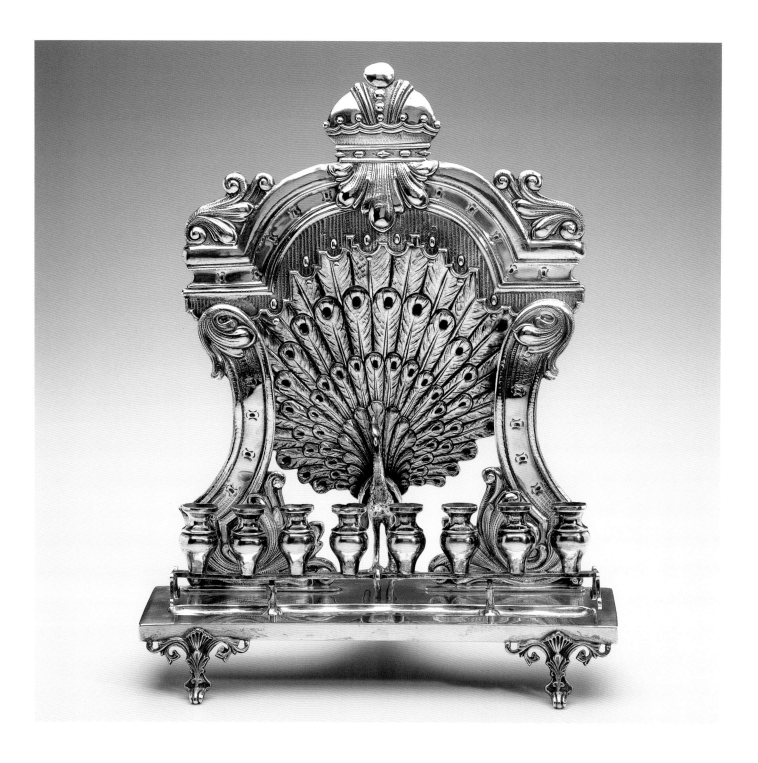

39

Josef Kohn

Vienna, 1872–1921

Silver: repoussé, traced, punched,
and cast; 12¹³⁄₁₆ x 10⅛ x 5¼ in.
(32.5 x 25.7 x 13.3 cm)

Gift of Dr. Harry G. Friedman,
F 474

A unique group of Austrian lamps, produced in the late nineteenth through early twentieth century, bears a three-dimensional figure of a peacock set within a frame, as if on the stage. The significance of the peacock in this context is unclear. The bird, with its spectacular coloring and magnificent tail, has taken on a variety of meanings throughout the ages and in different cultures. In antiquity it was a symbol of immortality and resurrection, while for Christians the eyes on the tail were seen as an emblem of the omniscience of God and the church. In many cultures the peacock is a symbol of beauty, the soul, and even of light. While the last named association seems most appropriate for a Hanukkah lamp, and one can imagine how beautifully the Hanukkah lights would reflect in the peacock's spread tail, it is difficult to determine whether this was the artist's intention.

HALLMARKS: Neuwirth, pls. 7:3 and 7:10. MAKER'S MARK: Neuwirth 1208. SIMILAR LAMPS: The Jewish Museum, F 96, and nos. 308 and 309 in the catalogue raisonné.

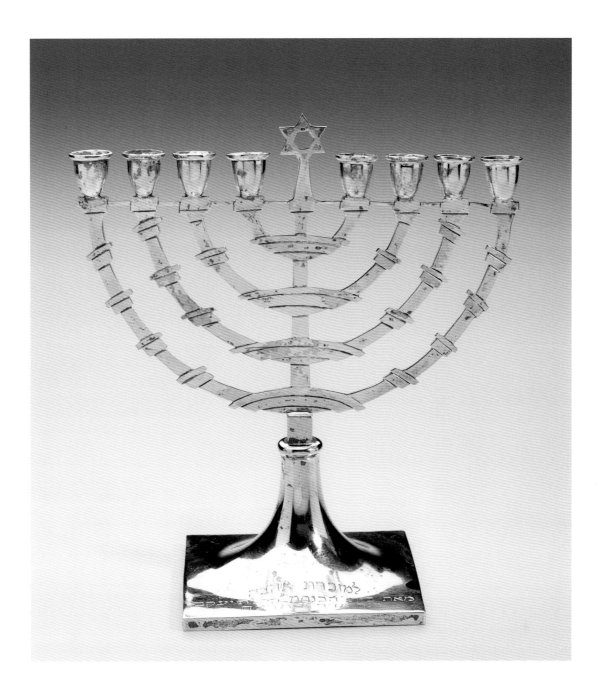

40

Maker: J and H
Vienna, inscription date 1935
Silver: engraved; 8¼ x 8⅛ x 4³⁄₁₆ in.
(21 x 20.6 x 10.7 cm)
Gift of Dr. Harry G. Friedman (?),
F 3150

HEBREW INSCRIPTION: / למזכרת אהבה
מאת בית הכנסת קהלת יעקב / וינה
אדר א' תרצה

A token of affection from the synagogue
Kahilath Jakob, Vienna, the first of Adar
[5]695 [=1935]

The modern design for this lamp consists of two sets of intersecting semicircles, one curving upward, and the other, in broken segments, curving down. Although it seems to be based in the design principles of such movements as the Bauhaus in Germany, which emphasized polished surfaces with little ornamentation as well as geometric forms, the concept was actually developed several decades earlier.

It was first employed by the artist E. M. Lilien in the cover he created for the Zionist journal *Ost und West* in 1901. His design consisted of a pattern of seven-branch menorot, in similar form to this lamp, and Stars of David, both of which had been adopted as emblems of the Zionist movement. *Ost und West* continued in publication for several decades, and it is possible that it served as an inspiration for the creators of this lamp.

Kahilath Jakob was a small prayer room located at Judengasse 11 in Vienna. The recipient of this lamp had only a few years to enjoy it before the disruptions of World War II. The synagogue was one of a few of the sixty-odd Jewish houses of worship in Vienna to survive the war.

HALLMARK: Neuwirth, pl. 8:4. MAKER'S MARK: "JxH" in rectangle. DATE OF ACQUISITION: between 1939 and 1941.

ITALY

The Italian Jewish community is the oldest in Europe; it was founded by immigrants and slaves brought from ancient Israel by Roman conquerors beginning around the first century B.C.E. Over the millennia, the Jews were subject to frequent expulsions from different regions of Italy, yet the diverse Jewish community maintained a rich cultural and spiritual life. The original population from ancient Israel was joined in the early fourteenth century by German and French Jews of Ashkenazi tradition fleeing persecution, and in the late fifteenth century by Spanish and Portuguese exiles. Communities of Levantine Jews from the eastern Mediterranean settled in Italy as well.

The Hanukkah lamps in the collection date primarily to the eighteenth and nineteenth centuries. This period began in the era of the Ghetto (c. 1555–1800), when Jews were forced to live in concentrated areas and were restricted in their movements and occupations. It continued into the period of emancipation as Jews struggled for full rights, linking their plight with that of the Italian fight for national unity that was achieved in 1861. The gradual easing of restrictions even before full emancipation led to widespread Jewish integration into Italian political and social life in the nineteenth century, with considerable numbers of Jews assimilating or converting to Christianity. The large quantity of Hanukkah lamps from this period is therefore a testament to the continued popularity of this holiday in Italy.

The vast majority of Hanukkah lamps from Italy were wall-hung bench types. This probably reflects Sephardi preference; the few found with legs may have been used by Ashkenazi families who maintained the traditions of their original homeland. For example, a table lamp in the Italian Synagogue in Jerusalem has the initials of an Abraham Ashkenazi, suggesting the Germanic origins of the owner (Nahon, p. 191; see Bialer and Fink, p. 160 center, right, for another example). A few menorah-form types are known as well, mainly for synagogue use. Early examples include a fifteenth- or sixteenth-century copper-alloy lamp and a seventeenth-century silver lamp, both in the Padua synagogue (fig. 15; M. Narkiss, no. 183).

SILVER LAMPS

Beautiful silver repoussé examples are known from the late seventeenth and eighteenth centuries. This chronological distribution coincides with the era when Italian silversmiths were importing cheaper silver from Mexico. Silver objects, once affordable only by the church and the wealthiest individuals, became obtainable by other classes (Lazar, p. 66). The ornamentation on these lamps is Baroque or Rococo in style, consisting of thick scroll-work frames, shells, and floral motifs. There is evidence that some of the silver hanging lamps were used in synagogues. The inscription on a late-eighteenth-century lamp in the collection (no. 45), "Light to honor God," for example, most likely indicates that it was donated to a synagogue. Additionally, the congregation of the Livorno synagogue used to light a similar type of lamp on Hanukkah in the years before World War II (Toaff, pp. 90–91, fig. 5).

Detail of no. 46.

The question of whether Jews could have made these silver lamps is complex. Since Italy was divided into many different political units, the granting of permission for Jews to engage in crafts varied from place to place and era to era. There are records of Renaissance Jewish gold- and silversmiths who were court jewelers in Ferrara and Naples, while at the same time Jews were prohibited from learning the trade of goldsmithing in fifteenth-century Venice (Roth 1964, pp. 195–96). Such a ban applied later to Rome and Mantua in the seventeenth through nineteenth century (Bunt, p. 135; Lazar, p. 67). By the eighteenth century, when the silver Hanukkah lamps became more common, Jews were practicing the gold- and silversmith's art in several areas, such as Florence, the Piedmont, Venice, and Rome. They were not always allowed to obtain a master's license, and thus were unable to mark their works (Bemporad 1989, pp. 122–23; Bemporad 1993a, p. 134; Wischnitzer, pp. 145–49).

CAST COPPER-ALLOY LAMPS

Italian cast lamps are primarily bench types, which can be divided into two distinct stylistic groups. The first has often elaborate relief decoration in Renaissance style, particularly of the sixteenth century. The second consists of flat openwork bands or scrollwork, sometimes in architectural form, without any surface decoration.

The type executed in relief is the more common. The sculptural quality and the motifs on the backplates reflect the Renaissance fascination with Greek and Roman antiquity, which was just then being revealed through archaeological excavations. Classical myths, fantastic creatures such as centaurs and satyrs, as well as decorative motifs found on the walls and vessels of ancient villas all became popular subjects. They inspired the creation of small bronze statuettes and similarly ornamented utilitarian objects such as inkstands, writing caskets, and doorknockers. These classical motifs were all represented in the backplates of Italian Hanukkah lamps. Several examples illustrate the Greek myth of the Judgment of Paris, in which Paris is asked to choose which of three goddesses is the fairest (no. 46). Other lamps incorporated sea-dwelling Tritons or centaurs, as well as putti, classical masks, and urns (see nos. 329 and 332 in the catalogue raisonné). The only Jewish motifs represented are those of biblical figures, particularly Judith, whose heroic act in slaying an enemy general took on various Jewish, Christian, and secular symbolism. Her representation on Italian Renaissance lamps may have been partly due to Judith's popularity as a symbol of civic virtue in the fight against the corrupt nobility. While the style and iconography of the backplates on these Renaissance-type Hanukkah lamps relate to other decorative art pieces of the period, differences in their size and shape would seem to indicate that the majority were designed specifically to be Hanukkah lamps.

A number of Jews of the late medieval period and early Renaissance achieved financial success with small loan banks, and thus had the means to adorn their homes with the decorative bronze objects that became so popular. Jewish patronage is evident in the Hanukkah

lamps, mortars with Hebrew inscriptions, and Jewish medals of Renaissance date. Jews also participated in bronze production, as exemplified by the works of Joseph de Levis of Verona (1552–1611/14) and his sons and nephews, although sometimes success as an artist came with the price of abandoning Judaism (Mann 1989a, pp. 50–55).

Although the Renaissance-type Hanukkah lamps in the collection are in styles current in the sixteenth century, all but one (no. 41) were produced centuries after the Renaissance, possibly as late as the nineteenth century. The primary means of creating sculptural bronzes in Renaissance Italy was through lost-wax casting. In this method, a wax model is created, encased in a matrix, and melted when the molten metal is poured into the mold. However, many of the extant Italian cast Hanukkah lamps were not lost-wax cast, but rather sand cast after a lost-wax model. These were produced by pressing a metal model into damp clay to make a mold, removing it, and filling the resulting cavity with molten metal. The sand-cast versions exhibit lower relief, loss of design elements through repeated casting, little or no surface chasing, and poor finishing. The reverse sides of the relief decoration are mostly concave, which can be the result of using lost-wax-cast pieces as models. According to Metropolitan Museum of Art conservator Richard Stone, sand casting of small sculpture was not common in Italy until probably the nineteenth century. The date of sand casting in Italy can be pushed back into the eighteenth century at least, based on an example in the collection with an inscription date of 1747/48 (no. 323 in the catalogue raisonné). The iconography on some of the lamps is not quite authentically Renaissance, and it is therefore likely that most of these sand-cast lamps date from the nineteenth century and the period of Renaissance revival (Schoenberger 1937, p. 7; Mann 1989b, p. 50; Bemporad 1989, p. 128; Clare Vincent, Metropolitan Museum of Art, personal communication).

The second type of cast Italian lamp has a completely different type of imagery and surface decoration from the sculptural, Renaissance-style lamps. This group is characterized by flat surfaces, elaborate open scrollwork, and the complete absence of surface ornamentation (e.g., no. 47). These are similar to the techniques found in eastern Europe and in some Dutch and Moroccan lamps (see nos. 4 and 75). This group of lamps has traditionally been attributed to Italy because they are hanging lamps, and because the oil wells are in Italianate form: round bowls with long spouts.

SHEET COPPER-ALLOY LAMPS

A second metalwork tradition, that of sheet metal, is also common for Italian bench copper-alloy lamps. Most often an undecorated sheet of metal is framed by cast arches or pediments, sometimes with applied cast elements in the center such as the seven-branch candelabrum of the Temple. The menorah is often depicted in the form described in the prophet Zechariah's vision, incorporating seven lamps or bowls and flanked by two olive trees, a version that is unique to Italy (see no. 44).

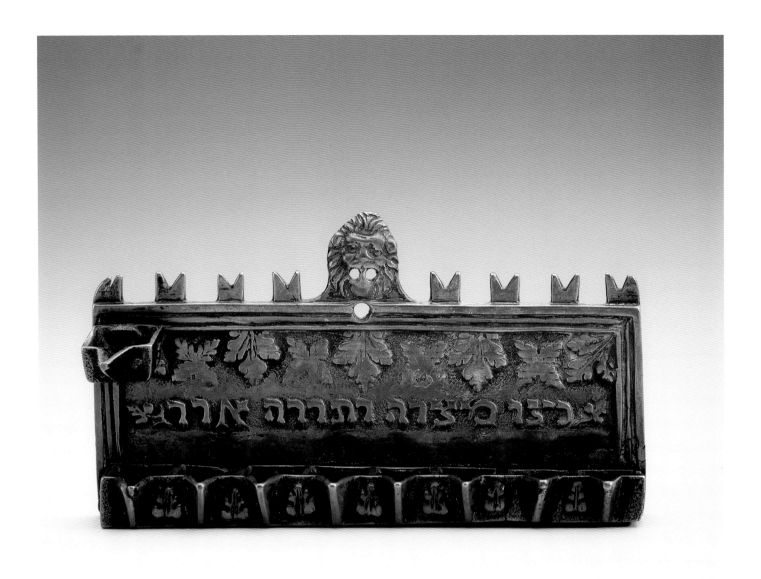

41

Italy, 16th century

Copper alloy: lost-wax cast; 4½ x
8⁷⁄₁₆ x 2¹⁄₁₆ in. (11.5 x 20.8 x 5.2 cm)
Gift of the Mr. and Mrs. Albert A. List
Family, JM 100-73

HEBREW INSCRIPTION: "For the com-
mandment is a lamp, and the teaching
is light" (Proverbs 6:23)

This lamp is made from the lost-wax process and therefore probably dates to the Renais-
sance. The crenellations across the top were derived from medieval architecture, seen, for
example, in the fourteenth-century Palazzo Vecchio in Florence. Their use on Hanukkah
lamps goes back at least to the fifteenth century, when they were depicted on a lamp in
an Italian Hebrew manuscript (see fig. 12).

A similar backplate form, with its rectangular shape and crenellations above, is found
on other Italian Hanukkah lamps with different imagery. One type is decorated with a
scene of two centaurs carrying off nymphs, and represents a copy of a writing box
plaque from Padua dated around 1500, to which the crenellations were added (Wixom,
no. 76). This suggests that a few Italian backplates may have been cast from parts of secu-
lar objects, or else copied from them. However, it is not clear when these lamps were
made, and as extant examples are poor castings, they may have been produced consider-
ably after the Renaissance.

PROVENANCE: Joseph B. and Olyn Horwitz Collection, Cleveland, c. 1950–70; purchased from Moriah Artcraft, New York,
c. 1973. BIBLIOGRAPHY: B'nai B'rith Klutznick Museum, no. 44. SIMILAR LAMPS WITH GRAPES: Skirball Cultural Center, acc.
no. 27.22; Musée Historique Louvain, Nancy (Sigal, p. 51 bottom); Sotheby's TA 1998b, lot 23. LAMPS WITH CENTAURS:
Israel Museum (Benjamin 1987, no. 126); Musée de Cluny (Klagsbald 1982, no. 19).

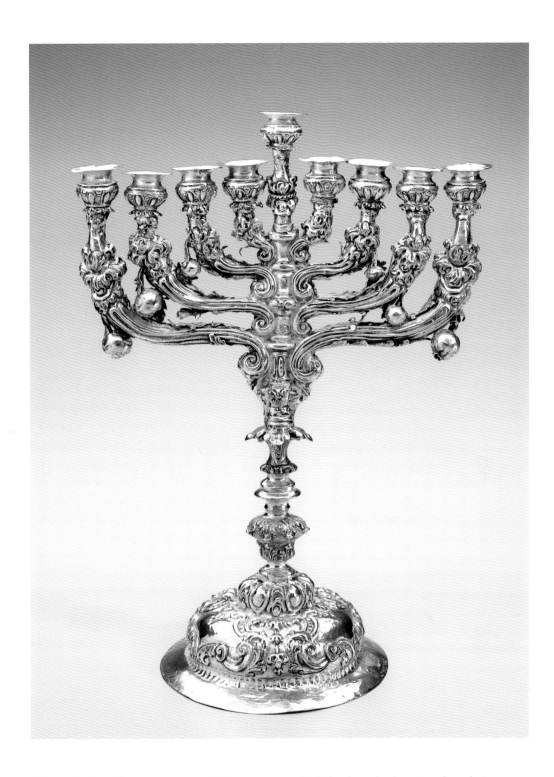

42

Maker: GI
Venice, 1712–49
Silver: mold-pressed,
repoussé, appliqué, and cast;
12¹¹⁄₁₆ x 9¹⁵⁄₁₆ x 5⁷⁄₁₆ in.
(32.2 x 25.3 x 13.8 cm)
Gift of Dr. Harry G. Friedman (?),
F 3579

Menorah-form lamps were much less common in Italy than the hanging bench types. Small lamps such as this were in use in synagogues, in contrast to the massive copper-alloy Hanukkah lamps seen in northern and eastern Europe (Fortis, p. 89). This Baroque-style silver lamp combines the traditional, labor-intensive method of repoussé in the base with a less expensive technique used for the arms. In repoussé, the silversmith hammers out, freehand, a raised design from the back. The arms on this lamp, however, were made in two separate pieces, a front and a back, which were hammered into a mold. The joints between the two halves were disguised by the application of leaves (Richard Stone, Metropolitan Museum of Art, personal communication). These were the first steps toward the die-stamping and factory production of the nineteenth century.

HALLMARKS: Pazzi, no. 245, and cf. no. 330. MAKER'S MARK: "GI" in oval with pinched sides. SIMILAR LAMP: Venice Jewish Community (Milano, no. 25).

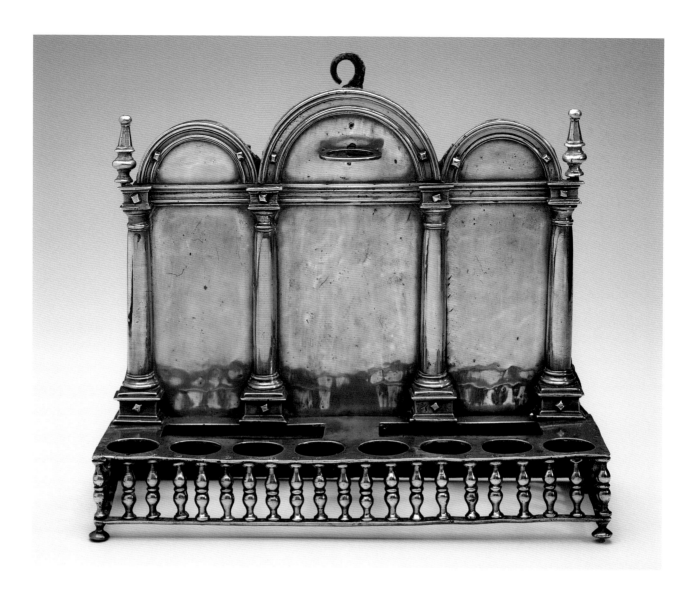

43

Italy, 18th century (?)

Copper alloy: sheet metal,
appliqué, and cast; wood; iron;

14⅛ x 16¼ x 5½ in.

(35.9 x 41.3 x 14 cm)

Gift of Dr. Harry G. Friedman,

F 2125

This lamp is the finest and most elaborate example of a group in the form of round arches supported by columns. These architectural elements are cast and applied to a backplate of sheet metal. The round arch originated in ancient Greek architecture; during the Renaissance, Filippo Brunelleschi revived the principles of classical architecture. The balustrade on the bench of the lamp, which would have held the oil containers, is also in Renaissance style.

The inspiration for the use of this architectural form on a Hanukkah lamp could possibly have been the Renaissance tabernacle frame. These wooden frames, consisting of a round arch supported by elaborate columns, were designed to hold religious images for private devotion, particularly in the fifteenth century (Newbery, Bisacca, and Kanter, p. 24, nos. 7–10). Instead of icons, the arches on the earliest versions of wall-hung Hanukkah lamps have only plain reflective sheets of metal.

The round arch continued to be used in buildings more or less through the nineteenth century, and so it is often difficult to determine the date of the lamps from architectural comparison alone. The examples in the collection all have sand-cast arches and columns, suggesting post-Renaissance dates, perhaps as early as the eighteenth century, when at least one sand-cast lamp in Italian style is known (see no. 323 in the catalogue raisonné).

PROVENANCE: purchased from R. Stora in 1948. BIBLIOGRAPHY: Kayser and Schoenberger, no. 123; Kleeblatt and Mann, pp. 66–67; Mann 1989b, no. 185. RELATED LAMPS: The Jewish Museum, nos. 338 and 339 in the catalogue raisonné.

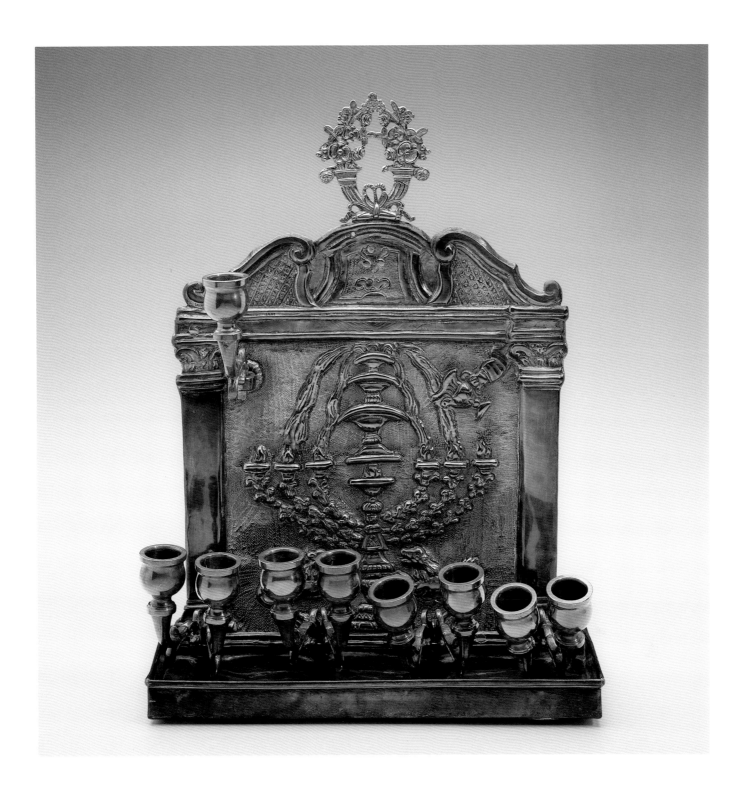

44

Italy, 18th century with
later additions

Copper alloy: repoussé,
traced, punched, and cast;
14⅜ x 10⅞ x 4¾ in.
(36.5 x 27.6 x 12.1 cm)

Gift of Dr. Harry G. Friedman,
F 2663

The central image on this repoussé lamp refers to one of the visions seen by the prophet Zechariah. His biblical book, written near the end of the Israelites' period of exile in Babylon, is filled with prophecies of the restoration of Judah and Jerusalem, the purification of the people, and the coming of the messianic age. It is read in synagogue on the Sabbath before Hanukkah. In the fifth vision, Zechariah sees a "lampstand all of gold, with a bowl on top of it, and its seven lamps thereon; there are seven pipes, yea, seven, to the lamps, which are upon the top thereof; and two olive-trees by it, one upon the right side of the bowl, and the other upon the left side thereof" (Zechariah 4:2–3). God tells Zechariah that the lampstand represented His word that the Israelites will prevail by divine spirit, and not by might, possibly a reference to the rebuilding of the Temple. The olive trees symbolize "the two anointed ones, that stand by the Lord of the

whole earth" (Zechariah 4:14), that is, Joshua and Zerubbabel, the high priest and the king at the time.

This vision has been interpreted in several ways on Italian Hanukkah lamps. Here, three bowls were placed one above the other, creating a fountain from which the oil flows into the containers. Other examples depict the two olive trees as well. The representation of an arm emerging from a cloud and pouring oil from a pitcher is a reference to the miracle of the jar of oil that burned for eight days. The hand therefore symbolizes the divine assistance rendered to the Maccabees and the people of Israel, and perhaps the divine spirit that will rebuild the Temple.

The architectural frame on this and similar lamps consists of a scrolled, broken pediment, usually with a scallop-shell finial. These elements, combined with the lattice pattern on the pediment, indicate a date in the first half of the eighteenth century for this lamp. The cornucopia finial and the candleholders are probably later additions (see no. 339 in the catalogue raisonné).

DATE OF ACQUISITION: 1950. SIMILAR LAMPS: The Jewish Museum, F 4204, F 3078, F 3439, and F 3500 (the latter a cast nineteenth-century version); Nauheim Collection, Frankfurt (M. Narkiss, no. 135).

Maker: GB

Florence (?), 1781–1800;
additions 1832–72

Silver: repoussé, engraved,
punched, and die-stamped;
wood; copper alloy;

23¼ x 28 x 4¾ in.

(59.7 x 71.2 x 12.1 cm)

The H. Ephraim and Mordecai
Benguiat Family Collection, S 262

HEBREW INSCRIPTIONS: On lamp:

נר לכבוד ה' / יוסף בר משה /
קאמפאניאנו י'צו

Light to honor God; Yosef son of Moshe
Campagnano M[ay God protect] h[im
and] p[reserve him]

On cartouches above:

פתוחי / חתם / קדש / ל'ה

"Like the engravings of a signet: Holy
to the Lord" [Exodus 28:36]

On frame above: Three blessings on kin-
dling the lights

This lamp is composed of disparate elements, probably made at different times. The orig-
inal part is the backplate and nine candleholders, which was later mounted in a wooden
frame. The drip pan was probably added then, as were the four inscribed cartouches
across the top. The practice of adding parts or reworking ceremonial objects was appar-
ently quite common in Italy (Bemporad 1993a, pp. 115–16).

The backplate is stamped with the maker's initials, but no city mark. It is likely that
it was made in Florence, since there is a Florence mark on the later drip pan. Made in
rococo style, with its C-scrolls, rocaille elements, and flowers, the lamp itself could date
from around 1750 to 1770. However, the absence of a city mark suggests that it was
made after 1781, when it was decreed that objects with a silver content below required
standards could not receive the mint mark (Mann 1989b, no. 191). Such conservatism in
decorative style is common in Italian Judaica, where the rococo style of the 1750s was
continued several decades after its heyday (Bemporad 1993b, p. 134).

The inscriptions include the words "Light to honor God" and "Holy to the Lord,"
which suggests that the lamp was dedicated to a synagogue. The donation was made by
Yosef Campagnano, whose name is inscribed in the central shield. It is possible that this
is the Giuseppe (Yosef in Hebrew) Vittorio Campagnano whose son gave a coral Torah
pointer to the Italian Synagogue of Florence in 1847 (Bemporad 1993a, p. 135). This
could be further evidence for the Florentine origin of the lamp.

The drip pan is marked with a stamp used by the city of Florence between 1832
and 1872. It is quite distinct in style from the backplate and was clearly made at a later
date. Similarly, the four cartouches across the top, which are rococo in style, have com-
pletely different scrollwork from the lamp and were therefore not part of the original
commission. All three elements were mounted to a wooden frame in nineteenth-century
neoclassical style, at which time the upper plaque with the three blessings for kindling
the lights was added.

HALLMARK: Bemporad 1993a, no. 48. MAKER'S MARK: "GB" in rectangle (on backplate). DATE OF ACQUISITION: 1925. SIMI-
LAR LAMPS: Jewish Community of Florence (Mann 1989b, no. 191); Mr. and Mrs. Michael M. Zagayski Collection (Schoen-
berger and Freudenheim, no. 122); Max Stern Collection, New York, acc. no. MS/H 534.

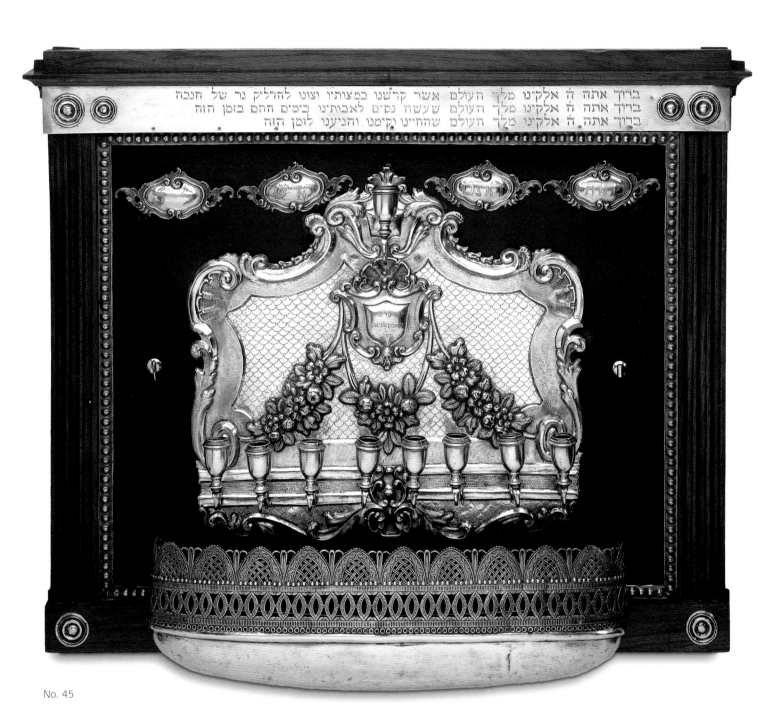

ברוך אתה ה׳ אלקינו מלך העולם אשר קדשנו במצותיו וצונו להדליק נר של חנכה
ברוך אתה ה׳ אלקינו מלך העולם שעשה נסים לאבותינו בימים ההם בזמן הזה
ברוך אתה ה׳ אלקינו מלך העולם שהחיינו וקימנו והגיענו לזמן הזה

No. 45

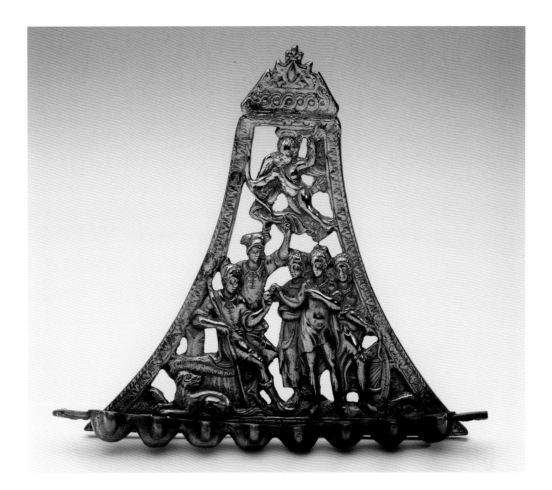

46

Italy, 18th–19th century (?)

Copper alloy: cast after lost-wax
original; 8¾ x 9½ x 2¹⁵⁄₁₆ in.
(22.2 x 24.1 x 7.5 cm)

Gift of Dr. Harry G. Friedman, F 5388

This unusually shaped lamp depicts the mythological scene of the Judgment of Paris. In this story, the shepherd Paris has been commanded by Zeus, through the god Hermes, to decide which of three goddesses is the fairest: Hera, Aphrodite, or Athena. The winner is to receive the golden apple of Eris, or Strife. Paris chooses beauty and love over wisdom and power, and hands the apple to Aphrodite. Later, under love's influence, Paris steals another man's wife, the beautiful Helen, thereby sparking the Trojan War. Paris is depicted on the lamp seated on the left with the god Hermes behind him. He has just handed the golden apple to Aphrodite.

The inclusion of the Judgment of Paris on a Hanukkah lamp is enigmatic and must be considered as purely decorative. The prototype of the backplate has been identified as the plaque on a German gunpowder box from the late sixteenth century (Eis 1977, p. 34; Benjamin 1987, p. 176). It is difficult to determine when the Hanukkah lamps were created; an antique plaque might have been used at any time to make sand-cast copies. The earliest publication of a lamp of this type occurred in 1903 with an example from the Guggenheim Collection, so the lamp type is probably at least as old as the turn of the twentieth century. The quality and height of the relief work on the Jewish Museum lamp, and the depth of the hollows on the reverse, suggest that the lamp is earlier than the Guggenheim lamp, and reasonably close to the lost-wax-cast model from which the backplate was derived. A second type of lamp with the same shape, presumably also derived from the plaque on a gunpowder box, depicts a scene of Greek warriors fighting over a suit of armor (Sotheby's NY 1986a, lot 427).

DATE OF ACQUISITION: 1963. SIMILAR LAMPS: Guggenheim Collection, Venice (Frauberger, fig. 46-53, bottom right); Israel Museum (Benjamin 1987, no. 133); Magnes Museum (Eis 1977, no. MC 15, p. 34); Joods Historisch Museum (Joods Historisch Museum, no. 54); Michael and Judy Steinhardt Collection, New York, acc. no. NY MJS 105; Jewish Museum Visual Resources Archive.

47

Italy(?), 18th–19th century(?)

Copper alloy: cast and hand-worked;
7¾ x 9⁵⁄₁₆ x 2¾ in. (19.7 x 23.3 x 7 cm)

The H. Ephraim and Mordecai Benguiat
Family Collection, S 113

In contrast to the sculptural Italian cast lamps with their Renaissance images of humans and mythical creatures, another group of cast lamps exhibits flat, unornamented surfaces and scrollwork designs. An Italian origin is suggested by the fact that the oil wells are Italianate in form: round bowls with long spouts. In addition, the one example of this type with provenance is located in a synagogue in Modena.

A variant of this type in the Wolfson Museum bears an inscription date of 1622/23, which appears to have been a late addition (Bialer and Fink, p. 160, center right).

DATE OF ACQUISITION: 1925. BIBLIOGRAPHY: Adler and Casanowicz 1899, no. 15; Adler and Casanowicz 1908, no. 113. SIMILAR LAMPS: The Jewish Museum, JM 14-54; Israel Museum (Benjamin 1987, no. 119; Landau, no. 25); Guggenheim Collection, Venice (Frauberger, fig. 54-61, center left); Jewish Community, Modena (Bondoni and Busi, no. 5.7:3); Skirball Cultural Center, acc. no. 27.10; Ticho Collection (M. Narkiss, no. 29); modern copy from Israel (Israel Export Institute, p. 73, left).

48

Italy, 19th century(?)

Copper alloy: cast and chased;

6 x 7⁷⁄₁₆ x 2⅜ in.

(15.3 x 18.9 x 6.1 cm)

Gift of Dr. Harry G. Friedman, F 3777

A number of Italian cast lamps bear a representation of the heroine Judith in a prominent position. Judith came to have varying symbolism over the millennia among both Jews and Christians. According to Leone di Modena, writing in the seventeenth century, Italian Jews honored her at Hanukkah because she was a Hasmonean descendant. Earlier, in Renaissance Florence, Judith took on a secular symbolism, becoming the embodiment of civic virtue and the struggle of the citizens of Florence against Medici rule. This was exemplified by Donatello's sculpture of her (fig. 21), on whose pedestal was the following inscription: "Kingdoms fall through Luxury, cities rise through virtues; behold the neck of Pride severed by the hand of humility" (Friedman, p. 236). The statue was eventually displayed in front of the city hall of Florence as a paradigm of the victory of the humble over the corruption of the mighty.

It is in this allegorical guise that Judith is depicted on Italian Hanukkah lamps. She wears not the sumptuous clothing described in the Bible, but a classical wrap of some kind that reveals much of her body. In one hand she raises a sword, in the other she holds the head of Holofernes. This form of representation became the standard iconography for depicting the courage of this heroine.

The issue of dating these cast Italian lamps is discussed in the chapter introduction. A date for this particular example can be based on that of a hybrid lamp in the collection whose lower half was cast from a related model (no. 328 in the catalogue raisonné). Instead of Judith, that lamp has two lions flanking a menorah, identical examples of which are found on eastern European lamps of nineteenth-century date.

DATE OF ACQUISITION: 1958. SIMILAR LAMPS: Ticho Collection (M. Narkiss, no. 28); Guggenheim Collection, Venice (Frauberger, fig. 46-53, upper left); Weinstein, no. 133. RELATED LAMP: The Jewish Museum, no. 327 in the catalogue raisonné.

Italy, late 19th–early
20th century

Copper alloy: cast; 35¹³⁄₁₆ x 25⅛ x
10⅜ in. (91 x 64.2 x 26.4 cm)

Gift of Dr. Harry G. Friedman, F 63

Occasionally, larger menorah-form lamps are found in Italian synagogues, for example, two in the Padua synagogue of the fifteenth to the seventeenth centuries (fig. 15; M. Narkiss, no. 183). This particular copper-alloy cast type is unusual in the floral decoration on the arms, in which sinuous flowers are placed between the arms rather than on them, and connect and even cover them.

The lamp appears to mix several different types, and an Italian origin is suggested by the only two other examples with provenance, both from Venice. One is in the Scuola Grande synagogue, and the other in the museum of the Jewish community. The flower brackets around the bottom of the shaft are reminiscent of eastern European Hanukkah lamps. However, the construction of this lamp is quite different from menorot from the east. Instead of the eastern European right-angled tenons that attach the arms and flowers to the shaft, this lamp uses screws and solder. Italian menorah-form lamps often have cups for oil placed on top of cylindrical sockets; these were included in the Jewish Museum lamp as well but were removed after its acquisition. The sinuous, Art Nouveau quality of the flowers and the method of assembly suggest a late-nineteenth- or early-twentieth-century date.

DATE OF ACQUISITION: between 1939 and 1941. SIMILAR LAMPS: The Jewish Museum, F 1407; Scuola Grande, Venice (Pinkerfeld, fig. 5); Venice, no. 11b; Parke-Bernet 1970, lot 47.

EASTERN EUROPE

The story of the Jews of eastern Europe, and of their Hanukkah lamps, is largely the story of Polish Jewry. Poland had originally consisted of an area similar to its current boundaries, plus Lithuania, and by the sixteenth century had expanded into the Ukraine and Belarus as well. Weakened by wars and invasions in the eighteenth century, Poland came under Russian domination, and between 1772 and 1795 the country was partitioned among three neighboring powers. Galicia went to Austria; Silesia, Poznan, and Pomerania to Prussia; and Lithuania, the Ukraine, and Belarus to Russia. The remaining part of Poland, called variously the Duchy of Warsaw and Congress Poland, eventually came under Russian control in 1815, and operated as a semiautonomous entity. The new Russian regions (with the exception of Congress Poland) became known as the Pale of Settlement, as Jews were confined to live within its borders and were not permitted to live in the rest of Russia. It was not until the 1860s, with Alexander II's attempts to assimilate the Jewish population into Russian society, that certain professional and wealthy Jews, including certified craftsmen, were allowed to live outside the Pale.

Before partition, Jews in Poland were frequently welcomed and protected by the nobles, who appreciated their skills as moneylenders, large-scale traders, and merchants, and often invited them to settle in their private towns. Conflicts did arise with the local populace, which occasionally erupted in violence against the community. In the Pale under Russian rule, Jews became a middle class mediating between the aristocracy and landed gentry on the one hand, and the peasantry on the other. They leased mills, inns, and forests, practiced crafts, and were merchants and peddlers. By the nineteenth century, a number had achieved great wealth from these activities, and as bankers and industrialists contributed considerably to the financial and commercial development of Russia. On the other hand, living as Jews was not easy; the tsars' efforts to eradicate their unique culture led to army conscription, the creation of secular schools, and expulsions from towns and villages to encourage their working the land as serfs. By the end of the nineteenth century, close to five million Jews lived in the Pale, the largest such community in the world. However, between 1881 and 1914, harsh conditions initiated by a series of government-sponsored pogroms caused some two million Jews to emigrate to the United States and Palestine.

Polish Jewish culture maintained its strength in the Pale, as well as in those former Polish regions under Austrian and Prussian control. The Hanukkah lamps that come from these regions date primarily to the eighteenth and nineteenth centuries, both before and after the partitions of Poland. The ambiguity or absence of marks or inscriptions on the earlier lamps often makes it difficult to determine whether they were made in Poland, Austria, Prussia, or Russia, and whether they were created before or after the partitions. The situation changes around the mid-nineteenth century, when more specific information on place and date can be derived from the marks on silver lamps produced primarily in Warsaw.

Two metalworking traditions are displayed in the eastern European bench and menorah-form lamps: one in silver and the other in cast copper alloy. Bench forms were, with

the exception of one type (see no. 50), provided with legs so they could stand. Two lamp types characteristic of eastern Europe are those made in silver filigree (see no. 57) and the heavy copper-alloy bench lamps that were extremely common. In addition, the lamps of this region are distinguished by their mixture of western European styles with motifs popular in eastern European folk art and architecture, especially those incorporating animals and birds. Strictly Jewish iconography is seen primarily in silver lamps shaped like Torah arks, possibly symbolizing the ark of the ancient Jerusalem Temple, as well as those with representations of seven-branch menorot, usually guarded by lions. These two motifs appear to have been employed in the eighteenth and nineteenth centuries. As in Austria, representations of lions flanking the Decalogue appeared in the later nineteenth and early twentieth centuries, and were popular on mass-produced silver-plated lamps.

SILVER LAMPS

Stylistically, the decoration on the silver lamps in the collection runs the gamut from realistic, masterful execution of plants and animals, to a more stylized, naïve representation (compare, e.g., no. 50 with nos. 55 and 58). The museum's lamps fall into two chronological categories. The first group was produced in the early nineteenth century or before, in centers outside of the capital, Warsaw. Many bear the Polish mark "12," which indicates the silver content of the metal in the Polish system, much as in the United States the word "sterling" indicates that the metal is 92.5% silver. The city and master marks that were required in Warsaw, the capital and silversmithing center of Poland, are absent on these lamps. The "12" assay mark can provide a key to the date and origin of individual lamps. It was in use in Poland before the partitions, and continued to be employed in Congress Poland until 1851, when the Russian assay mark of "84" (zlotys) was adopted. The "12" was also employed as an unofficial mark on lamps in the Pale of Settlement until the mid-nineteenth century, and overlapped with the Russian "84" mark, which began to appear there in the 1820s (Martyna, p. 176). The second chronological group in the collection consists of lamps made after 1850, most of them from Warsaw.

It is likely that most of these lamps were made by Jewish silversmiths, since Polish Jews had been granted freedom of economic activity as far back as the thirteenth century (Wischnitzer, p. 208). A 1548 census recorded 10,000 Jewish craftsmen, including goldsmiths and copper workers, and a census of 1857 in Congress Poland identified 533 Jewish goldsmiths outside of Warsaw (Wolf, p. 14). By the latter half of the sixteenth century, Jews were being granted the title of royal goldsmith and were invited by princes to work on their estates, and in the early seventeenth century they established their own gold- and silversmith guilds (Wischnitzer, pp. 214, 235; Kremer, p. 37). Much like their Christian counterparts, these served as religious and welfare associations, and each guild had its own synagogue, rabbi, and funds for the sick and needy.

CAST COPPER-ALLOY LAMPS

The largest component by far of the museum's Hanukkah lamp collection consists of cast copper-alloy lamps in bench form that were created in eastern Europe. Most likely brought to New York City by Jewish immigrants in the late nineteenth and early twentieth centuries, they were eventually disposed of by subsequent generations in thrift shops and antique stores, where they were purchased for the museum by Dr. Harry G. Friedman from the 1930s through 1960s. Such lamps were greatly treasured by their original owners and deemed worthy of bringing to America, since cast copper-alloy lighting devices were expensive and could only be afforded by wealthy and middle-class urban households (Zholtovskiy, p. 83).

An imaginative variety of decorative motifs and styles are exhibited on these cast lamps. Architectural forms, geometric shapes, deer, lions, and birds were variously combined with scrollwork, heraldic eagles, and seven-branch menorot to create a multitude of types and subtypes. Certain elements were apparently drawn from Ukrainian folk art, and P. M. Zholtovskiy, who has published extensively on Ukrainian brass-casting, suggests that these are more characteristic of the earliest styles (Zholtovskiy, pp. 94–95). For example, the series of rhomboids across the bottom of the backplate seen in no. 54 is based on designs in wooden sculpture, while pairs of snake heads like those on the backplate frame of no. 62 were also found on buckles. The guilloche pattern of joined ovals on the frontpiece of no. 51 is characteristic of western Ukrainian architecture of the second half of the eighteenth century, and the six-pointed rosette found on several lamps is a folk symbol of the sun (see no. 377 in the catalogue raisonné).

Eastern European cast bench lamps are composed of separate parts fitted together with tenons or screws: a backplate, the bench for the oil containers or candleholders, and sidepieces with feet for support. A unique feature of these lamps is the pair of candleholders that are placed on the sidepieces. While one clearly served as the *shamash*, the function of the second is unclear. Varying explanations have been proposed, including that it was a backup light in case the *shamash* was extinguished (B. Narkiss, 1997 lecture), or that it merely provided a sense of symmetry (Shachar 1981, p. 132).

The date and origin of these cast lamps has been difficult to determine, since none of them bear foundry marks and few have inscriptions that mention places or dates. Some types probably continued in production for a century or more, and the mixture of folk art and western European decorative art styles makes it difficult to date them stylistically, although Zholtovskiy had suggested that none were earlier than the eighteenth century (Zholtovskiy, p. 34).

Since these cast lamps are such an important component of the collection, an effort was made to determine more precisely when each was produced by studying features that may have changed over time. First, the backplates of the lamps were examined to see if they

represented successive casting generations and therefore different dates (see no. 51 for a discussion of this process). An analysis of lamps from successive generations indicated one clear marker of chronological evolution—the method used to assemble the parts. Earlier generations were put together using rectangular prongs called tenons that were inserted into a hole in the corresponding piece. Many times, a few of the square tenons had been converted into screws by tapping. In later lamps, the square tenons disappeared completely and only screws were used, probably because this was a more secure method of holding the parts together. When this transition occurred can be estimated from inscribed lamps with dates of 1796/97, 1823, and 1862, all of which used the tenon-and-screw method of assembly (Hoshen, no. 84; Balaban 1932, p. 359; and no. 380 in the catalogue raisonné). Thus, the use of all-tenon or tenon-and-screw construction should be broadly dated from the eighteenth century, by which time production apparently begins, to the first half of the nineteenth century. Lamps assembled with screws alone can be roughly dated from the mid-nineteenth until probably the early twentieth century.

With menorah-form cast lamps, there are more aids to determining the time and place of their production. Most of them were made for synagogues and a few bear dedicatory inscriptions that include dates. In addition, photographs of synagogue interiors document where lamps of different types were used. Finally, comparisons with the arms and candleholder shapes of hanging brass lamps from Europe with known dates and origins assist as well.

Lvov was the main center of brass-casting in Galicia, with its most important period of production being the fifteenth to seventeenth century (Zholtovskiy, p. 12). It is impossible to determine whether the numerous copper-alloy lamps from eastern Europe were produced in that city. However, several groups of lamps were systematically collected for museums in the regions of eastern Galicia and in Volhynia and Podolia in the western Ukraine, and thus these are suggested as the possible origins for the lamps in the collection (Hoshen, p. 51; Uritskaya, p. 24). Jews were prohibited, along with Ukrainians and Armenians, from joining the brass-casting guilds from around 1400, when Poland took over the western Ukraine. However, Jews appeared to have worked in the industry, although only one master's name is known, that of Barukh, who created a large lamp for his synagogue in Pohrebyshche, Ukraine (see fig. 3; Zholtovskiy, p. 13; Wischnitzer, p. 234).

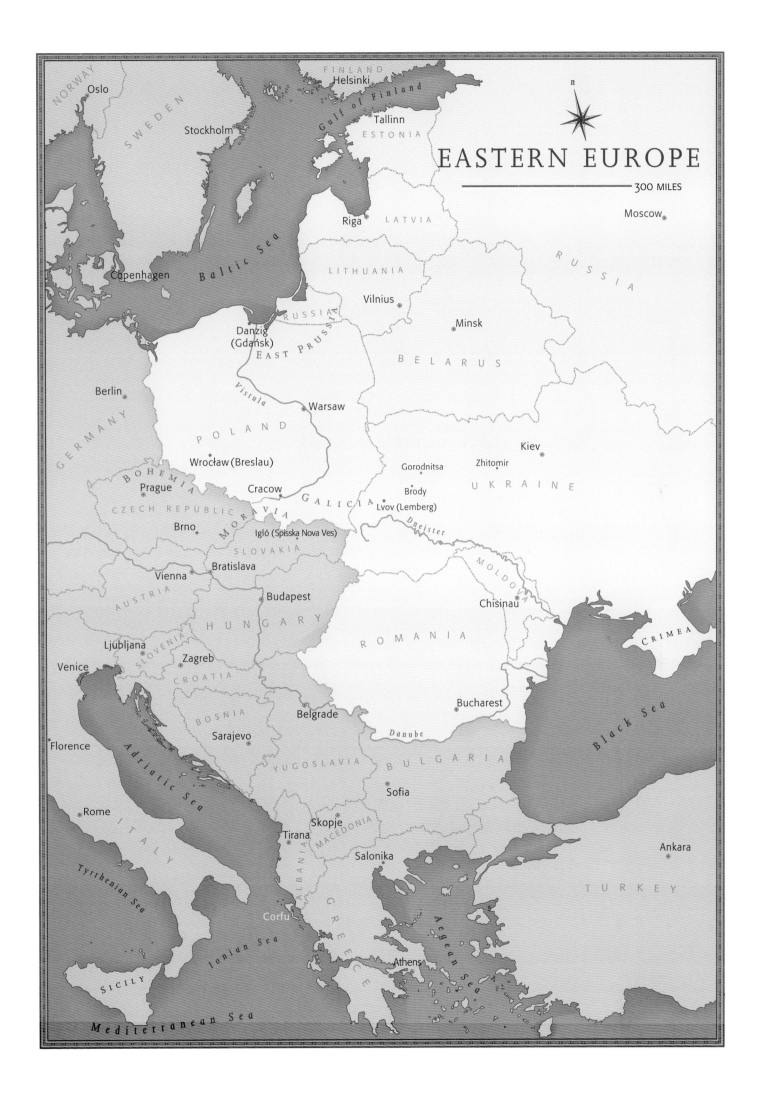

EASTERN EUROPE

n

300 MILES

NORWAY

Oslo

SWEDEN

Stockholm

Copenhagen

FINLAND

Helsinki

Gulf of Finland

Tallinn

ESTONIA

Riga

LATVIA

LITHUANIA

Vilnius

Minsk

BELARUS

Moscow

RUSSIA

Baltic Sea

RUSSIA

Danzig
(Gdańsk)

EAST PRUSSIA

Berlin

GERMANY

Vistula

Warsaw

POLAND

Kiev

Gorodnitsa

Zhitomir

Wrocław (Breslau)

BOHEMIA

Prague

Cracow

GALICIA

Brody

UKRAINE

CZECH REPUBLIC

Brno

MORAVIA

Lvov (Lemberg)

Igló (Spisska Nova Ves)

Dneister

SLOVAKIA

Bratislava

Vienna

AUSTRIA

Budapest

MOLDOVA

Chisinau

HUNGARY

Ljubljana

SLOVENIA

Zagreb

Venice

CROATIA

ROMANIA

Florence

Adriatic Sea

BOSNIA

Sarajevo

Belgrade

Bucharest

Danube

Black Sea

CRIMEA

ITALY

Rome

YUGOSLAVIA

BULGARIA

Sofia

Skopje

Tirana

MACEDONIA

Tyrrhenian Sea

ALBANIA

Salonika

Ankara

GREECE

TURKEY

Corfu

Ionian Sea

Aegean Sea

SICILY

Athens

Mediterranean Sea

50

Maker: ZK
Brody, 1787
Silver: repoussé, pierced,
appliqué, parcel-gilt, and cast;
copper alloy; 27⁷⁄₁₆ x 16¹⁵⁄₁₆ x 4½ in.
(69.7 x 43 x 11.4 cm)
The H. Ephraim and Mordecai
Benguiat Family Collection, S 260

The form and decoration of this tour de force of the silversmith's art are derived from those of the Torah arks of Polish synagogues of the eighteenth century (see fig. 20). Arks are wooden or stone structures designed to house the most sacred object in Judaism, the Torah (first five books of the Hebrew Bible). Those of eastern Europe were particularly ornate, consisting of multistoried structures ornamented with elaborate openwork wooden carving. Their style was related both to the European Baroque and Rococo, in their scrollwork and twisted columns, and to local folk art, in their profusion of animals and birds that filled the curling vines.

In this lamp, the ark has been rendered in pierced silver repoussé work that has been partly gilded, and mounted on a brass back, allowing for a lively contrast of gold and silver. A "balcony" under the ark doors supports the oil containers in the form of leaping lions. Below, the double-headed eagle of Austria proudly spreads its wings, as Brody was under Austrian rule when this lamp was made. The fact that it was designed to hang on the wall, rather than stand on feet, makes this lamp highly unusual for eastern Europe. Wall-hung Hanukkah lamps were more of a tradition of Sephardi and Mizrahi Jews of, respectively, Iberian and Middle Eastern origin. Jews did immigrate to Poland from many lands, including Spain and Italy in the fourteenth century, and a century later there was quite active trade between Jews of the Brody region and Venice, home of a Sephardi community. Thus, the hanging lamp may reflect the holdover of customs brought by immigrants and traders.

The Jews of Brody were granted the right to engage in all types of crafts in 1699, and by the eighteenth century Jewish metalsmiths were renowned for the quality of their work. The maker of this Hanukkah lamp is unrecorded, and could possibly have been Jewish.

Other lamps of this type were created in the same region of Galicia and date to the second half of the eighteenth century. Standing versions of the silver ark-shaped lamp appeared in the 1870s (see no. 343 in the catalogue raisonné), and twentieth-century imitations of the wall-hung lamps are known as well (see, e.g., a copy made in Peru, no. 96).

HALLMARKS: Lepszy 55; Tardy 1980, p. 207, top right (Paris import stamp). MAKER'S MARK: "B" over "ZK" in oval with arc above. PROVENANCE: in Paris between 1864 and 1893 (based on Paris import stamp); acquired in 1925. BIBLIOGRAPHY: Kleeblatt and Mann, pp. 110–11; Kayser and Schoenberger, no. 138. SIMILAR LAMPS: Israel Museum (Landau, no. 53); Myra Salomon Collection (Guttmann, pl. XV); Bendheim Collection, New York; Sotheby's TA 1998a, lot 138; Jewish Museum, London (Barnett, no. 242); Sotheby's TA 2001b, lot 314; Sotheby's TA 1999, lot 116; Consistoire, no. 423; O'Reilly's 1967b, lot 151; Schoenberger and Freudenheim, no. 133.

Eastern Galicia or western
Ukraine, second half 18th century

Copper alloy: cast; 11⅜ x 10 x 5½ in.
(28.9 x 25.4 x 14 cm)

Gift of Dr. Harry G. Friedman, F 2949

This lamp portrays two kneeling deer, their heads turned gracefully backward, their hooves touching an acanthus plant. Several of the decorative elements suggest an eighteenth-century date for this design scheme. Acanthus leaves became most popular in the Baroque period, while the oval frieze on the lower portion is characteristic of western Ukrainian architecture of the second half of the eighteenth century (Zholtovskiy, p. 95).

The museum owns eight examples of this type, which proved most beneficial when seeking to identify diagnostic traits that would establish the actual dates that each eastern European cast lamp was produced. The lamps were all made by sand casting, in which a model, often of wood or metal, is pressed into fine sand mixed with clay, then removed, and molten brass poured into the impression. The finished product will always be about one to two percent smaller than the model. When a model wears out, a casting from that model, which is smaller, is often used as the model for the next generation. One can therefore establish successive generations from a single or related model if one has identical cast pieces that are increasingly smaller than the largest version.

Using tracings of the backplates of each of the eight lamps, it was possible to establish several generations and observe changes in the way the pieces were constructed over time (see the chapter introduction). These helped establish a relative chronology, and aided by several dated examples, some idea of when all the lamps in the collection were created was obtained.

This lamp proved to be probably the earliest eastern European cast lamp in the museum's possession. Although now missing the upper portion, it is the largest in size and exhibits the finest execution, the most delicate openwork, and the greatest amount of casting detail of any of its type in the collection.

Two examples in the Museum of Ethnography and Crafts in Lvov suggest that the type was used in eastern Galicia.

INKED INSCRIPTION: "Br. 813. 11365 r." (on reverse). DATE OF ACQUISITION: 1952. SIMILAR LAMPS: The Jewish Museum, F 173, F 2948, F 178, F 2950, X 1963-18 (gift of Judge Max M. Korshak), and M 419 and no. 380 in the catalogue raisonné (dated 1862); Kantsedikas, unpag.; Zholtovskiy, p. 96.

52

Eastern Galicia or western
Ukraine, 18th–mid-19th century

Copper alloy: cast, traced, punched,
and appliqué; 12¹⁵⁄₁₆ x 12⅜ x 6 in.
(32.9 x 31.4 x 15.2 cm)

Gift of Dr. Harry G. Friedman, F 3032

It has always been presumed that this lamp and others like it, with their steeply pitched roofs and upper arcades, were imitations of eastern European wooden synagogues. These buildings had angled roofs of often elaborate and unusual forms (e.g., Piechotka and Piechotka, no. 3). However, the façades of many of these Hanukkah lamps are decorated with an incised stone- or brickwork pattern, and therefore they could not have been modeled after wooden structures. Moreover, the symmetrical arrangement of the columns, door, and window is not characteristic of the synagogues in question. In actuality, the architectural elements seem to have been derived from several different prototypes, combining west and east, rural and urban, brick and wood. The overhanging roofs supported by columns above the central door, and the arched gallery above, were characteristic features of wooden homes in Poland, for example, in the city of Cracow (Kalinowski and Klos, figs. 109–10). The distinctively shaped window above the doorway, which consists of an oval with two squared extensions, was characteristic of various eastern European log-built structures, including church belfries (Mokłowski, p. 485 and fig. 333:2; Chrzanowski and Piwocki, fig. 25). This kind of window is also found in a Jewish context, over the doors of a baroque-style Torah ark in the synagogue of Zamość in western Galicia (Fuks et al., p. 136). This was probably based on Baroque architectural models, in which oval windows were arranged above arched doors, as in the early eighteenth-century Belvedere Castle in Vienna (Blunt, fig. 270).

By contrast, the presence of birds, possibly storks, and the occasional snake on the roofs suggests an East European model. They may derive from the carved ridge poles of Polish/Russian wooden structures (Opolovnik and Opolovnika, figs. 4–5), or from Polish folklore. The stork was highly esteemed and believed to be a kindred spirit of humans. A household upon whose roof a pair of storks chose to nest was considered blessed with good fortune, and if a public building such as a church was chosen, the whole community shared in the good luck (Knab, p. 92).

In sum, it appears that these lamps may have been attempting to depict a Baroque structure, either a home or a synagogue, with elements added from local architecture, such as the overhanging roofs, galleries, and birds.

Only one dated example of this type has been published, and it is also the only example with a known provenance. It is a lamp from the synagogue of Buczaczu in Galicia and dated 1823. Further evidence of dating and origin of this type is present in the birds with their turned-back heads and pointed wings. These are quite similar to those on a cast hanging lamp from the Ukraine dated to the second half of the eighteenth century (Zholtovskiy, p. 90).

DATE OF ACQUISITION: 1952. BIBLIOGRAPHY: Kayser and Schoenberger, no. 136. SIMILAR LAMPS: The Jewish Museum, F 2486, M 399, F 3561, JM 48-61 (gift of Mr. and Mrs. Samuel Lemberg), F 2799, F 4123, and F 177 and no. 375 in the catalogue raisonné; Russian Ethnographic Museum (Beukers and Waale, p. 64, acc. nos. 5943-68 and 6802-2); Kantsedikas, p. 52; Lvov Museum of Ethnography and Crafts (Hoshen, no. 87); Buczaczu synagogue, Galicia (Balaban 1932, p. 359).

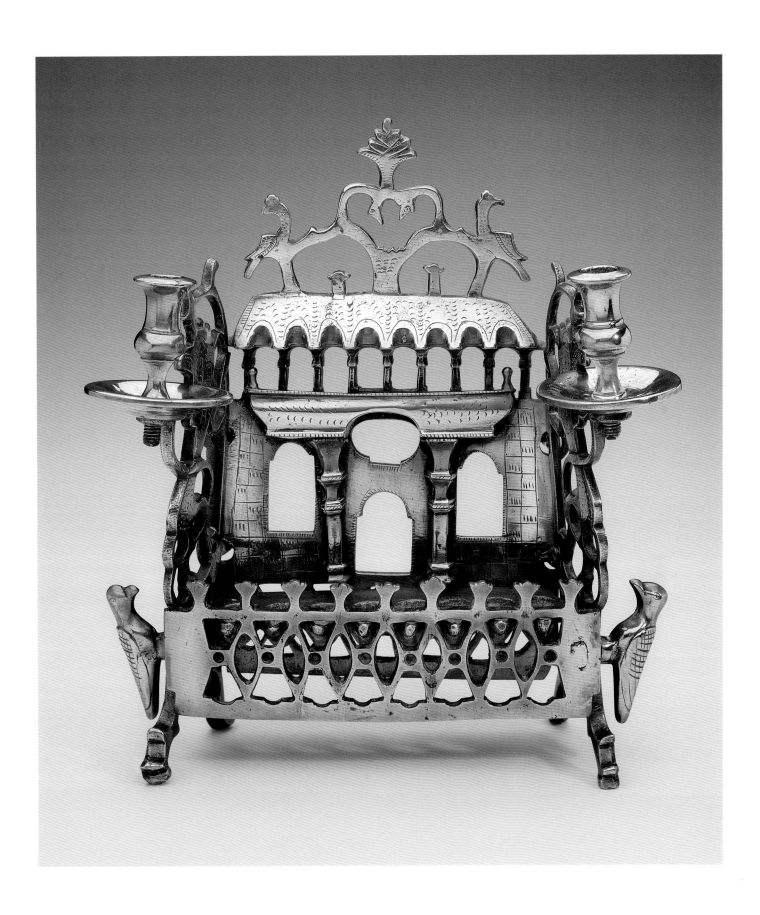

53

Eastern Europe(?),
18th–early 19th century
Copper alloy: cast and gilded;
44⁵⁄₁₆ x 37¹³⁄₁₆ x 20¹¹⁄₁₆ in.
(112.6 x 96.1 x 52.6 cm)
Gift of Dr. Harry G. Friedman,
F 3481

There was a tradition in Ashkenazi synagogues of placing a large menorah-form Hanuk-kah lamp near the Torah ark or reader's desk. Synagogues were perceived as small versions of the ancient Temple in Jerusalem, and the menorah served as a reminder of the lampstands that once flanked the entrance to the inner sanctuary (I Kings 7:49). The rabbis of the Talmudic period forbade exact replications of the Temple and its implements, but allowed a menorah as long as it did not have seven branches. Thus, Hanukkah menorot in synagogues had a dual function: to publicize the miracle to the congregation and travelers, and to remind them of the Temple.

The ornate scrolls, flowers, and lion feet on this lamp are characteristic of eastern European synagogue lamps and argue for an origin in that region. This example has beautifully designed arms with three-dimensional flowers that are part of the casting and were more difficult to execute than the attached flowers of many eastern European synagogue menorot. The copper alloy has been gilded, a method of surface treatment called ormolu. This was commonly employed in Europe and the United States from the seventeenth to mid-nineteenth century in order to prevent tarnish (Fennimore, p. 26).

DATE OF ACQUISITION: 1953. SIMILAR LAMP: Mira Salomon Collection (Guttmann, pl. XIV).

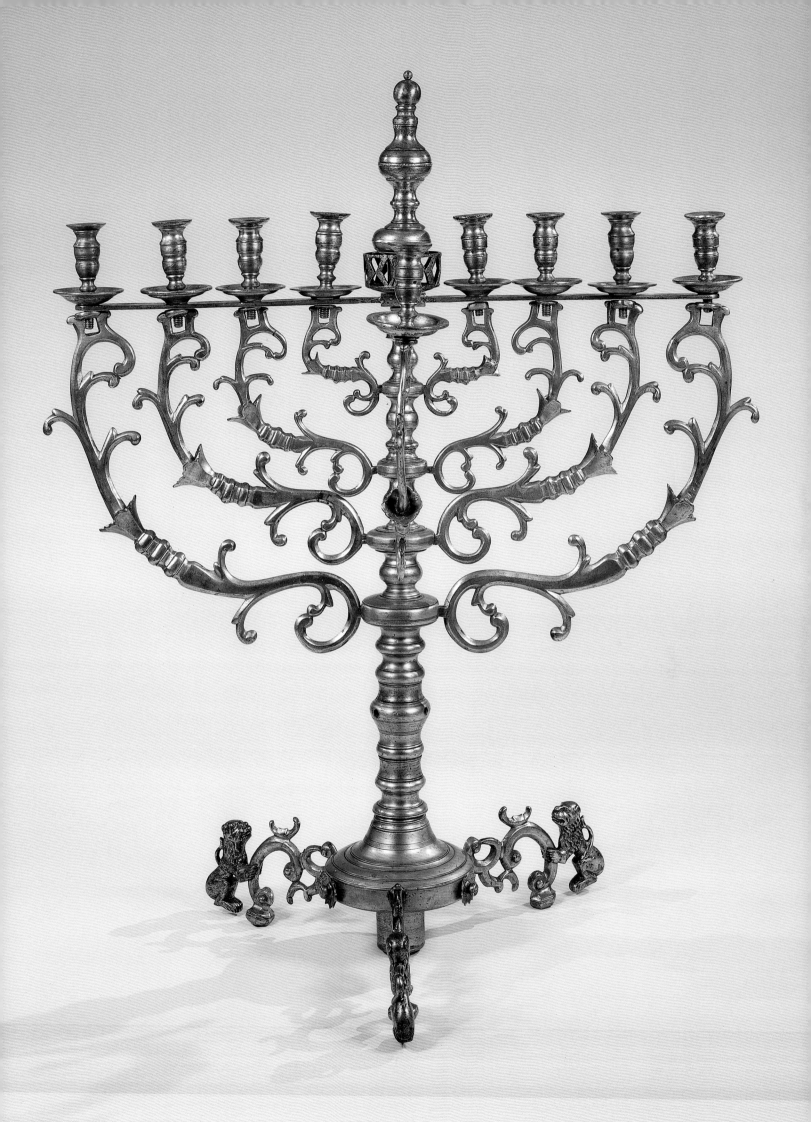

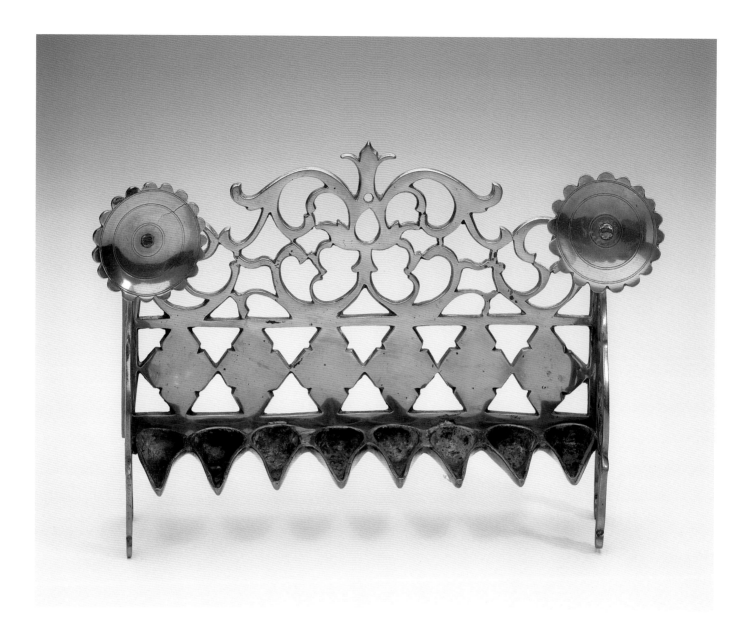

54

Eastern Galicia or western
Ukraine, 18th–mid-19th century
Copper alloy: cast; 8⅝ x 12⅞ x 3¼ in.
(21.9 x 32.7 x 8.3 cm)
Gift of Dr. Harry G. Friedman, F 3652

The designs on this backplate are a good illustration of the combination of west European decorative arts styles and Ukrainian folk motifs that characterizes cast Hanukkah lamps from eastern Europe. The elegant scrollwork on the upper portion of the lamp, topped by a fleur-de-lis, is suggestive of the baroque style, which originated in the design centers of western Europe. Across the bottom, however, is a series of rhomboids, which are completely atypical for western European metalwork. They have been compared to ornamentation found on Polish/Russian wooden sculpture (Zholtovskiy, pp. 94–95).

An unusual feature on this lamp type is the substitution of trumpet-shaped flowers for the two candleholders typically found on the sidepieces of eastern European lamps. These are reminiscent of the reflectors found on European hanging brass lamps of the seventeenth century, although they do not seem to be positioned in such a way that they could reflect the lights. Such flowers are also found around the bases of large cast menorah-form lamps from eastern Europe (see, e.g., no. 449 in the catalogue raisonné).

DATE OF ACQUISITION: 1957. SIMILAR LAMPS: The Jewish Museum, F 1638 and F 4394; Lvov Museum of Ethnography and Crafts (Kantsedikas, unpag.).

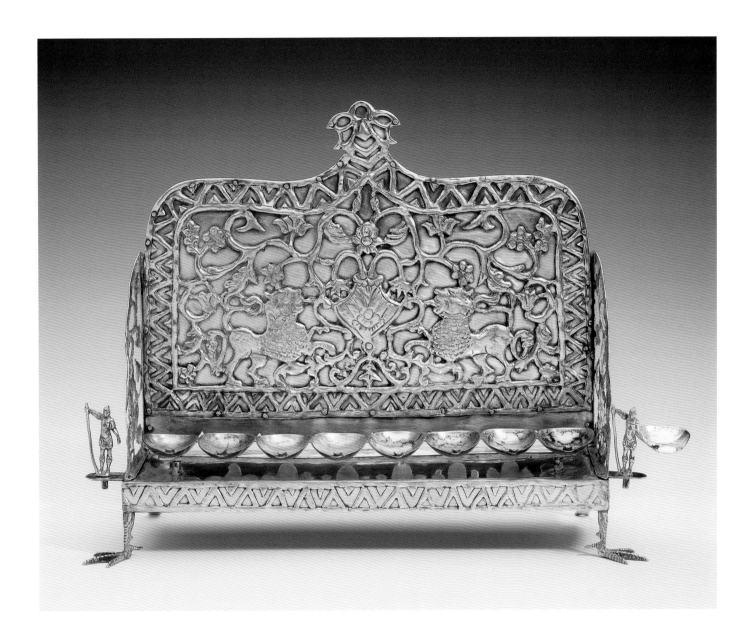

55

Poland or Russia, late
18th–early 19th century

Silver: pierced, repoussé,
appliqué, and cast;
8⅞ x 12½ x 4⅛ in.
(22.5 x 31.7 x 10.5 cm)

Gift of Dr. Harry G. Friedman,
F 5772

The backplate is executed in a lively, naïve style that is typical for eastern Europe. It consists of an openwork panel mounted on a solid backing, which is also characteristic of that region, as distinct from Austria and Germany, where the artists preferred to allow one to see through the openwork. Particularly amusing are the legs, which are in the shape of chicken feet.

The baroque character of the imagery, with its paired lions and flowering vines, suggests the piece might date to the eighteenth century, but such vinework continued later in eastern Europe, for example, in Torah shields dated to the first half of the nineteenth century (Grafman 1996, nos. 141, 143–44). A very similar lamp with marks helps establish the place and date of origin, since it bears the pre-1851 Polish assay mark "12."

PROVENANCE: Michael Kaufman Collection; purchased at Coleman Auction Galleries, 1965. BIBLIOGRAPHY: Coleman, lot 40. RELATED LAMPS: The Jewish Museum, nos. 347 and 348 in the catalogue raisonné; Jewish Museum, London (Barnett, no. 250); private collection, Chicago; O'Reilly's 1967a, lot 124.

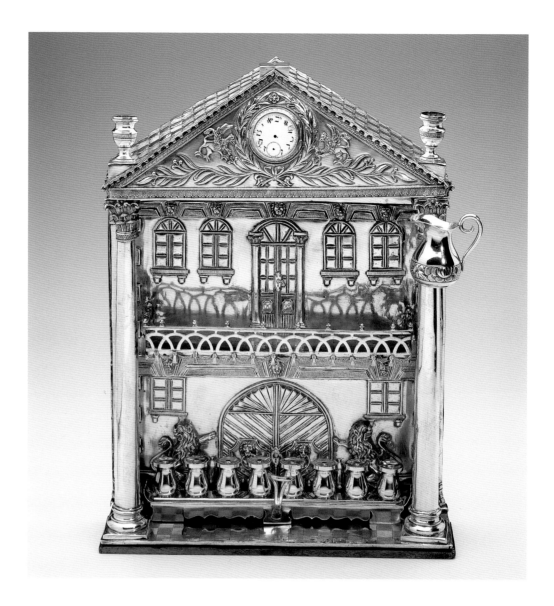

56

Poland or Russia,
early 19th century

Silver: repoussé, engraved, traced,
punched, pierced, appliqué, and cast;
wood; enamel; 16¹⁵/₁₆ x 14³/₁₆ x 3⁷/₁₆ in.
(43 x 36 x 9.1 cm)

Gift of Mr. and Mrs. Samuel Lemberg,
JM 3-53

This unusual lamp is in the form of an imposing two-story building with classical-style pediment and columns. The current oil row is a replacement; based on similar examples, the original oil containers, placed on the balcony, would have consisted of rampant lions.

By far the most fascinating feature on the lamp is the clock placed in the pediment, all the more distinctive because the numbers are rendered in Hebrew, which uses letters of the alphabet instead of numerals. The addition of the timepiece gives the building the appearance of a town hall, whose clock would strike the hours for all citizens to hear. Clocks are included on several other architectural-form Hanukkah lamps as well, most of which appear to come from eastern Europe. For example, a lamp said to have belonged to the rabbi of Trisk in the Ukraine was, by the time of its publication in 1928, in the possession of a Jew from Warsaw. Hanukkah lamps with timepieces may have been inspired by the elaborate table clocks that became popular in the early nineteenth century (Ottomeyer and Pröschel, pl. 45, nos. 6.1.2 and 6.1.3; Daniels and Markarian, no. 144). The owner could light the lamp on Hanukkah, and display it the rest of the year as a clock.

The origin and date of this lamp, which is not marked, can be determined by comparison to other lamps with similar elements. These include a lamp at the Skirball Cultural Center with an inscription date of 1813/14 that is almost certainly eastern European, and a second lamp sold at Christie's with a pre-1851 Polish assay mark.

DATE OF ACQUISITION: 1953. RELATED LAMPS: The Jewish Museum, no. 344 in the catalogue raisonné; Skirball Cultural Center (Berman 1979, fig. 1); Christie's Amsterdam 1988, lot 233. OTHER CLOCK LAMPS: Israel Museum (Landau, nos. 56 and 56.1).

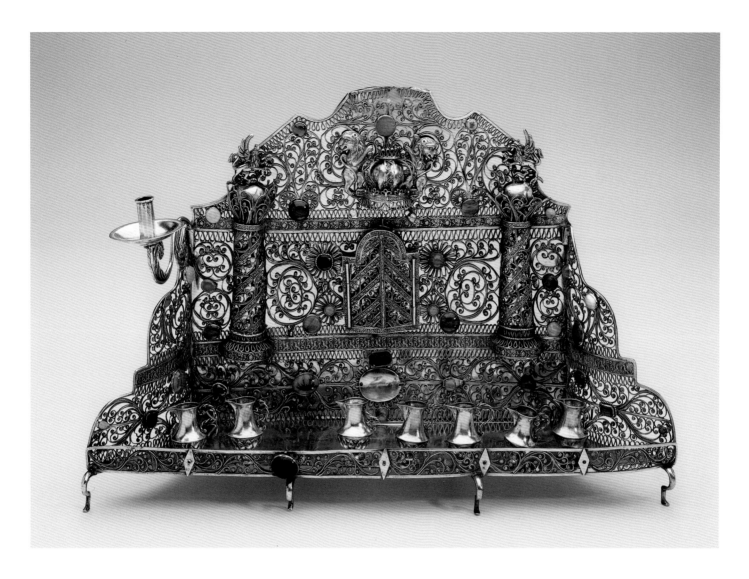

57

Poland or Russia,
first half 19th century

Silver: filigree, appliqué, and
cast; semiprecious stones; glass;
10¹³⁄₁₆ x 16¾ x 4¼ in.
(27.5 x 42.5 x 12.1 cm)
Gift of Mrs. H. Pereira Mendes,
S 1020

Like no. 50, this lamp is in the form of a Torah ark. It is made of silver filigree, a technique in which silver wires are bent or curled to form various patterns. Since the technique is basically the same the world over, what distinguishes the workmanship of one period and place from another is the pattern of the filigree, as well as any appliqué elements such as granules, enamel, or small diamond-shaped plaques. Observation of the patterns on eastern European filigree Hanukkah lamps reveals that a distinct change took place over the course of the nineteenth century. The wires on the earlier-nineteenth-century examples, as seen here, were usually shaped into heart or oval forms that covered the surface of the lamp. Filigree work on lamps made in the latter half of the nineteenth century, predominantly from Zhitomir, Ukraine, consists of broad S-shaped swirling patterns.

The profusion of colored "stones" is unusual for these filigree lamps. Imitations of precious stones became fashionable in the eighteenth century, perhaps because of the prevalence of robbers who preyed upon travelers (Savage, p. 93).

The rolled band decoration that frames the doors provides the earliest possible date of production, since it was created through a mechanized technique that only became common in the early nineteenth century (Victor, p. 25).

HALLMARK: "12". MAKER'S MARK: standing antelope in oval. DATE OF ACQUISITION: 1937. SIMILAR LAMPS: The Jewish Museum, JM 67-52 (gift of Samuel Lemberg), F 2572, and JM 17-60 (gift of Mrs. Herbert A. May; Kanof 1969, fig. 152) and nos. 345 and 346 in the catalogue raisonné; Historical Treasures Museum of the Ukraine (Varshavskaya, nos. 104–5); Muzeum Narodowe w Warszawie (Martyna, no. 314). LATER UKRAINIAN LAMPS: Phillips 1996, lot 213; Parke-Bernet 1960, lot 111; Israel Museum, acc. no. 118/24; Kestenbaum 2000, lot 22; Sotheby's NY 1986b, lot 305; Sotheby's NY 1987, lot 347; Sotheby's NY 1986a, lot 429.

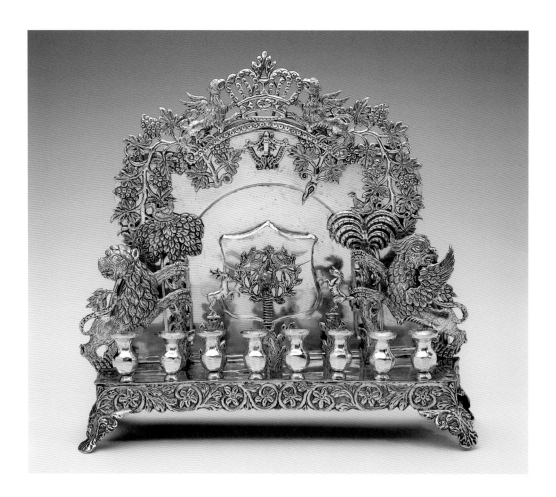

58

Poland or Russia,
first half 19th century

Silver: parcel-gilt, repoussé, appliqué,
and cast; 11⅜ x 12 x 3¼ in.
(28.9 x 30.5 x 9.5 cm)

Gift of the Danzig Jewish
Community, D 206

This lamp is a representation of the Garden of Eden, with its two famous trees, the one of Life and the other of Knowledge. Lush grapevines frame the scene, and birds roost in the treetops. The moment depicted is after the Fall, after Adam and Eve were expelled from the Garden and two cherubim put in place to guard the way to the Tree of Life (Genesis 3:24). Our notion of cherubim as round, rosy children with wings was formed in the Renaissance, but various biblical descriptions suggest much more formidable creatures. While the cherubim who guarded the ark in Solomon's Temple had one face and two wings each, the prophet Ezekiel describes creatures with four wings and four faces, including those of a man, lion, ox, and eagle (Ezekiel 1:10). The biblical term cherub (*keruv* in Hebrew) most plausibly came from an ancient Akkadian word for an intermediary who carried humans' prayers to the gods. Ancient Near Eastern versions of these beings were represented as various winged creatures such as bulls, lions, and griffins, who were part bird and part lion. Here both a lion and a griffin have been left to guard the trees.

A number of lamps of this type were produced in Poland and in Russia during the nineteenth and early twentieth centuries, and they underwent increasing simplification in design and manufacturing technique over time. By the late nineteenth century, the two trees and the two animals were no longer different species, and many lamps were produced in a die press instead of by repoussé. Copies are still being made and sold, for example, at Grand Street Silver Company in New York.

HALLMARK: "12". MAKER'S MARK: standing antelope or deer in oval. PROVENANCE: Lesser Gieldzinski Collection, Danzig, late nineteenth century to 1904; donated to the Great Synagogue of Danzig in 1904; acquired in 1939. BIBLIOGRAPHY: Danzig, no. 25; Mann and Gutmann, no. 43. SIMILAR LAMPS: The Jewish Museum, F 494, JM 34-66 (gift of Mrs. Oscar Perlberger), and F 5316 (mark: standing goat in rectangle); Russian Ethnographic Museum (Beukers and Waale, p. 79, acc. no. 6802-39); Sotheby's TA 1996a, lot 363. RELATED LAMPS: The Jewish Museum, nos. 349 and 352–54 in the catalogue raisonné.

Eastern Europe, early
19th century (?)

Copper alloy: cast; 27⁹⁄₁₆ x 14⁷⁄₈ x
7⁷⁄₁₆ in. (70 x 37.9 x 18.9 cm)

Gift of Dr. Harry G. Friedman (?),
F 3338

This unusual lamp is a three-dimensional rendering of the Garden of Eden, entered up a flight of stairs and through a portal. The garden is surrounded by a fence and palm trees. In the center is the Tree of Knowledge, filled with fruit, a snake wound around its trunk. According to the biblical story of the Garden of Eden, Adam and Eve were allowed to eat the fruit of all the trees in the garden except that of the Tree of Knowledge of Good and Evil. The snake, however, persuaded Eve to eat of that fruit, thereby plunging humankind into suffering and toil. Depictions of the Garden of Eden are found on one other group of Polish Hanukkah lamps in which both the Trees of Life and Knowledge appear (see no. 58).

The reason for the connection of this scene with the festival of Hanukkah is unclear, although the Jewish association of the menorah form with a tree goes back to the sixteenth century. At that time, the kabalist Guillaume Postel of Italy and France wrote an interpretation of the menorah seen by Moses. At one point he equated it with a tree, containing within it the body of universal man, and serving as a model for the creation of the world and its duration (Idel, p. 145). Trees are also important components in Russian folk art, and depictions of the Tree of Life, and of the fruit-bearing Tree of Knowledge, are common (Hilton, p. 177).

The palmette motif that forms the tops of the surrounding trees is neoclassical in inspiration, thereby suggesting an early-nineteenth-century date. It may, however, have been added later.

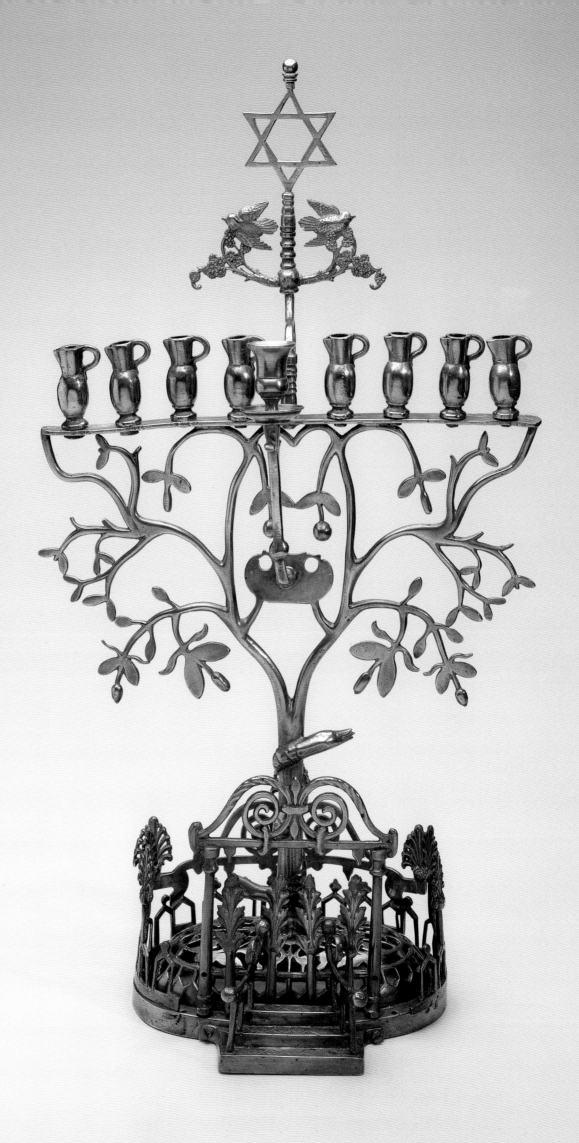

No. 59

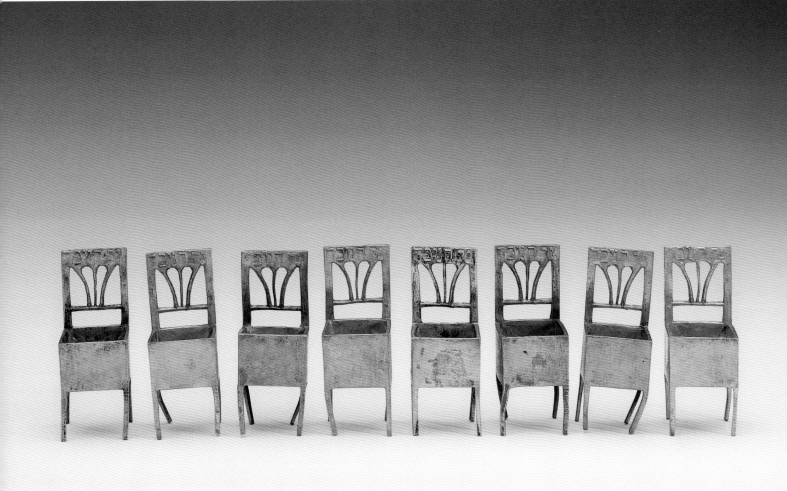

60

Eastern Europe or Germany,
19th century

Pewter: cast; each chair: 3⅟₁₆ x
1⅟₁₆ x 1³⁄₁₆ in. (7.8 x 3 x 3 cm)

Gift of Dr. Harry G. Friedman, F 473

HEBREW INSCRIPTION: Hanukkah light

The tradition of making cast lead or pewter objects for Hanukkah was centered in Germany, Bohemia, and eastern Europe. Children would create lead dreidls (special tops used for a Hanukkah game) from molds they often made themselves (Mitteilungen, p. 38; Goodman, p. 167–68; D. Altshuler, nos. 134–36). These would be melted down at New Year's. Chair Hanukkah lamps were made of pewter, which has a higher melting point than lead and thus for the most part was not destroyed by the flames of the lights. The reason for choosing the chair form is unknown, and perhaps it is a whimsical interpretation of the bench lamp.

The square chair back with its three curved splats is characteristic of the Biedermeyer style of Germany, and was a form prevalent in the 1820s (Pressler and Straub, nos. 233–39). The term *Biedermeier* was originally a derogatory one, and the style was perceived as a mixture of various neoclassical elements that became popular among the newly prosperous classes of Europe.

Other examples of pewter chair lamps in the collection, in different shapes (listed below), are the only published ones with known provenance and date. These came from Russia between 1868 and the end of the nineteenth century.

DATE OF ACQUISITION: between 1939 and 1941. SIMILAR LAMPS: The Jewish Museum, JM 56-65 (by Pesah Serebrenik, Bobruisk, Russia; gift of Julia Serebrenik), JM 102-73 (gift of the Chernick Family) and S 1503 (possibly by Moshe Manne, Russia); Berman 1996, p. 66; Sotheby's TA 2001b, lot 316; Sotheby's TA 1990, lot 299; Sotheby's NY 1990, lot 186; Magnes Museum (Eis 1977, no. MC 52); Bezalel Museum (M. Narkiss, no. 111); Rejduch-Samkowa and Samek, figs. 5–7; Wolfson Museum (Bialer and Fink, p. 156); Israel Museum (Shachar 1981, no. 376).

61

Maker: BD

Lvov (Lemberg), 1867–72

Silver: cast, engraved, and
traced; 34¼ x 23⅞ x 15 in.
(87 x 60.6 x 38.1 cm)

Gift of Dr. Harry G. Friedman
in memory of Adele Friedman,
F 5119

Among the large brass synagogue lamps of eastern Europe, one particular type was quite common, especially in Galicia. It had arms decorated with buds and applied cup-like flowers, following the biblical description of the first menorah made for the Tabernacle in the desert (Exodus 25:31–40). Departing from the biblical tradition, these lamps also had eagle finials and lion supports for the base. Flowers on ornate brackets were attached around the lower shaft, in a form similar to those found on Galician/Ukrainian chandeliers, where they served as reflectors behind the candles. On the Hanukkah lamps, however, the flowers have been completely divorced from their original function, since they are nowhere near the candleholders. Instead, they create the suggestion that the menorah form is the Tree of Life, a common association in Judaism (see discussion in no. 59).

Copper-alloy examples with inscription dates indicate that this type was popular in the second half of the eighteenth century. However, several silver versions were made in the latter half of the nineteenth century in Lvov, as represented in the collection by this magnificent example. It appears to be a copy of a nearly identical lamp that stood in the Przedmiejskiey Synagogue in Lvov until 1939, which is said to have been made in Breslau in 1775 (Balaban 1909, fig. 33). At least two other copies of this Lvov lamp were made around 1870. The history of the museum's lamp before its sale in Vienna in 1960 is unknown. However, it served a distinguished function more recently when, on December 10, 2001, it became the first Hanukkah lamp to be kindled by an American president in the White House residence.

HALLMARKS: Rohrwasser, pl. 15, upper right with "F"; Neuwirth, pl. 6:11. MAKER'S MARK: "BD" in rectangle. PROVENANCE: sold at Dorotheum Kunstabteilung, Vienna, in 1960; purchased from E. Pinkus, New York, in 1960. BIBLIOGRAPHY: Dorotheum, lot 1085. SIMILAR LAMPS: Moldovan Family Collection, New York (Grafman 1999, no. 71); Parke-Bernet 1949, lot 177; Parke-Bernet 1950, lot 144.

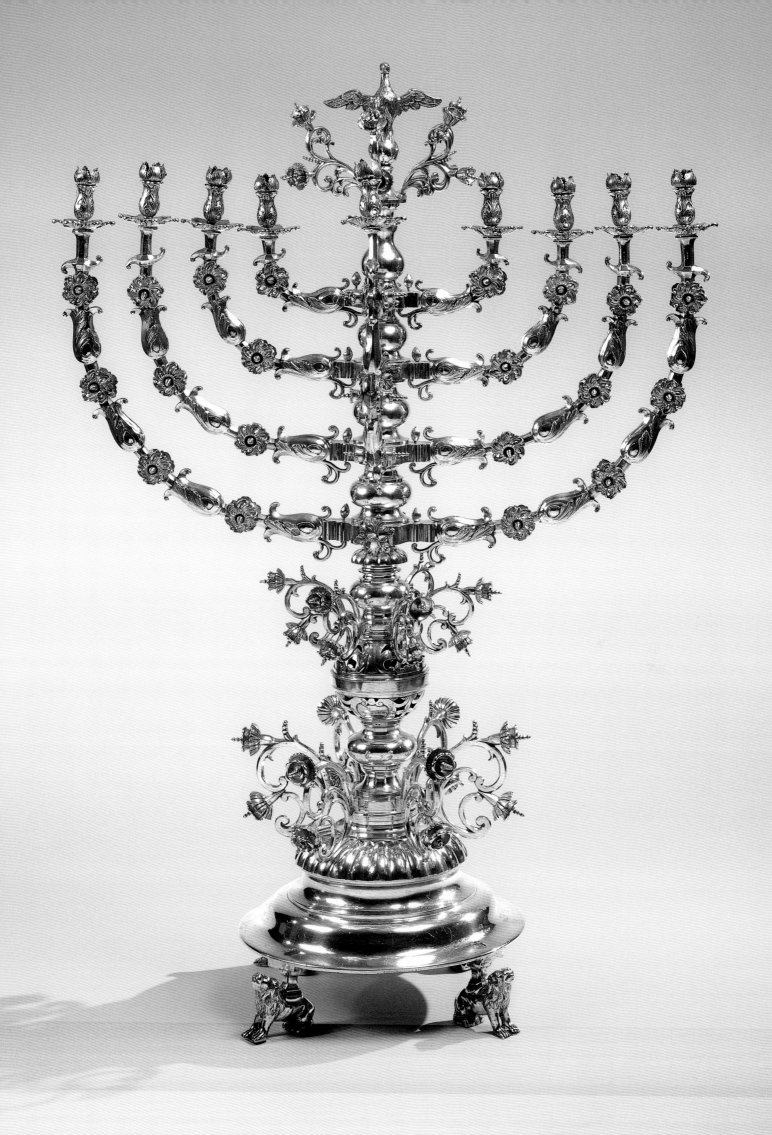

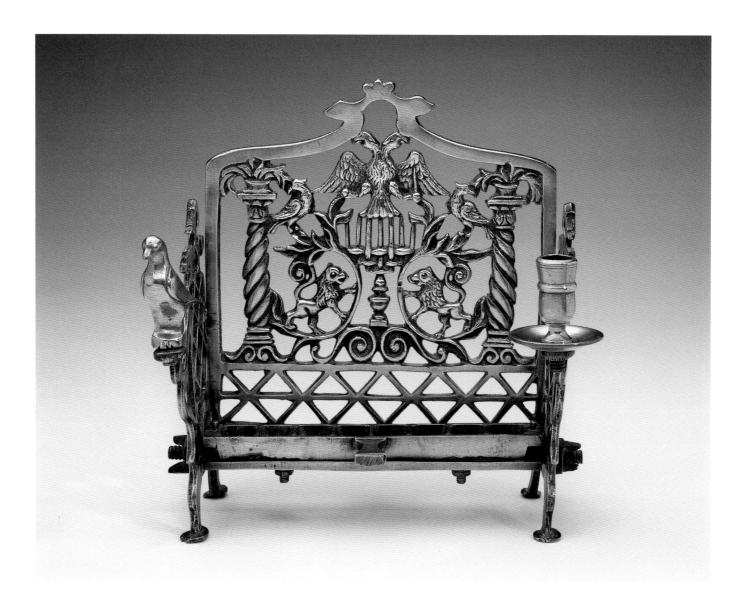

62

Eastern Galicia or
western Ukraine, mid-19th–
early 20th century

Copper alloy: cast; 10¾ x 10¹⁵⁄₁₆ x
6⁵⁄₁₆ in. (27.3 x 27.8 x 16.1 cm)

Gift of the Danzig Jewish
Community, D 207

In this complex design, a double-headed eagle, flanked by two birds, is placed above
a menorah. The latter is guarded by two lions within foliate scrolls. The double-headed
eagle was used as a royal emblem by a number of European rulers who claimed a rela-
tionship to or descent from Holy Roman emperors. These included the rulers of Ger-
many, Russia, and Austria. The imperial eagle is found on many types of Jewish ceremo-
nial art, part of a larger tradition of honoring the rulers of the countries in which Jews
lived and praying for their welfare.

Since the lamp was probably cast in Poland, the inclusion of the double-headed
eagle indicates that the design for the backplate would not have been created any earlier
than the end of the eighteenth century. It was at that time that Galicia and the Ukraine
became part of the Austrian and Russian Empires, and their double-headed imperial ea-
gles were incorporated into Jewish ceremonial art. Further support for this suggestion
is provided by an example in the Lvov Museum of Ethnography and Crafts, which has
an inscribed date of 1796/97. This and other examples in the Jewish Museum collection
would appear to be later versions produced in the second half of the nineteenth century,
based on the use of screws to assemble the parts.

PROVENANCE: Lesser Gieldzinski Collection, Danzig, late nineteenth century to 1904; donated to the Great Synagogue of
Danzig in 1904; acquired in 1939. BIBLIOGRAPHY: Mann and Gutmann, no. 45; Danzig, no. 27. SIMILAR LAMPS: The Jew-
ish Museum, F 98, F 145, and M 76, and no. 398 in the catalogue raisonné; Lvov Museum of Ethnography and Crafts
(Kantsedikas, unpag.; Hoshen, no. 84).

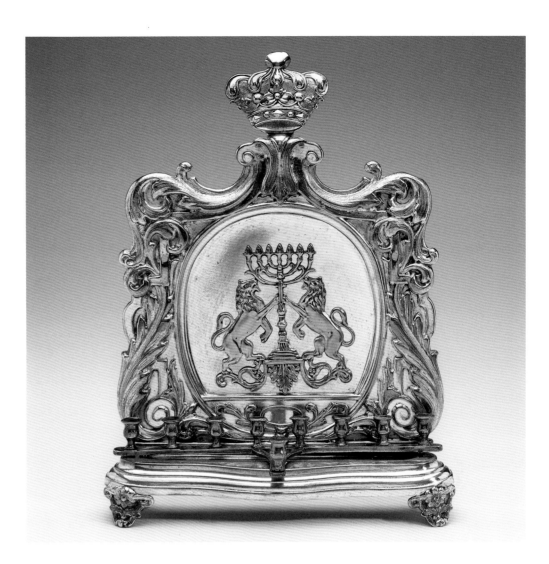

63

B. Henneberg
Warsaw, late 19th–
early 20th century
Copper alloy: die-stamped,
silver-plated, and appliqué;
12¾ x 9½ x 3⅝ in.
(32.4 x 24.1 x 9.2 cm)
Gift of Dr. Harry G. Friedman,
F 1643

The mass production of Hanukkah lamps that occurred in Germany and Austria with the popularity of the die press also spread to eastern Europe. Warsaw, in Congress Poland, was a major center of production in the late nineteenth century, a time that witnessed the rise of important factories like Fraget, Norblin, and Pogorzelski.

These various workshops produced large numbers of Jewish ceremonial objects; they used similar models and even exchanged parts. This assembly-line production, with specialization in particular backplate or appliqué designs by one or two makers, was probably a cost-saving device that enabled the mixing and matching of backplate and center decoration. Another means of decreasing expenses was to produce the lamps in copper alloy with a silver-plate finish. Years of loving polishing by owners often caused the plating to wear away in places, as has occurred on this example.

In the late nineteenth century, when so many of these lamps were being made, Warsaw was home to the largest Jewish community in the world. Although some Jews achieved financial success in commerce, banking, and industry, the majority were shopkeepers, artisans, and laborers. These silver-plated, stamped Hanukkah lamps would have been more affordable to this populace.

This lamp is particularly treasured as it belonged to the mother of Dr. Harry G. Friedman, the collector who donated most of the Hanukkah lamps in the museum's collection.

MAKER'S MARKS: "B. Henneberg Warszawa" in oval, star in center; "241". PROVENANCE: belonged to the mother of Dr. Harry G. Friedman; acquired in 1945. SIMILAR LAMPS: The Jewish Museum, F 1534. RELATED LAMPS WITH SIMILAR LIONS AND MENORAH: The Jewish Museum, X 1952-24 (maker RIS; Jewish Cultural Reconstruction) and F 3839 (by R. Plewkiewicz and Co., Warsaw branch of Württembergisches Metallwarenfabrik), and nos. 365–67 in the catalogue raisonné.

64

Jan Pogorzelski (active
before 1851–c.1910)
Warsaw, 1893
Silver: repoussé, traced,
engraved, punched, and cast;
26¼ x 18 x 8¼ in.
(68 x 45.7 x 21 cm)
Gift of Dr. Harry G. Friedman,
F 192

INSCRIPTION: "H" and "S"
superimposed

By the mid-nineteenth and into the early twentieth century, converter lamps became popular among Jews in Austria, Hungary, Czechoslovakia, and Poland. These consisted of an upper section of a menorah-form lamp that had a socket at the bottom which could be inserted into a candlestick. This no doubt allowed manufacturers to sell lamps more cheaply, since the purchaser need only buy the top portion and could use candlesticks already in his or her possession, probably Sabbath lights. There are numerous examples in the collection of just the upper parts, as well as sets in which the candlesticks were made by a different artist.

The firm of Jan Pogorzelski was one of several Warsaw silversmiths producing this type of lamp with grape clusters and leaves entwined around the arms. The earliest examples, by Michael Świnarski and Pogorzelski, date to the 1850s and 1860s. Reproductions are known from the later twentieth century. For example, the Grand Street Silver Company in New York ambitiously advertised its version as a reproduction of seventeenth- and eighteenth-century pieces, and extolled a special feature: the arms could be rotated for use as a secular candelabrum.

HALLMARKS: Lileyko, p. 100, third mark from bottom, with "1893"; eagle in circle. MAKER'S MARK: Lileyko, no. 50. DATE OF ACQUISITION: between 1939 and 1941. SIMILAR LAMPS: The Jewish Museum, F 194 and D 205, and nos. 443 and 444 in the catalogue raisonné; Butterfield and Butterfield, lot 533; Muzeum Narodowe w Warszawie (Martyna, nos. 316–20). OTHER WORKS BY POGORZELSKI: Lileyko, figs. 94–97.

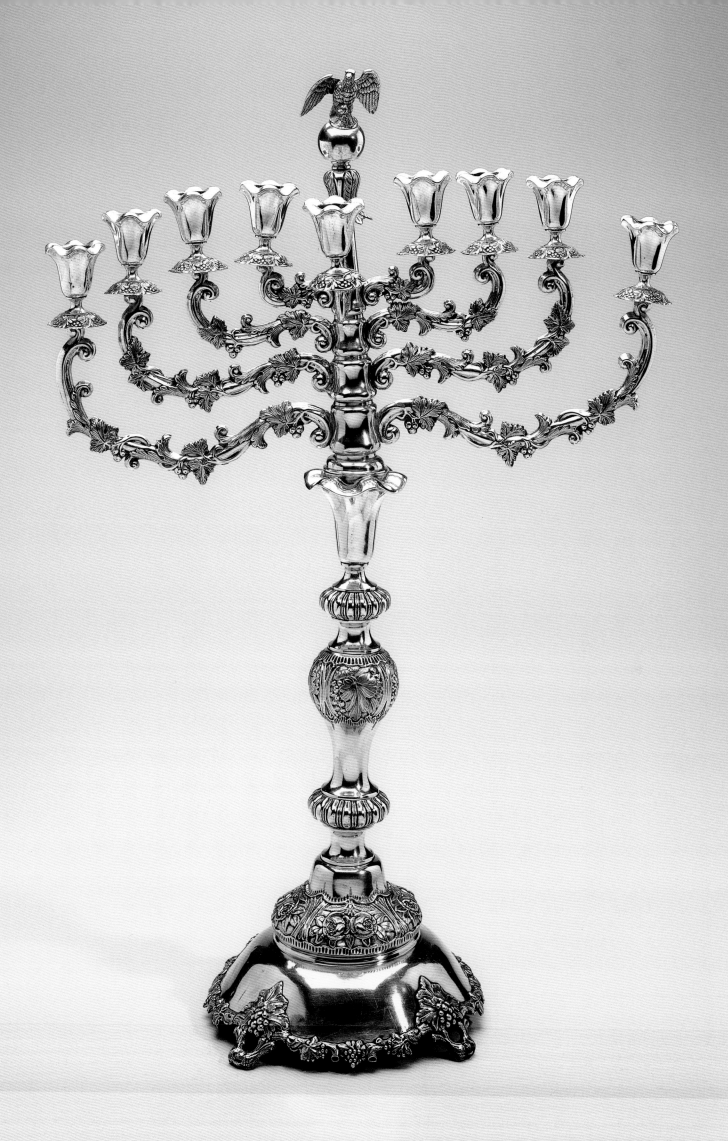

65

Eastern Europe, c. 1900

Copper alloy: cast and
engraved; 29½ x 26⅝ x 13⅞ in.
(75 x 67.6 x 35.2 cm)

The Rose and Benjamin Mintz
Collection, M 446

HEBREW INSCRIPTION: "These lights
are holy"

This large and unique lamp represents a lively blending of styles and iconography. The decoration on the backplate consists of paired birds and lions, the latter rendered with stylized manes and beaklike mouths that reflect folk traditions. The two griffins above would seem to have been made by a different artist, as they are stiffer and more awkward in form, with unnaturally elongated bodies. Yet another style is represented by the piece across the front of the candleholders, bearing a lion and lioness. These are depicted in a more naturalistic way than the lions above, and a greater sense of depth is achieved by the way that the leaves curl over the lions' backs. A fourth style is evidenced in the three-dimensional cast figures of a bear, a gorilla, and elephants, which are quite realistic in execution.

The piece gives the impression of having grown organically over time, beginning with the inner frame containing the two birds. While it is rendered in the same style as the upper section with the lions, there is no exact duplication of scrollwork, flowers, or leaves between them. The elephants, bear, and gorilla may have been the original supports, but the lamp seems to have then been placed on a heavy, flat base with dolphin feet. The griffin and candleholder at top appear to be afterthoughts. There is one precedent for this elaborate composition. An openwork wooden Hanukkah lamp made in 1869 by a Galician artist has some of the same features as the Jewish Museum lamp: an upper panel with elaborate vinework, a menorah, and a pair of deer, and a lower panel comprising the front of the bench, which has two birds surrounded by acanthus leaf scrolls (M. Narkiss, no. 115; Bronner 1926b, p. 710).

Several factors point to a date around the turn of the twentieth century. The first is the style of the lion and lioness, which resembles Art Nouveau. In addition, the palm trees on the top were popular on nineteenth- and early-twentieth-century silver lamps from eastern Europe representing the Garden of Eden (see no. 58).

DATE OF ACQUISITION: 1947. BIBLIOGRAPHY: M. Narkiss, no. 113; Kleeblatt and Mann, pp. 126–27; Berman 1996, p. 78.

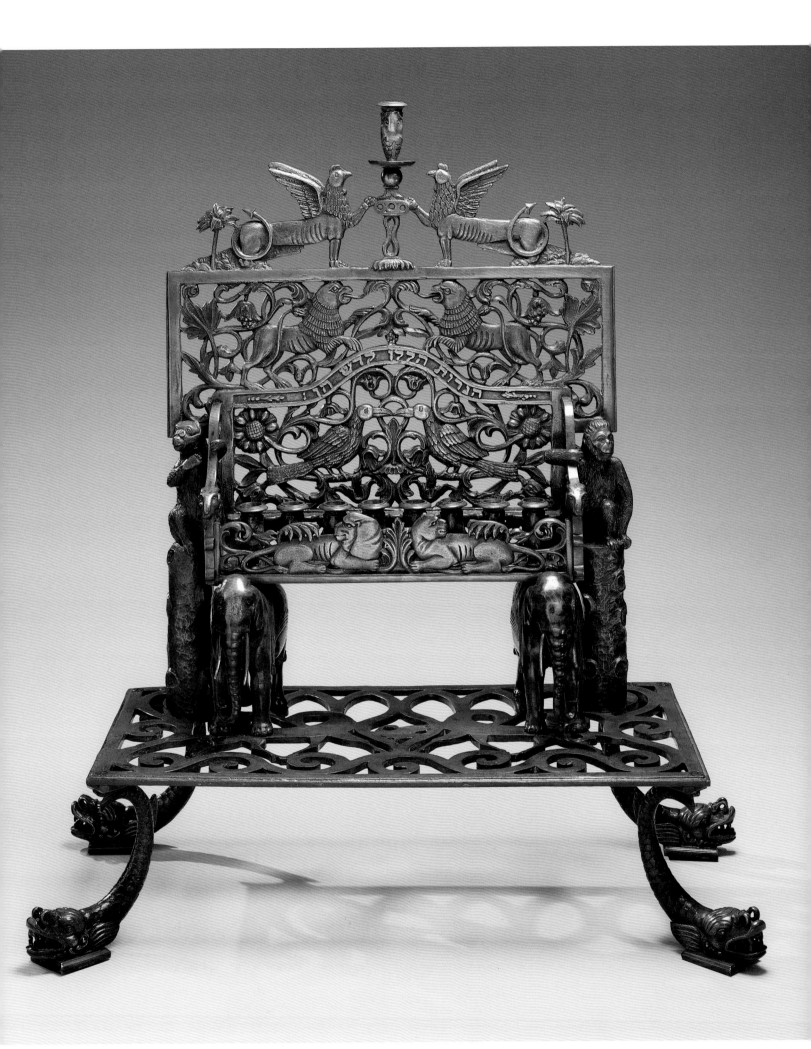

OTHER EUROPEAN COUNTRIES

The majority of the European lamps in the collection come from eastern Europe and Germany. The Netherlands, Italy, and Austria are well represented, but with smaller numbers of lamps. This chapter includes other European countries for which the museum owns only a handful of examples. The four lamps from the United Kingdom all date to the twentieth century; the three included in the catalogue raisonné portion of this book appear to have been influenced by eastern European and German prototypes. The single lamp from Denmark is by a Lithuanian immigrant, Barukh Griegst, who combined elements of an eastern European prototype with the Jugendstil of the early twentieth century (no. 69). Nine examples in the collection from Bohemia/Moravia, the current Czech Republic, indicate traditions of metalworking in silver and copper-alloy sheet metal, as well as cast copper alloy (e.g., nos. 66 and 67). Two cast lamps from Greece demonstrate connections with Italy (see no. 68).

The catalogue raisonné includes lamps from additional European lands. From France come two examples (nos. 468 and 469), one fashioned in a camp for children of deportees after World War II. Switzerland and Romania are represented by three examples (nos. 470, 471, and 484). The five lamps from Hungary include a menorah-form piece by a Jewish silversmith, Fridericus Becker, Jr., who was a member of the Pressburg silver guild in the first half of the nineteenth century (no. 483).

This geographical representation in the collection probably reflects the sizes of the Jewish population in these European countries, the patterns of Jewish immigration to the United States, and the history of the museum's collecting. Almost three-quarters of the lamps were acquired by Dr. Harry G. Friedman from the 1930s through the mid-1960s, mostly in New York and vicinity. A good number, no doubt, were brought to the United States during the two major waves of immigration that occurred from Germany and eastern Europe in the nineteenth and early twentieth centuries. Other major collections that were acquired by the museum also came from Germany (the Danzig Collection and the Jewish Cultural Reconstruction gift) and eastern Europe (the Mintz Collection), as well as the Mediterranean (the Benguiat Collection).

Detail of no. 69.

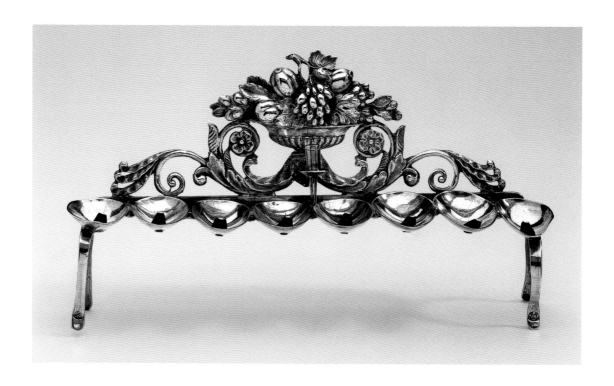

66

Maker: JR or TR

Brno, Moravia, 1826

Silver: die-stamped and pierced;

4¹/₁₆ x 7⅞ x 1⅞ in.

(10.3 x 20 x 4.8 cm)

The Rose and Benjamin

Mintz Collection, M 384

Bohemia and Moravia are today in the political entity known as the Czech Republic. They were part of the Habsburg Empire, centered in Austria, from 1526 to 1918. This lamp, made in Moravia, bears certain features of Austrian silver lamps, including an Austrian hallmark, the spoon-shaped oil containers, and the openwork backplate. However, other aspects of the silverwork are more characteristic of Bohemia and Moravia. The delicacy of the backplate imagery and style is a feature of Brno silver, as seen, for example, in a Torah shield dated 1813 (D. Altshuler, cat. 41). Other Czech features include a tendency to more diminutive forms in lamps, the simple curved strips for legs, and the absence of a drip pan below the oil containers.

Brno, where this lamp was made, was one of six royal cities in Moravia. The rulers expelled Jews from these centers in the fifteenth and early sixteenth centuries, and the expulsion remained in force until 1848, after this lamp was made. Despite the prohibition against living in Brno, individual Jews settled illegally, and by the eighteenth century they were allowed to worship in private, set up a Hebrew printing press, and even came to own the city bank. However, a full community was not established until emancipation.

Although the maker of this lamp is unidentified, theoretically he could have been Jewish. By the sixteenth century, individual Jewish goldsmiths were granted privileges to work in Prague, and by the seventeenth century all Bohemian Jews were allowed to practice crafts. Excluded from the Christian guilds, Jews of this period formed their own, which later received official sanction, in 1805 (Wischnitzer, pp. 159, 182; Mann 1983, p. 138).

HALLMARK: Rohrwasser, p. 13, center with letter "F". MAKER'S MARK: script "JR" or "TR" in oval. DATE OF ACQUISITION: 1947. SIMILAR LAMPS: Sotheby's TA 1987, lot 236; Moldovan Family Collection, acc. no. 96.

67

Bohemia, late 19th century

Copper alloy: cast; 7⅞ x 9¾ x 2¾ in.
(20 x 24.7 x 7 cm)

Gift of Dr. Harry G. Friedman, F 3391

On the backplate of this lamp is a wreath with a pointed hat in the center. This is a depiction of the distinctive headgear mandated to Jews in the Middle Ages to differentiate them from Christians. It eventually came to be the symbol by which Jews were recognized, and as early as the 1620s was adopted as the emblem of the Jewish community of Prague, where it appears on the Prague Jewish butcher's guild key and on community seals. A nineteenth-century tradition holds that the symbol was awarded to the Jews by Emperor Ferdinand III in 1648 after the Jews had helped in the defense of Prague against a Swedish siege, and it became known as the "Swedish hat." However, given the fact that it was in use before 1648, and that there is no record in the extensive annals of the region of this imperial award, this tradition seems to have little basis in fact (Putík, pp. 12, 30–31, 34–35).

There are only a few lamp types from Bohemia and Moravia that were cast in copper alloy. These were possibly inspired by the more common eastern European lamps. A number of construction features are the same: the use of separate parts assembled with tenons or screws in the same position, and the shape of the oil containers. One major difference is in the sidepieces, which in Czech lamps are thin, solid, and often in the shape of human figures. In addition, the two candleholders so characteristic of eastern European lamps are absent on Czech examples.

The sidepieces on lamps of this type consist of figures of Moses and Aaron. The poorness of the casting, which lacks the surface detail found in other examples, suggests this is a later version of the lamp.

68

Greece, inscription date 1867/68

Copper alloy: cast, wrigglework, traced, and tinned; 9⅛ x 12¼ x 2¾ in. (23.2 x 31.1 x 7 cm)

Gift of Dr. Harry G. Friedman, F 1267

HEBREW INSCRIPTION:

שמו / דוד / רוסטי / כי נר מצוה
ותורה / אור שנת / ת'ר'כ'ח' לפ'ק

Shmu[el?] David Rosetti
"For the commandment is a lamp, and the teaching is light" (Proverbs 6:23) in the year [5]628 [=1867/68]

This particular type of hanging lamp, with its circular scrolls, buds, and palmette finial, was characteristic of Greece in the later nineteenth century. Examples with inscriptions and provenance come from Salonika in northern Greece, as well as from Corfu off the western Greek coast and from Cairo. Despite the complex political history of these three places, there was considerable movement of population and probably exchange of goods among them. Salonika was a major port city that served as a crossroads for trade with both east and west, and members of the large Jewish community, often half of the total population, were active as merchants and artisans. From 1430 to 1912 the city was under Turkish control.

Corfu was ruled by Venice from 1386 until 1797, after which it was subject to France and Britain until it was annexed by Greece in 1864. Many Greek Jews fled to Corfu in the 1820s, after Greek independence was achieved, since they had supported the Ottoman rulers. Greek Jews also settled in Egypt in the nineteenth and twentieth centuries.

The lamp bears a certain similarity to Italian cast scrolled lamps (see no. 47), and the shape of the oil containers is also paralleled in some Italian examples. Jews from Italy had settled in Greece beginning in the late fifteenth century, and, like other immigrants from Iberia, Hungary, North Africa, and eastern Europe, they maintained their own communities and synagogues. In two instances, the names inscribed on lamps of this type are Italian, although other nationalities are represented as well. Perhaps the type evolved from Italian prototypes and continued in use by descendants of Italian immigrants, and eventually spread to the larger Jewish population.

DATE OF ACQUISITION: 1943. SIMILAR LAMPS: The Jewish Museum, F 4374; Bezalel Museum (M. Narkiss, no. 40); Sotheby's TA 1995a, lot 366; Wolfson Museum (Bialer and Fink, p. 159 bottom left, inscribed "Corfu, 1871"); Magnes Museum (Eis 1977, no. MC 6, from the Jewish Community of Cairo).

69

Barukh Shlomo Griegst
(b. Lithuania, 1889–1958)
Copenhagen, 1924

Silver: cast and hammered; 9⅛ x
9½ x 3¾ in. (23.2 x 24.1 x 9.5 cm)

Purchase: Judaica Acquisitions Fund,
1994-6

HEBREW INSCRIPTION: "To kindle the
Hanukkah light"

The Jewish community in Denmark, in existence for more than three hundred years, has always been small (under ten thousand people), and thus ceremonial art from this country is uncommon. This lamp was created by silversmith Barukh Shlomo Griegst, who was born in Gardsdai, Lithuania, and emigrated to Denmark in 1902 (Barfod, Kleeblatt, and Mann, no. 85). His arrival coincided with a large migration of eastern European Jews fleeing the pogroms and wars of the early twentieth century. Griegst had also lived in Paris, Berlin, and Dresden, the major cultural and artistic centers of his day. He worked mainly in the style of the German Art Nouveau, or Jugendstil, and this influence can be seen in the organic movement of many elements in the backplate design. The Star of David in particular is rendered in the sinuous plant forms of Art Nouveau, its interlacing lines blending with the rest of the scrollwork.

However, there is a second influence at work in this lamp. On the upper half of the backplate are lions, a menorah with interlaced arms, a Hebrew inscription, and a scalloped top edge, all of which are taken directly from a type of eastern European lamp that was made in the nineteenth century (see no. 406 in the catalogue raisonné). The interlaced menorah, while it relates formally to Jugendstil, was common on eastern European tombstones from the nineteenth century (Diamant, pls. 14, 15). Griegst must have been very familiar with this lamp type, and perhaps even owned an example, to have recreated it so faithfully; his Lithuanian origins would make such an association quite reasonable. He has blended the traditional and the modern in a highly personal way.

HALLMARK: "830 S" (see Tardy 1980, p. 103). MAKER'S MARK AND SIGNATURE: "B. Griegst / 1924" handwritten; "B. Griegst" stamped. PROVENANCE: offered for auction at Christie's Amsterdam twice in 1990; purchased from Moriah Galleries, New York, in 1994. BIBLIOGRAPHY: Christie's Amsterdam 1990a, lot 349; Christie's Amsterdam 1990b, lot 133. RELATED LAMP BY GRIEGST: Christie's Amsterdam 1990b, lot 132. OTHER WORKS BY GRIEGST: Copenhagen Synagogue (Barfod, Kleeblatt, and Mann, no. 85); Collection Chief Rabbi Bent Melchior, Copenhagen (Barfod, Kleeblatt, and Mann, no. 83).

70

Frederick J. Kormis
(British, b. Germany,
1897–1986)
London, 1950
Copper alloy: cast and engraved;
16¾ x 13⅛ x 3¹⁵⁄₁₆ in.
(42.5 x 33.3 x 10 cm)
Gift of Karl Nathan, JM 22-50

HEBREW INSCRIPTION: יהודה מכבי
Judah Maccabee

The dominant image on this lamp is Judah Maccabee, the leader of the revolt that brought about the liberation and rededication of the Jerusalem Temple. Yet despite his importance to the holiday, he was rarely represented on Hanukkah lamps over the millennia. As discussed in the introductory essay, the rabbis of antiquity placed a new interpretation on the events of the story, stressing divine intervention, rather than human courage and strength.

It is only in the twentieth century that Judah Maccabee begins to appear on lamps, although small stock figures of soldiers on German lamps of the eighteenth century may have been a reference to the hero. The Zionist call for a return to the land of Israel and a new kind of Jew who could farm and defend it revived the association of the holiday with the military heroes of the Hanukkah tale. In the mid-twentieth century, the struggle for Israel's independence and the new miraculous victories that took place were seen to echo those of the Maccabees in ancient times. As a consequence, images of modern soldiers and of the ancient fighters began to appear on Hanukkah lamps.

Frederick J. Kormis was trained in Frankfurt but fled to London in 1939 to escape the Nazis. He is known primarily as a medalist. In the early 1940s, he created more than seventy-five portrait medals commissioned by Samuel Friedenberg for a Jewish "Hall of Fame" (Rezak). This series later became part of the collection of The Jewish Museum.

SIGNATURE: "KORMIS". DATE OF ACQUISITION: 1950. OTHER WORKS BY KORMIS: Friedenberg, pp. 105–6; Rezak, p. 104.

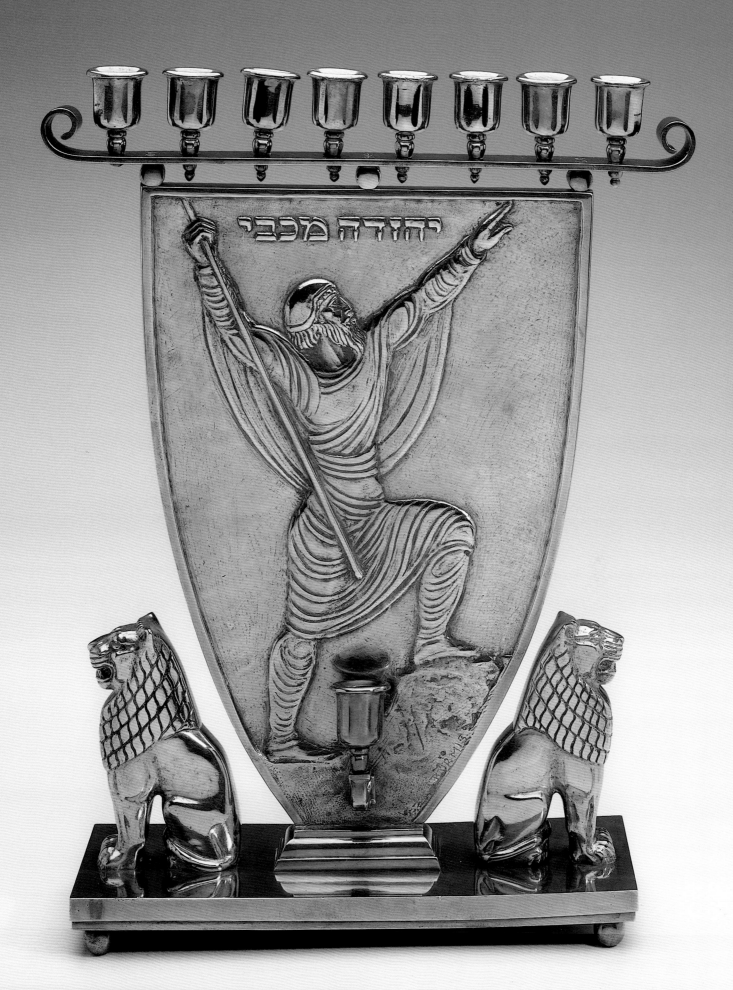

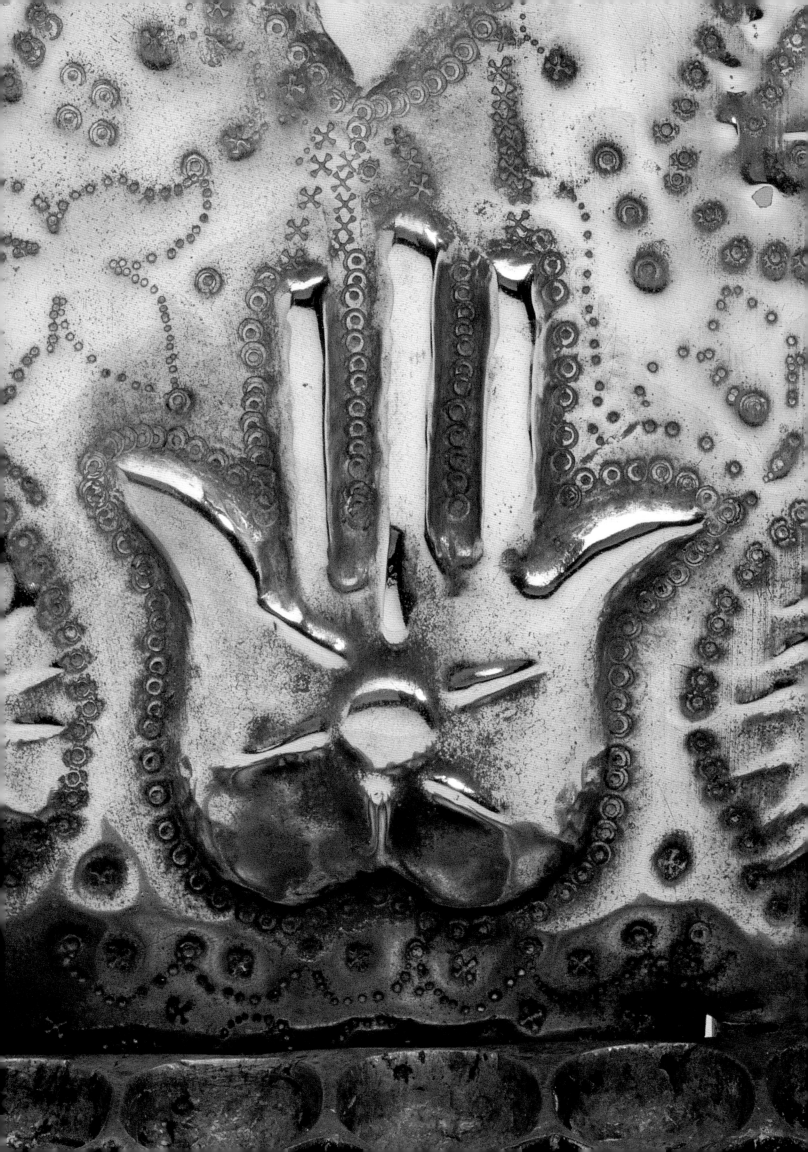

NORTH AFRICA

The Jewish population of Morocco, Algeria, and Tunisia comprised two distinct groups in origin and cultural affinity. The earliest inhabitants came from ancient Israel, probably at least as early as the Roman period, and assimilated native Berber customs. They were joined by other Jews from the Middle East and the Mediterranean after the Arab conquest in the seventh century. The second group consisted of Jews who fled Spain after the persecutions of 1391 and the expulsion of 1492. These Jews often maintained their Spanish language and traditions, eventually combining them with aspects of local culture. Islamic rulers were for the most part beneficent, treating Jews as one of the protected minorities (dhimmi). However, times of tolerance were occasionally punctuated by outbreaks of violence or restrictions on Jewish life. In the nineteenth and early twentieth centuries, foreign control of North Africa caused the Jewish communities to lose autonomy and come under secular governance, which led to greater assimilation. Algeria and Tunisia became French protectorates in 1830, and parts of the Moroccan coast came under Spanish control in 1859 and again in 1912, when the rest of Morocco became a French protectorate.

Jews served as diplomats and merchants, while many engaged in one of a wide variety of crafts. Metalworking was one of the Jewish specialties, and Moroccan sources going back to the sixteenth century indicate that in many cities and towns all or the majority of metal craftsmen were Jewish. By the late nineteenth and early twentieth centuries, a number of Jewish silversmiths were recorded in Meknes and six hundred gold- and silversmiths in Fez, while in Sefrou more utilitarian metalwork was produced (Deshen, pp. 33, 37). Jewish artisans on the island of Djerba, Tunisia, were renowned for their metallurgical skills as far back as the tenth and eleventh centuries and were brought into Algeria to make goods for the Muslims (B'nai B'rith Klutznick Museum, p. 16). This Jewish predominance in the metal crafts was quite different from the situation in Europe, where Jews were occasionally prohibited from engaging in gold- and silversmithing, and reflects the Muslim attitude toward working with metals. Although metalsmithing was never mentioned in the Koran, various later commentaries discouraged the hoarding of gold and silver, and men were forbidden to wear ornamentation in precious metals (Ghabin, pp. 84–87). Muslims appear to have viewed metalworking in a negative light and best left to those of other faiths, although their attitudes and their participation in the craft seem to have fluctuated over time (Muchawsky-Schnapper 2000, p. 113).

The earliest lamp from North Africa that can be dated with certainty is of a cast type with floral decoration, and it has an inscription date of 1743/44 (see no. 536 in the catalogue raisonné). Several others, decorated with quatrefoil "windows," were recorded in the 1870s and 1880s, providing some evidence for their period of use (see no. 533 in the catalogue raisonné). It is difficult to establish the dates of individual lamps, especially cast ones that could have continued in production for many generations. Jews in Islamic lands did not in general value old things, and when metalwork was worn or in need of repair they would often melt it down and fashion a new object (Rabaté and Rabaté, pp. 14, 17;

Detail of no. 77.

Muchawsky-Schnapper 2000, p. 116). Thus, the lamps in the collection have been dated to the nineteenth and early twentieth centuries.

The places where specific types were used and possibly produced can be reconstructed thanks to the work of Zayde Schulmann. In the late 1940s and 1950s, he gathered examples of Jewish ceremonial art throughout Morocco and meticulously recorded the places where he obtained them (Benjamin 2002). The lamps, now in the Israel Museum, and their documentation have enabled an understanding of the distribution of distinct types in North Africa, as characterized by their form and decoration.

All the North African lamps in the collection are bench forms and, with one exception, were wall hung. The large menorah-form lamps found in so many European synagogues seem not to have been used in North Africa until very recently; a nineteenth-century source mentions the use of ceiling-hung lamps in Algerian synagogues (Landsberger 1954, p. 363).

Hanukkah lamps from all over North Africa exhibit certain features, derived from Islamic art, in common. Shared decorative elements include a colonnade of horseshoes or

pointed arches, arabesque scroll decoration, and birds. Three different types of materials and formative techniques are found: silver, copper-alloy sheet metal, and cast copper alloy, all often with openwork designs. The greatest regional differences are seen in the cast lamps. Those made in central Morocco, in towns in or near the Atlas Mountains, are more vertically oriented, and every area of the surface is covered with arabesque designs that are raised, stamped, or engraved (see no. 72). This follows the Islamic predilection for richly patterned ornamentation in all art forms, from architecture to carpets. By contrast, the cast lamps found in coastal cities in Morocco, Algeria, and Tunisia are more horizontal in orientation, and most have no surface decoration at all (see no. 75). The latter feature would appear to be more closely related to casting traditions in Italy, and in fact some Italian types were probably made in North Africa (see no. 76). Algeria and Tunisia are actually quite close to southern Italy, and a number of Italian Jews, particularly from Livorno, settled in North African ports in the seventeenth and eighteenth centuries (Hirschberg, pp. 20–25, 83). No doubt they brought their own traditions in ceremonial art with them.

A second type of Hanukkah lamp that was characteristic of the coast was produced in the region of Tétouan, Morocco. Made of copper-alloy sheet metal, it bears pierced and engraved ornamentation as well as applied cast columns (see no. 73).

A most interesting lamp type is quite similar to the repoussé copper-alloy lamps of the Netherlands (see no. 77). Examples collected by Schulmann come primarily from the center of Morocco, in cities such as Meknes, Marrakech, and Fez. They demonstrate strong ties between North Africa and the Jewish community of the Netherlands. Moroccan and Algerian Jews served as government agents and businessmen in Holland during the seventeenth century, and a number of Dutch Jews settled in Algeria (Hirschberg, pp. 15–16, 262–64).

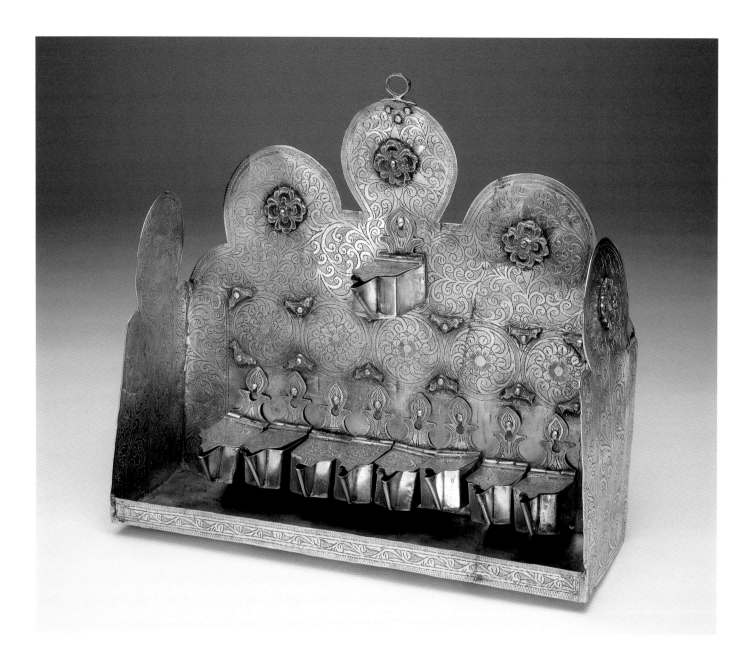

71

Essaouira, Morocco,
19th–early 20th century

Silver: traced, appliqué, parcel-gilt,
and cast; 10⅞ x 11¹⁵⁄₁₆ x 4¹⁄₁₆ in.
(27.6 x 30.3 x 10.3 cm)

Purchase: Judaica Endowment
Fund and the Nash Aussenberg
Memorial Fund, 1996-46

Silver lamps from North Africa are rare, and the form of and ornamentation on this piece do not appear in other Hanukkah lamps. Closely related decorative devices and motifs are, however, employed in jewelry. Gilt appliqué rosettes like those on this lamp are characteristic of bracelets, anklets, and belt buckles from Essaouira. These works date from the nineteenth century through the early years of the twentieth century, after which silversmithing in Essaouira began to decline (Rabaté and Goldenberg, pp. 36, 47, 121; Mann 2000a, nos. 72–73). Another design element on this lamp consists of incised rosettes with circular centers and radiating striations on the petals. This particular form of rosette decorates jewelry from Essaouira, Marrakech, and Meknes, and dates from the nineteenth to early twentieth century (Rabaté and Rabaté, p. 122; Rabaté and Goldenberg, pp. 76:6, 184:2, 186:4).

The sidepieces on the lamp are incised with images of a fish and a bird. Both can be symbols of fertility, since they are creatures capable of laying large quantities of eggs. Birds, especially in pairs, can often symbolize love in Islamic culture (Rabaté and Goldenberg, p. 172; Al-Jadir, p. 18). It is therefore possible that this lamp was intended as a wedding gift, incorporating good wishes for many children.

PROVENANCE: purchased from A. Stein, Brooklyn, New York, in 1996. BIBLIOGRAPHY: Mann 2000a, no. 31.

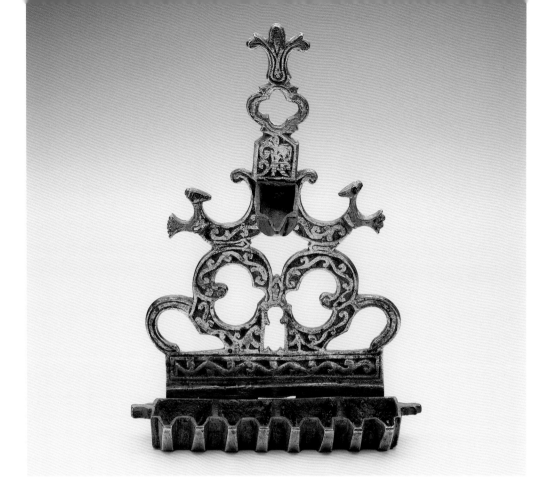

72

Central Anti-Atlas Mountains(?),
Morocco, 19th–early 20th
century

Copper alloy: cast and enameled;
8 x 5¾ x 2⅝ in. (20.3 x 14.6 x 6.7 cm)
Gift of Dr. Harry G. Friedman, F 2467

This lamp belongs to a cast group made in the Atlas Mountains whose surface is ornamented with vinework executed in thick raised lines. The enamel that fills the voids left by the raised decoration is a rare survival on Moroccan Hanukkah lamps; it is typical of work in the Central Anti-Atlas Mountains, found, for example, on rifles and daggers of the nineteenth century (Grammet and de Meersman, nos. 24–25).

Lamps with similar open scrollwork containing two kidney-shaped spaces in the center were also made in Italy and eastern Europe, where they had different finials and there were generally no birds (see no. 426 in the catalogue raisonné). The origin of the type has been attributed to fifteenth-century Italy (M. Narkiss, no. 18), but such an early date requires further documentation. Connections between North Africa and Italy were strong from the seventeenth century on, particularly with Livorno. Jews from that community came to live in nearby Algeria and Tunisia, and Livornese Jews controlled Algerian trade (Hirschberg, pp. 20–25, 83). Italian Jews were also found in eastern Europe, having arrived in Poland and Lithuania after major disruptions further west in the fourteenth and fifteenth centuries. In turn, Polish Jews were important in trade with Venice from the fifteenth century on. These interconnections between Italy and North Africa on the one hand, and Italy and eastern Europe on the other, suggest mechanisms by which this scrolled lamp form might have attained such a disparate distribution.

A number of distinctly Moroccan features have been added to transform this lamp into an Islamic type: the two birds, the arabesques covering every inch of the surface, the horseshoe arch in the center, and the oil containers, which consist of four large wells with two spouts each. Other versions of this type with different surface decoration were found in the northern Atlas Mountains further to the west, in such cities as Demnat, indicating the wider distribution of the form.

DATE OF ACQUISITION: 1949. SIMILAR LAMPS: The Jewish Museum, S 1293, F 1871, F 3242, and F 2159; Israel Museum (Benjamin 2002, nos. 73, 78; Shachar 1981, no. 379; acc. nos. 118/397 and 118/374; M. Narkiss, no. 38).

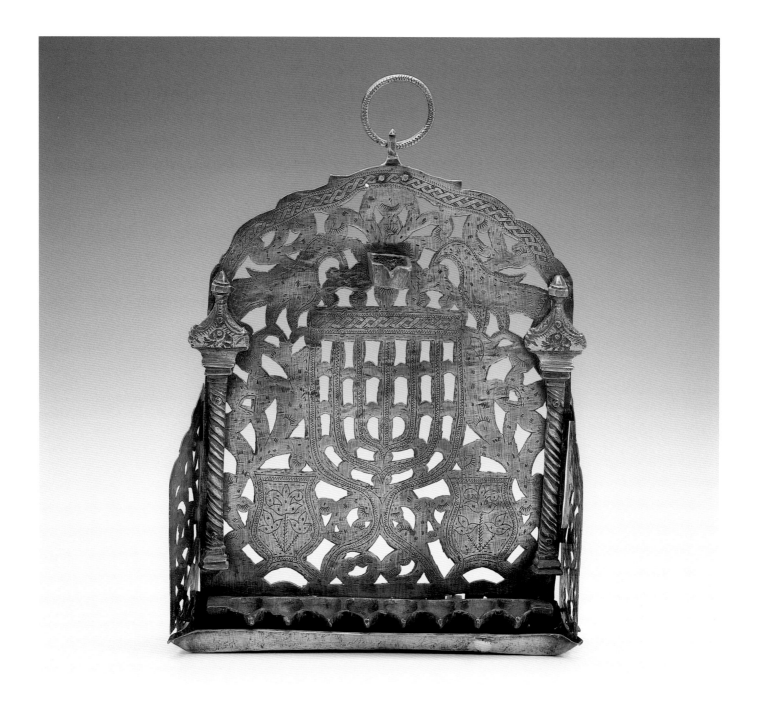

73

Tétouan(?), Morocco,
19th–early 20th century

Copper alloy: traced, punched,
pierced, appliqué, and cast;
12¹⁄₁₆ x 10 x 2¾ in.
(30.7 x 25.4 x 7 cm)
Gift of Dr. Harry G. Friedman,
F 4373

The central decorative element on this lamp is the seven-branch menorah, flanked by two vases. The majority of lamps of this type bear two Hebrew inscriptions. The first, "The seven lamps shall give light in front of the lampstand" (Numbers 8:2), describes the menorah of the Temple in Jerusalem. The second, "Blessed shalt thou be when thou comest in, and blessed shalt thou be when thou goest out" (Deuteronomy 28:6), is a reference to where the Hanukkah lamp should be placed. From ancient times, the lamp was supposed to be hung on the doorpost of one's home, to publicize the miracle that took place during the Maccabean revolt. As one entered the door, the lamp would be on the left, opposite the mezuzah. Although in later times many Jewish communities came to place the light indoors, Moroccan Jews have preserved the earlier tradition.

Four very similar examples, now in the Israel Museum, were obtained in Tétouan in the late 1940s and 1950s, suggesting the origin for this type.

PROVENANCE: private collection, New York; purchased at Parke-Bernet in 1957. BIBLIOGRAPHY: Parke-Bernet 1957, lot 201. SIMILAR LAMPS: The Jewish Museum, F 167, F 3767, F 199, F 4161, U 7681, and JM 33-69 (gift of Edouard Roditi); Israel Museum (Benjamin 2002, nos. 1–2; acc. nos. 118/460, 118/556, and 118/109).

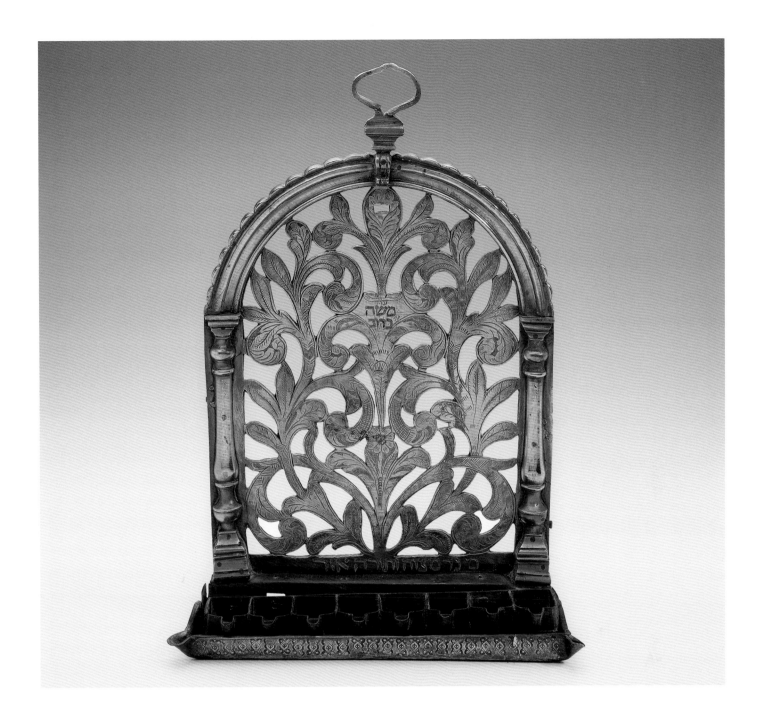

74

Morocco, possibly Fez,
19th century

Copper: pierced, traced,
punched, appliqué, and cast;
15 x 10⅞ x 3⅝ in.
(38.1 x 27.6 x 9.3 cm)
Gift of Dr. Harry G. Friedman,
F 3491

HEBREW INSCRIPTIONS: ע׳ה / משה כרוב
M[ay he rest in] p[eace]; Moshe Karoub;
"For the commandment is a lamp, and
the teaching is light" (Proverbs 6:23)

The elegant floral scrollwork on this lamp is framed by a cast arch supported by two columns. This is reminiscent of a group of Italian lamps with cast and applied round arches (e.g., no. 43), although none have the openwork of this example. The connections between North Africa and Italy are discussed in the chapter introduction, and it is possible that the concept of a lamp with a round arch originated in Italy, although local inspiration is also conceivable. Several types of Moroccan lamps have applied columns, either of the smooth or twisted variety, and this type of openwork decoration of floral vines appears to have been popular in Fez (e.g., no. 72). Thus, production in North Africa seems likely for this lamp.

The lamp was owned by a Moshe Karoub, who had his name inscribed in the center. At his death, the abbreviation for the expression "May he rest in peace" was added above his name; this is clearly written in a different hand.

DATE OF ACQUISITION: 1976. RELATED LAMPS: Israel Museum (Benjamin 2002, nos. 20, 24–25; acc. nos. 118/452 and 118/376).

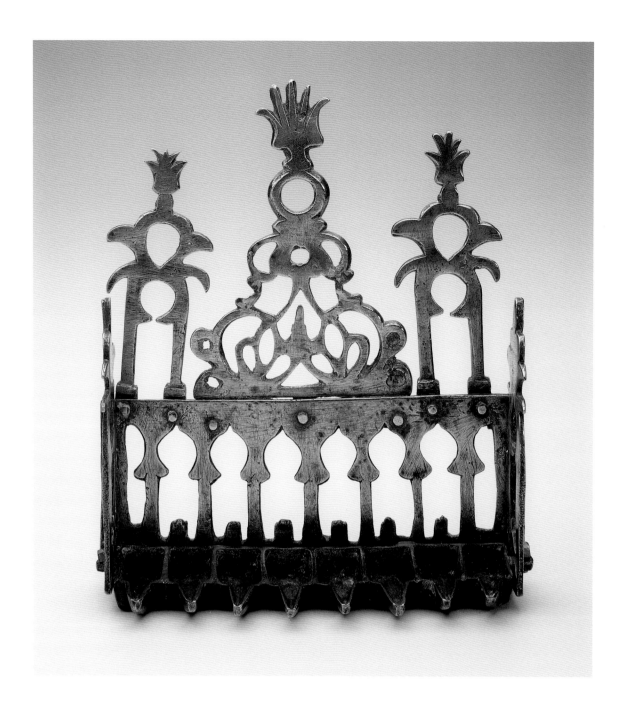

75

Coastal Morocco, Algeria, or
Tunisia, 19th–early 20th century

Copper alloy: cast; 9⁵⁄₁₆ x 8 x 3 in.
(23.6 x 20.4 x 7.6 cm)

Gift of Dr. Harry G. Friedman (?),
F 3771

This is an example of the coastal type of North African lamp, with its smooth, undeco-
rated surface and essentially horizontal orientation. The possible connections of coastal
types to Italian lamps are discussed in the chapter introduction. The backplate design
consists of a rectangular plaque with an openwork colonnade of arches; the scrollwork
and rickety towers above the colonnade are separate and attached by rivets. All the ele-
ments on this lamp are of Islamic inspiration, from the types of arches to the prominent
hamsas, or raised hands, which are believed to have protective powers in both Jewish
and Muslim culture.

This particular lamp type appears to be common along the western part of the
North African coast, from Morocco to Tunisia. Examples have been obtained in the
coastal cities of Rabat, Algiers, and Djerba.

SIMILAR LAMPS: The Jewish Museum, F 5618 and F 2336, and no. 539 in the catalogue raisonné; Israel Museum (Benjamin
2002, no. 125; acc. nos. 118/413, 118/416, and 118/419); Musée d'art et d'histoire du Judaïsme (Sigal, p. 53 bottom).

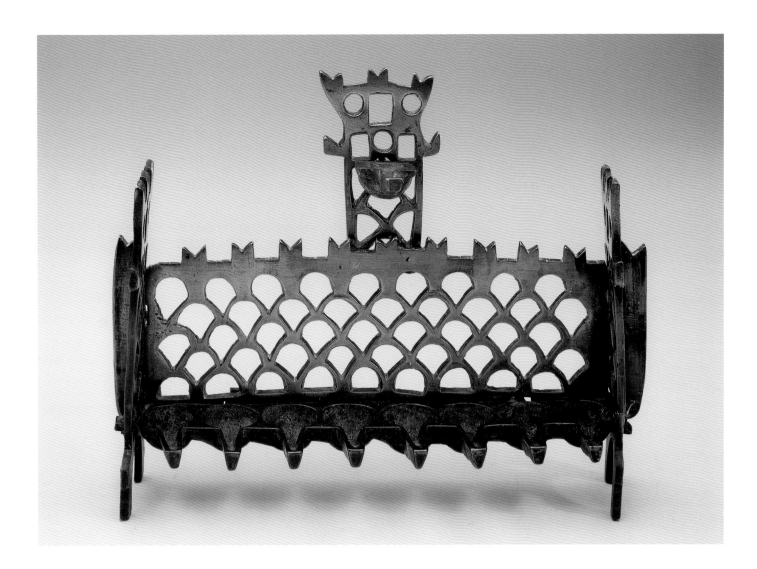

76

Coastal North Africa,
19th–20th century

Copper alloy: cast; 7⁷⁄₁₆ x 10⅛ x 3⅛ in.
(18.9 x 25.7 x 8 cm)

Gift of Dr. Harry G. Friedman, F 152

This lamp represents a combination of Italian and North African elements. The rectangular backplate form with crenellations across the top is found on some Italian lamps (see no. 41). The oil containers, with their round wells and long spouts, are also a distinctly Italian type.

However, several indicators suggest that this example was made in North Africa. The backplate was cast from the same model as a lamp in the Israel Museum that was purchased in Morocco. In addition, an example of this type of backplate has the same scrolled element in the center that is found on coastal North African lamps such as no. 75. Sidepieces are common on North African lamps, but are never found in Italy. Finally, two features on this lamp are shared with coastal North African lamps: the inclusion of tower-form sidepieces, and the use of rivets to fasten the towers to the top of the backplate. These factors argue for the transformation of a type originally from Italy, which lacked the sidepieces and towers, into a North African one. For a discussion of the links between Italy, Tunisia, and Algeria, see the chapter introduction.

A variant version in the collection with the same fishscale pattern has a triangular form, without the crenellations (F 1016). The poor finish and North African oil wells of that lamp indicate a similar origin.

SIMILAR LAMPS: Israel Museum (Benjamin 1987, no. 127, and see nn. 3–4; Landau, no. 8; acc. no. 118/385); Guggenheim Collection, Venice (Frauberger, fig. 46-53 bottom center); Victoria and Albert Museum (Keen, no. 20); O'Reilly's 1967b, lot 167; Nauheim Collection (M. Narkiss, no. 45); Magnes Museum (Eis 1977, no. MC 8); Ginevra Neppi Collection, Milan (Cusin, unpag.); Jewish Museum, London (Barnett, no. 46); Sotheby's TA 2000, lot 212; Weinstein, no. 187. RELATED LAMP: The Jewish Museum, F 1016 (with triangular backplate).

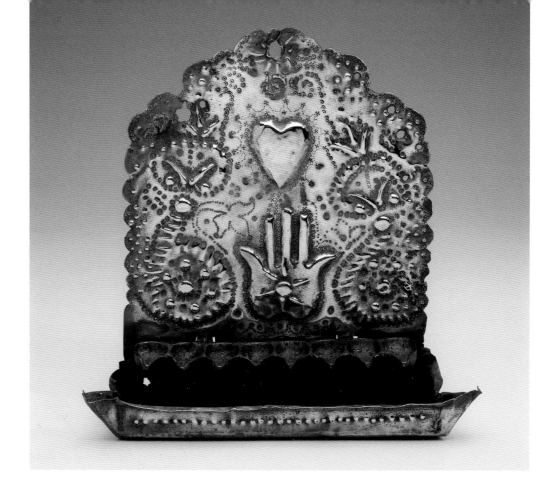

77

Morocco, second half
19th century

Copper alloy: repoussé,
punched, and cast;
11 x 11 x 4 in.
(27.9 x 27.9 x 10.2 cm)
Gift of Elaine D. Elmaleh,
F 2750a

Repoussé sheet-brass lamps were common in Holland (e.g., nos. 2, 3, 6, and 7). However, a number of similar lamps were also purchased in Morocco. For lamps without provenance, it has therefore long been difficult to determine whether they were made in Europe or North Africa.

In an effort to resolve this difficulty, a study was undertaken of a group of sheet-metal lamps in the Joods Historisch Museum in Amsterdam, many of which were obtained in Holland, and a group collected in the late 1940s and 1950s by Zayde Schulmann in various cities of Morocco, now in the Israel Museum. An analysis of the types of metals, techniques of decoration, as well as of the construction and method of fastening the drip pan, showed few differences among the lamps from the two countries. The only factors that seemed to clearly distinguish them were the placement of the *shamash*, the methods used for suspension, and the types of oil containers used. Almost all the Dutch lamps had the *shamash* on the proper left side, while in Moroccan examples it was located in the top center. In addition, the Dutch lamps were suspended by a hole pierced in the top, while many Moroccan lamps had an additional sheet brass strip riveted to the backplate that held a suspension ring. Finally, some of the examples from Morocco had sheet-metal oil rows that were mounted on cylindrical shafts and attached to the drip pan. This is characteristically Moroccan, found on other types of Moroccan lamps as well. Cast oil containers were often the same shape in both countries, but those originating in Holland were made from different models than those found in North Africa.

The use of the Middle Eastern motif of the hand or *hamsa* in the center of the backplate of the museum's lamp, as well as the provenance, confirms that it is Moroccan made. According to museum records, the original owner of the lamp, Esther Elmaleh, came from a North African family.

PROVENANCE: collection of Esther Elmaleh; bequest to her daughter-in-law Elaine Elmaleh in 1970; acquired in 1971. RELATED LAMPS: The Jewish Museum, nos. 542–44 in the catalogue raisonné.

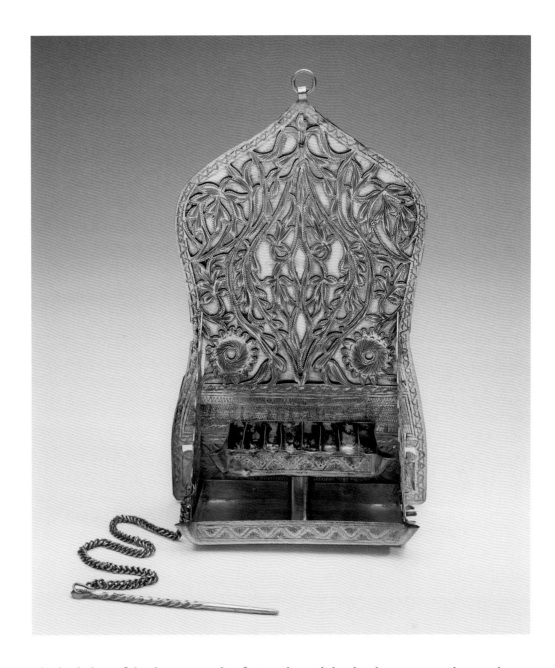

78

Morocco, 20th century

Silver: pierced, engraved, wrigglework, and appliqué; 9¹⁵⁄₁₆ x 6⁵⁄₁₆ x 3⅜ in. (25.2 x 15.7 x 8.6 cm)

Gift of Dr. Harry G. Friedman, F 5606

The backplate of this lamp is made of pierced metal that has been mounted on a silver backing. Every surface of the scrollwork is covered with engraved lines in a zigzag pattern, called wrigglework. Similar pierced designs with wriggled decoration were used on a variety of Moroccan ceremonial objects, including prayer shawl bags, memorial lights for women (*kandil*), and mezuzah covers. In Morocco, mezuzot (parchment scrolls containing prayers that Jews place on their doorposts) are housed in niches cut into the doorposts of the rooms in homes or synagogues. The niches are then protected by metal or fabric covers. The same form has been used for both the Hanukkah lamp backplate and the mezuzah cover. As a lamp, it resembles an ogee-shaped arch. When turned upside down, it becomes a shield-shaped mezuzah cover. An unusual inclusion with this lamp is a silver pick on a chain, possibly used for tending the wicks in the oil containers.

Hanukkah lamps and related works in this style come from Essaouira and Meknes and date to the early twentieth century.

PROVENANCE: purchased from Jacob Posen, New York, in 1964. SIMILAR LAMPS: Wolfson Museum (Muller-Lancet and Champault, no. 121); Moldovan Family Collection, New York (Grafman 1999, no. 74); Harvard University (Gilboa, no. 52); Max Stern Collection, New York, acc. no. MS/H 525; Sotheby's TA 1990, lot 296. RELATED WORKS: *kandil* in Shlomo Pappenheim Collection (Muller-Lancet and Champault, no. 52); prayer shawl bags in The Jewish Museum (Mann 2000a, nos. 17–18).

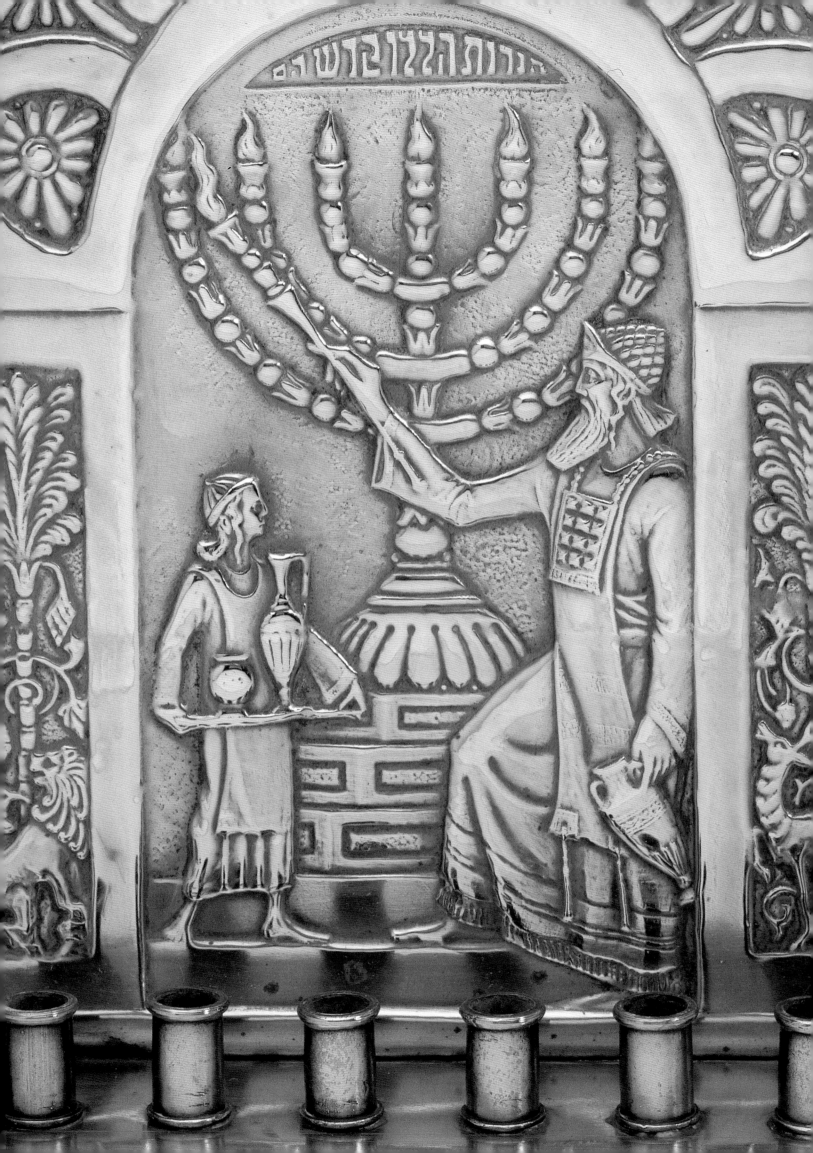
הנרות הללו קודש

THE MIDDLE EAST AND ASIA

ISRAEL

Hebrew presence in the land of Israel began with the patriarch Abraham in the early second millennium B.C.E. The first Israelite kingship was established under Saul and David around 1000 B.C.E., but the sovereign nation underwent a number of setbacks over the succeeding centuries. It split into two kingdoms, and Assyrians from northern Mesopotamia (now Iraq) conquered and dispersed the inhabitants of the northern kingdom, Israel, in the late eighth century B.C.E. Two centuries later, Judah, the southern kingdom, came under the control of the Babylonians of southern Mesopotamia. After successive rule by the Persians and then the Greeks, the Maccabean revolt reestablished independent kingship until the Roman takeover in 63 B.C.E. From the seventh century C.E. through 1917, the land of Israel was mostly under the rule of a succession of Islamic empires, the most recent being the Ottoman. Jewish communities existed there throughout the centuries, although much of the time the population was small; for example, around 1800 there were perhaps five thousand Jews. The indigenous inhabitants who had never left the land were joined during the medieval period by Sephardi immigrants from Spain, Ashkenazim from central and eastern Europe, and North Africans. Concentrated in cities or small towns, most attempted to make a living through crafts such as fabric dyeing or metalsmithing, but economic conditions were often difficult and many relied on funds raised from Diaspora communities. Jerusalem, Safed, Hebron, and Tiberias among other cities became major centers of learning and spirituality for the entire Jewish world.

This situation changed in the later nineteenth century. More secularly oriented west European intellectuals joined with eastern European Jews seeking the restoration of traditional Jewish values to forge a movement to return to the land of Israel and work the ancestral soil. These Zionist pioneers formed agricultural settlements and collectives, fostered the use of Hebrew as a vernacular language, and favored the creation of a national state. The two different populations of Palestine, the more religious existing community and the Zionist newcomers, managed to coexist, the one seeing Israel as the Holy Land, the other hoping for the creation of a Jewish nation.

The lamps in the collection date to the twentieth century, and reflect the situations faced by the various populations living in the land of Israel and their attempts to create a new Jewish identity. The earliest were produced in the Bezalel School of Arts and Crafts in Jerusalem, which was founded in 1906 to create a new "Hebrew" style, as well as to stimulate crafts industries that would help support the Zionist settlers in Palestine. The brainchild of Boris Schatz, a Lithuanian-born artist (1866–1932), the school reflected a combination of the nationalist trends springing up in Europe, the Zionist ideal of creating a vibrant homeland for Jews, and art-world currents such as the Arts and Crafts movement, which emphasized a return to handcrafts, nature, and ancient national themes as well as modern national identity. The teachers at the school were mainly Europeans, and the works they created embodied a curious blend of Islamic and European styles (particularly

Detail of no. 79.

Art Nouveau), secular and Jewish motifs, and ancient and modern references (see nos. 79–81). All were designed to create an idealized image of the new Jew in his or her biblical homeland. Unfortunately, financial difficulties caused the school to close in 1929.

Six years later, the New Bezalel School opened under the directorship of Joseph Budko (1888–1940), who was originally from eastern Europe. Rejecting the romanticization of the earlier school, Budko and the artists immigrating to Palestine with the rise of Nazism espoused the modern aesthetic of movements like the Bauhaus as the Jewish art of the future. Generations of New Bezalel–trained artisans and designers turned away from distinctive Jewish iconography in favor of the geometric shapes, unornamented surfaces, and internationalism of modernist design. Sometimes only the form and possibly a Hebrew inscription indicated the Jewish ritual function of the work. Two German-born Judaica artists who contributed greatly to the design of contemporary ceremonial art were teachers at Bezalel: Ludwig Y. Wolpert and David Gumbel (see, respectively, nos. 97–99 and 32). Zelig Segal and Amit Shur are two important graduates represented in the collection who

have continued to work in Israel, creating innovative ceremonial art that constantly re-imagines the form while subtly overlaying it with Jewish content (see nos. 85 and 84).

Other trends are reflected in the Hanukkah lamps of the twentieth century as well. An example of immigrant adaptation in Israel can be seen in the work of Yemenite Jews who began arriving in Palestine at the end of the nineteenth century. They contributed their expertise in silver filigree to the Bezalel workshops, but also created new versions of the stone lamps used in their homeland (see no. 82). Hanukkah lamps made in the 1950s, after the establishment of the State of Israel in 1948, frequently embodied nationalistic images of victorious soldiers and the emblems of the state (e.g., nos. 558 and 559 in the catalogue raisonné).

IRAQ

The Jewish community of Iraq has roots going back to the sixth century B.C.E., when the Babylonian Empire conquered the kingdom of Judah and the kings and nobility were exiled to Babylonia (now southern Iraq). In the seventh century C.E., Mesopotamia came under Islamic control, and the Jews lived under a succession of empires much as their co-religionists in the land of Israel did. The political and social position of the Jews changed with each new caliph, and there were periods of tolerance and others of more severe restrictions and discrimination. In spite of these vicissitudes, Jews managed to survive and many times to succeed, becoming physicians, writers, government officials, and economic leaders. They were renowned for their rabbinical academies and their Jewish scholarship, and produced a Babylonian version of the Talmud, the compendium of commentary on Jewish law and lore, between the third and fifth centuries.

By the nineteenth century, when two of the lamps in the collection were made, the Jews had successfully integrated into Muslim life, for example, holding high governmental office and dominating trade with Europe and the Far East. This situation continued under the British Mandate beginning in 1917. However, once Iraq gained independence in 1932, Jews were dismissed from their posts and hampered from engaging in commerce. With the declaration of the State of Israel in 1948, repressive measures against the Jews were instituted, and a mass exodus began, at first illegally, to Iran and Israel.

It is probable that the Hanukkah lamps in the collection were made by Jews, since Jewish goldsmiths and workers in other metals were known there from the first millennium and continued to practice into the Ottoman period (Wischnitzer, pp. 57, 67–68). Most likely the Muslim prejudice against engaging in metalwork, discussed in the chapter on North Africa, applied in Iraq as well.

INDIA

The history of the Jews in India is long and complex, extending back more than one thousand years. The traditional Indian attitude of tolerance for other ethnic or religious groups

enabled Jews to find a secure homeland and retain their religious identity while at the same time integrating into Indian economic, social, and military life. Indian Jewish culture is quite varied, since three separate groups settled in South Asia, each with its own historical, linguistic, and cultural affiliations. The Bene Israel probably arrived as early as the second century B.C.E. and settled in the villages of the Konkan region, and later Bombay, on the western coast. For centuries they remained isolated from other Jewish communities, and practiced a simple form of Judaism incorporating Muslim and Hindu customs. They did not celebrate Hanukkah at all until the nineteenth century, when it was introduced from one of the other Indian Jewish communities. A second distinct community, that of Jews living in Cochin on the southwestern coast, may have arrived as early as the first century C.E. They became active in the local pepper trade, and many were prominent merchants and financiers. The third group, the Baghdadi, came primarily from Syria and Iraq in the late eighteenth century and founded communities in Calcutta in the east and in Surat and Bombay in the west. The new arrivals brought with them the Arabic culture and Jewish observances of their homelands, and were attracted by the rich opportunities for trade between India and the Middle East.

The lamps in the museum's collection come from the nineteenth and twentieth centuries, when all three communities were thriving; they reached a population peak of some thirty-five thousand people. In the late 1940s, many Jews left India, either attracted to the newly established State of Israel, or else concerned about the economic situation after the transition to Indian independent rule. Today, very few Jews remain, and the centuries-old way of life of Indian Jewry may eventually disappear.

79

Ze'ev Raban
(b. Lodz 1890,
d. Jerusalem 1970)
Sharar Cooperative, Bezalel
School, Jerusalem, early 1920s

Copper alloy: die-stamped; 10¾ x
8⅛ x 2³⁄₁₆ in. (27.3 x 20.6 x 5.6 cm)

Gift of Dr. Harry G. Friedman, F 5455

HEBREW INSCRIPTIONS: "These lights
are holy" / Bezalel Jerusalem

This lamp combines many of the complex stylistic elements and symbols that character-ized the Bezalel School's aesthetic. European Art Nouveau is reflected in the interlacing arch around the central panel, and in the graceful forms of the gazelle and the date palms. The latter two are indigenous to the land of Israel, thus also conjuring up roman-tic images of the Middle East. Interest in biblical history is reflected in the central scene depicting the High Priest lighting the Temple menorah. Finally, reference is made to the ancient Jewish state through the use of a simulated coin at the top, suggesting the type that would have been minted by ancient Hasmonean kings as a symbol of independence from Hellenistic and Roman control. This is echoed by the symbols across the bottom of the bench, including the grape, pomegranate, and date palm, which were also taken from ancient Jewish coins.

The designer of this lamp was Ze'ev Raban, one of the major artists of the early Bezalel School from 1912 until 1929, when it closed. Raban was amazingly prolific and versatile, and he continued designing carpets, metalwork, book illustrations and posters, public relations material, even furniture and architectural ornamentation. Despite the wave of modernism that swept Israel, Raban maintained his more tradition-based style and iconography throughout his career.

MAKER'S MARK: Shilo-Cohen 1982, p. 236, no. 8. DATE OF ACQUISITION: 1963. SIMILAR LAMPS: Congregation Emanu-El, New York (Grossman 1989b, no. 165); Einhorn Collection, Jerusalem (Goldman Ida, no. 82).

80

Bezalel School,
Jerusalem, 1908–29

Silver: cast, filigree, and pierced;
turquoise; carnelian; 4⅞ x 8¹⁵⁄₁₆ x
1½ in. (12.4 x 22.7 x 3.5 cm)

Gift of Dr. Harry G. Friedman, F 4904

HEBREW INSCRIPTIONS: Hanukkah;
"These lights are holy"

This richly patterned silver lamp depicts a pair of lions guarding a menorah. Behind them, two priests hold torches for lighting the lamp. The artist may have based their hairstyles as well as the decoration and cut of their wide-sleeved tunics on Persian reliefs of the sixth through fourth century B.C.E. The closest parallel for the priests' costume is on a colored tile relief of a royal guardian from Susa, who holds a staff in front of him in the same way the priest holds the torch (Porada, pl. 42). Susa was excavated beginning in 1884, and the relief could possibly have served as a model for the artist who designed this lamp.

The columns and crenellated roof are suggestive of the ancient Jerusalem Temple, the focus of the Hanukkah story. The inclusion of common Middle Eastern stones—turquoise and carnelian—as well as the Yemenite-style filigree work further contribute to the Eastern character of the lamp. It was probably created in the silver filigree workshop, which was founded in 1908, two years after the opening of the Bezalel School.

MAKER'S MARK: "בצלאל" (Bezalel). BIBLIOGRAPHY: Shilo-Cohen 1982, no. 665; Lawrence, no. 21. SIMILAR LAMPS: Congregation Emanu-El, New York (Grossman 1989b, nos. 167–68); Sotheby's NY 1985b, lot 126; Shilo-Cohen 1983c, p. 224.

81

Bezalel School,
Jerusalem, 1909–29

Copper alloy: repoussé, traced,
and pierced; semiprecious stones;
5⅞ x 11⅝ x 2⅛ in.
(15 x 29.1 x 5.4 cm)

Gift of the Estate of Prof. and
Mrs. Richard Gottheil and Eva Leon,
JM 26-54

HEBREW INSCRIPTION:

אם אין אני לי מי לי

"If I am not for myself, who is for me?"
(Ethics of the Fathers 1:14)

The tensed crouch of the lions, as if about to tear open their prey, and the contrasting colors of the stone and the copper candleholder create a lively sense of movement that is characteristic of Art Nouveau. This is heightened by the eastern interlace pattern and the stalking, sinuous lions below. A Hebrew inscription has been encoded in the center of the arch of the backplate, barely distinguishable from the interlace surrounding it. It contains a verse from the Ethics of the Fathers, quoting Rabbi Hillel of the first century, who asked, "If I am not for myself, who is for me?" By this Hillel meant to signify the importance of caring for one's own body, based on humankind's likeness to God. While this may at first seem to be self-serving, the passage counters this sentiment as it continues: "If I care only for myself, what am I?" The final question in this famous quotation ends with "If not now, when?"—an admonition not to postpone one's duty.

MAKER'S MARK: "בצלאל ירושלם" (Bezalel Jerusalem). BIBLIOGRAPHY: Lawrence, no. 51. SIMILAR LAMPS: The Jewish Museum, F 4018; Congregation Emanu-El, New York (Grossman 1989b, no. 166).

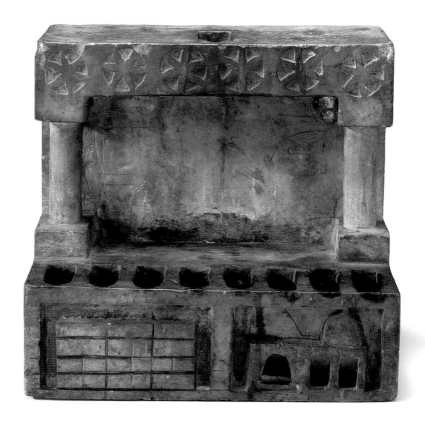

82

Palestine, c. 1880–1930

Limestone: chiseled, incised,
and painted; 8⅜ x 9¼ x 6 in.
(21.3 x 23.5 x 15.2 cm)

Gift of the Collection of Oscar
and Regina Gruss, 1994-706

Stone Hanukkah lamps are known from only three regions: Morocco, Yemen, and Avignon, France, the last-named a unique and very early example of medieval date (see fig. 8). They all share the same block form with oil wells carved out on the top. It has been suggested that their use in such far-flung locales may represent the survival of an ancient custom of using stone lamps, perhaps originating in Israel (B. Narkiss 1988, p. 13; Muchawsky-Schnapper 1982, p. 81). This theory is difficult to substantiate, however, since stone lamps of this blocklike form are unknown from archaeological excavations in Israel up through the Byzantine period.

The stone lamp in the Jewish Museum collection is of Yemenite type, possessing the rowboat-shaped oil wells typical of both secular and ritual lamps from that country. However, its architectural form as well as its carved and painted decoration are completely unknown on Hanukkah lamps made in Yemen. This more elaborate lamp represents an adaptation by Yemenite immigrants, who first came to Palestine around 1880. Finding work in the stone-cutting trade, they would occasionally make stone lamps while constructing houses. This production continued through the 1930s (Muchawsky-Schnapper 1982, p. 82).

The architectural form of the lamp, with its two columns supporting an architrave decorated with rosettes, echoes the ancient Roman-period tombs carved into the rocks around Jerusalem. These could easily have served as the inspiration for the lamp. On the front of the bench are depictions of two important Jewish sites in Israel: a wall, most likely the Western Wall in Jerusalem, and a domed structure, probably the tomb of the matriarch Rachel.

PROVENANCE: purchased by Mr. and Mrs. Gruss in 1962 or 1963 from a private owner in Switzerland; acquired in 1994.
SIMILAR LAMPS: Israel Museum (Landau, nos. 7 and 38).

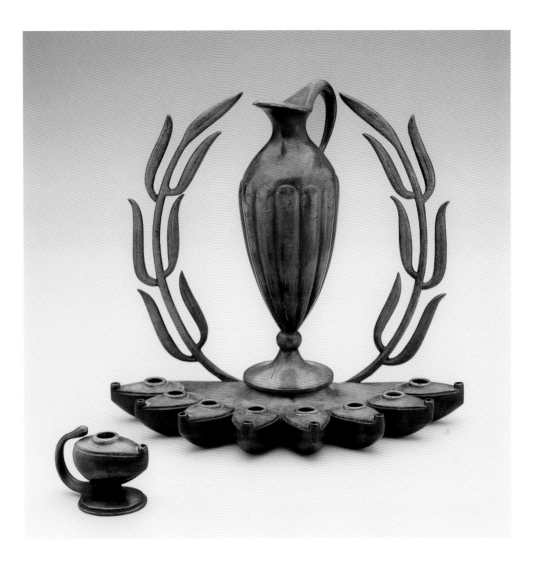

83

Maurice Ascalon
(b. Hungary 1913,
d. United States 2003)
Pal-Bell Co., Tel Aviv, 1950

Copper alloy: cast and patinated;
7⅝ x 8⅜ x 4⁵⁄₁₆ in.
(19.4 x 21.3 x 11 cm)

The Jewish Museum, JM 6-54

Fashioned two years after the creation of the State of Israel, this lamp harks back to ancient models in its form and surface decoration. The shape of the oil containers simulates that of Roman lamps, while the green patina suggests the coloration found on ancient bronzes. This type of patination was a favorite form of surface decoration in the land of Israel from the days of the early Bezalel School, and was chosen to link the art of the new settlers to that of their ancient ancestors (Shilo-Cohen 1983a, p. 281). The pitcher in the center is a reference to the miracle of the sanctified oil during the ancient dedication of the Jerusalem Temple.

The maker, Maurice Ascalon, trained in Brussels and Milan before immigrating to Palestine in 1934. Among his works is a large copper sculpture, *The Toiler of the Soil, the Laborer, and the Scholar*, which decorated the façade of the Palestine Pavilion at the 1939 World's Fair and is now in the collection of the Spertus Museum, Chicago. Ascalon started the Pal-Bell Company in the late 1930s for the production of ritual and secular decorative arts objects. This lamp won first prize at the 1950 Tel Aviv Design Competition.

Ascalon immigrated to the United States in 1956, where he taught sculpture at the University of Judaism in Los Angeles, and founded Ascalon Studios. His son and grandson now run the studio and continue to produce large-scale sculpture for public spaces and houses of worship.

MAKER'S MARKS: "PAL-BELL CO. LTD." with interlace design in rounded square. HALLMARK: "MADE IN ERETZ ISRAEL". DATE OF ACQUISITION: 1954. BIBLIOGRAPHY: Braunstein and Weissman Joselit, no. 46, fig. 68. SIMILAR LAMPS: Palestine Galleries, p. 3; Natalie Halpern Eichen Collection (Plous, no. 39). OTHER WORKS BY ASCALON: Smithsonian American Art Museum Art Inventories Catalogue, http://www.siris.si.edu.

Amit Shur was born in Kibbutz Kinneret, Israel, in 1955. She completed her studies in the Department of Gold and Silversmithing at the Bezalel Academy of Art and Design in 1984. From 1980 to 1993, she taught jewelry-making at the Canadian Hadassa-Wizo Neri Bloomfield College of Design. The recipient of many awards, Shur won the coveted Jesselson prize for Contemporary Judaica Design in 1994. Her work has appeared in many exhibitions in Israel and abroad, including *Nerot Mitzvah* at the Israel Museum in 1985 as well as in commercial galleries (Weiser, p. 65).

Shur's lamp is constructed of two parts—a shallow square metal container that holds the necessary oil and an aluminum cover, pierced with a series of small cross-shaped slits, that allows one to pull the wicks through the slits in preparation for lighting. Although designed as a Hanukkah lamp, the artist concedes that the lamp could be used for other occasions—"the lamp is a modular use lamp for birthdays, holidays and eternity occasions (i.e., commemorative occasions etc.)" (artist's statement, 1986).

Shur's design is guided by a sense of practicality and purpose. Regarding the creation of Hanukkah lamps she makes the following observations:

An original Hanukkah Menorah represents a challenge that is at once Jewish and universal. . . . I focused on its original and most basic function. When one strips away the ornamentation accumulated over the centuries, one is left with an object that was devised essentially as a practical solution in response to the commandment of performing a specific ritual, namely kindling the lights. That activity directly ties the object to present-day Jews, who continue to perform the same ritual in commemoration of the original event. . . . I was ultimately guided by the same practical concept as that which presumably guided the original design, namely, the creation of a depression in the material so that it can be filled with oil. My menorah is thus an attempt to return, in terms of its basic design, to its ancient and original function. At the same time it is essentially a product of the present century because of the technology used to create it (artist's statement, n.d., courtesy the Spertus Museum).

Shur cites three main elements as key to her work. "Foremost of these is its practical usefulness. . . . The other two are observance of religious ritual and perpetuation of the Jewish cultural tradition" (artist's statement, n.d.). SR

SIGNATURE: "Amit Shur / 6 /1986 / Israel". DATE OF ACQUISITION: 1986. BIBLIOGRAPHY: Lawrence, no. 72. OTHER JUDAICA BY SHUR: Friedberg, fig. 5; Israel Museum, p. 17; Waale, p. 31; Weiser, p. 66.

85

Zelig Segal
(Israeli, b. 1933)
Jerusalem, 1986
Copper alloy: cast and
silver-plated;
1¼ x 12⅝ x 2 in
(3.2 x 32 x 5.1 cm)
Purchase: Judaica
Acquisitions Fund,
1986-120 a,b

Zelig Segal is an Israeli artist who is passionately interested in creating ritual objects that bring a fresh, imaginative approach to Jewish ceremony. He strives for modern design solutions that link the technological innovations of today with ancient traditions. Simple, geometricized shapes and an aesthetic of refined simplicity characterize his work, which is profoundly colored by his knowledge and training in Judaism and its traditions. Segal received his religious training in a *heder* and *yeshivah* and studied metalsmithing and Judaica at Jerusalem's New Bezalel School under Ludwig Y. Wolpert and David Gumbel, two of the most influential leaders in Jewish ceremonial design of the twentieth century. He graduated in 1954, and later headed the school's Department of Gold and Silversmithing from 1964 to 1968 (Weiser, p. 61).

The juxtaposing of negative and positive elements is a recurring theme in Segal's work. The artist finds myriad ways to express this concept—sometimes using the profiles to create a plus/minus tension, other times working with surface finishes to create a sense of differentiation. Segal ingeniously continues his exploration of positive and negative space with this 1986 Hanukkah lamp. The lamp simply consists of two sliding bars each notched with eight semicircular openings. When aligned, the notches form receptacles for candles. The bars are made to slide—so that as each day of Hanukkah passes, the number of holes can be increased to mark the passing of a new day of the celebration. Segal's design creates a lamp which is reduced to its most essential elements—a support with eight holes and a *shamash*. The *shamash* is placed at the top end of one of the bars—subtly differentiated from the other candle receptacles by its distance. Segal's lamp seems somehow caught between contemporary sculpture and modern machinery, and yet is informed by Jewish tradition. The artist said about the meaning of this lamp: "The two halves are in remembrance of the destruction of the Temple. When the Messiah comes it will become one unit. I wanted people to see the miracle of Hanukkah in the Hanukkah lamp by the fact that you start with the first candle, and then the second day the second candle" (artist's statement, 2003). Segal created a Hanukkah lamp that is more than a static object. His work is active—it is altered not only by the illumination of additional candles, but also by the actual shifting of the two bars so that a new receptacle is created each day. This subtlety is yet another example of Segal's thoughtful and innovative approach to ceremonial art. SR

SIGNATURE: "Z. Segal"; "1986"; "Jerusalem / Israel". DATE OF ACQUISITION: 1986. OTHER WORKS BY SEGAL: Fishof and Zalmona; Israel Museum, p. 74; Friedberg, no. 8; Weiser, p. 62.

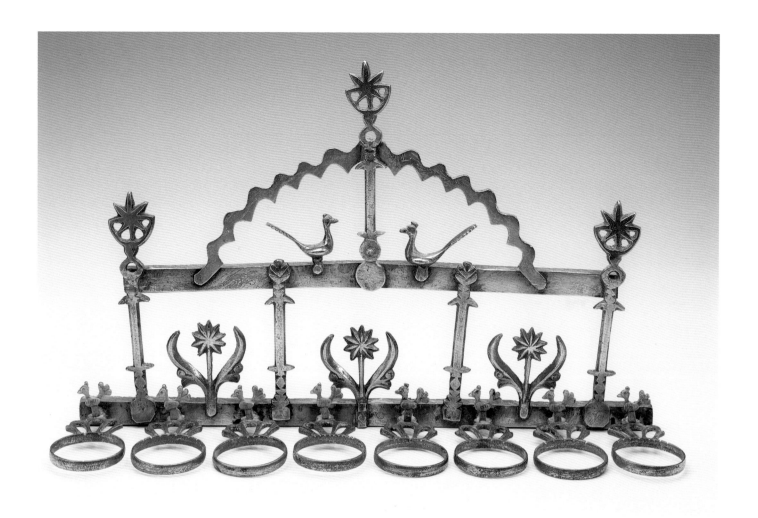

86

Baghdad,

19th–early 20th century

Copper alloy: cast; 10⅝ x 17¾ x 4½ in.

(27 x 45.1 x 11.5 cm)

Gift of Dr. Harry G. Friedman, F 4254

The iconography and form of Iraqi Hanukkah lamps reflected changing political and economic conditions, as Iraq went from Ottoman rule to British takeover in 1917, and finally to independence in 1932 (Sharoni-Pinhas). Ottoman-period lamps were all of the wall-hung variety typical in Islamic lands, and decorated with symbols taken from the Muslim world. This is exemplified in this lamp by the stars in crescents, Islamic emblems that took on a new significance when adopted by the Ottoman Empire as its symbol. The birds had a more religious meaning; those on the lamp appear to be peacocks, which can be associated in Islam with light. Many Iraqi lamps of this type, including a second example in the Jewish Museum collection, have prominent *hamsas*, or raised hands, which in both Jewish and Muslim culture are believed to have protective powers. The eight rings on this lamp, each decorated with a peacock, once held large glass oil cups.

This lamp type has been dated to the nineteenth century (Sharoni-Pinhas, no. 1); this dating is supported by a similar example in the Smithsonian Institution, Washington, D.C., which was acquired in the Middle East between 1899 and 1913.

PROVENANCE: purchased from S. Wattenberg, Long Branch, New Jersey, in 1956. SIMILAR LAMPS: The Jewish Museum, F 2919; Babylonian Jewry Museum (Sharoni-Pinhas, no. 1); Ticho Collection (M. Narkiss, no. 165); Wolfson Museum (Hechal Shlomo, acc. no. 69/246); Israel Museum (Shachar 1981, no. 386); Smithsonian Institution (Cohen Grossman 1997, p. 163).

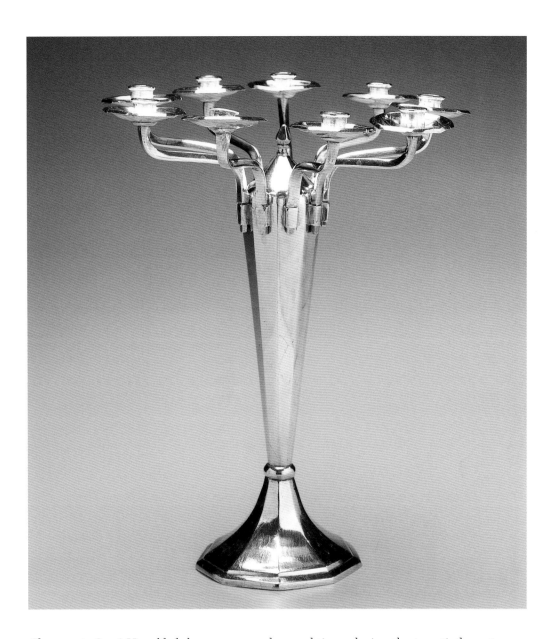

87

Baghdad, 1940

Silver: repoussé, punched,
and cast; 10⁷⁄₁₆ x 8⁵⁄₁₆ in. (diameter)
(26.5 x 21.1 cm)

Gift of Sun Soffair, 1996-153

Changes in Iraqi Hanukkah lamps occurred several times during the twentieth century, in tandem with changes in political rule. Around the 1920s, during the period of British government, a European-style menorah-form lamp was introduced, probably by the influx of British personnel and other Europeans. With Iraqi independence in 1932, a completely new type of lamp became popular in Iraq, a standing lamp with arms placed in a circle around the shaft. This form may have evolved from the menorah-shaped lamp introduced a decade earlier, but the reason for its popularity is unclear (Sharoni-Pinhas, p. 46). Moreover, a lamp with lights in the round can, according to many rabbinical authorities, negate the efficacy of the ritual (see introductory essay). Most Jewish communities, including those in Iraq, developed Hanukkah lamps with lights in a straight line in order to avoid this problem. Many rabbis in Iraq did in fact have difficulties with the form of this new round lamp, but the chief rabbi Yosef Ḥayyim ruled that it was acceptable as long as there was enough space between the individual lights so that they did not resemble a single flame (Sharoni-Pinhas, p. 47).

The donor of this lamp is an Iraqi Jew from Baghdad who emigrated to the United States.

PROVENANCE: purchased by Sun Soffair in Baghdad in 1940; acquired in 1996. SIMILAR LAMPS: Babylonian Jewry Museum (Sharoni-Pinhas, nos. 5–6); Weinstein, no. 179; Christie's Amsterdam 1986, lot 184; Sotheby's London 1988, lot 172; Kestenbaum 2000, lot 16; Kestenbaum 2001, lot 13.

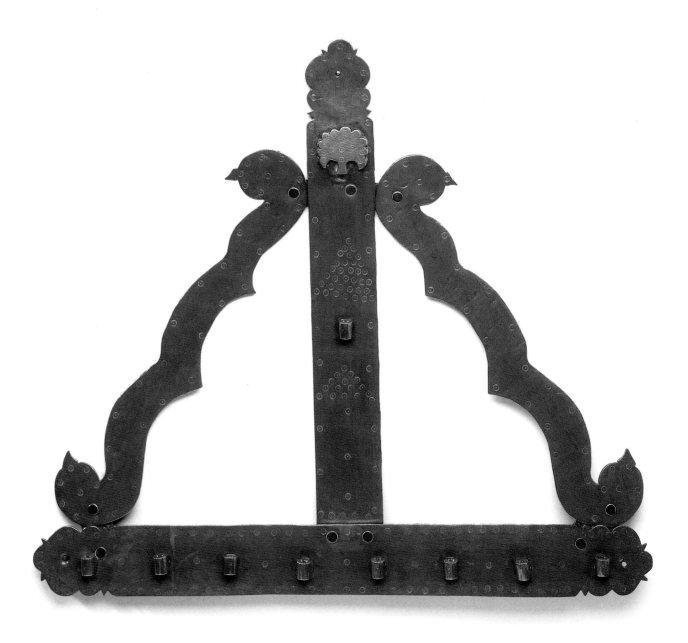

88

Cochin(?), 19th–20th century

Copper alloy: punched, appliqué,
and cast; 23 1/16 x 26 3/4 x 7/8 in.
(58.1 x 68 x 2.2 cm)

Gift of Dr. Harry G. Friedman, F 5115

All three Jewish communities in India used Hanukkah lamps with backplates composed of three metal strips arranged in a triangular form. Those on the Cochini lamps have curvilinear shapes, as represented here, while those on Baghdadi lamps are straight with a scalloped edge (Slapak, p. 84 bottom left). Sockets across the bottom of this lamp would have held long curved metal brackets, now missing, in which glass cups for the oil were placed (as in no. 89). This method of holding the oil containers was adopted by the Cochini community from the Baghdadi and Bene Israel Jews, and was most likely introduced from Iraq (see, e.g., no. 86; Slapak, p. 85, 91). Cochini oil containers traditionally consisted of an attached row of ovoid metal vessels, or a metal shelf across the bottom of the lamp with holes for glass cups (see no. 572 in the catalogue raisonné).

PROVENANCE: purchased from Keymans Antique Shop, New York, in 1960. SIMILAR LAMPS: Magnes Museum (Eis 1977, nos. MC 73–74); Wolfson Museum (Slapak, p. 93 bottom left).

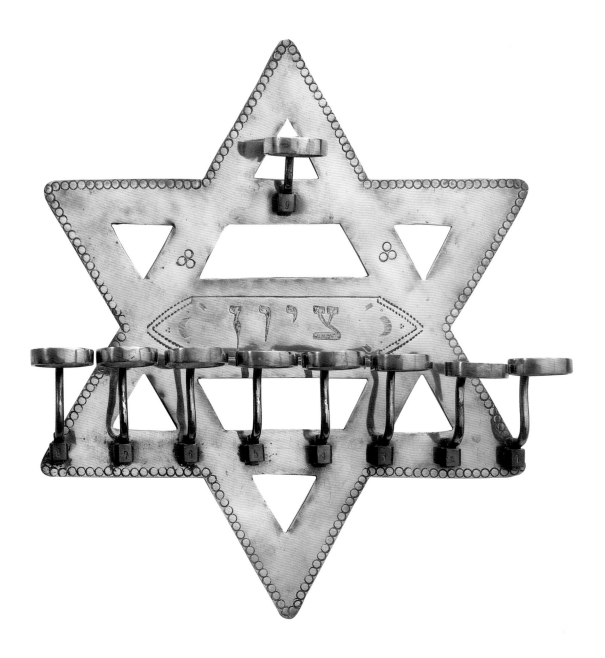

89

India, end of the
19th–20th century

Copper alloy: pierced, engraved,
traced, punched, and cast; 18½ x
15¾ x 4¾ in. (47 x 40 x 12.1 cm)

Purchase: gift of Mr. and Mrs. Sidney L.
Quitman, by exchange, 1998-57

HEBREW INSCRIPTION: Zion

Lamps in the form of the Star of David are characteristic of the Bene Israel community, which is centered around Bombay on the western coast of India. The star was adopted as the Zionist emblem at the First Zionist Congress in Basel, in 1897, although it had become popular on all types of ceremonial art even earlier in the nineteenth century. The inclusion of the word "Zion" with the star form may here reflect Zionist sympathies on the part of the Bene Israel community. However, interest in a Jewish homeland was tempered by fears that the Bene Israel would not be accepted in a Jewish state founded by western Jews (Roland, p. 80).

A second lamp in the museum collection is a replica of this type, donated by a member of the Bene Israel community living in New York. Fearful that traditional forms were fast disappearing, he commissioned the lamp from a New Delhi metalsmith around 1980.

PROVENANCE: purchased at Sotheby's Tel Aviv in 1998. BIBLIOGRAPHY: Sotheby's TA 1998a, lot 317. SIMILAR LAMPS: The Jewish Museum, 1986-15 (gift of Erna and Samuel Daniel Divekar in memory of Yerusha and Michael Daniel Divekar); Israel Museum (Shachar 1981, no. 388; Slapak, p. 83 bottom right, p. 84 top right, p. 85); Magnes Museum (Eis 1977, nos. 66–68); Aden (Goldsmith and Messa, p. 18).

THE AMERICAS

The arrival of Jews in the Western Hemisphere began with Christopher Columbus and several members of his crew who were New Christians, or forced converts from Judaism. Small numbers of Judaizing New Christians settled in South America from the sixteenth century on. A community of Sephardi Jews was established in Brazil when it was under Dutch rule, and twenty-three refugees from there, fleeing the Portuguese conquest and Inquisition, became the first Jewish settlers in North America. In 1654 they arrived in a town called New Amsterdam, known today as New York City.

These Sephardi newcomers were soon outnumbered by Ashkenazi immigrants from central and eastern Europe. In the early nineteenth century there were no more than four thousand Jews in the United States, engaged in plantation agriculture, land speculation, finance, industry, and the professions. Tremendous growth in the population occurred between 1820 and 1880, as Jews arriving from Germany, Poland, Bohemia, and Moravia swelled the numbers to over a quarter of a million. During this period, Jews identified strongly with German American culture and with Reform Judaism, which sought a more relaxed, rationalist interpretation of the traditions. After the Civil War, Jews became particularly prominent in the ready-made clothing industry, after having supplied uniforms for the troops during the war.

During this phase of settlement Jews were finally recognized politically in all the states. Although equality had been guaranteed on the federal level by the Constitution in 1787, in effect most power lay with the individual states, and barriers to Jewish participation in government persisted in some states for decades after independence. Although Jews in America were never subject to the violent persecutions and expulsions found in Europe, in various periods they did encounter anti-Jewish prejudice as well as private restrictions on entry into professions, universities, and social organizations.

The last major wave of immigration took place between 1880 and 1929, composed of eastern European Jews fleeing pogroms, expulsions, and lack of opportunities to earn a living. By 1929, Jews in the United States numbered four and a half million, the largest Jewish community in the world. The new immigrants became petty traders, laborers, or businessmen, particularly in the clothing industry, and their culture was primarily Yiddish. Their children, however, became wholly Americanized, and moved into finance, real estate, the entertainment industry, the professions, and white-collar occupations.

A similar mass immigration occurred in the late nineteenth century to South America, where the Jewish population had remained relatively small until then. Argentina attracted the largest number of newcomers; these came mostly from central and eastern Europe, with smaller numbers from the Balkans and Islamic lands.

The earliest lamps in the collection from the United States date to the period of eastern European immigration. Most either display the eclectic revivalist styles of contemporaneous European decorative arts, or else imitate silver and brass cast types unique to eastern Europe, sometimes with distinctive American variations (see nos. 91 and 93). Mostly

Detail of no. 103.

185

mass-produced, they lack the careful handwork of silver repoussé, and were likely marketed to the immigrant population and their descendants. In fact, many of the silver objects bear an imitation Russian silver assay mark of "84" alongside the American guarantee mark of "sterling," probably to convince the newcomers that the works were in fact silver.

American-made silver lamps of the caliber found in Europe in the eighteenth and early nineteenth centuries are rare. It is possible that these are still held in private hands and therefore largely unknown to scholars, or else Jews may have brought or imported their lamps from Europe. This is exemplified by a lamp owned by the Schiffs, a prominent New York family at the end of the nineteenth and beginning of the twentieth century who originally came from Frankfurt. The lamp had been made in Frankfurt at least 150 years earlier and could conceivably have been a family heirloom (no. 12). By contrast, many of the menorah-form lamps made in the United States were cast from an inexpensive metal alloy called "white" or "pot" metal that was then silver-plated (see no. 596 in the catalogue raisonné).

The true creativity in American Hanukkah lamps comes only after World War II. Although a few examples of modernist styles such as Arts and Crafts and Machine Age of prewar date are found in the collection (e.g., nos. 94 and 95), it was not until after the war that the smooth unornamented surfaces and linear emphasis of the international style were fully adopted in American Judaica. A major impetus was the establishment of the Tobe Pascher Workshop in The Jewish Museum in 1956, the goal of which was to create ceremonial art in a contemporary idiom that would enhance traditional rituals and express the vibrant future of Judaism. The museum brought in Ludwig Y. Wolpert, a silversmith trained in Germany and by then a teacher at the New Bezalel School in Jerusalem, to head the workshop. Wolpert was soon joined by his student Moshe Zabari, who continued as director of the workshop after Wolpert's death in 1981. The large number of synagogues founded after World War II, mostly in response to the movement of population into the suburbs, provided a receptive market for their works, and commissions went out all over the country and abroad. The funders of the workshop, Dr. Abram Kanof and his wife, Dr. Frances Pascher, also provided acquisitions funds for several Jewish museums to purchase workshop pieces for their collections.

Wolpert brought the clean lines of modern decorative arts to Judaica. His only surface ornamentation was the calligraphic forms of Hebrew letters in appropriate inscriptions (see nos. 97–99). Also beginning in the 1950s, ceramists Gertrud and Otto Natzler began to create Hanukkah lamps with modern forms and elaborate glazes (see no. 100). Architects designing modern-style synagogues in the 1950s commissioned sculptors to create large menorot and Hanukkah lamps, resulting in works that pushed the boundaries of form and decoration (see no. 615 in the catalogue raisonné).

Through the 1980s, American Hanukkah lamps were largely formalist experiments, taking the form in new directions, and reflecting current trends in the art world, while

often embodying spiritual and historic ideals. For example, a lamp by Moshe Zabari of crumpled metal and called *Masada* was created at a time when new finds were being excavated from this famous site in Israel (no. 101). From the 1980s on we begin to see fine artists and architects who had never made ceremonial art turn to making Hanukkah lamps, sometimes inspired or commissioned to do so by curators at Jewish museums. Works by contemporary artists Joel Otterson and Matthew McCaslin blur the lines between crafts and fine arts, between function and display (see nos. 107 and 110). An expansion of the concept of Hanukkah to more worldly concerns is seen in the lamp by Salo Rawet, entitled *In Search of Miracles*, which consists of sixty test tubes filled with oil and wicks, meant to be lit all year long for the betterment of the world (no. 108).

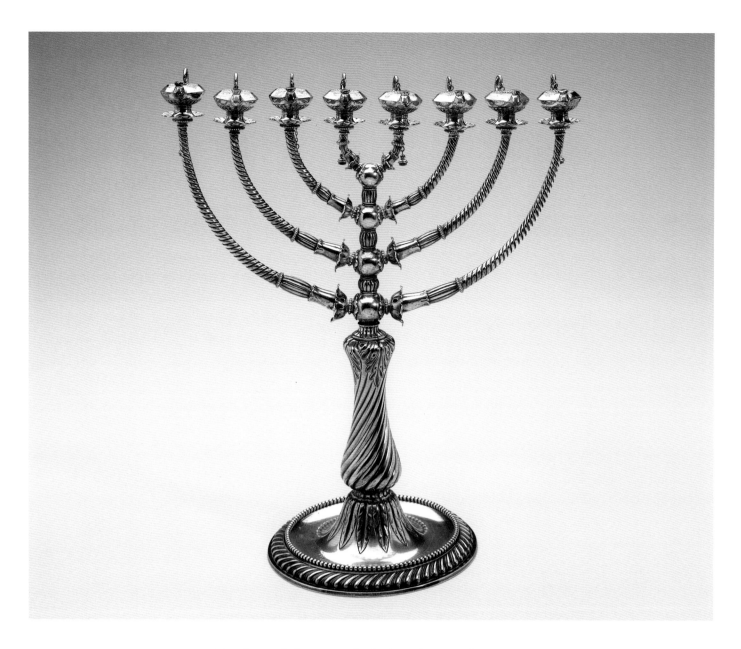

90

Gorham Manufacturing
Company (1865–1961)
Providence, Rhode Island, 1885;
inscription date 1918/19

Silver: cast and engraved; 13⅞ x

12 x 6⅛ in. (34.1 x 30.5 x 15.6 cm)

Gift of Louis S. Brush, S 1366

ENGLISH INSCRIPTION: Presented by
Louis S. Brush 5679 [=1918/19]

The diagonal fluting on the body and arms of this lamp lends it a Moorish air, compounded by the oil containers that resemble Aladdin's lamps. In fact, the latter are in the form of Roman oil lamps, and are reminders of a method of lighting used in the Temple in Jerusalem. The Hebrew word "menorah" actually means lampstand, and the seven-branch menorah originally served in the Temple as a stand to support individual oil lamps. This can be seen in representations in ancient Jewish art, for example, on a Roman burial plaque of the third or fourth century in The Jewish Museum (see fig. 6).

The great influx of eastern European Jews beginning in the 1880s caused the Jewish population in the United States to increase from around two hundred eighty thousand to four and a half million by 1925. This potential market for ceremonial objects must have captured the attention of the big silver manufacturers such as Gorham, one of the largest in the nineteenth century. Gorham was among the first to employ machinery in the production of silver objects, yet in the 1890s they returned to hand-hammered work, creating a line of highly regarded Art Nouveau–style objects such as mirrors and vases (Krekel-Aalberse, p. 100; Rainwater, p. 90; Bowman, no. 71). This lamp was made in 1885, the first year that Gorham began to manufacture ecclesiastical objects.

HALLMARK: "STERLING". MAKER'S MARKS: Rainwater, p. 70, 4th line from bottom, left, and p. 71 (Gorham mark for 1885). DATE OF ACQUISITION: before 1947(?). OTHER JUDAICA BY GORHAM: The Jewish Museum, F 4456, JM 26-49, and JM 27-54.

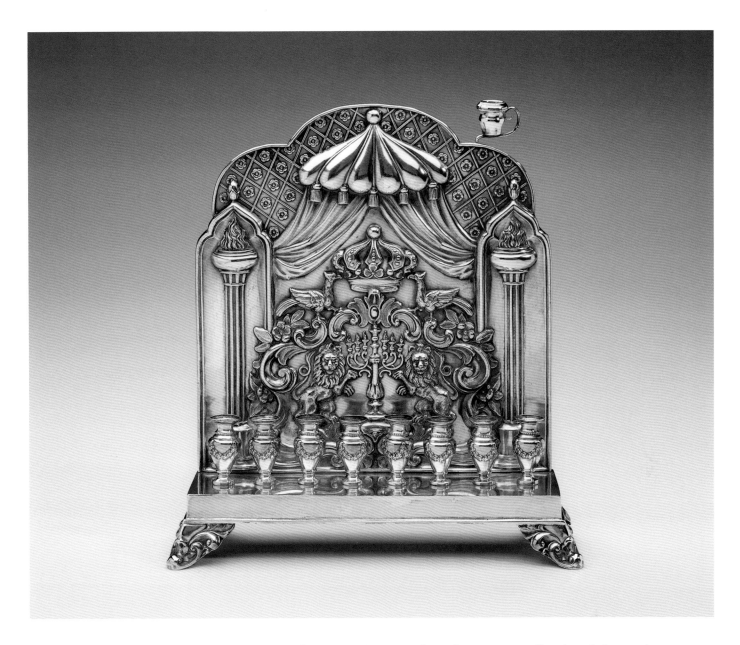

91

United States, late 19th–
early 20th century

Silver: die-stamped; 10¼ x
10¼ x 3⅛ in. (27.3 x 26 x 7.9 cm)

Gift of Frieda Schiff Warburg, S 1217

The mixture of styles on this lamp, from the rococo scrollwork and diamond pattern to the Gothic niches for the columns, are typical of late-nineteenth-century revivalism in Judaica. An American origin can be deduced from the fact that this lamp was pressed from the same die stamp as another lamp in the collection that has American machine-made screws. In addition, the use of the Russian assay mark "84" without the required city and maker's mark also suggests American production.

The lamp was donated to the museum by Frieda Schiff Warburg. She and her husband, Felix, who achieved great wealth in the banking business in New York, were major philanthropists in the first half of the twentieth century. Her family, the Schiffs, had been instrumental in the founding of the Henry Street Settlement House and the Visiting Nurse Service of New York, organizations which Frieda and Felix Warburg maintained an active interest in. She also served as president of the Young Women's Hebrew Association and was a supporter of Hadassah. Of particular interest is the fact that in 1944 Mrs. Warburg donated her mansion on Fifth Avenue and 92nd Street as the home of The Jewish Museum.

HALLMARK: "84". DATE OF ACQUISITION: 1941. SIMILAR LAMP: The Jewish Museum, F 104.

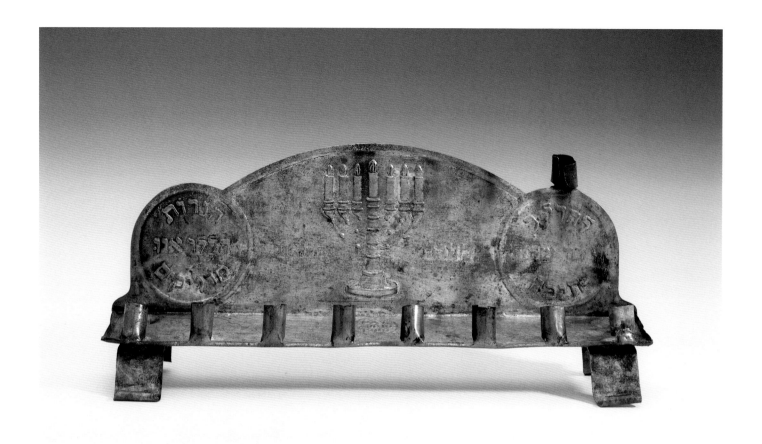

92

United States, after 1909

Tin plate: stamped; 4⅛ x 9¹⁵⁄₁₆ x
2⅜ in. (10.5 x 25.2 x 6 cm)

Purchase: Judaica Acquisitions Fund,
1986-78

HEBREW INSCRIPTIONS: "To kindle the
Hanukkah light"; "These lights are holy"
מנורות האור
Lampstands of the light

Tin lamps, inexpensively stamped out in large numbers, were distributed to children by Hebrew schools and Jewish organizations throughout the twentieth century. Many have the same patent date found on this lamp, or a patent number. This patent was taken out by Tobias Cohn of New York City in 1909. Cohn invented not the entire lamp, but a combination oil container with candleholder that could be stamped out of a single piece of metal. The oil receptacle had crimped edges, and the candleholder was placed at the rear edge. The patent application makes no mention of the use of this device on a Hanukkah lamp. Cohn stated only that "the object of my invention is to provide in an economical yet strong and durable manner a device, in which both oil and candles may be burned, or either one to the exclusion of the other" (United States Patent Office, no. 930,592).

Cohn's combination lighting device apparently did not survive for very long, since all but one of the fifteen lamps of this type in the collection have just candleholders. It would appear that after a transitional period when both oil and candles were used for Hanukkah, American Jews preferred the more convenient candles. In spite of this fact, Cohn's patent continued to be acknowledged on the lamps.

HALLMARK: "PAT. AUG. 10. 1909". PROVENANCE: purchased at Lubin Galleries in 1986. SIMILAR LAMPS: The Jewish Museum, S 1368-1, S 1368-2, S 1368-4, S 1368-5, S 1368-7, S 1368-8, S 1368-9, S 1368-10, S 1368-12, S 1368-14, U 7113, U 7503, U 8512, and F 5453.

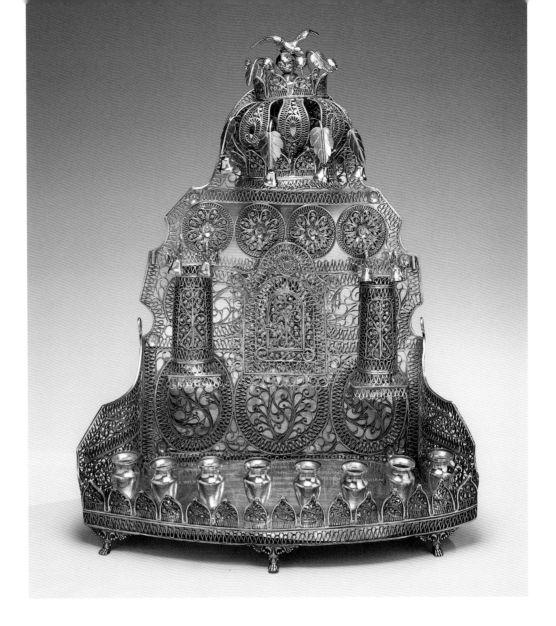

93

United States, after 1921

Silver: filigree, appliqué, and cast; copper alloy; 21 x 18½ x 9 in. (53.3 x 47 x 22.9 cm)

Gift of the Brooklyn Jewish Center, 1985-5

HEBREW INSCRIPTION:

נדבת ר' חיים זלמן מנחם עם זוגתו
רחל פייגע קורשאן / למרכז היהודי
דברוקלין / לזכור נשמת אמו רחל
פעסע בת ר' יעקב מאיר / שנפטרה
שנפטרה ז' מ' אב תרפא

English inscription (translation of above): Presented to the Brooklyn Jewish Center by Mr & Mrs Sol M. Kurshan in memory of their beloved mother, Rachel P. Kurshan, died August 11, 1921

This oversize version of the traditional filigree lamp of eastern Europe (see no. 57) was made in the United States. It imitates the Torah ark form, with its columns, door (complete with Torah inside), and crown above. Even the pattern of the filigree, with its heart- and oval-shaped designs, is based on eastern European prototypes of the first half of the nineteenth century.

The marks on this lamp tell a fascinating story of immigration and adaptation. They appear to follow the Russian marking system, but are patently false. One mark is an unregistered variation on a Moscow city mark, while both the Russian and American assay marks (the "84" and the "sterling") are present. Transplanted eastern European masters, or sharp American businessmen, used these imitation marks to convince the new immigrants either that the works were made in Russia, or that the silver content was the same as that required in Russia.

This lamp was dedicated to the Brooklyn Jewish Center in (or after) 1921, the year the donor's mother died, probably on the occasion of the completion of its new synagogue the same year. The building, located on Eastern Parkway, was large and grandly decorated. Serving as more than just a house of worship, it was one of the earliest community centers, and included a health club, day school, and restaurant. The declining population in that area of Brooklyn eventually caused the synagogue to close its doors in 1983.

HALLMARKS: false Moscow mark with "1882"; "84"; "STERLING". PROVENANCE: Brooklyn Jewish Center, 1921–85; acquired in 1985. RELATED LAMPS: The Jewish Museum, nos. 575 and 576 in the catalogue raisonné.

94

United States, after 1926

Copper alloy: cast and gilded;

6½ x 8½ x 1¾ in.

(16.5 x 21.6 x 4.4 cm)

Gift of Dr. Harry G. Friedman, F 99

The letters comprising the candleholders spell out the name of a Jewish woman's organization, Ivriah (Jewess). When a 1925 survey revealed that the majority of Jewish children were not attending religious schools, the Jewish Education Association decided to target their mothers in an effort to increase interest in religious and cultural training. Using the slogan "The Jewish Mother of Today for the Jewish Mother of Tomorrow," the Women's Division of the Jewish Education Society founded Ivriah in 1926. Its primary activities were to increase registration in Jewish schools through community outreach, to provide symposia and lectures on Jewish culture for women, to raise scholarship funds for Jewish schools, and to run a children's school.

Although this lamp was made by casting, its hammered surface was meant to simulate the look of handcrafted metalwork that was being produced in the first quarter of the twentieth century (e.g., Bowman, nos. 76–77). Such work was part of the Arts and Crafts Movement, which advocated a return to hand production in decorative arts after the late-nineteenth-century popularity of machine-stamped ware.

DATE OF ACQUISITION: between 1939 and 1941. SIMILAR LAMP: Skirball Cultural Center, acc. no. 27.140; Sotheby's NY 1981, lot 125. RELATED LAMP: The Jewish Museum, no. 603 in the catalogue raisonné.

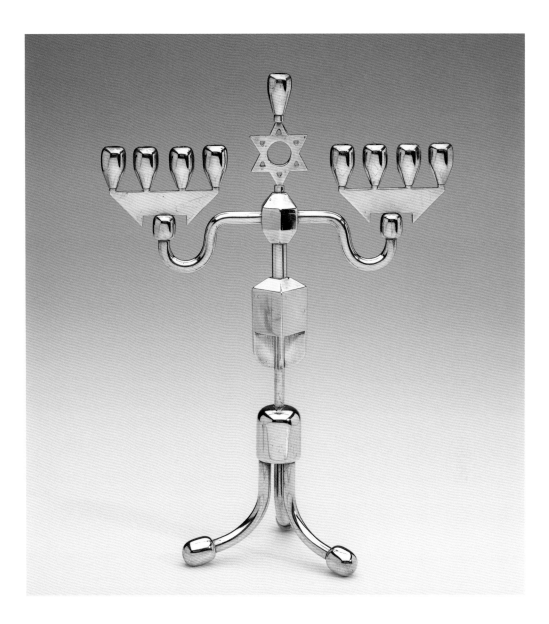

95

United States, 1930s–40s

Copper alloy: cast; 11½ x 8⁹⁄₁₆ x
3¹¹⁄₁₆ in. (29.2 x 21.7 x 9.4 cm)

Gift of Dr. Harry G. Friedman, F 1725

This playful lamp, possibly meant to simulate a human form, was made out of geometric, machinelike parts. The power of machines had captured the imagination of artists in the nineteenth century, but it was not until World War I that machines small and large came to permeate every facet of daily life, from the clock to the radio to the telephone. A true Machine Age in art and design emerged, which saw beauty in the smoke, gears, and bolts that drove the great engines, as well as in their streamlined speed and precise construction. Several different styles succeeded each other in the 1920s and 1930s, from a concentration on the angular, geometric forms of the machine parts to a focus on aerodynamic and biomorphic shapes.

This lamp appears to embody the streamlined style prevalent in the 1930s. The candleholders are shaped like teardrops, the classic aerodynamic form of the age. The teardrop was inspired by new types of planes, and found its way to all types of objects, from automobiles and pencil sharpeners to chairs. Similarly, although some of the knobs on the lamp are faceted, they are more rounded in form, in contrast to the sharp angularity of the earlier decade (Wilson, Pilgrim, and Tashjian).

The use of screws standardized according to the inch system to assemble the parts indicates an American origin for this lamp.

DATE OF ACQUISITION: 1946. RELATED LAMP: The Jewish Museum, no. 512 in the catalogue raisonné.

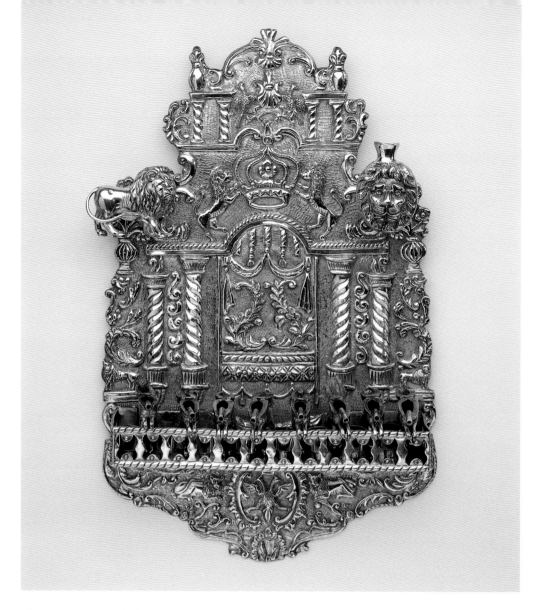

96

Inndustria

Cuzco, Peru, 20th century

Silver: repoussé, traced, and cast; 16⅞ x 11¼ x 2½ in. (42.8 x 28.5 x 6.4 cm)

Gift of Dr. Harry G. Friedman, F 1834

This Peruvian-made lamp is a close imitation of a type of Polish lamp of which there is an example in the collection from Brody, dated 1787 (see no. 50). Both pieces exhibit the multistory structure of Polish and Russian Torah arks, with two columned tiers, elaborate scrollwork on the sides, and the curtains in front of the ark doors. The balcony railing, the leaping lion oil containers, and even the double-headed eagle on the bottom have been faithfully copied in the Peruvian lamp. The South American artist has added some original touches in the form of the three-dimensional lion and lion head that serve as the *shamash* and oil container.

The history of this piece is unknown, and thus the circumstances of its commission remain intriguing. The availability of silver in a number of Central and South American countries led to the commissioning of Jewish ceremonial art for American consumption. This piece was probably intended for export, since the city name of Old Cuzco is in English. However, there were Jewish communities in Peru beginning in the late sixteenth century, and it is possible that this lamp was made for local use. These first settlers consisted of conversos, Sephardi Jews who were forced to convert but who secretly followed Jewish tradition. Beginning in the mid-nineteenth century, waves of immigration came from central Europe, North Africa, the Ottoman Empire, and finally Germany and eastern Europe, these last of Jews fleeing the Nazis. No community, however, is recorded as living in Cuzco.

HALLMARKS: "PERU 925"; "STERLING". MAKER'S MARKS: "INNDUSTRIA"; "OLD CUZCO". PROVENANCE: purchased from Rare Antiques in 1946.

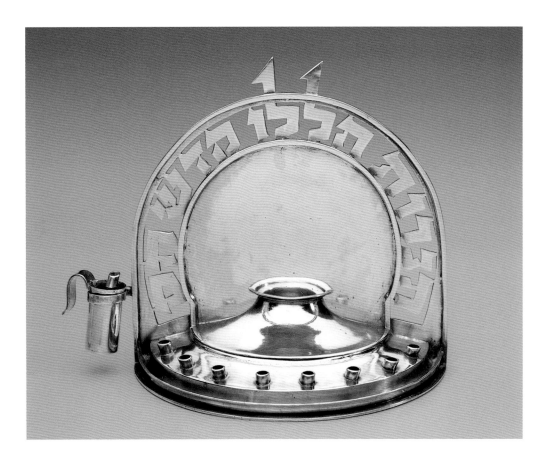

97

Ludwig Y. Wolpert
(b. Germany 1900,
d. United States 1981)
Jerusalem, 1935–48
Silver: pierced; 4⁵⁄₁₆ x 5⅛ x 2¼ in.
(11 x 13 x 5.7 cm)
Purchase: Judaica Acquisitions
Fund, 1984-56 a,b,c

HEBREW INSCRIPTION: "These lights
are holy"
HALLMARK: "925"; "MADE IN
PALESTINE"
MAKER'S MARKS: "וולפרט" (Wolpert);
"ירושלם" (Jerusalem)
PROVENANCE: purchased from Sima
Grafman, Jerusalem, in 1984.
BIBLIOGRAPHY: Lawrence, no. 71.

Ludwig Yehuda Wolpert is regarded as one of the greatest Judaica artists of the twentieth century. His contribution to Jewish ceremonial art is tantamount to the role that the Bauhaus, Mies van der Rohe, Eric Mendelsohn, and other pioneers of the modern design movement played in changing the outlook of modern architecture and design. Wolpert reshaped a late-nineteenth-century art form that had looked to the past for its inspiration and infused it with the aesthetic spirit of the twentieth century.

Wolpert's artistic career began with private sculpture instruction and a program of study at the School of Arts and Crafts in Frankfurt, Germany. In 1925, he embarked on a three-year study of metalsmithing, which he then used to develop designs for Jewish ceremonial objects. By 1931, he had succeeded in combining his training and interests in the creation of a remarkable silver-and-ebony seder plate, that was first exhibited at the Berlin Museum of Arts and Crafts (Bernstein 1987, p. 31). The work was a radical step for ceremonial art as it employed a geometric functionalist style associated with the Bauhaus and modernism. It marked a turning point for Judaica. Wolpert's approach to his work was straightforward; the surface was kept plain so that the decoration did not overwhelm the object or detract from the beauty of the metal (Kayser, unpag.). The artist used conventional fabrication techniques to shape, pierce, and overlay his works. Elegantly proportioned and uncluttered, his work exudes a sense of the sacred and mystical, a quality that is palpable even to those unfamiliar with Jewish rituals or Judaica. Part of the remarkable "inner content" that the artist strived for in his work came from his encyclopedic and intimate familiarity with Jewish literature, history, liturgy, and symbolism (Bernstein 1976, pp. 65–66).

Wolpert brought the same vitality to his designs for Hanukkah lamps—a substantial collection of which is in The Jewish Museum. Particularly notable examples include a lamp from the early to mid-1950s, no. 98, which features bold arc-shaped segments that create a menorah form. Wolpert's sleek and simple design, and the inexpensive material

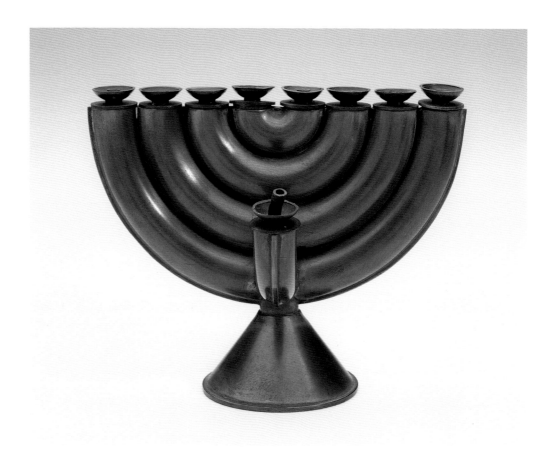

98

Ludwig Y. Wolpert

Jerusalem, 1950–55

Copper alloy: repoussé;

5¼ x 7 x 4 in.

(13.3 x 17.7 x 10.2 cm)

Gift of the Abram and

Frances Kanof Collection of

Contemporary Ceremonial Art,

JM 41-60

MAKER'S MARK: "וולפרט" (Wolpert) in
rectangle above "ירושלם" (Jerusalem)

DATE OF ACQUISITION: 1960

from which the lamp is fashioned, copper alloy, reaffirmed his belief that good design should be relevant to people of today and should be readily affordable to every person. While the design of the lamp is bold and modern, the rich patination of the metal and the use of oil are references to the traditions of the past.

His superb design sense and understanding of proportion is particularly evident in no. 99, a 1978 hanging Hanukkah lamp which is composed of a single band of silver that zigzags back and forth in a series of arcs, creating a highly schematic menorah shape. Here Wolpert reduced the menorah form to its leanest essentials.

Wolpert favored Hebrew letters as ornamentation for his works. His ceremonial objects "bloom with imaginative versions of the ancient calligraphy" (Kanof 1976, unpag.), which he carefully selected to complement the purpose of each piece. The letters represent far more than mere decoration. They were a means of expressing the sacredness of the Hebrew alphabet and a way to create a spiritual aura for his ceremonial works. The Hebrew alphabet was Wolpert's most important motif, and he used it extensively in his Judaica and sculpture, treating it with an almost mystical reverence. This usage is particularly evident in a third Hanukkah lamp in the museum's collection, no. 97, which was made in Jerusalem and dates from 1935 to 1948, the period prior to the foundation of the State of Israel. The small lamp makes prominent use of Hebrew text for its ornamentation—a Hebrew sentence reading "These lights are holy" made from cut silver letters is incorporated into an arc-shaped band rising from the base. The lamp's streamlined shape has an almost machinelike appearance. Wolpert conceived of the design of this lamp as a

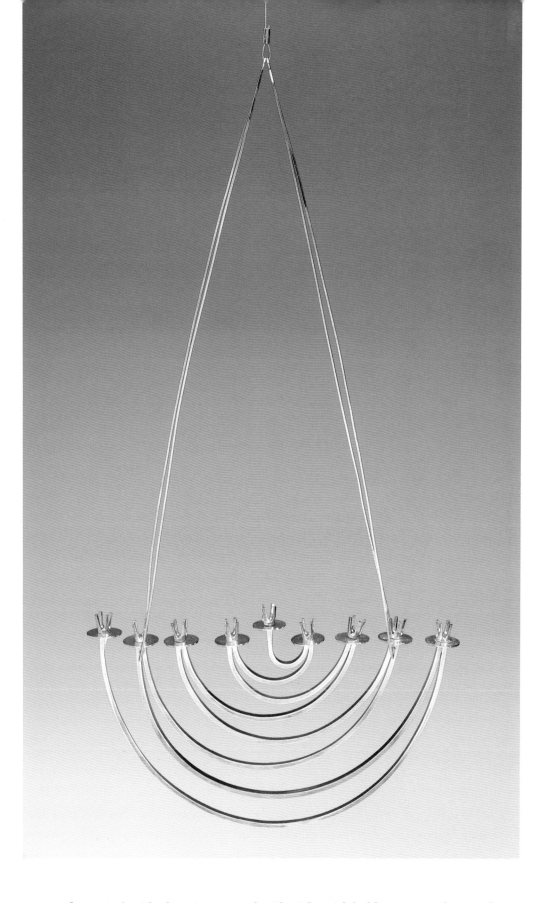

99

Ludwig Y. Wolpert
New York City, 1978

Silver: hand worked;

20¾ x 10⅜ x 1½ in.

(52.7 x 26.3 x 3.2 cm)

Gift of Herbert and Shirley

Jacobs in memory of Naomi

Routtenberg, JM 32-78

HALLMARK: "STERLING"

MAKER'S MARK: "WOLPERT"

DATE OF ACQUISITION: 1978

series of semicircles. The base is mounted with eight wick holders arranged in a semicircular form with a small silver jug for the *shamash*. The jug recalls the tiny cruse of oil that sustained the Temple menorah for eight days.

Wolpert became the first widely known artist to make ceremonial Judaica a life's work rather than the focus of an occasional commission. His pioneering work quietly revolutionized an entire genre. SR

OTHER WORKS BY WOLPERT: Jewish Museum 1976; Kleeblatt and Mann, pp. 178–79.

Otto Natzler (American,
b. Austria 1908)
Simi Valley, California, 1956
Earthenware with lava glaze;
21 x 5½ x 42 in.
(53.3 x 14 x 106.7 cm)
Purchase: Judaica Acquisitions Fund
and Mimi R. T., Ruth I. and Lewis D.
Surrey Gift in honor of Albert W.
Surrey, 1988-30

Gertrud and Otto Natzler's fascination with ceramics began in 1930s Vienna, where they met, formed a relationship, and launched their careers as ceramists. Their training was largely a self-taught experience fraught with trial and error, which Otto later characterized as a series of accidents (Clothier, p. 21). It often consisted of tireless experiments that gradually revealed to them how they could achieve a specific shape or glaze effect. For example, Otto conducted more than two thousand five hundred glaze experiments and kept copious records on the results, giving him a repertoire of surfaces and finishes that would later bring them much acclaim and success. Gertrud devoted herself to the creation of the vessels, and her uncanny sense for shape and line was described by Otto as a kind of innate "feeling for form [*Formgefühl*]. . . . At times I had the feeling in observing her turning or throwing that literally one millimeter change in one dimension meant the difference between day and night to her" (Clothier, p. 26). As a team, the Natzlers created strikingly beautiful forms with remarkable surface finishes.

The Natzlers focused on ceramics as a sculptural and artistic medium, rather than as a vehicle for functional objects, and this emphasis may explain why ceremonial objects were never a high priority for them. However, in 1956 Shlomo Bardin, founder and director of the Brandeis Institute (now the Brandeis-Bardin Institute) in California, encouraged them to explore Judaica. From 1956 until 1960, the Natzlers served as artists-in-residence and instructors at Brandeis Camp Institute, which offered intensive Jewish-related studies and arts for college-age students. Bardin persuaded the Natzlers to create memorial lamps for the Brandeis collection. Each lamp the couple created was inscribed with the Hebrew text, "Man comes from dust and returns to dust."

During their years at the Brandeis Institute, Otto Natzler also began making slab-constructed Hanukkah lamps such as The Jewish Museum's example (Gilbert, unpag.). Unlike Gertrud's sinuous, wheel-thrown forms, Otto's work was slab-built and architectural in feeling. The Jewish Museum's lamp, which dates to 1956, is coated with a gray-green glaze that Otto first developed in 1940 and called "lava" (Gilbert, unpag.; Minneapolis, p. 45). It was precisely the type of surface treatment for which the Natzlers were famous, and capitalizes on what some people would view as glaze defects—craters and rough surface texture. Otto purposely cultivated these glazes to evoke "what has been done by nature in the process of earth's creation" (Clothier, p. 33). The verdigris color and encrusted surface also have associations with the antique, and may recall the ancient story of Hanukkah.

The Natzlers' body of Judaica is small and rarely seen, yet the pieces are informed by a spiritual quality and evince a mood of quiet and contemplation. SR

SIGNATURE: "Otto / Natzler / 1956". DATE OF ACQUISITION: 1988. BIBLIOGRAPHY: Jewish Museum 1958, unpag. OTHER LAMPS BY NATZLER: Cohen Grossman 1996, pl. 36. SELECTED REFERENCES ON NATZLER: Conroy; Clark; Levin; LACMA; Jewish Museum 1958; Kardon; Gilbert.

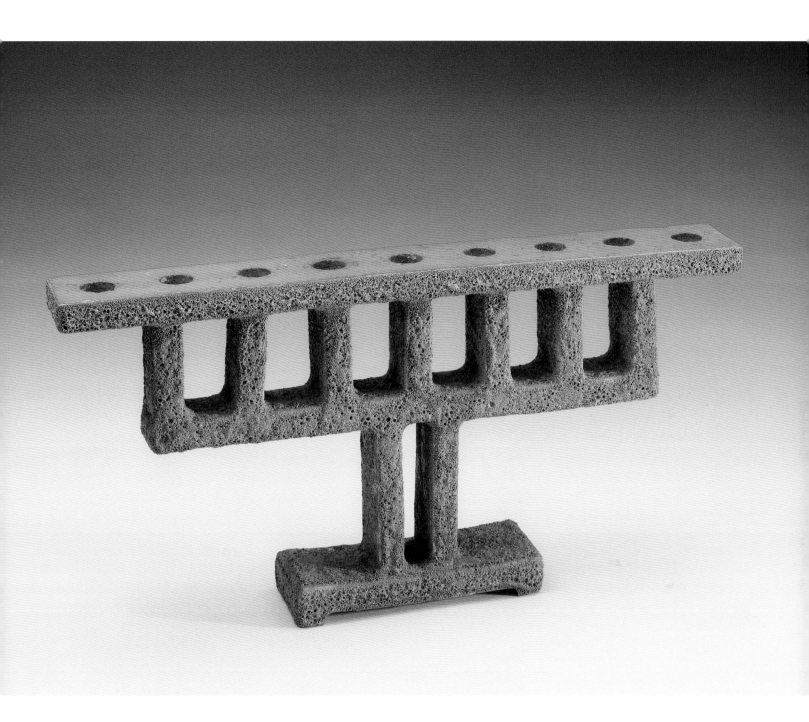

101

Moshe Zabari (Israeli, b. 1935)
Masada
New York City, 1968
Silver: hand-worked and embossed;
6¾ x 11¾ in. (17.1 x 29.3 cm)
Gift of the Albert A. List Family,
JM 253-68 a,b,c

For almost thirty years, Moshe Zabari was director and artist-in-residence at the Tobe Pascher Workshop in The Jewish Museum. The workshop was a center for the encouragement of the finest contemporary design, as well as an actual silversmithing studio within the walls of the museum. Zabari's tenure there marked a rich period in the development of contemporary Jewish ceremonial art.

Zabari, the son of a Turkish mother and a Yemenite father, was brought up in an Orthodox Jewish household, where studying and participating in the rituals and observances of a traditional home were a vital part of his life. In 1955, after his release from the army, Zabari entered the Bezalel Academy of Art and Design in Jerusalem, where he studied with some of its most influential artists, including David Gumbel and Ludwig Y. Wolpert. Their theories were infused with the teachings of the Bauhaus and the International Style, and exerted a lasting influence on Zabari. A bold reduction of form and overall simplicity characterize his style and reflect the mentorship of his illustrious teachers. Hebrew letters, both as decoration and as structural components, are key elements to his work, and he developed a particular fascination for incorporating ancient texts and proto-Hebraic lettering in his pieces.

Zabari was one of the few artists of the twentieth century to devote his entire career to the creation of objects for Jewish devotional use. Part of his rationale for working in ceremonial art was that they include a spiritual dimension, "and my fondest hope is that whoever uses a ceremonial object will capture a personal truth and the essence of the ceremony being celebrated" (Zabari).

Zabari's Hanukkah lamp entitled *Masada* is composed of hammered sheets of silver that take on the actual shape of the isolated rock on the edge of the Judean Desert. The rippling surfaces give the piece a highly charged vivacity and energy analogous to the fire of the Festival of Light itself. *Masada* links two great events of Jewish history: the triumph through martyrdom of the Jewish zealots at Masada in 73 C.E. and the victory of Judah Maccabee over the Greeks in 164 C.E. The inspiration to create this Hanukkah lamp came from an exhibition on Masada held at The Jewish Museum in 1967. SR

DATE OF ACQUISITION: 1968. BIBLIOGRAPHY: Berman 1986, no. 18. SIMILAR LAMP: Skirball Cultural Center, acc. no. 27.121. OTHER WORKS BY ZABARI: Berman 1986; Skirball; Jewish Museum 1982; Weiser, pp. 75–76; Kleeblatt and Mann, pp. 194–95.

102

Mae Rockland Tupa
(American, b. 1937)
Miss Liberty
Princeton, New Jersey, 1974
Wood covered in fabric with cast
plastic figures; 11 x 24 x 7 in.
(27.9 x 60.9 x 17.8 cm)
Gift of the artist, 1984-127

ENGLISH INSCRIPTION: closing lines
of Emma Lazarus's poem "The New
Colossus":
"Keep, ancient lands, your storied
pomp!" cries she
With silent lips. "Give me your tired,
your poor,
Your huddled masses yearning to
breathe free,
The wretched refuse of your teeming
shore.
Send these, the homeless, tempest-
tossed to me,
I lift my lamp beside the golden door!"

As a child, Mae Rockland Tupa attended one of the largely secular Yiddish *shuls* in the Bronx. These schools advocated adherence to Jewish customs and traditions as a way of assuring the survival of Judaism. The artist recalled a special Hanukkah performance at her school, an event that occurred when she was eight or nine years old:

Eight of us, draped in sheets, wearing paper crowns, holding books in our left hands and candles in our right, were lined up across the stage. A ninth child (the *shammash*) lit our candles one at a time. As she did so we raised our candles in the air and recited a line from Emma Lazarus's poem "The New Colossus": "Give me your tired, your poor, your huddled masses yearning to breathe free, the wretched refuse of your teeming shore. . . ." The parents wept, and we were proud because that poem was us. Our parents had immigrated to the Land of the Free, the *Golden Medina*. We were the wretched refuse and we were breathing free. It was a great feeling (Schafter Rockland, pp. 45–46).

Although connected to the childhood memory, Rockland Tupa's unusual Hanukkah lamp is far more than a realization of a childhood memory. The artist brought the trends of the contemporary art world to bear on its creation and imbued the piece with political overtones about America's treatment of the Jews.

The plastic Statues of Liberty and the dime-store flags that ornament this lamp recall the assemblage movement of the 1950s and '60s. Like the work of Jasper Johns, Robert Rauschenberg, and Arman, Rockland Tupa's work relies heavily on found, almost banal objects for its artistic commentary. The imagery illustrates how overexposure and commercialization can undermine the power of even the most potent symbols (Kleeblatt and Wertkin, no. 126).

Rockland Tupa also conceived this piece as a political statement. Jews have become an integral part of America, and the artist uses the full panoply of patriotism to represent this change. She also configured some of the statues to comment on America's role vis-à-vis the Jews, by turning some of them backwards. The artist intended this as a "bit of historical commentary. The Statue of Liberty, a gift from France to America in 1886, has stood at the entrance to New York Harbor as a beacon of hope. . . . But there have been times when Miss Liberty looked away and America closed its doors to the persecuted . . . as when the steamship St. Louis was denied haven in Miami and nine hundred Jews were sent back to Nazi Germany" (Schafter Rockland, p. 47). SR

SIGNATURE: "Mae Rockland / 1974"; "מלכה" (Malcah). DATE OF ACQUISITION: 1984. BIBLIOGRAPHY: Kleeblatt and Wertkin, no. 126. SIMILAR LAMP: Dr. Solomon and Mickey Batnitzky Collection (Plous, no. 59). OTHER WORKS BY ROCKLAND TUPA: Schafter Rockland.

No. 102

103

Richard Meier

(American, b. 1935)

New York City, 1985

Tin-coated copper; 11¹³⁄₁₆ x

13¾ x 2 in. (29.9 x 35 x 5.1 cm)

Purchase: Samuel and Rose Riemer

Private Foundation Gift, 1998-31

Richard Meier received his architectural training at Cornell University. His career is marked by many notable structures, including the Getty Center in Los Angeles, the High Museum in Atlanta, the Frankfurt Museum of Decorative Arts, and others. These have become among the most striking examples of the built landscape in the last twenty years. Meier credits some of the leading lights of twentieth-century architecture as his inspiration. He writes, "Le Corbusier was a great influence, but there are many influences. . . . We are all affected by Le Corbusier, Frank Lloyd Wright, Alvar Aalto, and Mies van der Rohe. But not less than Bramante, Borromini, and Bernini. Architecture is a tradition, a long continuum. Whether we break with tradition or enhance it, we are still connected with the past. We evolve" (Meier).

In 1985, Meier designed a Hanukkah lamp for an exhibition at the Israel Museum entitled *Nerot Mitzvah: Contemporary Ideas for Light in Jewish Ritual*. Meier wrote, "In the design of the Hanukkah lamp I was trying to express the collective memory of the Jewish people. Each candleholder is an abstracted representation of an architectural style from significant moments of persecution in the history of Jews. The first being the expulsion of the Jews from Egypt and the last symbolizing the towers of the concentration camps in Germany. These are not intended as literal representations of specific events but rather as reminders of the common past and struggles that Jewish people have suffered and their resilience and strength that is so wonderfully captured by the Hanukkah story" (Meier, artist's statement, 2003). The architectural elements include an obelisk, a classical column, a crenellated tower, and a Gothic pointed arch. They not only demonstrate a progression through historical time, but perhaps also suggest the passage of time during the Hanukkah holiday. Regarding memory and tradition, Meier has written that "part of the significance of an awareness of architectural history is that we again value permanence, continuity and, therefore quality" (Meier). SR

MAKER'S MARK: "R.Meier #3 / mfg le Corbeau". DATE OF ACQUISITION: 1998. SIMILAR LAMP: Skirball Cultural Center (Cohen Grossman 1996, pl. 35); Israel Museum, no. 1.

Peter Shire (American, b. 1947)
Menorah #7
Los Angeles, 1986
Painted steel, anodized aluminum,
and chrome; 21¼ x 22½ x 17 in.
(54 x 57.1 x 43.2 cm)
Purchase: Judaica Acquisitions
Endowment Fund, 1989-20

Ceramic teapots, motorcycle repair, and the design group Memphis may seem an incongruous combination, but they are all part of Peter Shire's career as an artist and designer, and are related to the creation of this superlative Hanukkah lamp, *Menorah #7*.

Shire, a graduate of Chouinard Art Institute in Los Angeles, began his career by creating whimsical ceramic teapots in the 1970s. These were extravagant, colorful, and geometrical creations, and far from the standard household variety. The teapots generated a great deal of interest in Shire's artistry—eventually attracting the attention of the celebrated Italian designer Ettorre Sottsass, who in 1981 invited Shire to become part of his international design group called Memphis, made up of a cadre of thirty artists from eight countries. Sottsass liked Shire's work, which features fragmented geometric volumes, giddy colors, and gravity-defying forms.

Shire's style has proven difficult to label: "It has been called New Wave, Constructivist or even Art Deco. He prefers his own labels—'Cookie Cutter Modern,' 'Mexican Bauhaus,' or even 'Frank Lloyd Wrong'" (Black, unpag.).

An important part of *Menorah #7* is its metal makeup. The lamp is fashioned from steel, chrome, and anodized aluminum. The materials and techniques used to create these forms are closely tied to Shire's enthusiasm for motorcycles. In the 1970s he owned a BSA Goldstar, and maintaining the bike brought him into contact with a range of metalworking equipment and techniques which he later used in his art (Smith, p. 3). Shire sees his menorah as "almost an encyclopedia of machine techniques, including lathe work, counter boring, etc." (artist's statement, 2003). Balance is crucial to the proper functioning of a motorcycle, and Shire continues this principle in *Menorah #7*—the candles fit into a cantilevered arm of metal affixed to the base. The arrangement creates a constellation almost like a mobile of colorful geometric forms and shapes that appear to float in space.

Menorah #7 is actually part of a larger group of Judaica Shire created that includes charity boxes and *mezuzot*, several of which are in the collection of the Skirball Cultural Center in Los Angeles. Prompted to explain his interest in Jewish ceremonial art, the artist credited working with the collections, staff, and supporters of the Skirball as a major factor, as well as his own investigations into the Jewish roots of his family (artist's statement, 2003). SR

SIGNATURE: "Shire 1986" underlined / "Menorah #7". DATE OF ACQUISITION: 1989. OTHER LAMPS BY SHIRE: Skirball Cultural Center (Cohen Grossman 1996, pl. 101); San Francisco, p. 128.

105

Harley Swedler
(Canadian/American, b. 1962)
Derivation 36/8
New York City, 1992

Cast aluminum and stainless steel;
3 x 7 x 36 in. (7.6 x 17.8 x 91.4 cm)
Purchase: Judaica Acquisitions Fund
and Floyd Lattin Gift, 1994-75

ENGLISH INSCRIPTION: "In place of
the thorn shall come up the cypress"
(Isaiah 55:13)
SIGNATURE: "Harley Swedler '92"
DATE OF ACQUISITION: 1992
BIBLIOGRAPHY: Swedler.

Born in Ottawa, Ontario, in 1962, Harley Swedler studied architecture at Carleton University in Ottawa and in Rome, and metalsmithing at Parsons School of Design, in New York City (Weiser, p. 67). Swedler's artistic and architectural training, fascination with Jewish ritual, and sense of inventiveness enable him to create concepts that serve ritual traditions in refreshing and unusual ways. He views Jewish ritual with a sense of awe and mystery, writing, "The rituals of Judaism are a bridge, potentially mending the rift, which distinguishes man from a divine source. I interpret these objects as a powerful expression of the collective longing for reunion, redemption, and comprehension" (artist's statement, 1993).

Swedler comments that his Judaica has developed its distinctive look "primarily because of the interpretive aspect of my design process. . . . I am most keenly aware of the way the piece will be used in the practice of the particular ritual associated. . . . The form and materials are a product of what the concept is about—what is the underlying meaning of a holiday, of man's relationship with G-d, of the history of the Jewish people. From that launching pad, there is an excavation, particular derivations of words, text, letters, and numbers. This is a true passion of mine—the concepts embodied in between the lines. The use of letters and numbers . . . helps to further define the universal nature of the piece" (artist's statement, 2003).

Among the museum's contemporary Judaica holdings are two works by Swedler, *Derivation 36/8* and *priva/See*. They demonstrate Swedler's thoughtful and imaginative approaches to ceremonial objects and illustrate the surprising variation possible among Hanukkah lamps. For *Derivation 36/8* the artist created a broad, stainless-steel, wedgelike form, on which he mounted thirty-six candle receptacles. The arrangement supplies the

106

Harley Swedler
priva/See
New York City, 1995

Cast aluminum; each piece approx.
1½ x 1½ in. (diameter) (3.8 x 3.8 cm)

Purchase: Judaica Acquisitions
Fund, 1996-76 a-rr

SIGNATURE: "Harley Swedler"
DATE OF ACQUISITION: 1996
BIBLIOGRAPHY: San Francisco, p. 134.

total number of holders needed for all of the candles lit on Hanukkah. One uses a different set of candleholders each night, beginning from the right. The resulting movement across the front of the lamp during the eight nights reminds one of the passage of time. The only embellishment of this sleek shape is an inscription along the lamp's face that refers to a traditional Hanukkah song "Ma'oz Tzur" (O Fortress, Rock of My Salvation). The song makes a typological reference to the holiday by recalling other victory stories about the Jews. One line refers to the story of the triumph of Mordecai and Esther over the evil Haman from the Book of Esther. The lyrics allude to Haman as a spiteful thorn, while likening Mordecai to a stately cypress. Swedler chose the words of Isaiah 55:13, "In place of the thorn shall come up the cypress," to capture the meaning of this popular song (artist's statement, 1992).

priva/See is an imaginative Hanukkah lamp consisting of forty-four pods of cast aluminum. Eight of the pods are unpolished and to be used for the *shamash;* the remaining thirty-six are made of reflective cast aluminum and make up the number of candles lit successively on nights one through eight of the holiday. The pods are fashioned to easily fit in the palm of the hand and invite touch. Each of these small shapes is equipped with a hole for the candle, and these forms can be arranged in any way one may wish. Swedler intended this lamp to be an "intensely private element for publicizing the miracle which characterizes the holiday of Hanukkah" (artist's statement, 1995).

"Working from my studio in New York, I create my own series of artifacts which evolve from my thoughts and ideas, in addition to alternative Judaica commissioned by private collectors" (artist's statement, 1993). SR

OTHER JUDAICA BY SWEDLER: Weiser, pp. 67–68. REFERENCE ON THE ARTIST: Swedler.

107

Joel Otterson
(American, b. 1959)
Unorthodox Menorah II
Cincinnati, 1993
Mixed metal pipes, cast bronze,
porcelain, and glass;
28½ x 48 x 12 in.
(72.4 x 121.9 x 30.5 cm)
Purchase: Judaica Acquisitions
Fund, Henry H. and Ruth Herzog
Gift, and Rabbi Louis Frishman
Gift, 1993-216

A key component of Joel Otterson's art is the relationship between an object's function and its symbolic purpose; this ideological stance makes Otterson an ideal candidate for creating Jewish ceremonial objects. But despite his interest in the symbolic, Otterson never made a ritual object until 1991, after he visited Israel and became aware of the power of the menorah form. Otterson discovered that this ancient candelabrum shape could be understood on many levels: it has deep religious meaning and is connected with the story of Hanukkah; it is a symbol of the State of Israel and an essential presence in many Israeli homes; and it is even a favorite souvenir for tourists (artist's statement). Touring the large and impressive collection of Hanukkah lamps in the Israel Museum inspired him to make a Hanukkah lamp entitled *Unorthodox Menorah,* which is in a private collection. The Jewish Museum commissioned this second lamp in 1993. Otterson's lamp builds on traditional forms but follows his quirky style, which reclaims objects from their everyday existence and reuses them in visually arresting and innovative new ways. One of the most striking elements of his lamp is the ornate armature of copper pipe fittings, which he welded together to form the menorah's branches. Copper pipes and soldering are a recurring theme in Otterson's work and recall the construction skills he learned from his father and brother (Krane, p. 12).

Otterson is a master of displacement—that is, juxtaposing unlikely elements to create surprising visual effects (Salvioni, p. 77), such as the hypermasculine Hulk Hogan figure that crowns *Unorthodox Menorah* II. During Otterson's stay in Israel, he noted that cartoon characters had invaded the realm of ceremonial objects. Bart Simpson, Smurfs, and Peanuts characters were regularly emblazoned on skullcaps worn by Jewish boys. The playfulness and charm of this idea inspired the artist to choose Hulk Hogan for this lamp. He reasoned, "If they can make a Bart Simpson skullcap, I can make a Hulk Hogan menorah" (artist's statement). The cast-glass image of Hulk might at first seem completely incongruous, but traditional Hanukkah lamps often featured a victorious figure, such as the biblical Judith, to suggest the triumph of the Jews over their oppressors. The artist updated this idea with an image of the famous television wrestler.

Along with its spreading copper arms and triumphant figure, *Unorthodox Menorah* II features what appears to be a vintage ceramic lamp as the main shaft. This base is a cast creation that the artist made to suggest the garish flower-covered ceramic lamps popular in the 1940s and '50s. Otterson uses this object as if it were a precious memento or souvenir. It is at once familiar and jarring, but resonates with the story of an old lamp that kept on burning. SR

DATE OF ACQUISITION: 1993. OTHER LAMPS BY OTTERSON: private collection, New York (D'Agostino, p. 16). OTHER WORKS BY OTTERSON: Krane.

108

Salo Rawet (b. Brazil, 1955)
In Search of Miracles
Oakland, California, 1995
Lead, wood, copper, glass, olive oil,
and cotton wicking; 7½ x 36 x 3½ in.
(19 x 91 x 9 cm)
Purchase: Peter Lane Gift, 1999-7 a,
b1-60,c,d,e

Salo Rawet was born in Rio de Janeiro and grew up in Israel, where he received a
B.S. degree. He moved to the United States where he earned a Bachelors and Masters of
Landscape Architecture degree at the University of Oregon, Eugene. Rawet is a sculptor
who uses found materials to explore difficult issues surrounding the human experience.
He delights in creating assemblages of materials that create disjunctions. These shock his
audience into reassessing the familiar (Brunson, p. 34).

Rawet achieves his goal by placing objects in unexpected combinations, so that they
convey an edgy, or even menacing and dangerous, quality. His titles also add an unusual
and often ironic twist. "My work draws on imagery that is rooted in the political and the
ethical undercurrents of post modern exigencies of contemporary life. The exploration of
Jewish identity in this context is primary to my work, where it assumes the presence of
relegated communal memories and their transformation into rudiments of virtue"
(artist's statement, 1998).

Rawet is involved in ceremony in many ways. He sees his art as a kind of ceremonial
act. He writes:

The process of Art making is to me a ceremonial act in itself and thus the outcome . . . is closely re-
lated to a ceremonial object. There seems to be an ambiguous zone in which art and ceremonial ob-
jects can coexist and still maintain their individual identities. Being born in Brazil and raised in both

Brazil and Israel . . . religious ceremonial art has had a mixed flavor for me. That which is associated with tropical Africa and South America and that which is associated with the Egyptian delta and the Middle East. One carnal, sensual and animalistic the other more formal, rigorous and clearly defined. I personally seem to make Art that applies both of these palates and in addition reflects the modern life we are all immersed in (artist's statement, 2003).

Concerning his Hanukkah lamp sculpture *In Search of Miracles,* Rawet explains that the work "presents an extended Hanukkah miracle and mandates a continuous light, one synchronized with the cycles of the sun and moon, daily, monthly, yearly renewing the miracle" (artist's statement, 1998). The lamp's life extends beyond the traditional eight days of the holiday to include the lunar cycles. It becomes an embodiment of hope and expresses "human attempts to intervene and support the divine process of exuding miracles in our daily life" (artist's statement, 1998). Created out of modern-day test tubes, Rawet's lamp contrasts the miraculous strides of modern medicine with spiritual miracles, as symbolized by the story of Hanukkah. SR

DATE OF ACQUISITION: 1999. BIBLIOGRAPHY: San Francisco, p. 115.

Rod Baer (American, b. 1951)
Every December
Los Angeles, 1995
Welded steel and mixed media;
16 x 12 x 8 in. (40.6 x 30 x 20.2 cm)
Gift of Alyne Salstone, 1998-55

Rod Baer earned his M.F.A. from the Claremont Graduate School in California, and has been active in the art world since the mid-1980s. Baer's sculptures and installations range in scale from small, intricately detailed works to large installation pieces. His art often incorporates everyday objects: books, chairs, TV sets, and so on, which he places in unusual settings and juxtapositions in order to create a dialogue about their meaning (Armory Center, p. 5).

Rusted metal appears frequently in Baer's art and he uses the material to contrast the solidity of steel with the corrosion that occurs to its surface with the passage of time. The artist explains that "rusting objects . . . serve as both relics and homages. . . . The density of steel imparts a solidity . . . while the exterior skin of active corrosion infers the evanescent and ephemeral" (Armory Center, p. 9).

Baer's Hanukkah lamp *Every December*, originally created for an invitational exhibition at the Jewish Museum of San Francisco, is highly unusual in a number of ways. Its architectural form suggests a humble, two-story house with mullioned windows and a slightly open door. Its rusted surface suggests age and the passage of years. The Hanukkah candles are placed within the structure, so that when lit, light pours through the door and windows creating a symbolic image of a cozy home ablaze with holiday light. Writes Baer, "Lighted candles of course have a certain universal symbolism, but for me Hanukkah is first and foremost a holiday of the home with the job of giving and taking tokens of love between family. From the outside you see a simple almost crude house, but it's the inside glow and sanctuary of a single family together basking in the radiance of the holiday candles that's the source and phenomenon of the story" (artist's statement, 1997). Baer notes that "traditionally menorahs were set in the window for passers-by of the community to see, so that *Every December* actually harkens to the early days in more ways than one. I would like to say that I knew that and incorporated it into my idea, but I didn't. On the other hand when one joins the spirit of something, certain forces of symbiosis and intuition join in, so I'm happy with the overlap" (artist's statement, 1997).

Baer's lamp is an embodiment of the home and the people who are part of the celebration of Hanukkah. For Baer, Hanukkah is a holiday of people, not of ceremony, and rather than creating the structure of a menorah-form Hanukkah lamp, the artist chose to emphasize the spirit of the holiday (artist's statement, 1997). SR

SIGNATURE: "R BAER"; "THING"; chair. DATE OF ACQUISITION: 1998. BIBLIOGRAPHY: San Francisco, p. 27. OTHER WORKS BY BAER: Armory Center. REFERENCE ON THE ARTIST: Pulka.

110

Matthew McCaslin
(American, b. 1957)
Being the Light
New York City, 2000
Light bulbs, porcelain light fixtures,
metal electrical conduit, switches,
and metal receptacle box;
62 x 44¼ x 10½ in.
(157.5 x 113.7 x 26.7 cm)
Purchase: Contemporary Judaica
Acquisitions Committee Fund
and the Judaica Acquisitions
Fund, 2001-14

Since the early 1990s, Matthew McCaslin has created sculptures and site-specific installations featuring industrial electrical materials, clocks, fans, and video monitors. Grounded in the formal and aesthetic strategies of Process Art and Post-Minimalism of the 1960s and 1970s, his work invites the viewer to consider his or her own relationship to technology, nature, and time.

In 2000, McCaslin was invited to participate in *Light x Eight*, The Jewish Museum's biennial Hanukkah exhibition of works by contemporary artists that use light. Struck by the beauty and diversity of the museum's display of Hanukkah lamps, the artist created a site-specific piece that at once referred to the rich historical tradition of this ceremonial object while reimagining it for the twenty-first century.

McCaslin's signature vocabulary of industrial materials—light bulbs, switches, and metal electrical conduit—is metaphorically relevant to the holiday. The artist sees industrial electrical hardware as a sublime material that lurks behind our walls, as ubiquitous as it is hidden, connecting us physically, culturally, and spiritually. Seeing the beauty of these industrial forms, the artist literally brings this infrastructure out of hiding "into the light," a most appropriate expression for Hanukkah, the Festival of Lights.

McCaslin's piece—both sculpture and Hanukkah lamp—plays with the combination of formal restriction and openness that he found so intriguing about this ritual object. On the traditional side, *Being the Light* follows some of the dictates for a Hanukkah lamp's configuration—eight lights, with a ninth acting as the *shamash*, or servitor, which kindles the other lights. The electrical system devised by the artist also cleverly reflects the traditional lamp: the *shamash* must be switched on before the other eight bulbs can be illuminated. In a final allusion to tradition, the switches for the eight lights are arranged in a single row, echoing the form of the bench-style Hanukkah lamp.

However, McCaslin also playfully departs from tradition. Notably, the lights are not at a typical uniform height, and turning on the switches in a row actually lights the bulbs nonsequentially rather than in the expected right to left order. Finally, at the same time that McCaslin is in dialogue with tradition, he also seems to be nodding at that most contemporary version of the Hanukkah lamp—the electric menorah that has become so popular in recent decades. FW

PROVENANCE: purchased from Sandra Gering Gallery in 2001. REFERENCE ON THE ARTIST: Bitterli and Wohlgemuth.

LAMPS MADE FROM OTHER OBJECTS

While many Hanukkah lamps in the collection were crafted by master silversmiths, others were converted from objects originally created for a completely different function, usually through the addition of a row of lights. A wide range of decorative-arts pieces were deemed suitable for this kind of transformation. Those co-opted from the secular world included eighteenth-century bed-warming pans, Australian tourist souvenirs, belt buckles, cruet stands, and cigarette cases. Another type of Jewish ritual object, the Torah shield, was occasionally used, since its flat form and Jewish iconography constituted the perfect backplate for a Hanukkah lamp. However, this practice went against Jewish tradition, since objects used in the service of the Torah are considered the most sacred and should not be demoted to less sacred levels. Military equipment was another popular source for Hanukkah lamp backplates and candleholders. The collection includes lamps made from eighteenth-century helmet plates, as well as shells and cartridges from the wars of the twentieth century, part of an art form called trench art.

It is not always clear if these converted objects were ever used as Hanukkah lamps, or merely created for the Judaica market. For the past century and more, forgeries of Jewish ceremonial art have been created for sale to an unsuspecting public. In the last few decades, the price of a Jewish ceremonial cup or pair of candlesticks was higher than that of their secular counterparts, and thus many objects were transformed into "Judaica," often by adding a Hebrew inscription. Several examples in the collection would appear to fall into this category, including Middle Eastern secular lamps with Hanukkah inscriptions, and a Christian missal stand, which originally held the holy books during the church service. Other "lamp" conversions are merely wacky: a gas fixture converted into a hanging Hanukkah chandelier, an inexpensive hanging planter imported from Spain in the 1950s, and a piece made of iron that was possibly once a coatrack.

Included also in this section of the catalogue raisonné are dubious lamps, which were probably never designed as Hanukkah lamps and were acquired by the museum in error.

Detail of no. 113.

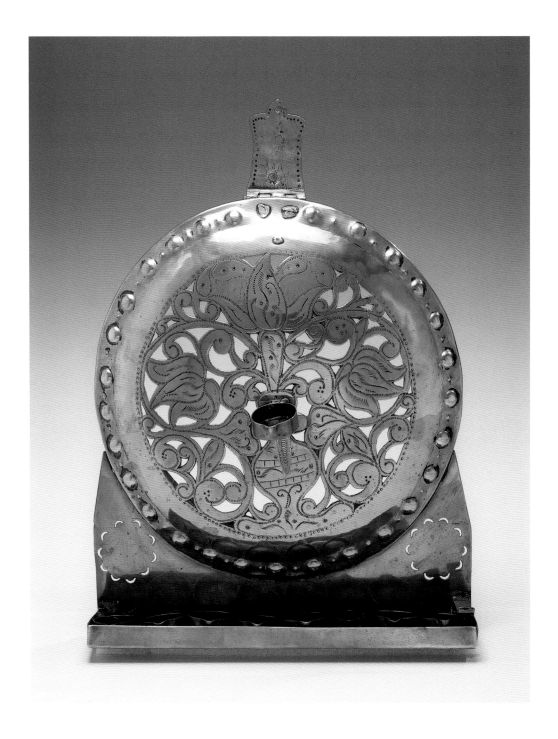

111

The Netherlands or Germany
and Italy (?), 18th century
with later additions

Copper alloy: repoussé, pierced,
traced, and punched; 16⅜ x 11¹⁵⁄₁₆ x
4 in. (41.6 x 32.9 x 10.2 cm)

Purchase: Eva and Morris Feld Judaica
Acquisitions Fund, 1982-46

The backplate of this lamp was originally the lid of a bed-warming pan, which would
have been heated with glowing coals and then used to warm the bed. The decorative
design, consisting of a vase with three large flowers and scrollwork below, can be seen
on similar pans from the Netherlands and Germany dating to the eighteenth century.
What appears to be a hanging device at top is the remnant of the attachment of the
long handle that formed part of the original bed warmer.

It was common, from at least the nineteenth century, to convert the lids of these
pans into decorative backplates for wall sconces (Caspall, p. 247), a practice that proba-
bly inspired the creation of the Jewish Museum lamp. The oil containers are oval, flat-
bottomed pans with shallow spouts, a shape reminiscent of those on a group of Italian
menorah-form lamps in the collection (see no. 341 in the catalogue raisonné).

DATE OF ACQUISITION: 1982. BIBLIOGRAPHY: Mann 1982, no. 28. SIMILAR BED-WARMER LIDS: Germanisches Nationalmu-
seum, Nuremberg (Deneke and Oppelt, no. 143); Gentle and Feild, no. 4 on p. 379; Braunschweiges Landesmuseum
(Wiswe, no. 177).

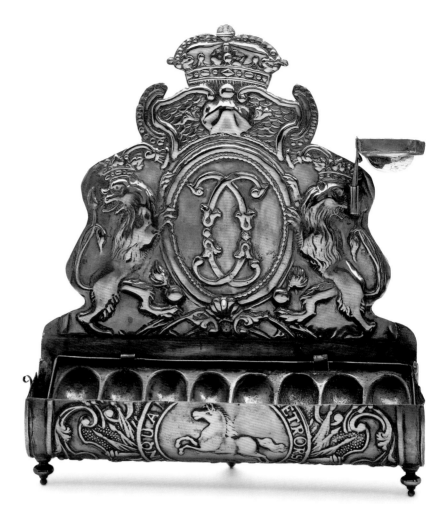

112

Braunschweig, Germany,
1776–80 with later additions

Copper alloy: die-stamped and
cast; 10½ x 9¼ x 2⅝ in.
(26.7 x 23.5 x 6.7 cm)

Gift of Dr. Harry G. Friedman,
F 1704

INSCRIPTIONS: Addorsed C's;
NUNQUAM RETRORSUM
[Latin: Never turn back]

This lamp was made from the ornamental metal plate affixed to the front of a grenadier's helmet, which had a tall conical shape. Grenadiers were trained to throw grenades during combat, and the helmet shield is, in fact, ornamented with flaming grenades, now on the sides of the lamp. Other Hanukkah lamps made of converted helmet plates are known from the Netherlands, Germany, and Austria and date to the eighteenth century. Quite a few were inscribed with the initials of either Frederick II of Prussia or Maria Theresa of Austria, whose countries were engaged in a conflict that culminated in the Seven Years' War of 1756–63.

It is not known why Jews chose to use such helmet plates for lamps. Many have martial imagery such as cannons, standards, drums, and horns, and it is possible that there was some association with the military victory celebrated at Hanukkah. The Dutch helmet plates could have belonged to Jewish soldiers; however, Austrian and German Jews were allowed to serve in the military only beginning in 1788 and 1812, respectively.

On this Hanukkah lamp, elements of the helmet plate were cut out to form the backplate and the drip pan. The row of sheet-metal oil containers was added at the time of the conversion. The horse at the bottom is a symbol of the Dukes of Braunschweig, in this case Charles I (d. 1780). All the armorial elements on this helmet were used by regiments that Charles lent to his relative King George III of England to fight in the American Revolutionary War (Helmut Nickel, Metropolitan Museum, personal communication).

DATE OF ACQUISITION: 1945. RELATED LAMPS: The Jewish Museum, nos. 627 and 628 in the catalogue raisonné; Israel Museum (Fishof 1985, nos. 3–5); Jüdisches Museum Frankfurt (Wachten, p. 54, and acc. no. JM 87-201); Hessisches Landesmuseum (Kräling, Scheurmann, and Schwoon, fig. 7, p. 63; Hallo, no. 100); State Jewish Museum, Prague (Hallo, cited in no. 99); Gross Family Collection, Tel Aviv (Cohen Grossman 1995, p. 70); Magnes Museum (Eis 1977, nos. MC 32–33); Bernheim-Neher Collection, Jerusalem (Ronnen); Wolfson Museum (Ronnen); Israel Museum Photo Archives (Ronnen). (I am grateful to Rafi Grafman and Vivian Mann for assembling many of these references.)

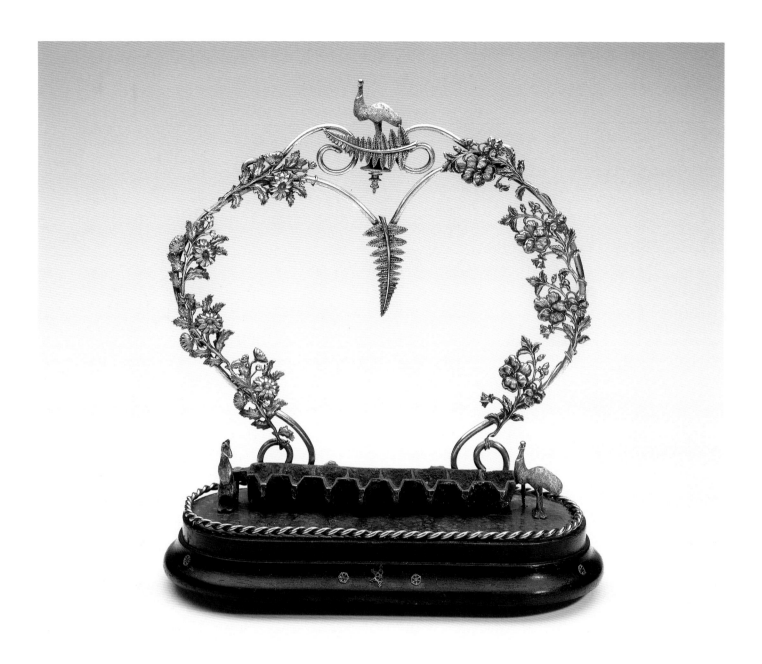

113

Australia and Morocco,
19th–20th century

Silver: die-stamped; copper alloy:
cast and silver-plated; wood;
12½ x 11½ x 5½ in.
(31.7 x 29.2 x 14 cm)
Gift of Dr. Harry G. Friedman (?),
F 3760

This object, minus the row of Hanukkah lights, was originally a souvenir from Australia. Its decoration consists of emus and kangaroos, as well as the leaves of the Australian tree fern, all symbolic of the Land Down Under. These elements are also seen on other mementos from there, such as an inkstand made in Melbourne to thank an Englishman for his generous support of projects in Australia (Fogg, p. 259).

A nineteenth-century Australian souvenir offered at auction in 1985 is very similar to the Hanukkah lamp, and has an emu egg suspended within the frame. The same was probably true for the museum's piece. At some point, its emu egg must have broken, and a secondary use for the frame was devised. A row of square oil containers taken from a Moroccan Hanukkah lamp was added to the base. The oil row could have been added any time in the nineteenth or twentieth century.

RELATED WORKS: Sotheby's NY 1985a, lot 12 (reference courtesy Hermes Knauer, Metropolitan Museum); Fogg, p. 259, top.

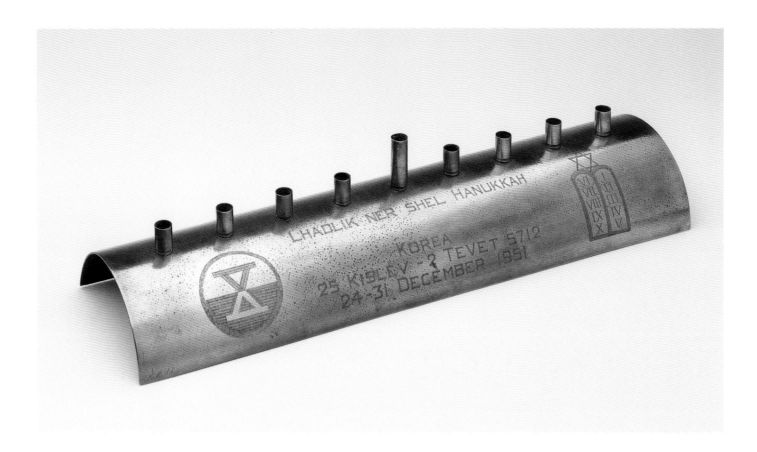

114

Donald E. Kooker (design);
Joy B. Steward, Robert J. Creato,
and Rene A. Vidaurri
(fabrication)
Korea and Japan, 1951
Copper alloy: cast, chased, and
punched; 2⅞ x 17 3/16 x 4⅝ in.
(7.3 x 43.6 x 11.7 cm)
Gift of Chaplain Meir Engel, JM 59-52

INSCRIPTIONS: LHADLIK NER SHEL
HANUKKAH / KOREA / 25 KISLEV–2
TEVET 5712 / 24–31 DECEMBER 1951

The story of this lamp's creation is a testament to the American principle of freedom of worship and to the spirit of cooperation that can exist between religious groups. The United States Army's X Corps was stationed in Korea in 1951. As Hanukkah approached, Chaplain Meir Engel was unable to locate a lamp so that he could celebrate the festival with the Jewish members of the Corps. Hearing of his dilemma, a fellow officer told Chaplain Engel to contact 1st Lt. Donald E. Kooker of the 1st Ordinance Medium Maintenance Company to help solve the problem. Lt. Kooker designed a Hanukkah lamp, which army craftsmen then fabricated out of a shell casing and cartridge shells. A friend of the chaplain then took the lamp to Japan, where the inscriptions were added. Chaplain Engel was indeed able to celebrate Hanukkah that year in Korea, and soon after donated this lamp to The Jewish Museum.

The use of shells and cartridges to fashion various types of objects started to become a common practice in the mid-nineteenth century, when this type of artillery was introduced. Such items have come to be called "trench art" after the trench-style warfare of World War I. The most common metal pieces produced were vases, lighters, letter openers, and finger rings, to name just a few. The contexts for their manufacture were varied. Some items were made by soldiers, either on or near the front, although many were made by blacksmiths or engineers farther in the rear. Soldiers also made trench art in hospitals and prisoner-of-war camps, often for sale. Civilians later picked up the detritus of war from the scrap heaps and fashioned objects for sale to soldiers and to the tourists who soon came to see the battlefield sites. Lastly, commercial firms in Europe and the United States would create objects out of souvenir ordnance brought home by returning soldiers. Many of the items were secular in nature, although crucifixes and pieces with images of the cross were made (Saunders, pp. 4–7, 9; Kimball, pp. 6–7). Items associated with Judaism appear to be rare.

DATE OF ACQUISITION: 1953.

BIBLIOGRAPHY

REFERENCES CITED

ADLER AND CASANOWICZ 1899
Adler, Cyrus, and Immanuel Moses Casanowicz. "Descriptive Catalogue of a Collection of Objects of Jewish Ceremonial Deposited in the U.S. National Museum by Hadji Ephraim Benguiat." *Report of U.S. National Museum* (1899): 545–61.

ADLER AND CASANOWICZ 1908
Adler, Cyrus, and Immanuel Moses Casanowicz. "The Collection of Jewish Ceremonial Objects in the United States National Museum." *Proceedings of the U.S. National Museum* 34, no. 1630 (1908): 701–46.

AL-JADIR
Al-Jadir, Saad. *Arab and Islamic Silver*. London: Stacey International, 1981.

D. ALTSHULER
Altshuler, David, ed. *The Precious Legacy: Judaic Treasures from the Czechoslovak State Collections*. New York: Summit Books, 1983.

AMERICAN JEWISH HISTORICAL SOCIETY
American Jewish Historical Society. *Heritage*. http://www.ajhs.org/about/Newsletter/fall-2001/page3.cfm.

ANDERSSON AND TALBOT
Andersson, Christiane, and Charles Talbot. *From a Mighty Fortress: Prints, Drawings, and Books in the Age of Luther, 1484–1546*. Detroit: Detroit Institute of Arts, 1983.

ARBEL AND MAGAL
Arbel, Rachel, and Lily Magal, eds. *In the Land of the Golden Fleece: The Jews of Georgia; History and Culture*. Tel Aviv: Beth Hatefutsoth, Nahum Goldmann Museum of the Jewish Diaspora and Defence Publishing House, 1992.

ARMORY CENTER
Armory Center for the Arts. *Rod Baer: A Selection of Constructed Situations, 1981–1994*. Exh. pamphlet. Pasadena: Armory Center for the Arts, 1994.

BAER
Baer, Leah. *Cultural Change: A Study of Changes in the Objects and Rituals of Iranian Jews*. Ph.D. diss., University of Chicago, 1990.

BALABAN 1909
Balaban, Majer. *Dzielnica żydowska: Jej dzieje i zabytki*. Lvov: Towarzystwa Miłośników Przeszłości Lwowa, 1909.

BALABAN 1932
Balaban, Majer. "Obyczajowość i życie prywatne żydow w dawnej Rzeczypospolitej." In *Żydzi w Polsce odrodzonej*, edited by Ignacy Schiper et al., 345–74. Warsaw: Żydzi w Polsce Odrodzonej, 1932.

BARFOD, KLEEBLATT, AND MANN
Barfod, Jorgen H., Norman L. Kleeblatt, and Vivian B. Mann, co-curators. *Kings and Citizens: The History of the Jews in Denmark, 1622–1983*. New York: The Jewish Museum, 1983.

BARNETT
Barnett, R. D., ed. *Catalogue of the Permanent and Loan Collections of the Jewish Museum London*. London: Harvey Miller; New York: New York Graphic Society, 1974.

BARQUIST
Barquist, David. *Myer Myers: Jewish Silversmith in Colonial New York*. New Haven and London: Yale University Art Gallery in association with Yale University Press, 2001.

BAUR
Baur, Veronika. *Metal Candlesticks: History, Styles, Techniques*. Atglen, Penn.: Schiffer Publishing, 1996.

BEMPORAD 1989
Bemporad, Dora Liscia. "Jewish Ceremonial Art in the Era of the City States and the Ghettos." In *Gardens and Ghettos: The Art of Jewish Life in Italy*, edited by Vivian B. Mann, 111–35. Berkeley and Los Angeles: University of California Press, 1989.

BEMPORAD 1993A
Bemporad, Dora Liscia. *Argenti Fiorentini dal XV al XIX secolo: Tipologie e marchi*. Florence: SPES, 1993.

BEMPORAD 1993B

Bemporad, Dora Liscia. "Due famiglie di gioiellieri Ebrei a Firenze tra sette e ottocento." *La Rasegna Mensile di Israel* 60, nos. 1–2 (1993): 122–36.

BENJAMIN 1987

Benjamin, Chaya. *The Stieglitz Collection: Masterpieces of Jewish Art.* Jerusalem: Israel Museum, 1987.

BENJAMIN 1992

Benjamin, Chaya. "The Sephardic Journey: 500 Years of Jewish Ceremonial Objects." In *The Sephardic Journey, 1492–1992*, edited by Sylvia Herskowitz, 94–130. New York: Yeshiva University Museum, 1992.

BENJAMIN 2002

Benjamin, Chaya. *Orot b'Harei ha-Atlas.* Jerusalem: Israel Museum, 2002.

BENOSCHOFSKY AND SCHEIBER

Benoschofsky, Ilona, and Sándor Scheiber. *A Budapesti Zsidó Múzeum.* Budapest: Corvina, 1987.

BERMAN 1979

Berman, Nancy M. "The Hirsch and Rothschild Hanukkah Lamps at the Hebrew Union College Skirball Museum." *Journal of Jewish Art* 6 (1979): 86–97.

BERMAN 1986

Berman, Nancy M. *Moshe Zabari: A Twenty-Five Year Retrospective.* New York: The Jewish Museum; Los Angeles: Hebrew Union College Skirball Museum, 1986.

BERMAN 1996

Berman, Nancy M. *The Art of Hanukkah.* New York: Hugh Lauter Levin Associates, 1996.

BERNSTEIN 1976

Bernstein, Bernard. "The Decade: Change and Continuity." *Craft Horizons* (June 1976): 65–66.

BERNSTEIN 1987

Bernstein, Bernard. "The Jewish Ceremonial Object in Contemporary History." *Metalsmith* (summer 1987): 30–37.

BEUKERS AND WAALE

Beukers, Mariëlla, and Renée Waale, eds. *Tracing An-Sky: Jewish Collections from the State Ethnographic Museum in St Petersburg.* Zwolle: Uitgeverij Waanders; St. Petersburg: State Ethnographic Museum; Amsterdam: Joods Historisch Museum, 1992.

BIALER AND FINK

Bialer, Yehudah L., and Estelle Fink. *Jewish Life in Art and Tradition.* 2nd ed. Jerusalem: Hechal Shlomo, 1980.

BITTERLI AND WOHLGEMUTH

Bitterli, Konrad, and Matthias Wohlgemuth, eds. *Matthew McCaslin: Works, Sites.* Ostfildern bei Stuttgart: Cantz, 1997.

DEN BLAAUWEN

den Blaauwen, A. L. *Nederlands zilver: Dutch Silver.* Amsterdam: Rijksmuseum, 1979.

BLACK

Black, Karen. "At Work with Peter Shire." *Copley News Service*, March 25, 1987.

BLUNT

Blunt, Anthony, ed. *Baroque and Rococo Architecture and Decoration.* New York: Harper and Row, 1978.

B'NAI B'RITH KLUTZNICK MUSEUM

B'nai B'rith Klutznick National Jewish Museum. *Jews in the Cultural Fusion of Tunisia.* Exh. pamphlet. Washington, D.C.: B'nai B'rith Klutznick National Jewish Museum, n.d.

DE BODT

de Bodt, Saskia. *Dated Ceramic Wares.* Rotterdam: Museum Boymans-van Bueningen Rotterdam, 1991.

BONDONI AND BUSI

Bondoni, Simonetta M., and Giulio Busi. *Cultura ebraica in Emilia-Romagna.* Rimini: Luisè Editore, 1987.

BOWMAN

Bowman, Leslie Greene. *American Arts and Crafts: Virtue in Design.* Los Angeles: Los Angeles County Museum of Art, 1990.

BRAUER

Brauer, Erich. *The Jews of Kurdistan.* Edited by Raphael Patai. Detroit: Wayne University Press, 1993.

BRAUNSTEIN 1985

Braunstein, Susan L. *Personal Vision: The Jacobo and Asea Furman Collection of Jewish Ceremonial Art.* New York: The Jewish Museum, 1985.

BRAUNSTEIN 1991

Braunstein, Susan L. "Hanukkah Lamp." In *Sigmund Freud's Jewish Heritage*, 7–10. Exh. pamphlet. Binghamton: State University of New York; London: Freud Museum, 1991.

BRAUNSTEIN AND WEISSMAN JOSELIT

Braunstein, Susan L., and Jenna Weissman Joselit, eds. *Getting Comfortable in New York: The American Jewish Home, 1880–1950.* New York: The Jewish Museum, 1990.

BRONNER 1926B

Bronner, Jakob. "Vier ostjüdische Chanukah-menoroth." *Menorah* 4, no. 12 (1926): 709–11.

BRUNSON
Brunson, Jamie. "San Francisco Fax, July 19, 1993." *Art Issues*, no. 29 (September–October 1993): 32–33.

BUNT
Bunt, Cyril G. E. *The Goldsmiths of Italy*. London: Martin Hopkinson and Company, 1926.

BUSCH
Busch, Ralf. "The Case of Alexander David of Braunschweig." In *From Court Jews to the Rothschilds: Art, Patronage, and Power, 1600–1800*, edited by Vivian B. Mann and Richard I. Cohen, 59–66. Munich and New York: Prestel, 1996.

BUTTERFIELD AND BUTTERFIELD
Butterfield and Butterfield, Los Angeles. *Important Judaica and Works of Art* (March 3, 1992).

CASPALL
Caspall, John. *Fire and Light in the Home Pre-1820*. Woodbridge, United Kingdom: Antique Collectors' Club, 1987.

CENTRAL-VEREIN-ZEITUNG
Central-Verein-Zeitung: Blätter für Deutschtum und Judentum (Berlin) 12, no. 48 (December 14, 1933).

CHILD
Child, Graham. *World Mirrors, 1650–1900*. London: Sotheby's Publications, 1990.

CHRISTIE'S AMSTERDAM 1986
Christie's Amsterdam. *Fine Judaica* (December 3, 1986).

CHRISTIE'S AMSTERDAM 1988
Christie's Amsterdam. *Fine Judaica* (May 11, 1988).

CHRISTIE'S AMSTERDAM 1990A
Christie's Amsterdam. *Judaica Books, Manuscripts, Works of Art, and Pictures* (June 20, 1990).

CHRISTIE'S AMSTERDAM 1990B
Christie's Amsterdam. *Judaica Books, Manuscripts, Works of Art, and Pictures* (December 19, 1990).

CHRISTIE'S AMSTERDAM 2000
Christie's Amsterdam. *Important Judaica, Dutch and Foreign Silver, and Objects of Vertu* (May 16, 2000).

CHRISTIE'S NY 1985
Christie's New York. *Judaica Books, Manuscripts, and Works of Art* (June 25, 1985).

CHRZANOWSKI AND PIWOCKI
Chrzanowski, Tadeusz, and Ksawery Piwocki. *Drewno w polskiej architekturze i rzeźbie ludowej*. Wrocław: Zakład Narodowy imienia Ossolińskich, Wydawnictwo Polskiej Akademii Nauk, 1981.

CITROEN, VAN ERPERS ROYAARDS, AND VERBEEK
Citroen, K. A., F. van Erpers Royaards, and J. Verbeek, *Meesterwerken in zilver: Amsterdams zilver, 1520–1820*. Amsterdam: Museum Willet-Holthuysen, 1984.

CLARK
Clark, Garth. *A Century of Ceramics in the United States, 1878–1978*. New York: E. P. Dutton, 1979.

CLOTHIER
Clothier, Peter. "Gertrud and Otto Natzler: A Ceramic Art in the Modernist Tradition." In *Gertrud and Otto Natzler: Collaboration/Solitude*, edited by Janet Kardon, 19–38. New York: American Craft Museum, 1993.

COHEN
Cohen, Richard I. "Self-Image through Objects: Towards a Social History of Jewish Art Collecting and Jewish Museums." In *The Uses of Tradition: Jewish Continuity in the Modern Era*, edited by Jack Wertheimer, 203–42. New York and Jerusalem: Jewish Theological Seminary of America, 1992.

COHEN GROSSMAN 1995
Cohen Grossman, Grace. *Jewish Art*. New York: Hugh Lauter Levin Associates, 1995.

COHEN GROSSMAN 1996
Cohen Grossman, Grace, ed. *New Beginnings: The Skirball Museum Collections and Inaugural Exhibition*. Los Angeles: Skirball Cultural Center, 1996.

COHEN GROSSMAN 1997
Cohen Grossman, Grace, with Richard Eigme Ahlborn. *Judaica at the Smithsonian: Cultural Politics as Cultural Model*. Washington, D.C.: Smithsonian Institution Press, 1997.

COLEMAN
Coleman Auction Galleries, New York. *Judaica (Jewish Ritual Art Objects): Collection of Michael Kaufman* (May 27, 1965).

CONROY
Conroy, Sarah Booth. "Earth, Fire, and Love: The Natzler Touch." *Los Angeles Times*, September 20, 1981.

CONSISTOIRE
Consistoire Central Israëlite de Belgique. *150 ans de judaïsme belge*. Belgium: Consistoire Central Israëlite de Belgique, 1980.

CUSIN
Cusin, Silvio. *Arte nella tradizione ebraica*. Milan: ADEI-WIZO, 1963.

D'AGOSTINO
D'Agostino, Ivana. "Anninovanta?" *Terzoocchio* 60 (September 1991): 16–17.

DANIELS AND MARKARIAN
Daniels, George, and Ohannes Markarian. *Watches and Clocks in the Sir David Salomons Collection*.

Jerusalem: L. A. Mayer Memorial Institute for
Islamic Art, 1980.

DANZIG

Sammlung jüdischer Kunstgegenstände der Synagogen-
Gemeinde zu Danzig. Danzig: Danzig Jewish Com-
munity, 1933.

DENEKE AND OPPELT

Deneke, Bernward, and Wolfgang Oppelt.
Ländlicher Schmuck aus Deutschland, Österreich, und
der Schweiz. Nuremberg: Germanisches National-
museum, 1982.

DESHEN

Deshen, Shlomo. The Mellah Society: Jewish Com-
munity Life in Sherifian Morocco. Chicago and Lon-
don: University of Chicago Press, 1989.

DIAMANT

Diamant, Max. Jüdische Volkskunst. Vienna and
Jerusalem: R. Löwit, 1937.

DIETZ 1907

Dietz, Alexander. The Jewish Community of Frank-
furt: A Genealogical Study, 1349–1849. Eng. ed. of
Stammbuch der Frankfurter Juden (1907). Edited by
Isobel Mordy. Camelford, United Kingdom: Van-
derher Publications, 1988.

DOROTHEUM

Dorotheum, Vienna. 549. Kunstauktion (September
13–16, 1960).

EDIDIN

Edidin, Ben M. Jewish Holidays and Festivals. New
York: Hebrew Publishing Company, 1940.

EIS 1977

Eis, Ruth. Hanukkah Lamps of the Judah L. Magnes
Museum. Berkeley: Judah L. Magnes Museum, 1977.

EIS 2000

Eis, Ruth. "An Eighteenth-Century Hanukkah
Lamp Rediscovered." In A Crown for a King: Studies
in Jewish Art, History, and Archaeology in Memory of
Stephen S. Kayser, edited by Shalom Sabar, Steven
Fine, and William M. Kramer, 97–102. Berkeley:
Judah L. Magnes Museum; Jerusalem and New
York: Gefen Publishing House, 2000.

ELIACH

Eliach, Yaffa. There Once Was a World. Boston, New
York, Toronto, and London: Little, Brown and
Company, 1998.

ENCYCLOPEDIA JUDAICA

Encyclopedia Judaica. Vol. 10. Jerusalem: Keter Pub-
lishing House, 1971.

ESCHWEGE

Eschwege, Helmut. Die Synagoge in der deutschen
Geschichte. Dresden: VEB Verlag der Kunst, 1980.

FENNIMORE

Fennimore, Donald L. Metalwork in Early America:
Copper and Its Alloys from the Winterthur Collection.
Winterthur, Del.: Henry Francis du Pont Win-
terthur Museum, 1996.

FISHOF 1985

Fishof, Iris. From the Secular to the Sacred: Everyday
Objects in Jewish Ritual Use. Jerusalem: Israel Mu-
seum, 1985.

FISHOF 1994

Fishof, Iris. Jewish Art Masterpieces from the Israel
Museum. Jerusalem: Hugh Lauter Levin Associates,
1994.

FISHOF AND ZALMONA

Fishof, Iris, and Yigal Zalmona. In a Single State-
ment: Works by Zelig Segal. Jerusalem: Israel Mu-
seum, 1992.

FOGG

Fogg, Georgia, ed. Sotheby's Art at Auction, 1986–87.
London and New York: Sotheby's Publications,
1987.

FORTIS

Fortis, Umberto. Jews and Synagogues. Venice: Edi-
zioni Storti, 1973.

FOX-DAVIES

Fox-Davies, A. C. A Complete Guide to Heraldry.
Revised and annotated by J. P. Brooke-Little. New
York: Bonanza Books, 1985.

FRANZHEIM

Franzheim, Liesel. Judaica: Kölnisches Museum.
Köln: Museen der Stadt Köln, 1980.

FRAUBERGER

Frauberger, Heinrich. "Über alte Kultusgegen-
stände in Synagoge und Haus." Mitteilungen der
Gesellschaft zur Erforschung jüdischer Kunstdenkmäler
zu Frankfurt am Main 3/4 (October 1903).

FRIEDBERG

Friedberg, Haya. "Gishot Pisuliot ba-Itzuv Menorot
Hanukkah Banot-Z´manenu." Proceedings of the
Ninth World Congress of Jewish Studies (Jerusalem) 2
(1985): 31–37. Division D.

FRIEDENBERG

Friedenberg, Daniel M. Jewish Minters and
Medalists. Philadelphia: Jewish Publication Society
of America, 1976.

FRIEDMAN

Friedman, Mira. "The Metamorphoses of Judith."
Jewish Art 12–13 (1986–87): 225–46.

FUKS ET AL.

Fuks, Marian, Zygmunt Hoffman, Maurycy Horn,
and Jerzy Tomaszewski. Polish Jewry: History and

Culture. Warsaw: Interpress, 1982.

L. B. GANS
Gans, L. B. *Goud- en zilvermerken van Voet*. Leiden and Antwerp: Martinus Nijhoff Uitgevers, 1992.

M. H. GANS
Gans, Mozes Heiman. *Memorbook: History of Dutch Jewry from the Renaissance to 1940*. Baarn: Bosch and Keuning, 1971.

GENIZI
Genizi, Haim. "Philip S. Bernstein: Adviser on Jewish Affairs, May 1946–August 1947." *Simon Wiesenthal Museum of Tolerance Online Multimedia Learning Center, Annual 3*, 1–28. http://motlc.wiesenthal.com/resources/books/annual3/chap06.html.

GENTLE AND FEILD
Gentle, Rupert, and Rachael Feild. *Domestic Metalwork, 1640–1820*. Woodbridge, United Kingdom: Antique Collectors' Club, 1994.

GERMANISCHES NATIONALMUSEUM
Germanisches Nationalmuseum. *Siehe der Stein schreit aus der Mauer: Geschichte und Kultur der Juden in Bayern*. Nuremberg: Germanisches Nationalmuseum, 1988.

GHABIN
Ghabin, Ahmad. "Jewellery and Goldsmithing in Medieval Islam: The Religious Point of View." In *Jewellery and Goldsmithing in the Islamic World: International Symposium*, edited by Na'ama Brosh, 83–92. Jerusalem: Israel Museum, 1987.

GIDALEWITSCH
Gidalewitsch, Georg. "Die Sammlung jüdischer Kult- und Kunstgegenstände im Bayerischen Nationalmuseum." *Bayerische Israelitische Gemeindezeitung* 21 (1928): 329–32.

GILBERT
Gilbert, Barbara. *Earth and Spirit: Otto Natzler at 80*. Exh. pamphlet. Los Angeles: Hebrew Union College, Skirball Museum, 1987.

GILBOA
Gilboa, Violet. *Catalog of the Bernice and Henry Tumen Collection of Jewish Ceremonial Objects in the Harvard College Library and the Harvard Semitic Museum*. Cambridge: Harvard University Library, 1993.

GLANVILLE
Glanville, Philippa, ed. *Silver: History and Design*. New York: Harry N. Abrams, 1997.

GOLDMAN IDA
Goldman Ida, Batsheva. *Ze'ev Raban: A Hebrew Symbolist*. Tel Aviv: Tel Aviv Museum of Art in collaboration with Yad Yzhak Ben-Zvi, 2001.

GOLDSMITH AND MESSA
Goldsmith, Dani, and Uriel Messa. *Aden: A Profile of a Jewish Community, 1839–1967*. Tel Aviv: Goldsmith and Messa, 1995.

GOODMAN
Goodman, Philip. *The Hanukkah Anthology*. Philadelphia and Jerusalem: Jewish Publication Society, 1992.

GOULD
Gould, Mary Earle. *Antique Tin and Tole Ware: Its History and Romance*. Rutland, Vt.: Charles E. Tuttle, 1958.

GRAFMAN 1996
Grafman, Rafi. *Crowning Glory: Silver Torah Ornaments of The Jewish Museum, New York*. New York: The Jewish Museum in association with David R. Godine Publisher, 1996.

GRAFMAN 1999
Grafman, Rafi. *A Mirror of Jewish Life: Selections from the Moldovan Family Collection*. Tel Aviv: Judaica Museum, Tel Aviv University, 1999.

GRAMMET AND DE MEERSMAN
Grammet, Ivo, and Min de Meersman, eds. *Splendeurs du Maroc*. Tervuren: Musée royal de l'Afrique centrale, 1998.

GROSSMAN 1989A
Grossman, Cissy. *The Jewish Family's Book of Days*. New York: Abbeville Press, 1989.

GROSSMAN 1989B
Grossman, Cissy. *A Temple Treasury: The Judaica Collection of Congregation Emanu-El of the City of New York*. New York: Hudson Hills Press, 1989.

GROSSMAN 1993
Grossman, Cissy. *The Collector's Room: Selections from the Michael and Judy Steinhardt Collection*. New York: Hebrew Union College–Jewish Institute of Religion, 1993.

GROTTE
Grotte, Alfred. *Deutsche, böhmische, und polnische Synagogentypen vom XI. bis Anfang des XIX. Jahrhunderts*. Berlin: Der Zirkel, 1915.

GRUNWALD
Grunwald, Max. "Etwas über jüdische Kunst und ältere jüdische Künstler: II. Nachtrag." *Mitteilungen zur jüdische Volkskunde* (1907): 103–17.

GUNDERSHEIMER AND SCHOENBERGER
Gundersheimer, Hermann, and Guido Schoenberger. "Frankfurter Chanukkahleuchter aus Silber und Zinn." *Notizblatt der Gesellschaft zur Erforschung jüdischer Kunstdenkmäler* 34 (1937): 2–28.

GUTH-DREYFUS AND HOFFMAN

Guth-Dreyfus, Katia, and Eve-M. Hoffman, eds. *Juden im Elsass*. Basel: Jüdisches Museum der Schweiz and Schweizerisches Museum für Volkskunde, 1992.

GUTMANN 1992

Gutmann, Joseph. "Feast of Lights: Art and Tradition of Hanukkah Lamps." In *Feast of Lights: Art and Tradition of Hanukkah Lamps*, edited by Anita Plous, 5–14. Detroit: Janice Charach-Epstein Museum/Gallery, Jewish Community Center of Metropolitan Detroit, 1992.

GUTMANN 1999

Gutmann, Joseph. "On Medieval Hanukkah Lamps." *Artibus et Historiae* 40 (1999): 187–90.

GUTTMANN

Guttmann, Henri. *Hebraica: Documents d'art juif; Orfèvrerie, peinture*. Paris: Librairie des Arts Décoratifs, n.d.

HALLO

Hallo, Rudolf. *Jüdische Kunst aus Hessen und Nassau*. Berlin: Soncino-Gesellschaft der Freunde des jüdischen Buches E.V., 1933.

HANEGBI AND YANIV

Hanegbi, Zohar, and Bracha Yaniv. *Afghanistan: The Synagogue and the Jewish Home*. Jerusalem: Center for Jewish Art and Hebrew University of Jerusalem, 1991.

HARBURGER

Harburger, Theodor. *Die Inventarisation jüdischer Kunst- und Kulturdenkmäler in Bayern*. Fürth: Jüdisches Museum Franken—Fürth und Schnaittach; Jerusalem: Central Archives for the History of the Jewish People, 1998.

HÄUSLER

Häusler, Wolfgang. *Judaica: Die Sammlung Berger; Kult und Kultur des europäischen Judentums*. Vienna and Munich: Jugend und Volk, 1979.

HECHAL SHLOMO

Hechal Shlomo, Jerusalem. *Dor va'Dor*. Jerusalem: Abraham Wix Religious Museum, 1961.

HEIMANN-JELINEK

Heimann-Jelinek, Felicitas. *Möchte´ ich ein Österreicher sein: Judaica aus der Sammlung Eisenberger*. Vienna: Jüdisches Museum der Stadt Wien, 2000.

HELBING 1930

Hugo Helbing, Frankfurt am Main. *Nachlass Frau Jacob W. Weiller, Frankfurt am Main* (October 21, 1930).

HENNIG

Hennig, Wolfgang. *Kunsthandwerk um 1900: Schenkung Brühl 1966 und 1986*. Berlin: Kunstgewerbe Museum, 1986.

HERNMARCK

Hernmarck, Carl. *The Art of the European Silversmith, 1430–1830*. London and New York: Sotheby Parke Bernet, 1977.

HILTON

Hilton, Alison. *Russian Folk Art*. Bloomington and Indianapolis: Indiana University Press, 1995.

HINTZE *BRESLAU*

Hintze, Erwin. *Die Breslauer Goldschmiede: Eine Archivalische Studie*. Breslau: Verein für das Museum Schlesischer Altertümer, 1906.

HINTZE *ZINNGIESSER*

Hintze, Erwin. *Die Deutsche Zinngiesser und ihre Marken*. Vols. 1–7. Leipzig: Verlag Karl W. Hiersemann, 1921–31.

HIRSCHBERG

Hirschberg, H. Z. *A History of the Jews in North Africa*. Leiden: Brill, 1981.

HIRSCHLER

Hirschler, Gertrude, ed. *Ashkenaz: The German Jewish Heritage*. New York: Yeshiva University Museum, 1988.

HOLY LAND TREASURES 2

Holy Land Treasures, Burlingame, Calif. *Antique Judaica: Catalogue Two*. n.d.

HONOUR

Honour, Hugh. *Goldsmiths and Silversmiths*. New York: G. P. Putnam's Sons, 1971.

HOSHEN

Hoshen, Sarah Harel. *Treasures of Jewish Galicia: Judaica from the Museum of Ethnography and Crafts in Lvov, Ukraine*. Tel Aviv: Beth Hatefutsoth, Nahum Goldmann Museum of the Jewish Diaspora, 1996.

IDEL

Idel, Moshe. "Binah, the Eighth *Sefirah*: The Menorah in Kabbalah." In *In the Light of the Menorah: Story of a Symbol*, edited by Yael Israeli, 143–46. Jerusalem: Israel Museum, 1999.

ILSE-NEUMAN

Ilse-Neuman, Ursula. "Karl Friedrich Schinkel and Berlin Cast Iron, 1810–1841." In *Cast Iron from Central Europe, 1800–1850*, edited by Elisabeth Schmuttermeier, 55–73. New York: Bard Graduate Center for Studies in the Decorative Arts, 1994.

ISRAEL EXPORT INSTITUTE

Arts and Crafts Center, Israel Export Institute. *Israel Arts and Crafts*. Jerusalem: Ministry of Commerce and Industry; Tel Aviv: Israel Export Institute, n.d.

ISRAEL MUSEUM

Israel Museum. *Nerot Mitzvah: Contemporary Ideas*

for Light in Jewish Ritual. Jerusalem: Israel Museum, 1986.

JACOBS AND WOLF

Jacobs, Joseph, and Lucien Wolf. Catalogue of the Anglo-Jewish Historical Exhibition: Royal Albert Hall, London, 1887. London: F. Haes, 1888.

JARMUTH

Jarmuth, Kurt. Lichter Leuchten im Abendland: Zweitausend Jahre Beleuchtungskörper. Braunschweig, Germany: Klinkhardt und Biermann, 1967.

JERUSALEM POST

"David Gumbel: Father of Silversmiths." Jerusalem Post, December 6, 1992.

JEWISH ENCYCLOPEDIA

Jewish Encyclopedia. Vols. 1–12. New York and London: Funk and Wagnalls, 1906–7.

JEWISH MUSEUM 1958

The Jewish Museum. Ceramics: An Exhibit; Gertrud and Otto Natzler. Exh. pamphlet. New York: The Jewish Museum, 1958.

JEWISH MUSEUM 1976

The Jewish Museum. Ludwig Yehuda Wolpert: A Retrospective. Exh. pamphlet. New York: The Jewish Museum, 1976.

JOODS HISTORISCH MUSEUM

Joods Historisch Museum, Amsterdam. Joodse feestdagen: Chanoeka. Amsterdam: Joods Historisch Museum, 1963.

JÜDISCHE MUSEUMSVEREIN

Jüdische Museumsverein Berlin. Bericht über die Gründungsversammlung des Jüdischen Museumsvereins Berlin. Berlin: [Jüdische Museumsverein Berlin], 1929.

JÜDISCHES LEXIKON

Jüdisches Lexikon. Vols. 1–4. Berlin: Jüdischer Verlag, 1927–30.

JÜDISCHES MUSEUM FRANKFURT

Jüdisches Museum Frankfurt am Main. Das Museum Jüdischer Altertümer in Frankfurt: Was übrig blieb. Frankfurt: Jüdisches Museum Frankfurt, 1988.

KALINOWSKI ET AL.

Kalinowski, Zdzisław, et al., eds. Materyały do architektury polskiej. Vol. 1, Wieś i miasteczko. Warsaw: Nakładem Gebethnera i Wolffa, 1916.

KAMPF

Kampf, Abram. Contemporary Synagogue Art: Developments in the United States, 1945–1965. New York: Union of American Hebrew Congregations, 1966.

KANOF 1969

Kanof, Abram. Jewish Ceremonial Art and Religious Observance. New York: Harry N. Abrams, 1969.

KANOF 1976

Kanof, Abram. "Ludwig Yehuda Wolpert." In Ludwig Y. Wolpert: A Retrospective. New York: The Jewish Museum, 1976.

KANOF 1986

Kanof, Abram. "The Tobe Pascher Workshop, 1956–1986." In Moshe Zabari: A Twenty-Five Year Retrospective, by Nancy M. Berman, 6. New York: The Jewish Museum; Los Angeles: Hebrew Union College Skirball Museum, 1986.

KANTSEDIKAS

Kantsedikas, Alexander. Masterpieces of Jewish Art: Bronze. Moscow: Image Advertising and Publishing House, n.d.

A. KAPLAN

Kaplan, Aryeh. The Laws of Chanukah from the Shulchan Arukh. New York and Jerusalem: Maznaim Publishing Corporation, 1977.

Y. KAPLAN

Kaplan, Yosef. "Court Jews before the Hofjuden." In From Court Jews to the Rothschilds: Art, Patronage, and Power, 1600–1800, edited by Vivian B. Mann and Richard I. Cohen, 11–26. Munich and New York: Prestel, 1996.

KARDON

Kardon, Janet, ed. Gertrud and Otto Natzler: Collaboration/Solitude. New York: American Craft Museum, 1993.

KARLINGER

Karlinger, Hans. Deutsche Volkskunst. Berlin: Im Propyläen Verlag, 1938.

KATZ, KAHANE, AND BROSHI

Katz, Karl, P. P. Kahane, and Magen Broshi. From the Beginning: Archaeology and Art in the Israel Museum, Jerusalem. London: Weidenfeld and Nicolson, 1968.

KAYSER

Kayser, Stephen. Excerpt from Eulogy in In Memoriam: Ludwig Y. Wolpert (October 17, 1982). Privately published.

KAYSER AND SCHOENBERGER

Kayser, Stephen, and Guido Schoenberger, eds. Jewish Ceremonial Art. Philadelphia: Jewish Publication Society of America, 1959.

KEEN

Keen, Michael E. Jewish Ritual Art in the Victoria and Albert Museum. London: HMSO, 1991.

KESTENBAUM 2000

Kestenbaum and Company, New York. *Fine Judaica: Books, Manuscripts, and Works of Art* (March 28, 2000).

KESTENBAUM 2001

Kestenbaum and Company, New York. *Fine Judaica: Books, Manuscripts, and Works of Art* (June 26, 2001).

KIMBALL

Kimball, Jane A. *Trench Art of the Great War and Related Souvenirs*, 2000. http://www.trenchart.org.

KLAGSBALD 1956

Klagsbald, Victor. *Art religieux juif: Reflet des styles 13e siècle au 19 siècle*. Paris: Musée d'Art Juif, 1956.

KLAGSBALD 1982

Klagsbald, Victor. *Jewish Treasures from Paris from the Collections of the Cluny Museum and the Consistoire*. Jerusalem: Israel Museum, 1982.

KLEEBLATT AND MANN

Kleeblatt, Norman L., and Vivian B. Mann. *Treasures of The Jewish Museum*. New York: Universe Books, 1986.

KLEEBLATT AND WERTKIN

Kleeblatt, Norman L., and Gerard C. Wertkin. *The Jewish Heritage in American Folk Art*. New York: Universe Books, 1984.

KNAB

Knab, Sophie Hodorowicz. *Polish Customs, Traditions, and Folklore*. New York: Hippocrene Books, 1993.

KRÄLING, SCHEURMANN, AND SCHWOON

Kräling, Ingrid, Konrad Scheurmann, and Carsten Schwoon, eds. *Juden in Kassel, 1808–1933*. Kassel: Thiele und Schwarz, 1987.

KRANE

Krane, Susan. *Art at the Edge: Joel Otterson; Home Sweet Home*. Exh. pamphlet. Atlanta: High Museum of Art, 1991.

KREKEL-AALBERSE

Krekel-Aalberse, Annelies. *Art Nouveau and Art Deco Silver*. New York: Harry N. Abrams, 1989.

KREMER

Kremer, Moses. "Jewish Artisans and Guilds in Former Poland, Sixteenth to Eighteenth Centuries." In *Beauty in Holiness: Studies in Jewish Customs and Ceremonial Art*, edited by Joseph Gutmann, 34–65. New York: Ktav Publishing House, 1970.

KRINSKY

Krinsky, Carol Herselle. *Synagogues of Europe: Architecture, History, Meaning*. New York: Architectural History Foundation; Cambridge and London: MIT Press, 1985.

KÜHNEL

Kühnel, Bianca. "The Menorah and the Cross: The Seven-Branched Candelabrum in the Church." In *In the Light of the Menorah: Story of a Symbol*, edited by Yael Israeli, 112–21. Jerusalem: Israel Museum, 1999.

LACMA

Los Angeles County Museum of Art. *Clay Today: Contemporary Ceramists and Their Work*. Text by Martha Drexler Lynn. Los Angeles: Los Angeles County Museum of Art, 1990.

LANDAU

Landau, Suzanne. *Architecture in the Hanukkah Lamp*. Jerusalem: Israel Museum, 1978.

LANDSBERGER 1941

Landsberger, Franz. "The Jewish Artist Before the Time of Emancipation." *Hebrew Union College Annual* 16 (1941): 321–414.

LANDSBERGER 1954

Landsberger, Franz. "Old Hanukkah Lamps: Apropos a New Acquisition of the Jewish Museum in Cincinnati." *Hebrew Union College Annual* 25 (1954): 347–67.

LAUGHLIN

Laughlin, L. I. *Pewter in America*. New York: American Legacy Press, 1981.

LAWRENCE

Lawrence, Sarah E. *Crafting a Jewish Style: The Art of Bezalel, 1906–1996*. Exh. pamphlet. New York: The Jewish Museum, 1998.

LAZAR

Lazar, Hava. "Jonah, the Tower, and the Lions: An Eighteenth-Century Italian Silver Book Binding." *Journal of Jewish Art* 3–4 (1977): 58–73.

LEPSZY

Lepszy, Leonard. *Przemysł złotniczy w Polsce*. Cracow: Miejskie Muzeum Przemysłowe, 1929.

LEVIN

Levin, Elaine. *The History of American Ceramics, 1607 to the Present: From Pipkins to Bean Pots to Contemporary Forms*. New York: Harry N. Abrams Publishers, 1988.

LEVINE

Levine, Lee. "The Menorah in the Ancient Synagogue." In *In the Light of the Menorah: Story of a Symbol*, edited by Yael Israeli, 109–12. Jerusalem: Israel Museum, 1999.

LILEYKO

Lileyko, Halina. *Srebra warszawskie w zbiorach Muzeum Historycznego m. st. Warszawy*. Warsaw: Państwowe Wydawnictwo Naukowe, 1979.

LOCKNER

Lockner, Hermann P. *Die Merkzeichen der Nürnberger Rotschmiede*. Munich: Deutscher Kunstverlag, 1981.

MANN 1982

Mann, Vivian B. *A Tale of Two Cities: Jewish Life in Frankfurt and Istanbul, 1750–1870*. New York: The Jewish Museum, 1982.

MANN 1983

Mann, Vivian B. "Symbols of the Legacy: Community Life." In *The Precious Legacy: Judaic Treasures from the Czechoslovak State Collections*, edited by David Altshuler, 110–63. New York: Summit Books, 1983.

MANN 1986

Mann, Vivian B. "The Golden Age of Jewish Ceremonial Art in Frankfurt: Metalwork of the Eighteenth Century." *Leo Baeck Institute Year Book* 31 (1986): 389–403.

MANN 1989A

Mann, Vivian B. "The Arts of Jewish Italy." In *Gardens and Ghettos: The Art of Jewish Life in Italy*, edited by Vivian B. Mann, 46–65. Berkeley and Los Angeles: University of California Press, 1989.

MANN 1989B

Mann, Vivian B., ed. *Gardens and Ghettos: The Art of Jewish Life in Italy*. Berkeley and Los Angeles: University of California Press, 1989.

MANN 2000A

Mann, Vivian B., ed. *Morocco: Jews and Art in a Muslim Land*. London: Merrell Publishers, 2000.

MANN 2000B

Mann, Vivian B., ed. *Jewish Texts on the Visual Arts*. Cambridge: Cambridge University Press, 2000.

MANN AND COHEN

Mann, Vivian B., and Richard I. Cohen, eds. *From Court Jews to the Rothschilds: Art, Patronage, and Power, 1600–1800*. Munich and New York: Prestel, 1996.

MANN AND GUTMANN

Mann, Vivian B., and Joseph Gutmann. *Danzig 1939: Treasures of a Destroyed Community*. New York: The Jewish Museum, 1980.

MARTYNA

Martyna, Ewa. *Judaica w zbiorach Muzeum Narodowego w Warszawie*. Warsaw: Muzeum Narodowe w Warszawie, 1993.

MEIER

Meier, Richard. Acceptance speech as the Pritzker Architecture Prize Laureate, 1984. http://www.pritzkerprize.com/meier.htm.

MESHORER

Meshorer, Yaakov. *Coins Reveal*. New York: The Jewish Museum, 1983.

METZGER AND METZGER

Metzger, Mendel, and Therese Metzger. *Jewish Life in the Middle Ages: Illuminated Hebrew Manuscripts of the Thirteenth to the Sixteenth Centuries*. New York: Alpine, 1982.

MICKENBERG

Mickenberg, David. *Songs of Glory: Medieval Art from 980 to 1500*. Oklahoma City: Oklahoma Museum of Art, 1985.

MILANO

Milano, Attilio. *Storia degli ebrei in Italia*. Turin: Giulio Einaudi Editore, 1963.

MILDENBERGER

Mildenberger, Hermann. *Jüdisches Museum Rendsburg*. Rendsburg, Germany: Jüdisches Museum Rendsburg, 1988.

MINNEAPOLIS

University Art Museum. *American Studio Ceramics, 1920–1950*. Minneapolis: University Art Museum, University of Minnesota, 1988.

MITTEILUNGEN

"Aus unseren Sammlungen. II." *Mitteilungen der Gesellschaft für jüdische Volkskunde*, no. 1 (1899): 3–40.

MOSES

Moses, Elizabeth. "Jüdische Kult- und Kunstdenkmäler in den Rheinlanden." *Aus der Geschichte der Juden im Rheinland: Jüdische Kult- und Kunstdenkmäler* 24, Heft 1 (1931): 99–200.

MUCHAWSKY-SCHNAPPER 1982

Muchawsky-Schnapper, Ester. "Oil Sabbath-Lamps and Hanukah-Lamps of Stone from the Yemen." *Journal of Jewish Art* 9 (1982): 76–83.

MUCHAWSKY-SCHNAPPER 2000

Muchawsky-Schnapper, Ester. *The Yemenites: Two Thousand Years of Jewish Culture*. Jerusalem: Israel Museum, 2000.

MULLER-LANCET

Muller-Lancet, Aviva. *Bokhara*. Jerusalem: Israel Museum, 1967.

MULLER-LANCET AND CHAMPAULT

Muller-Lancet, Aviva, and Dominique Champault, eds. *La vie juive au Maroc*. Jerusalem: Israel Museum; Tel Aviv: Editions Stavit, 1986.

NADOLSKI

Nadolski, Dieter. *Altes Gebrauchszinn*. Leipzig: Edition Leipzig, 1983.

NAHON

Nahon, Umberto. *Holy Arks and Ritual Appurtenances from Italy in Israel.* Tel Aviv: Devir Publishing House, 1970.

B. NARKISS 1988

Narkiss, Bezalel. "The Gerona Hanukkah Lamp: Fact and Fiction." *Jewish Art* 14 (1988): 6–15.

M. NARKISS

Narkiss, Mordecai. *Menorat ha-Ḥanukah* (with English summary). Jerusalem: National Bezalel Museum, 1939.

NEUBECKER

Neubecker, Otto. *A Guide to Heraldry.* New York, St. Louis, and San Francisco: McGraw-Hill Book Company, 1979.

NEUWIRTH

Neuwirth, Waltraud. *Lexikon Wiener Gold- und Silberschmiede und ihre Punzen, 1867–1922.* Vienna: Dr. Waltraud Neuwirth, 1976.

NEWBERY, BISACCA, AND KANTER

Newbery, Timothy J., George Bisacca, and Laurence B. Kanter. *Italian Renaissance Frames.* New York: The Metropolitan Museum of Art, 1990.

OPOLOVNIK AND OPOLOVNIKA

Opolovnik, Alexander, and Yelena Opolovnika. *The Wooden Architecture of Russia: Houses, Fortifications, and Churches.* Edited by David Buxton. London: Thames and Hudson, 1989.

O'REILLY'S 1967A

O'Reilly's Plaza Art Galleries. *Judaica: Gold, Silver, Pewter, Brass, and Other Ritual Objects from the Collection of Joseph Hershkowitz and Others* (June 8, 1967).

O'REILLY'S 1967B

O'Reilly's Plaza Art Galleries. *Judaica: Gold, Silver, Pewter, and Brass Ceremonial Objects from the Collection of Herman Lowenthal and Others, including S. Bernstein and M. Kaufman* (November 16, 1967).

OTTOMEYER AND PRÖSCHEL

Ottomeyer, Hans, and Peter Pröschel. *Vergoldete Bronzen: Die Bronzearbeiten des Spätbarock und Klassizismus.* Munich: Klinkhardt und Biermann, 1986.

PARKE-BERNET 1949

Parke-Bernet Galleries, New York. *Jewish Ritual Silver and Other Hebraica* (December 6, 1949).

PARKE-BERNET 1950

Parke-Bernet Galleries, New York. *Pre-Columbian Pottery, Gothic and Renaissance Art, Jewish Ritual Silver* (October 19, 1950).

PARKE-BERNET 1957

Parke-Bernet Galleries, New York. *Judaica Including Gold and Silver Ritual Objects from the Collection of Tullio Castelbolognesi* (February 14, 1957).

PARKE-BERNET 1959

Parke-Bernet Galleries, New York. *The Notable Art Collection of Felix Kramarsky* (January 7–10, 1959).

PARKE-BERNET 1960

Parke-Bernet Galleries, New York. *Judaica: Silver and Gold and Other Ritual Objects* (May 11, 1960).

PARKE-BERNET 1964

Parke-Bernet Galleries, New York. *The Michael M. Zagayski Collection of Rare Judaica* (March 18–19, 1964).

PARKE-BERNET 1970

Parke-Bernet Galleries, New York. *From the Collection of the Late Ignat Mahler* (May 20, 1970).

PARKE-BERNET 1978

Parke-Bernet Galleries, New York. *Judaica and Other Works of Art* (February 14, 1978).

PARKE-BERNET 1980

PB Eighty-Four, New York. *Judaica and Related Works of Art* (May 6, 1980).

PAZZI

Pazzi, Piero. *I punzoni dell'argenteria e oreficeria veniziana.* Venice: Monastero de San Lazzaro degli Armeni, 1990.

PECHSTEIN

Pechstein, Klaus. *Deutsche Gold-Schmiedekunst vom 15. bis zum 20. Jahrhundert aus dem Germanischen Nationalmuseum.* Berlin: Verlag Willmuth Arenhövel, 1987.

PHILLIPS 1996

Phillips, New York. *Fine Judaica, Hebrew Books, and Works of Art* (November 26, 1996).

PINKERFELD

Pinkerfeld, Jacob. *The Synagogues of Italy.* Jerusalem: Bialik Institute, 1954.

PLOUS

Plous, Anita. *Feast of Lights: Art and Tradition of Hanukkah Lamps.* Detroit: Janice Charach-Epstein Museum/Gallery, Jewish Community Center of Metropolitan Detroit, 1992.

PORADA

Porada, Edith. *The Art of Ancient Iran: Pre-Islamic Cultures.* New York: Crown Publishers, 1965.

PRESSLER AND STRAUB

Pressler, Rudolf, and Robin Straub. *Biedermeier-Möbel.* Munich: Battenberg Verlag, 1986.

PULKA

Pulka, Wesley. "Sculptors Explore Twentieth-Century Avant Garde Concepts." *Albuquerque Journal,* July 28, 1996.

PURIN 1998
Purin, Berhnard. "... *Ein Schatzskästlein alter jüd-ischer Geschichte": Die Sammlung Gundelfinger im Jüdischen Museum Franken.* Fürth: Jüdisches Museum Franken—Fürth und Schnaittach, 1998.

PUTÍK
Putík, Alexander. "The Origin of the Symbols of the Prague Jewish Town. The Banner of the Old-New Synagogue. David's Shield and the 'Swedish' Hat." *Judaica Bohemiae* 29 (1993): 4–37.

RABATÉ AND RABATÉ
Rabaté, Jacques, and Marie-Rose Rabaté. *Bijoux du Maroc: Du haut Atlas à la vallée du Draa.* Aix-en-Provence: Sarl Édisud, 1996.

RABATÉ AND GOLDENBERG
Rabaté, Marie-Rose, and André Goldenberg. *Bijoux du Maroc: Du haut Atlas à la Méditerranée.* Aix-en-Provence: Sarl Édisud, 1999.

RADOVANOVIĆ AND MIHAILOVIĆ
Radovanović, Vojislava, and Milica Mihailović. *Jewish Customs: The Life Cycle.* Belgrade: Federation of Jewish Communities of Yugoslavia and Jewish Historical Museum Belgrade, 1998.

RAINWATER
Rainwater, Dorothy T. *Encyclopedia of American Silver Manufacturers.* 3rd rev. ed. West Chester, Penn.: Schiffer Publishing, 1986.

RAPHAËL AND WEYL
Raphaël, Freddy, and Robert Weyl. *Juifs en Alsace: Culture, société, histoire.* Toulouse: Edouard Privat, 1977.

REITZNER
Reitzner, Viktor. *Alt-Wien-Lexikon für Österreich-ische und süddeutsche Kunst und Kunstgewerbe.* Band 3, *Edelmetalle und deren Punzen.* Vienna: Viktor Reitzner, 1952.

REJDUCH-SAMKOWA AND SAMEK
Rejduch-Samkowa, Izabella, and Jan Samek. "Judaika w zbiorach Muzeum Uniwersytetu Jagiellońskiego: 1. Wyroby z kamienia i metali." *Zeszyty Naukowe Uniwersytetu Jagiellońskiego: Opuscula Musealia* 8 (1996): 112–33.

REZAK
Rezak, Ira. "The Samuel Friedenberg Project: A Privately Commissioned Medallic Jewish Hall of Fame c. 1940." *Médailles* (2001): 99–113.

RHEINISCHER VEREIN
Rheinischer Verein für Denkmalpflege und Heimatschutz. *Aus der Geschichte der Juden im Rheinland: Jüdische Kult- und Kunstdenkmäler* 24, Heft 1 (1931).

RIJKSMUSEUM
Rijksmuseum, Amsterdam. *Koper en brons: Onno ter kuile.* Amsterdam: Rijksmuseum; The Hague: Staatsuitgeverij, 1986.

ROHRWASSER
Rohrwasser, Alfred. *Österreichs Punzen: Edelmetall-Punzierung in Österreich von 1524 bis 1987.* 2nd ed. Perchtoldsdorf, Austria: Verlag Johann L. Bondi und Sohn, 1987.

ROLAND
Roland, Joan G. "The Jews of India: Communal Survival or the End of a Sojourn?" *Jewish Social Studies* 42, no. 1 (1980): 75–90.

RONNEN
Ronnen, Meir. "Hanukka Lamps from Frederick's Battlefields." *Jerusalem Post Magazine*, December 7, 1979.

ROSENAN
Rosenan, Naftali. *L'Année juive.* Zurich: Genossen-schaftsdruckerei, 1976.

ROTH 1974
Roth, Cecil. Introduction to *Catalogue of the Permanent and Loan Collections of the Jewish Museum London*, edited by R. D. Barnett, xiii–xix. London: Harvey Miller; New York: New York Graphic Society, 1974.

RUBENS
Rubens, Alfred. *A History of Jewish Costume.* New York: Crown Publishers, 1973.

SALVIONI
Salvioni, Diana. "Joel Otterson: Caution: Objects in This Mirror May Be Closer Then [sic] They Appear!" *Flash Art* (April 1987): 76–77.

SAMEK 1993A
Samek, Jan. *A History of the Gold and Silver Crafts in Poland.* Warsaw: Interpress, 1993.

SAN FRANCISCO
Jewish Museum of San Francisco. *Light Interpretations: A Hanukkah Menorah Invitational.* San Francisco: Jewish Museum of San Francisco, 1995.

SÄNGER
Sänger, Reinhard W. *Das deutsche Silber-Besteck.* Stuttgart: Arnold'sche Verlagsanstalt, 1991.

SAUNDERS
Saunders, Nicholas J. "Trench Art: Symbols and Memories of the Great War and Beyond." *Hellfire Corner: Tom Morgan's Great War Web-Pages.* http://www.hellfire-corner.demon.co.uk/saunders.htm.

SAVAGE
Savage, George. *Forgeries, Fakes, and Reproductions.* New York and Washington, D.C.: Frederick A. Praeger, 1963.

SCHAFTER ROCKLAND
Schafter Rockland, Mae. *The Hanukkah Book.*
New York: Schocken Books, 1975.

SCHEFFLER *HESSENS*
Scheffler, Wolfgang. *Goldschmiede Hessens: Daten, Werke, Zeichen.* Berlin and New York: Walter de Gruyter, 1976.

SCHLEE
Schlee, Ernst. *German Folk Art.* Tokyo, New York, and San Francisco: Kodansha International, 1980.

SCHLIEMANN
Schliemann, Erich, ed. *Die Goldschmiede Hamburgs.* Hamburg: Verlag Schliemann, 1985.

SCHMUTTERMEIER
Schmuttermeier, Elisabeth. "The Central European Cast Iron Industries." In *Cast Iron from Central Europe, 1800–1850,* edited by Elisabeth Schmuttermeier, 75–85. New York: Bard Graduate Center for Studies in the Decorative Arts, 1994.

SCHNÜTGEN-MUSEUMS
Schnütgen-Museums der Stadt Köln. *Rhein und Maas: Kunst und Kultur, 800–1400.* Köln: Schnütgen-Museums der Stadt Köln, 1972.

SCHOENBERGER 1937
Schoenberger, Guido. "Ein Gang durch die Sammlung Nauheim." In *Siegmund Nauheim und seine Sammlung,* edited by Hermann Gundersheimer, 6–20. Frankfurt: Museum Jüdischer Altertümer in Frankfurt am Main, 1937.

SCHOENBERGER 1951
Schoenberger, Guido. "A Silver Sabbath Lamp from Frankfort-on-the-Main." In *Essays in Honor of Georg Swarzenski,* edited by Oswald Goetz, 189–97. Chicago: Henry Regnery in cooperation with Verlag Gebr. Mann, Berlin, 1951.

SCHOENBERGER AND FREUDENHEIM
Schoenberger, Guido, and Tom L. Freudenheim. *The Silver and Judaica Collection of Mr. and Mrs. Michael M. Zagayski.* New York: The Jewish Museum, 1963.

SCHOLTER-NEES AND JÜTTNER
Scholter-Nees, Mechtilde, and Werner Jüttner. *Niederrheinische Bauertöpferie 17.–19. Jahrhundert.* Dusseldorf: Rheinland-Verlag, 1971.

SCHOONHEIM
Schoonheim, F. *De joodse gemeente van Edam, 1779–1886.* Edam: Vereniging oud Edam, 1989.

SCHUBERT
Schubert, Kurt, et al. *Das Österreichische Jüdische Museum.* Eisenstadt: Österreichische Jüdische Museum in Eisenstadt, 1988.

SCHWARZ 1913
Schwarz, Karl. "Arnold Zadikow." *Ost und West,* 13. Jahrgang (1913): 779–90.

SCHWARZ 1928
Schwarz, Karl. *Die Juden in der Kunst.* Berlin: Welt-Verlag, 1928.

SCHWARZ 1949
Schwarz, Karl. *Jewish Artists of the Nineteenth and Twentieth Centuries.* New York: Philosophical Library, 1949.

SCHWARZ N.D.
Schwarz, Karl. "Der Bildhauer Arnold Zadikow: Zu seiner Ausstellung im Rahmen der internationalen Kunstschau anlässlich des 'anno santo' in Rom." N.p., n.d.

SED-RAJNA
Sed-Rajna, Gabrielle. *Jewish Art.* New York: Harry N. Abrams, 1997.

SELING
Seling, Helmut. *Die Kunst der Augsburger Goldschmiede, 1529–1868.* Munich: Verlag C. H. Beck, 1980.

SELZ
Selz, Peter. *Art in Our Times: A Pictorial History, 1890–1980.* New York: Harry N. Abrams, 1981.

SHACHAR 1981
Shachar, Isaiah. *Jewish Tradition in Art: The Feuchtwanger Collection of Judaica.* Jerusalem: Israel Museum, 1981.

SHARONI-PINHAS
Sharoni-Pinhas, Eidit. "Menorot Ḥanukah mei-Baghdad: Aspaklaryah l'Yaḥasei Yehudim-Muslamim." In *Bein Yahadut l'Islam ba-R'i Ha-Amanut,* edited by Shalom Sabar, 44–48. Jerusalem: Center for Jewish Art, 1995.

SHELDON AND GEFFEN
Sheldon, Margaret, and David Geffen. *Temple Israel Chanukah Exhibit.* Exh. pamphlet. Scranton, Penn.: Temple Israel, 1993.

SHILO-COHEN 1982
Shilo-Cohen, Nurit, ed. *"Bezalel" shel Shatz.* Jerusalem: Israel Museum, 1982.

SHILO-COHEN 1983A
Shilo-Cohen, Nurit. "The Problem of Identifying and Dating Bezalel Objects." In *Bezalel, 1906–1929,* edited by Nurit Shilo-Cohen, 247–82. Jerusalem: Israel Museum, 1983.

SHILO-COHEN 1983C
Shilo-Cohen, Nurit, ed. *Bezalel, 1906–1929.* Jerusalem: Israel Museum, 1983.

SIGAL

Sigal, Laurence. *Musée d'art et d'histoire du Judaïsme: The Guide.* Paris: Imprimerie Blanchard, Le Plessis-Robinson, 1999.

SKIRBALL

Skirball Cultural Center. *Homecoming to the Holy Land: New Works by Moshe Zabari.* Los Angeles: Skirball Cultural Center, 1998.

SLAPAK

Slapak, Orpa. *The Jews of India: A Story of Three Communities.* Jerusalem: Israel Museum, 1995.

SMITH

Smith, Penny. "Fast Forward: The Work of Peter Shire." *Ceramics, Art, and Perception,* n.d. http://www.ceramicart.com.au/shire.htm.

SOTHEBY'S LONDON 1988

Sotheby's London. *Judaica Books, Manuscripts, and Works of Art* (May 5–6, 1988).

SOTHEBY'S NY 1981

Sotheby's New York. *Good Judaica and Related Works of Art* (May 13, 1981).

SOTHEBY'S NY 1985A

Sotheby's New York. *Property from the Fowler Museum* (February 14–16, 1985).

SOTHEBY'S NY 1985B

Sotheby's New York. *Important Judaica: Books, Manuscripts, and Works of Art* (June 26, 1985).

SOTHEBY'S NY 1986A

Sotheby's New York. *Important Judaica: Books, Manuscripts, and Works of Art* (May 28, 1986).

SOTHEBY'S NY 1986B

Sotheby's New York. *Important Judaica: Books, Manuscripts, and Works of Art* (December 18, 1986).

SOTHEBY'S NY 1987

Sotheby's New York. *Important Judaica: Books, Manuscripts, and Works of Art* (December 14, 1987).

SOTHEBY'S NY 1989

Sotheby's New York. *Important Judaica, Books, Manuscripts, and Works of Art* (December 18, 1989).

SOTHEBY'S NY 1990

Sotheby's New York. *Important Judaica: Books, Manuscripts, and Works of Art* (June 25, 1990).

SOTHEBY'S TA 1987

Sotheby's Tel Aviv. *Judaica: Books, Manuscripts, and Works of Art* (May 24, 1987).

SOTHEBY'S TA 1990

Sotheby's Tel Aviv. *Important Judaica: Books, Manuscripts, Works of Art, and Paintings* (April 18–19, 1990).

SOTHEBY'S TA 1991

Sotheby's Tel Aviv. *Important Judaica: Books, Manuscripts, Works of Art, and Paintings* (October 2, 1991).

SOTHEBY'S TA 1993

Sotheby's Tel Aviv. *Important Judaica: Books, Manuscripts, Works of Art, and Paintings* (October 5, 1993).

SOTHEBY'S TA 1995A

Sotheby's Tel Aviv. *Judaica* (April 23, 1995).

SOTHEBY'S TA 1996A

Sotheby's Tel Aviv. *Important Judaica* (April 12, 1996).

SOTHEBY'S TA 1998A

Sotheby's Tel Aviv. *Important Judaica* (April 15, 1998).

SOTHEBY'S TA 1998B

Sotheby's Tel Aviv. *Important Judaica* (November 9, 1998).

SOTHEBY'S TA 1999

Sotheby's Tel Aviv. *Magnificent Judaica* (December 9, 1999).

SOTHEBY'S TA 2000

Sotheby's Tel Aviv. *Magnificent Judaica* (October 25, 2000).

SOTHEBY'S TA 2001A

Sotheby's Tel Aviv. *Magnificent Judaica* (April 17, 2001).

SOTHEBY'S TA 2001B

Sotheby's Tel Aviv. *Judaica* (October 11, 2001).

STAATLICHES MUSEUM SCHWERIN

Staatliches Museum Schwerin. *Kunst und Reformation: Schloss Güstrow, 4. Juni–25. Juli 1999.* Schwerin, Germany: Staatliches Museum, 1999.

SWANN 1989

Swann Galleries, New York. *Hebraica and Judaica* (June 25, 1989).

SWEDLER

Swedler, Harley. "Unione e delimitazione: Art and Judaism." *L'Arca* (February 1993): 103.

TARDY 1980

Tardy. *Les Poinçons de garantie internationaux pour l'argent.* 13th ed. Paris: Tardy, 1980.

TOAFF

Toaff, Alfredo. "Il Museo della Comunità Israelitica." *Liburni civitas: Rassegna di attività municipale a cura del comune de Livorno* 4, fasc. 2 (1931): 87–99.

UNGERLEIDER MAYERSON

Ungerleider Mayerson, Joy. *Jewish Folk Art from Biblical Days to Modern Times.* New York: Summit Books, 1986.

URITSKAYA

Uritskaya, Ludmila. "Ashkenazi Jewish Collections of the State Ethnographic Museum in St. Petersburg." In *Tracing An-Sky: Jewish Collections from the State Ethnographic Museum in St Petersburg*, edited by Mariëlla Beukers and Renée Waale, 24–57. Zwolle: Uitgeverij Waanders; St. Petersburg: State Ethnographic Museum; Amsterdam: Joods Historisch Museum, 1992.

VARSHAVSKAYA

Varshavskaya, Margarita, et al. *Treasures of the Torah from the Collection of the Historical Treasures Museum of the Ukraine*. Kiev: Historical Treasures Museum of the Ukraine, 2000.

VICTOR

Victor, Stephen K. " 'From the Shop to the Manufactory': Silver and Industry, 1800–1970." In *Silver in American Life*, edited by Barbara McLean Ward and Gerald W. R. Ward, 23–32. New York: American Federation of Arts, 1979.

VOET

Voet, Elias. *Merken van Haagsche goud- en zilversmeden;Voorafgegaan door Haagsche goud- en zilversmeden uit de XVIe, XVIIe, en XVIIIe eeuw door H. E. van Gelder*. The Hague: Nijhoff, 1941.

WAALE

Waale, Renée. *Light: Contemporary Design in Jewish Ceremony*. Amsterdam: Joods Historisch Museum, 1988.

WACHTEN

Wachten, Johannes, ed. *Jüdisches Museum Frankfurt am Main*. Munich and New York: Prestel, 1997.

WEBER

Weber, Annette. "Splendid Bridal Gifts from a Sumptuous Wedding Ceremony of 1681 in the Frankfurt Judengasse." *Jewish Art* 19/20 (1993/94): 168–79.

WEINSTEIN

Weinstein, Jay. *A Collector's Guide to Judaica*. New York: Thames and Hudson, 1985.

WEISER

Weiser, Sharon, ed. *And I Crown You with Wreaths . . .* Jerusalem: International Judaica Design Competition, 1996.

WEISSMAN JOSELIT

Weissman Joselit, Jenna. "'Merry Chanuka': The Changing Holiday Practices of American Jews, 1880–1950." In *The Uses of Tradition: Jewish Continuity in the Modern Era*, edited by Jack Wertheimer, 303–25. New York and Jerusalem: Jewish Theological Seminary of America, 1992.

WEIZMAN

Weizman, Sandra Morton. *Artifacts from "A Coat of Many Colours: Two Centuries of Jewish Life in Canada."* Hull, Quebec: Canadian Museum of Civilization, 1990.

WILSON, PILGRIM, AND TASHJIAN

Wilson, Richard Guy, Dianne H. Pilgrim, and Dickran Tashjian. *The Machine Age in America, 1918–1941*. New York: Harry N. Abrams, 1986.

WISCHNITZER

Wischnitzer, Mark. *A History of Jewish Crafts and Guilds*. New York: Jonathan David, 1965.

WISWE

Wiswe, Mechthild. *Hausrat aus Messing und Kupfer aus dem Braunschweigischen Landesmuseum*. Braunschweig, Germany: Braunschweigisches Landesmuseum, 1980.

WIXOM

Wixom, William D. *Renaissance Bronzes from Ohio Collections*. Cleveland: Cleveland Museum of Art, 1975.

WOLF

Wolf, Albert. "Etwas über jüdische Kunst und ältere jüdische Künstler." *Mitteilungen der Gesellschaft für jüdische Volkskunde* 9, no. 1 (1902): 12–74.

WÜRTTEMBERGISCHES 1894/95

Württembergisches Metallwarenfabrik. *Musterbuch der Württembergischen Metallwaren-fabrik Geislingen-St.* Geislingen an der Steige, Germany: Württembergisches Metallwarenfabrik, 1894/95.

YOUNG

Young, Bonnie. *A Walk through the Cloisters*. New York: The Metropolitan Museum of Art, n.d.

ZABARI

Zabari, Moshe. "M Zabari." In *Moshe Zabari: A Twenty-Five Year Retrospective*, by Nancy M. Berman, 35. New York: The Jewish Museum; Los Angeles: Hebrew Union College Skirball Museum, 1986.

ZHOLTOVSKIY

Zholtovskiy, P. M. *Khudozhne littia na Ukraini XIV–XVIII st*. Kiev: Naukova Dumka, 1973.

INDEX

maker's mark, use of term, 3

Makhir, Moshe N., 30

"Ma'oz Tzur" (traditional Hanukkah
 song), 207

Maria Theresa, empress of Austria,
 24, 74, 91, 219

marks, use of term, 3

Masada (Zabari), 27, 187, **200**

Mattathias, 7

McCaslin, Matthew, 187

 Being the Light, 187, 214, **215**

McNarney, Joseph T., 32, 89

Meier, Richard, lamp by, **203**

Meiri, Menahem ben Solomon, 10,
 16

menorah, seven-branch, 18–19

 on burial plaque, **14**

 definition of term, 1, 188

 in desert Tabernacle, 18

 function of, 128

 on Hanukkah lamps, 10

 as lampstand for separate lights,
 14–15

 supported by lions, 25

 symbolism of, 10, 11, 18–19,
 25, 94

menorah-form Hanukkah lamps,
 13–15, 18–19

 in circle, **181**

 as converter lamps, 92, 142

 in synagogues, 18–19, 114, 128

Menorah #7 (Shire), 204, **205**

metalworking techniques

 dapping, 45, 53

 filigree, 133

 lost-wax casting, 103, 104, 163

 parcel-gilding, 2

 punching, 2

 repoussé, 2, 44, 105, 164

 sand casting, 103, 124

 tracing, 2

 wrigglework, 71, 165

mezuzot, 160, 165

Middle East

 copper-alloy lamps, 30

 map, 168

 stone lamps, 174

 see also Iraq; Israel

Mintz, Rose and Benjamin, **34**, 35

Mintz Collection, 35, 147

Mishnah, 8, 24

Miss Liberty (Rockland Tupa), 201,
 202

Mizrahi Jews, 8, 122

Moorish revival style, 22

Moravia, *see* Bohemia/Moravia

Mordecai, 207

Morocco, 155–166

 Atlas Mountains, lamp, 159

 cast oil rows, 164

 coastal region, lamps, 162, 163

 copper-alloy lamps, 159–164

 design elements in, 157, 159

 Dutch style in lamps, 44, 157, 164

 Essaouira, 158

 Fez, 161

 Jewish community in, 155

 lamp of Italian style, 157, **163**

 lamp with floral scrollwork, **161**

 lamp with *hamsa*, 44, 157, **164**

 lamp with "kidney bean" holes,
 27, 157, **159**

 lamp with menorah and vases,
 157, **160**

 lamp with towers, 22, 103, 157,
 162

 mezuzah covers in, 165

 pierced silver lamp, 27, **165**

 Schulmann's work in, 156

 sheet-metal lamps, 44, 164

 silver lamps, 158, 165

 silver lamp with gilt appliqué
 rosettes, 32, **158**

 stone lamps, 174

 Tétouan, 160

 see also North Africa

Moses, 21, 68, 135

Moses Maimonides, 6, 31

Muche, Christian Gottlieb, lamp with
 Judith image, **74**

Münster, 79

Myers, Myer, 13

Nabratein, Israel, Torah ark fragment,
 24, **25**

Natzler, Gertrud, 186, 198

Natzler, Otto, 186, 198

 ceramic lamp, 186, 198, **199**

Neoclassicism, 22, 27, 78, 80, 82, 135

neo-Gothic style, 22, 27, 97

Netherlands, 43–55

 Amsterdam, 46–50

 bed-warming pans, **218**

 Bravo lamp, Jamaica, 31, 43,
 49–50, **49**, 103

 coats of arms on lamps, 25

 copper-alloy lamps, 30, 43–45,
 46–50, 52–54

 The Hague, 51

Hermans lamp, **55**

Jewish settlements in, 43, 46,
 48, 51

Judith as symbol on lamps, 24

lamp made from bed-warming
 pan, 218, **218**

lamp with figures holding tapers,
 48

lamp with hearts and ewer, **47**

lamp with menorah, **53**

lamp with pelican piercing her
 breast, 16, **46**

lamp with sunflowers, **52**

menorah-form synagogue lamp,
 54

and North Africa, 157

Reynier de Haan lamp, 23, 26,
 43, **51**

silver lamps, 43, 51

stoneware lamp, **55**

tulip mania in, 47

New Bezalel School, Jerusalem, 27,
 168

Nördlingen, Rabbi Joseph Juspa
 Hahn, 30, 57

Norman architecture, 22

North Africa, 155–165

 Algeria, 155, 157

 architectural elements in lamps,
 22

 coastal region, lamps, 162, 163

 common elements in, 156–157,
 159, 163

 copper-alloy lamps, 30

 dating procedures, 155

 decorative styles in, 27

 Dutch style in lamps, 44, 157, 164

 Italian types of lamps in, 157, 159,
 163

 map, 156

 Morocco, 155–166

 see also Morocco

 Tunisia, 155, 157

North America

 Jewish settlers in, 185

 see also United States

Nuremberg, 30, 58, 67, 77

oil

 miracle of, 10–11, 47, 74, 108

 as precious commodity, 10, 31, 44

oil containers, 58, 76, 92, 103, **112**,
 148, 163

oil lamps, ancient, 14, **14**

trench art, 217, 221, **221**

Truman, Harry S., 32, **32**

Tunisia

 design elements in, 157

 Jewish community in, 155

 see also North Africa

Turkey

 Ottoman Empire, 167, 169, 180

 tin lamps, 31

 treaty of Austria and, 91

Twelve Tribes of Israel, 24, 86, **87**

Ukraine

 architectural elements in lamps,
 119

 Barukh of Pohrebyshche, 12, **12**,
 120

 chandeliers, 138

 double-headed eagle, 140

 folk art, 119, **130**

 see also eastern Europe

United States, 188–193, 198–215

 Baer lamp, 212, **213**

 Brooklyn Jewish Center, 191

 copper and copper-alloy lamps,
 192, 193, 196, 203

 earthenware lamp, 198

 Gorham silver lamp, **188**

 Ivriah lamp, 186, **192**

 Jewish populations in, 185, 188

 lamp with lions and menorah,
 189, **189**

 Machine Age lamp, 27, 186, **193**

 McCaslin lamp, 187, 214, **215**

 Meier lamp, **203**

 menorah-form lamps, 186, **188**

 mixed media, 201, 204, 208–215

 Natzler lamp, 186, 198, **199**

 Otterson lamp, 187, 208, **209**

 Rawet lamp, 210–211, **210–211**

 Revolutionary War, 219

 Rockland Tupa lamp, 201, **202**

 Shire lamp, 204, **205**

 silver lamps, 186, 188, 189, 191,
 195, 197, 200

 "sterling" marks in, 118, 191

 Swedler lamps, 15, 21, 206–207,
 206, 207

 tin lamp, 190, **190**

 Torah ark form lamp, 185, **191**

 Wolpert lamps, 27, 168, 186,
 195–197, **195, 196, 197**

 Zabari lamp, 27, 187, **200**

United States Army, 35, 221

Unorthodox Menorah II (Otterson),
 187, 208, **209**

Venice, 102, 105, 159

Vidaurri, Rene A., 221

Vienna, 84, 91, 93–99

wall-mounted Hanukkah lamps,
 with triangular backplate, 16, **16**

Wallnöfer, Joseph, sofa-shaped lamp,
 93

wall sconces, 16, **17**, 44

Warburg family, 33, **33**, 189

Warsaw, 117, 141, 142

Weizmann, Chaim, 33

Weygang, August, 76

Wichers, Nicolaus Lübbert, inkstand,
 20

Wiener Werkstätte, 84

Wissenschaft des Judentums move-
 ment, 33–34

Wolpert, Ludwig Y., 27, 37, **38**, 168,
 186, 200

 hanging silver lamp, 168, 186,
 196, **197**

 menorah-form lamp, 168, 186,
 195–196, **196**

 silver-and-ebony seder plate, 195

 silver lamp with Hebrew inscrip-
 tion, 27, 168, 186, **195**,
 196–197

wrigglework, 71, 165

Wright, Frank Lloyd, 20–21

Württembergisches Metallwarenfab-
 rik, 83, 84

Yafeh, Mordecai, 10

Yemen, stone lamps, 174

Yemenite Jews, 169, 174

Zabari, Moshe, 37, **38**, 186

 Masada, 27, 187, **200**

Zadikow, Arnold, lamp with
 emblems of Twelve Tribes, 86, **87**

Zechariah, 103, 107–108

Zionist movement, 29, 99, 153, 167,
 183

244